Varieties of Modernism

Varieties of Modernism

Edited by **Paul Wood**

Yale University Press, New Haven and London
in association with The Open University

This publication forms part of an Open University course: AA318 *Art of the Twentieth Century.* The complete list of texts which make up this course can be found in the Preface. Details of this and other Open University courses can be obtained from the Course Information and Advice Centre, PO Box 724, The Open University, Milton Keynes MK7 6ZS, United Kingdom: tel. +44 (0)1908 653231; e-mail general-enquiries@open.ac.uk

Alternatively, you may visit the Open University website at http://www.open.ac.uk where you can learn more about the wide range of courses and packs offered at all levels by the Open University.

To purchase a selection of Open University course materials, visit the webshop at www.ouw.co.uk or contact Open University Worldwide, Michael Young Building, Walton Hall, Milton Keynes MK7 6AA, United Kingdom for a brochure. tel. +44 (0)1908 858785; fax +44 (0)1908 858787; e-mail ouwenq@open.ac.uk

Yale University Press The Open University
47 Bedford Square Walton Hall
London Milton Keynes
WC1B 3DP MK7 6AA

First published 2004 by Yale University Press in association with The Open University.

Copyright © 2004 The Open University.

Every effort has been made to trace all copyright owners, but if any have been inadvertently overlooked, the publishers will be pleased to make the necessary arrangements at the first opportunity.

Library of Congress Control Number : 2004105256

ISBN 0–300–10142–2 (cloth)
ISBN 0–300–10296–8 (paper)

Edited, designed and typeset by The Open University.
Printed and bound by CS Graphics, Singapore

1.1

Contents

PART FOUR The Resumption of the Avant-Garde

Preface

This is the third of four books in the series *Art of the Twentieth Century*. Although the books can be read independently and are accessible to the general reader, as a series they form the main texts of an Open University third-level course of the same name.

Varieties of Modernism is concerned with the art of the middle third of the twentieth century. It consists of a short introduction followed by four parts, each of which is organised around a particular issue. The first part focuses on developments in French art during the 1930s, when Paris regained its position at the forefront of the avant-garde after initiatives in Germany and the USSR succumbed to the dictatorships of Hitler and Stalin. Topics discussed include abstraction, Surrealism in France and the Caribbean, and the persistence of an interest in figurative art. The next two parts survey developments in the USA between the 1930s and the 1960s. The first looks at the emergence of Abstract Expressionism out of the socially conscious art of the 1930s, and the second addresses the consolidation of American modernism and the ambivalent position of Minimal Art. The final part discusses the challenge posed to canonical modernism centred on 'autonomous' painting by the emergence of a heterogeneous 'neo-avant-garde' involving performance, installation and a wide-ranging interest in popular culture and the conditions of modern urban life.

All the books in the series include teaching elements. To encourage the reader to reflect on the material presented, most chapters contain short exercises in the form of questions printed in bold type. These are followed by discursive sections, the end of which is marked by a small black square. In addition, cross-references to topics covered in the other books in the series are provided throughout.

The four books in the series are:

> *Frameworks for Modern Art*, edited by Jason Gaiger
>
> *Art of the Avant-Gardes*, edited by Steve Edwards and Paul Wood
>
> *Varieties of Modernism*, edited by Paul Wood
>
> *Themes in Contemporary Art*, edited by Gill Perry and Paul Wood

There is also a companion reader:

> *Art of the Twentieth Century: A Reader*, edited by Jason Gaiger and Paul Wood

Open University courses are the result of a genuinely collaborative process and the book editors would like to thank the following people for their invaluable contributions: Julie Bennett, Kate Clements, Andrew Coleman and Alan Finch, course editors; Pam Bracewell, tutor assessor; Glen Darby and Liz Yeomans, graphic designers; Nicola Durbridge, learning and teaching advisor; Janet Fennell, course assistant; Heather Kelly, course manager; Liam Baldwin, Mary Jane Gibson, Jane Lea, Mariana Sonnenberg and Jo Walton, picture researchers. Special thanks are due to Professor Alex Potts, Department of the History of Art, University of Michigan, who as external assessor for the course read and commented on all the materials throughout the production process.

Introduction

Paul Wood

Varieties of Modernism is the third in a series of four books dealing with the art of the twentieth century as a whole, although each may be read independently. This book discusses the art of the middle third of the twentieth century. Its immediate predecessor provided an introduction to the work of the European modern movement up to the early 1930s, and its successor addresses the 'postmodernism' of the period since the late 1960s. This book is unusual in that it spans the great caesura of the Second World War. Conventionally, art history has divided into 'pre-' and 'postwar' periods, but we have chosen to focus our study of the central years of the twentieth century under a rubric of 'modernism and its others', or, as it might alternatively be conceived, of 'the varieties of modernism'.

Much hinges on how 'modernism' is understood, and there tends generally to be a slippage between relatively inclusive and exclusive usages. The most exclusive sense, which is particularly associated with the writing of the American critic Clement Greenberg and the formalist tradition of which he was part, restricts authentic 'modernism' to an increasingly 'purified' lineage of abstract art. Such art aimed at producing intensified aesthetic effects in spectators through the composition of the forms and colours of the paintings themselves, which were understood as autonomous pictorial entities with, at best, only a secondary reference to the world of physical things. This gave rise to the idea of a modernist 'mainstream', running from the late work of Paul Cézanne, through Henri Matisse and Piet Mondrian to Jackson Pollock, Mark Rothko and others, and culminating in the 1960s. It has become almost routine in recent 'post-modernist' art history and criticism to caricature this approach as involving an arid, even haughty sense of the elevated experience of art: a conception of art as, if not entirely careless of the world, then offering itself as a kind of rarefied compensation for its trials. Even a more sympathetic account would have to concede that modernism in its narrower sense remained focused on the technical and formal properties of the work of art, and its aesthetic effect on the emotions of its 'disinterested' spectator.

According to a broader understanding, 'modernism' becomes a synonym for the wider modern movement in art often described as the 'avant-garde' (another multivalent term with its own problems of definition). On this understanding it denotes the succession of 'isms' ranging from Cubism and Surrealism to Abstract Expressionism, Dada, Pop Art, and many more. These include practices that were marked not so much – or not only – by the pursuit of aesthetic value, as by a variegated and, to the outsider, often eccentric engagement with the multifarious experience of modern life: technology, alienation, commodification, tensions between subjectivity and the collective which mark all our lives – all of us, that is, whose experience has been that of the developed West during the twentieth century.

The first two parts of this book look in detail at aspects of art practice in the 1930s on both sides of the Atlantic. The chapters in Part One discuss the diversity of the situation in Paris (then still the undisputed capital of modern

art) and the 'ethnographic' dimension of Surrealism. In Part Two, the focus shifts to the USA. Chapter 3 engages with debates over artistic realism and modernism in the 1930s, and with how competing senses of modern art became resolved in favour of abstraction under the impact of the Second World War and its aftermath. The emergence of a fully-fledged abstract art in the USA is then discussed, from quite different perspectives, in the following two chapters. Chapter 4 looks at the formal and technical development of the work of Jackson Pollock, and Chapter 5 discusses the implication of Abstract Expressionism in wider contemporary debates about gender, especially those concerning masculine identity.

One of the key issues facing art history of the central years of the twentieth century is the matter of relative continuity or discontinuity between the pre- and post-Second World War situations, and how this should be characterised. After a long period when it was normal to distinguish quite sharply between the 1930s and the 1950s, to play down the social and political dimension of art in the 1930s in favour of a supposedly purified and independent modernist abstraction which flowered after the war, historians have redrawn the picture in two broad ways. On the one hand, they have emphasised the persistent need felt by artists – Realists and avant-gardists alike – to address the overarching conditions of their time. On the other hand, they have traced ways in which even supposedly autonomous abstract art enfolds and embodies many such concerns despite the absence of overt picturing. For example, the question of the identity of the artist is a major issue in considerations of Abstract Expressionism. Art, especially 'modern' art, had never previously enjoyed a particularly prominent place in American culture. After a period of total war, and the permeation of the society by military rhetoric and the supposedly masculine values of courage, plain speaking and controlled aggression, it would be surprising to find American artists adopting the postures of, say, decadent bohemia. Nowhere is this borne out more powerfully than in the welded metal sculpture of David Smith (who worked in a tank factory during the war) (Plate 1). It is hardly surprising that, among artists of the same generation, Jackson Pollock appears to be a roustabout, or Barnett Newman a businessman: these were American types. Cigarette holders, long hair and kidney-shaped palettes would not have been taken very seriously in Manhattan in the late 1940s. Of course, how the dress codes, the heavy drinking, tough talking and so on, are reflected in the art, *and* what their significance is for the spectator, remain open questions.

Attending closely to both text and context – to the production of the work of art and to the circumstances of its production – may show why and how the art of the late 1940s and 1950s remains compelling and interesting today. Even though one can no longer take its own sustaining myths at face value (for example, as a quasi-existentialist rhetoric of man's eternal confrontation with the sublime), it would be hard to imagine any comprehensive account of the art of the twentieth century that did not accord Abstract Expressionism a prominent place.

As well as the question of relative continuity and discontinuity between the art of the 1930s, 1940s and 1950s, another issue that takes on considerable

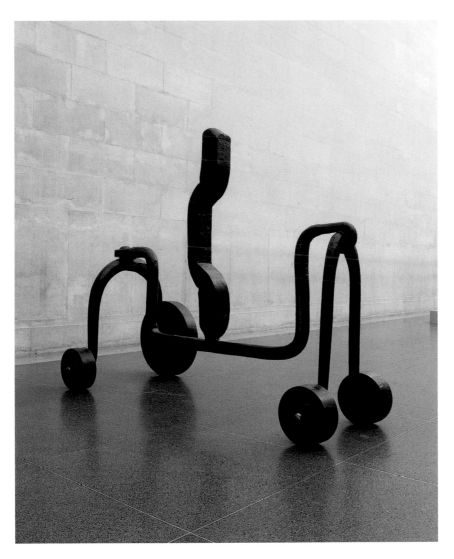

Plate 1
David Smith,
Wagon II, 1964, steel,
273 × 283 × 112 cm.
(© Tate, London
2003. © Estate of
David Smith/VAGA,
New York/DACS,
London 2004.)

importance is the relationship between different parts of the international art world. At the start of the twentieth century, Paris was the centre of the art world. By 1920, Berlin and Moscow had some claim to being at the forefront of the modern movement. Both were eclipsed by dictatorships by the early 1930s, and Paris was again the capital of modern art, but by 1940 France had fallen to Hitler. By 1950, if not earlier, the baton seemed to have passed to New York. That, at any rate, was for long the conventional wisdom. It was this that licensed a sense of the 'triumph' of the New York School, and an equivalent sense that everything else, particularly everything European, had become second-rate: had, in modernist parlance, been relegated from the 'mainstream' to 'provincial'.[1] The sheer scale of the operation of the American art world should not be underestimated: throughout the 1950s, there was a burgeoning art market, a growth in related museums and commercial galleries, and an increasing number of journals devoted to the subject. By the 1960s, the American art world was unquestionably dominating internationally.

Even though recent art history has tended to emphasise such contextual factors, it would be entirely wrong to neglect the impact of the art itself. When American art was first seen abroad on a large scale, often through the touring programmes of the Museum of Modern Art, New York, with considerable covert sponsorship from American government agencies, its impact was genuine; there is too much contemporary testimony to doubt this. Although many in Europe were undoubtedly resistant to the wider American cultural invasion, avant-garde artists were deeply impressed by Pollock and Rothko, and later by Robert Rauschenberg, Jasper Johns and Andy Warhol. The USA holds a contradictory position internationally, not least as culture edges into ideology and politics, but it would be a mistake to allow opposition to American politics to obscure the pre-eminence of American art during the two decades following the Second World War.

Having said that, recent art history has begun to balance the account and to qualify the previously dominant assessment of American influence. After a period in which Abstract Expressionism, Pop Art, minimalism and so forth seemed to eclipse everything else, or at least to provide the stimuli to which everything else was a response, historians have begun to produce more pluralist accounts: accounts concerned to situate avant-garde activities in relation to their own local cultural and political contexts, rather than just in relation to American modernism. The evolution and transformation of art in the 1950s and 1960s forms the subject of Parts Three and Four of this book. Chapters 6, 7 and 8 concentrate on developments in the USA; while continuing the discussion of American art, Chapters 9, 10, 11 and 12 also look at contemporary work in Europe and elsewhere.

Although with hindsight one can see that the art of the early, no less than the later, twentieth century, was marked by a plurality of conflicting tendencies rather than a clear-cut mainstream and various critical subordinates, nonetheless it is hard to deny that modernism in its 'formalist', 'reductive', 'purified' sense was hegemonic. When Greenberg looked back in 1960 and wrote his synoptic essay 'Modernist Painting',[2] it was certainly an exclusive account of what he considered to matter in modern art, but it was not a groundless fantasy. The 'modernist mainstream' did look powerful. Picasso and Matisse were giants. Pollock and Rothko could be regarded as their legitimate descendants. Duchamp was still, by comparison with what came later, a relatively marginal figure; certainly not the avatar of postmodernism that he became. Other figures who have subsequently come to be regarded as important precursors for the art of the late twentieth century remained similarly unsung. Francis Picabia appeared at best a joker (Plate 2). Lucio Fontana seemed peripheral. Hardly anybody had heard of Soviet Constructivism. The main point is that the crisis of the First World War and the Russian Revolution, when some modernists reverted to figuration and others tried to transform their practice beyond 'art' as such, had been weathered. Despite the Wall Street Crash and the rise of dictators, capitalism survived, and so did modern art.

It was the Second World War that stamped the authority of an American-led global system, which eventually wore down its sole competitor through decades of Cold War and aggressive military force. For better or worse, modernism had become the official art of this system, and its counter-currents

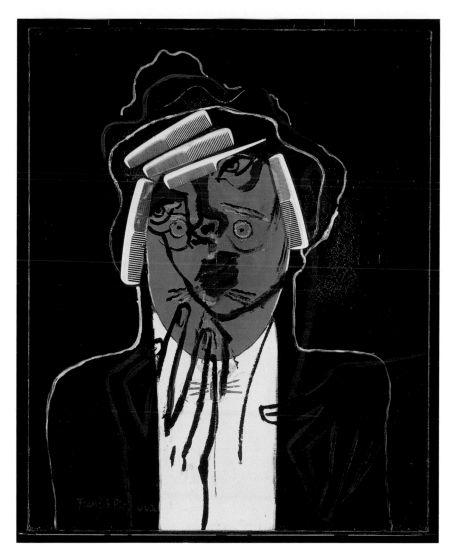

Plate 2
Francis Picabia,
Le Beau Charcutier,
c.1924–6/1929–35,
oil and mixed media
on canvas, 92 × 74 cm.
(© Tate, London
2003. © ADAGP,
Paris and DACS,
London 2004.)

existed within what the philosopher Herbert Marcuse, in relation to political counter-currents, called the 'repressive tolerance' of the system at large.[3] It is worth reminding ourselves that, from that point of view, modernism looked as though it had won through. What the masters of the Italian Renaissance in the fifteenth century achieved was to set in train a system that through the development and codification of the academy was to *be* art in the West for the next four hundred years. There was nothing in 1960 to say that the long struggle to achieve a 'free' and 'independent' modernist art, purified of religion and politics, at home now in a liberal culture that was itself set to become permanent, was not poised to enjoy a long period of development, exploration and stabilisation. No one knew it was going to be dead in a decade.

At this point, the analogy between culture and politics breaks down. Whereas liberal capitalism went from strength to strength, ultimately becoming the global model by the end of the twentieth century, the 'high modernism' discussed in Chapter 6, imploded. Hegel's melancholic adage that 'the owl of Minerva takes wing only at dusk' is borne out nowhere more eloquently

than in the situation of modernism.[4] Greenberg's summative 'Modernist Painting' appeared as a radio talk in 1960 and in its definitive form in 1965. His influential book of essays, *Art and Culture*, was published in 1961.[5] His impact on younger critics, such as Rosalind Krauss and Michael Fried, occurred at the same time and their contributions to modernist theory were in place by the later 1960s. Yet the practice that critical theory subtended, arcing back a century to Manet (the figure nominated by Greenberg as the first modernist), shuddered to a stop within a decade of his text's appearance. No modernist painting of any consequence followed that of Kenneth Noland and Jules Olitski; in fact, it may be argued that Frank Stella had already set the limit of the tradition and that their 'post-painterly abstraction' was, by comparison, already a conservative footnote. No significantly original modernist sculpture (and sculpture had always been modernism's poor relation) followed that of Anthony Caro. It may indeed be argued that the Minimalist objects of the 1960s had already surpassed Caro's formal compositions in space in terms of their interrogation of the limits of the modernist research programme. Indeed, Minimal Art increasingly appears to be a 'crux', to use the term of the critic Hal Foster.[6] A work such as Carl Andre's *Equivalent VIII*, colloquially known as 'the bricks' (Plate 3), could exemplify this point, which simultaneously marked the end of modernist reductionism (into a modular unit such as a brick), and the turn into something else (an installation). The fate of modernist criticism, no less than modernist art, tells a similar story. Greenberg virtually stopped writing apart from a few Olympian 'seminars' on problems of aesthetics. Fried turned to eighteenth- and nineteenth-century art history and, by the mid-1970s, Krauss had developed an explicit 'postmodernism', theorised as such.

In the mid- to late 1960s, modernism's end game was played out both in theory and in practice. This was not merely due to the emergence in the 1950s of a 'neo-avant-garde' consisting of oppositional counter-trends, such as Fluxus and 'happenings'. These were undoubtedly significant in loosening the dominance of canonical medium-specific modernism. But, as we have already remarked, modernism in its hegemonic sense had always had its 'others'. What really confers the sense of a new conjuncture is the fusion of those heterodox practices with a relentless and systematic exploration of modernism's own contradictions: its medium-specificity, its sense of the artistic author, its sense of the artistic spectator and, perhaps above all, its sense of the relation of theory to practice. The new conjuncture consisted in the emergence, in rapid succession, of Minimal and Conceptual Art. What emerged was the 'postmodernist' constellation proper.

Around the time of the First World War, two developments in art that served to map the field of possibilities for the next period occurred almost simultaneously. On the one hand, there was the emergence of abstract painting; on the other, the Duchampian 'readymade'. The former was all essence, its status conferred (according to modernist theory) by its possession of 'significant form';[7] the latter all context, its art status confirmed by being set in a discourse of institutions and texts.

Something comparable happened in the 1960s. Modernist reductionism reached its limit in the simplified minimalist object. Almost immediately artists pushed beyond the object as such, initially to undifferentiated 'stuff' and quickly

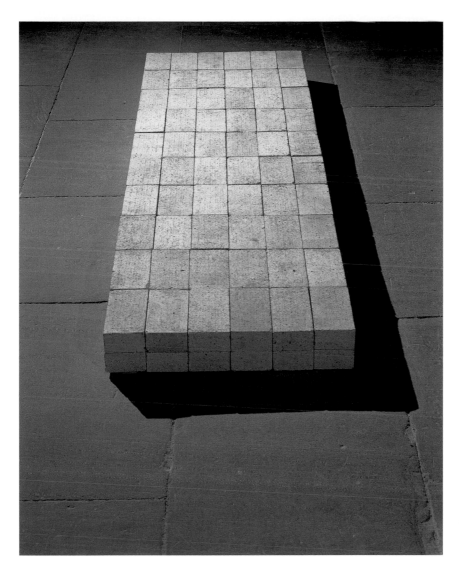

Plate 3
Carl Andre,
Equivalent VIII,
1966, firebricks,
12 × 229 × 68 cm.
(© Tate, London 2003.
© Carl Andre/VAGA,
New York/DACS,
London 2004.)

to all kinds of activities with or without a basis in the articulation or distribution of materials at all. These developments equally rapidly ushered in a full-blown Conceptual Art, initially dedicated to an analysis of the object of art, and then to the practice of art in its widest sense. By the end of the 1960s, the condition of 'art' was far different from what it had been when Greenberg composed 'Modernist Painting'. The passage from an art of 'Form' to an art of 'Material' to an art of 'Idea' had been rapid, and by its end modernism in its hegemonic form seemed to have become historical. Far from exclusive, the field of art appeared to have become infinite.

This book takes these developments up to the emergence of Pop Art and Minimal Art in the USA, as well as discussing contemporary developments in Europe, culminating in the activities of the Situationist International. Its closing point, as much for the sake of convenience as for any tenable sense of historical closure, may be thought of as 1968. It has become conventional to regard that year as a kind of hinge, when old alignments and oppositions ended, and a new socio-cultural configuration began to be constructed. In art,

the late 1960s, if not that particular year, do seem to mark a turning point from a modernist past into a postmodernist present. As the reader will no doubt be tired of hearing, these terms require caution; they are contested and can be used to mean different things. But if we are to speak at all, we have to recognise that a paradigm of art activity that had in effect cohered the research programme of modern art from the beginning of the twentieth century, and had done so sufficiently powerfully to be able to accommodate a range of oppositional tendencies within its overall sphere of influence, broke up under the pressure of its internal contradictions.

Whether what we have learned, somewhat unhappily, to call 'postmodernism' turns out to be yet another stage in modernism is something that will only become evident in a retrospect longer than our own. What is beyond doubt is that the terms governing what counted as modern art underwent transformation. This book discusses selected aspects of the varieties of modernism that were extant between the early 1930s and the apparent break-up of the paradigm in the late 1960s. The fourth book in the present series will take up the narrative from that point.

Notes

1 See, for example, Irving Sandler, *The Triumph of American Painting*, and Michael Fried, *Three American Painters* (1965). Extracts from the latter are reprinted in Harrison and Wood, *Art in Theory 1900–2000*, VIB9, pp.787–93, which opens with the sentence, 'For twenty years or more, almost all the best new painting and sculpture has been done in America' (p.787).

2 Greenberg, 'Modernist Painting' (1960), in Harrison and Wood, *Art in Theory 1900–2000*, VIB5, pp.773–9.

3 Marcuse, 'Repressive Tolerance', in Wolff, Moore and Marcuse, *A Critique of Pure Tolerance*.

4 Hegel, Preface to *The Philosophy of Right* (1821). Hegel's implication is that when retrospective knowledge of some practice is formulated, it is an indication that its moment has passed.

5 Greenberg, *Art and Culture*.

6 Foster, 'The Crux of Minimalism', in *The Return of the Real*, pp.35–68.

7 Bell, 'The Aesthetic Hypothesis' (1913), in Harrison and Wood, *Art in Theory 1900–2000*, IB16, pp.107–8.

References

Foster, H., *The Return of the Real*, Cambridge MA: MIT Press, 1996.

Greenberg, C., *Art and Culture*, Boston: Beacon Press, 1965.

Harrison, C. and Wood, P. (eds), *Art in Theory 1900–2000: An Anthology of Changing Ideas*, Oxford, Blackwell, 2002.

Hegel, G.W.F., *The Philosophy of Right*, trans T.M. Knox, London: Oxford University Press, 1967.

Sandler, I., *The Triumph of American Painting*, New York: Praeger, 1970.

Wolff, R.P., Moore Jr, B. and Marcuse, H., *A Critique of Pure Tolerance*, Boston: Beacon Press, 1965.

1

The European Avant-Garde in the 1930s

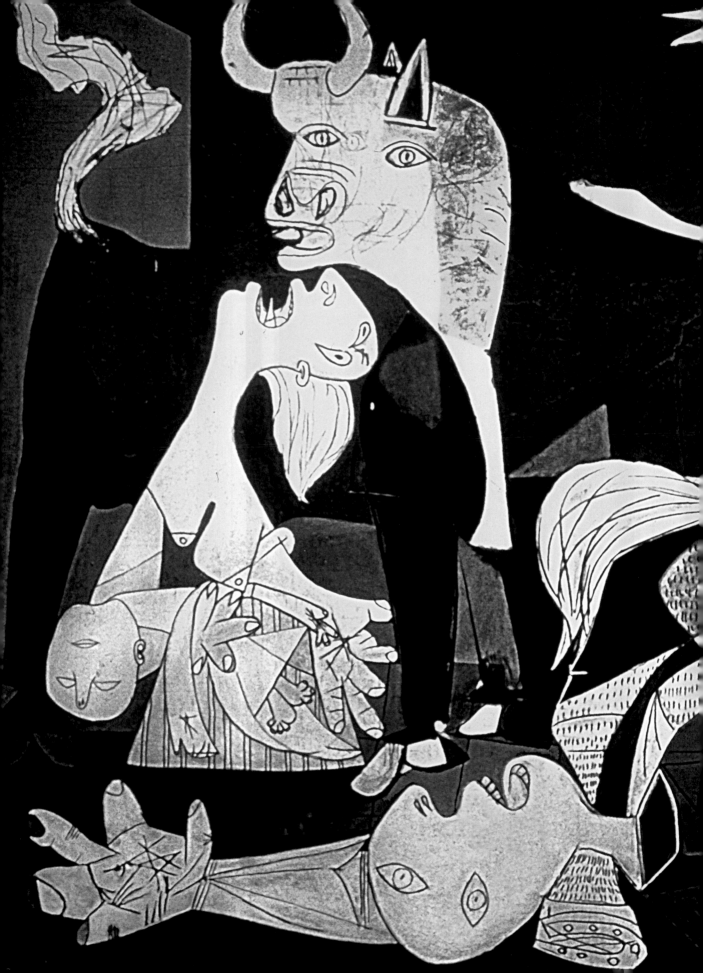

CHAPTER 1

Art in Paris in the 1930s

Emma Barker

Writing about the 'Exposition Internationale des Arts et des Techniques dans la Vie Moderne' ('International Exhibition of Arts and Techniques in Modern Life') staged in Paris in 1937, the painter Amédée Ozenfant observed:

> In architecture, as with all the other arts and techniques, it is
> our advances that are being shown, advances definitely gained,
> consolidated. Not many radical innovations … Some people,
> I know, would like to have seen a radical demonstration of
> ultra-modern building. Such as the Eiffel Tower provided in 1889.
> The fact is that, as I said, we are not in a moment of innovation,
> but one of taking stock.[1]

Although Ozenfant's primary reference point here is architecture, his assessment of the 1930s as a period of no great innovation is (as he points out) also applicable to other art forms. The decade did not witness any bold new departures to compare to the avant-garde movements that had emerged during the first quarter of the century. The decline of artistic radicalism after 1930 can at least partly be explained as a consequence of the economic crisis of 1929 onwards, which led to the collapse of the market for modern art in the early 1930s and fostered a widespread disillusionment with modernity as exemplified by the city and the machine.[2] However, there is a risk of taking an overly negative view of the decade, at least so far as France is concerned. With hindsight, it is all too easy to see French culture and society of the 1930s as moving inexorably towards the Vichy regime, established after France's defeat by Germany in 1940, under which traditionalist values became official ideology and avant-garde art was condemned as 'decadent'. This kind of determinism is belied by the sheer diversity of artistic production at the time, some of which can be aligned with right-wing political views but which mostly testifies to the problematic character of straightforward equations between a particular style and a specific ideology.

Part of the problem with defining the 1930s as a period of stasis or even reaction in French art is that it reflects and reinforces a teleological account of the history of twentieth-century art, in which New York inevitably emerges triumphant as the capital of modern art after 1945. The fact is, however, that Paris was more than ever the centre of the art world during this decade.[3] Not only did such canonical figures as Pablo Picasso, Georges Braque, Fernand Léger, Piet Mondrian and Constantin Brancusi continue to live and work in Paris, but growing political repression in Russia and Germany led many other artists to seek refuge in France, including Wassily Kandinsky (who arrived in 1934). Of the previously established avant-garde movements, both Surrealism and abstraction were still very much alive and had a significant presence in

PLATE 1.1 (facing page) Pablo Picasso, detail of *Guernica* (Plate 1.25).

the Parisian art world, each with its own organisational framework of groups, journals and exhibitions. Moreover, the depression and the increasingly menacing political climate did not simply serve to undermine an avant-gardist commitment creating a new art for a new world; on the contrary, what is remarkable about the period is the extent to which the Parisian art world became politicised. Many artists and intellectuals rallied to the cause of anti-Fascism, creating a broad left-wing cultural front, while a desire to respond to the contemporary crisis led to significant modifications in artistic practice. On an institutional level, the decade is notable as the period in which modernism at last gained official acceptance in France, with the foundation of a museum of modern art in Paris in 1937.

In what follows, my central aim will be to explore the relationship between art and politics in 1930s Paris in terms of the fundamental oppositions informing contemporary cultural debate: tradition and progress; nationalism and internationalism; autonomy and commitment; man and machine; civilisation and barbarism. A convenient starting point is provided by the 'Exposition Internationale' of 1937, which encapsulates many of these tensions. I will go on to consider established forms of figurative art and new developments in abstraction, both aspects of artistic practice that were widely seen as being untouched by the conflicts and crises of the time. Political considerations come to the fore in relation to the question of realism, which became a focus of debate in the mid-1930s; the central issue here was whether or not modern art could be accessible to a mass audience. Finally, I will consider some of the diverse artistic responses to the growing international crisis, with particular reference to the Spanish Civil War; the position of Surrealism is important here, as too is Picasso's *Guernica* (Plate 1.25), which was painted for the Spanish pavilion at the 'Exposition Internationale'.

The 'Exposition Internationale' of 1937

Nationalism and classicism

The exhibition was staged under the auspices of the Popular Front, an anti-Fascist alliance of left-wing parties, which came to power in June 1936. The primary objectives were economic: to stimulate the depressed economy, to reduce unemployment, to promote tourism and to showcase French products and technology. The project not only involved the building of some 300 temporary pavilions (44 of them as national pavilions for the foreign participants) on the exhibition site along the banks of the Seine, but also two huge permanent structures: the Palais de Chaillot and the Palais de Tokyo, both of which were to house museums. The Popular Front prime minister, Léon Blum, expressed the hope that the exhibition would embody a unifying, non-partisan sense of national identity, but the changes made by his government to the plans it inherited from previous governments aroused the hostility of the Right, who compared it unfavourably to the 'Exposition Coloniale Internationale' ('International Colonial Exhibition') of 1931.[4] One of the Popular Front's principal initiatives was to take steps to make the

exhibition more widely accessible, by, for example, laying on special trains to bring visitors from the provinces.

A late addition to the exhibition was the Peace Pavilion, which embodied the themes of international solidarity and shared humanity that were supposed to underlie the whole enterprise. The idealistic official rhetoric was belied, however, by the dramatic confrontation between the German and Soviet pavilions (Plate 1.2), which made all too apparent the threat of war presented by the political polarisation of the era. Albert Speer's tower, in a simplified neo-classical style and surmounted by the Nazi eagle, faced down Vera Mukhina's gigantic figures of the *Industrial Worker and Collective Farm Woman*, who, poised atop Boris Iofan's upward-surging pavilion, appeared to be rushing forward into the breach, respectively brandishing a hammer and a sickle. Despite their shared scale, significant aesthetic differences can be discerned between the two pavilions. Compare, for example, Mukhina's sculpture with the bronze figures by Josef Thorak, which stood at the entrance to the German pavilion (Plate 1.3). Thorak's poised, muscular heroes were intended to recall ancient Greek sculpture, which was in turn identified with the Aryan ideal of health and racial purity. Mukhina's figures, by contrast, were made of iron, a material more associated with industry, and were dynamic rather than static, workers rather than athletes; they exemplified the officially sanctioned style of Socialist Realism (to be discussed further below).

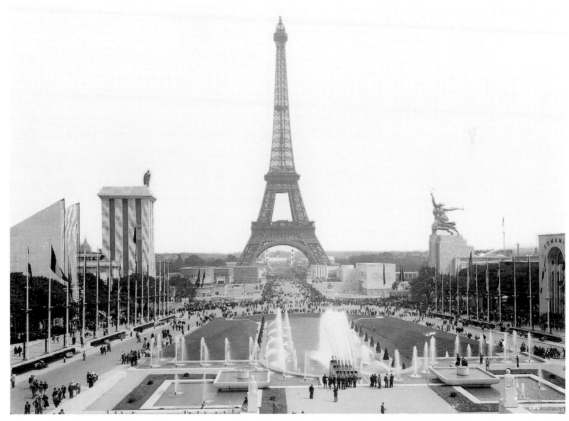

PLATE 1.2 Photographer unknown, view of the 'Exposition Internationale', Paris, 1937, featuring on the left the German pavilion by Albert Speer and on the right the Soviet pavilion by Boris Iofan, with sculpture by Vera Mukhina. (Photo: Roger-Viollet, Paris. © DACS, London 2004.)

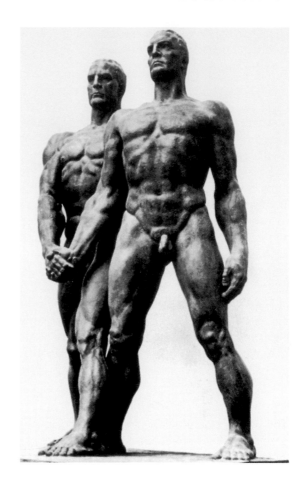

PLATE 1.3 Josef Thorak, *Comradeship*, sculpture
from the German pavilion, 'Exposition
Internationale', 1937, Paris, bronze,
height 670 cm. (© Thorak-Archive/
MARCO/Bodenstein.)

The modernised classical idiom of the German pavilion was shared by the Palais
de Chaillot and the Palais de Tokyo, which displayed the same combination of
tall, slender columns and idealised figure sculpture to similarly grandiose effect.
Given that France was a democracy at the time, this resemblance can be seen as
troubling the neat equivalence between classicism and Fascism suggested by the
comparison outlined above. It has indeed been argued that, far from having an
ideological basis, this was simply the style of the period for public buildings. The
crucial point, however, is that the supposed universalism of classicism allowed
its accumulated cultural authority to be appropriated by different nations, each
of which could lay claim to be its true heir. The link between classicism and
nationalism can be demonstrated with reference to Aristide Maillol, who was
consecrated as France's greatest living sculptor in 1937, when three rooms were
devoted to his work in the exhibition 'Les Maîtres de l'Art Indépendant' ('Masters
of Independent Art', on which see below). In the extensive literature published
on Maillol in the 1920s and 1930s, his impassive female figures, at once sensual
and idealised, were invariably characterised as the embodiment both of a southern
Mediterranean spirit and of the French classical tradition, which was conventionally
said to combine a sense of order with a commitment to nature (Plate 1.4).
Acclaim for Maillol's classicism was informed by a conception of national identity
that was deeply conservative, although not specifically Fascist. One of his greatest
supporters, however, was the pro-Fascist critic Waldemar George, who hailed
him as 'a true French sculptor',[5] and Maillol was himself friendly with Hitler's
favourite sculptor, Arno Breker.

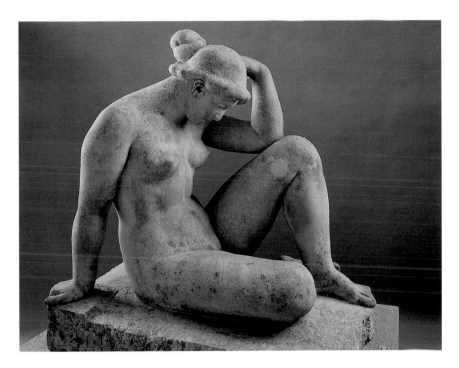

PLATE 1.4
Aristide Maillol,
The Mediterranean,
1905, limestone,
114 × 78 × 108 cm.
(Oskar Reinhart
Collection, Winterthur,
Switzerland.
© ADAGP, Paris and
DACS, London 2004.)

Tradition and modernity

The use of a classical idiom for the new French museums, together with the predominance of traditional figurative styles in their internal decoration, is indicative of the conservative tastes of the bureaucrats who commissioned them. By contrast, the works commissioned for the exhibition by officials of the Popular Front reveal a much greater openness to modern art. A notable example was the Aeronautical Palace, where it took the personal intervention of Blum to ensure that a decorative scheme commissioned from the painter Robert Delaunay went ahead. As a result, a pavilion dedicated to emphatically modern technology was decorated in an appropriately bold, abstract manner, with rhythmic circles in bright colours (Plate 1.11). It is significant that the project was a collaboration, involving a team of artists working under Delaunay's direction; such collective work could be seen to embody a spirit of solidarity, exemplary of the Popular Front. This project can be contrasted with Raoul Dufy's vast mural, *The Muse of Electricity*, in the Palace of Electricity and Light, which employed a traditional allegorical mode to represent modern technology.

The association between modern art, technological and scientific progress, and the politics of the Left was reinforced by the commissions for the Palace of Discovery. These included Léger's mural celebrating hydro-electric power, *The Transmission of Energy*, which combines the rectilinear, monochrome forms of high technology with dynamic, colourful natural imagery: note the waterfall in the centre and the rainbow (Plate 1.5). This too was a collaborative project since Léger's design was executed by three of his students. It offered a utopian vision of industry and nature working in harmony for the benefit of mankind. The union of art and science was embodied in more traditional allegorical terms by Jacques Lipchitz's *Prometheus Strangling the Vulture* (Plate 1.6), which was originally intended to represent the spirit of discovery (in classical mythology, Prometheus stole fire from the gods for the benefit

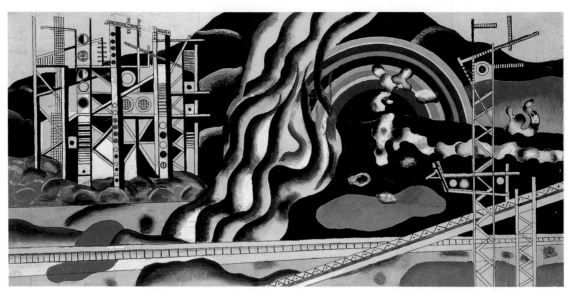

PLATE 1.5 Fernand Léger, *The Transmission of Energy*, study for mural in the Palace of Discovery, 'Exposition Internationale', Paris, 1937, gouache and pencil on paper, 100 × 509 cm. (Musée Fernand Léger, Biot. Photo: RMN – Gérard Blot. © ADAGP, Paris and DACS, London 2004.)

of mankind). However, it also lent itself to political interpretation as an anti-Fascist work, since the figure wore a revolutionary's Phrygian bonnet and the vulture evoked the Nazi eagle. A right-wing journalist claimed that it demonstrated 'by contrast the classical French taste and what would become of it under Bolshevik influence'.[6] After further protest, it was removed. At issue here were not only the sculpture's vigorous, non-classical style and its political connotations but also, on a deeper level, Lipchitz's Jewish, immigrant origins. These origins, which he shared with other avant-garde sculptors, provided ammunition for those who saw modern art as a corrupting foreign agent, inimical to the 'purity' of the French tradition.

However, the oppositions between tradition and modernity, nationalism and internationalism, did not necessarily align neatly with the political distinction between Right and Left. A concern with national tradition was most conspicuously manifested within the exhibition in the Regional and Rural Centres. The prominence accorded to the Regional Centre reflected the priorities of the exhibition commissioner Edmond Labbé, who had been appointed by a previous, centre-Right government. However, the Rural Centre (for which Léger produced another mural) was sponsored by the Popular Front, which also demonstrated its commitment to France's rural traditions by founding a national folklore museum, the Musée des Arts et Traditions Populaires. The Front's support for these traditions may be taken as evidence of the growing influence of conservative social and cultural values during this period. However, it is clear that a concern with rural, provincial France cannot simply be equated with political reaction, and, as the emphasis on modern technology in the Rural Centre reveals, did not necessarily entail a rejection of progress. Greater ambivalence towards modernity is apparent in Labbé's promotion of traditional artisanal production. His regionalist agenda was informed by his belief that 'the factory, made to the measure of the machine, will never definitively supplant the workshop, made to the measure of man'.[7]

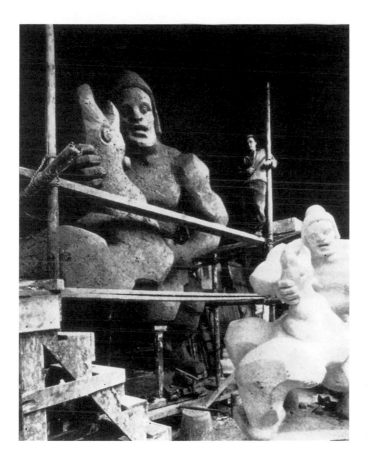

PLATE 1.6
Jacques Lipchitz with two plasters of
Prometheus Strangling the Vulture,
1936–7, large plaster, height 914 cm
(destroyed). (© Estate of Jacques Lipchitz,
courtesy Marlborough Gallery, New York.)

Promotion and persuasion

The traditionalist insistence on the virtues of hand-crafting was countered by the prominence of the new media in the 1937 exhibition, which included pavilions devoted to advertising and the cinema. Photography was extensively used in the different pavilions, as were photomontages.[8] The latter included two photomural projects undertaken by Léger, one of them for the Rural Centre. The second project was for the Pavillon des Temps Nouveaux ('Pavilion of New Times'), a structure designed by the architect Le Corbusier, who had been granted the site and modest funds for the work at the last minute. This project comprised four separate murals, each concerned with different aspects of urban life: *Work*, for example, consisted of a montage of industrial objects (a propeller, a pylon etc.). For both projects, Léger made use of his standard compositional devices: juxtaposition of fragments, contrasts of form, abrupt shifts in scale, monochrome combined with bright colour. However, his engagement with photomontage at the time of the 1937 exhibition was a one-off in his career. He saw it primarily as a political instrument, stating: 'For those whom we call abstract artists such works are … outside of their true expression, a way to serve to the best of their abilities and nothing more.'[9] Photomontages were, for him, quite distinct from the (hand-crafted) paintings he produced in the privacy of his studio. Thus, even as he committed himself to popularising the ideals of the Popular Front, Léger continued to uphold the importance of aesthetic autonomy.

A heightened emphasis on the communication of an ideological message to a mass audience, propaganda in short, can be seen to have characterised the exhibition of 1937 by comparison with previous *exposition universelles* or world's fairs. While this is most obviously true of the competing national pavilions, it also applies to the French contributions. A case in point is the Pavillon des Temps Nouveaux, which differs in highly significant ways from the Pavillon de l'Esprit Nouveau ('Pavilion of the New Spirit'), which Le Corbusier designed for the international exhibition of the decorative arts held in Paris in 1925. The earlier pavilion served as a manifesto for the machine aesthetic promoted by Le Corbusier and Ozenfant in their journal *L'Esprit nouveau*: white, geometrical and equipped with readymade furnishings, it was intended to demonstrate the benefits of functionalism and standardisation in housing. The later pavilion, by contrast, was a 'museum of popular education' housed in a tent-like structure that was at once primitive and technically innovative; inside, techniques of persuasion like photomontage were used in order to communicate Le Corbusier's ideas in a vivid and compelling manner. Whereas previously he had seen architecture as in itself an agent of social change, Le Corbusier now addressed himself directly to contemporary social and political issues. The case of Le Corbusier is a problematic one, since the architect had dabbled with anti-democratic political ideas in the early 1930s and later joined the Vichy government. Nevertheless, the Pavillon des Temps Nouveaux can be taken as exemplary both of the evolution of modernist practice, as it responded to the economic and political crisis of the 1930s by seeking to reconnect with the world, and of the Popular Front's readiness to draw into its embrace artists and writers whose commitment to the Left was slight or even (as in Le Corbusier's case) uncertain.

However, the broad alliance created by the Popular Front did exclude one important element in the Parisian cultural scene of the 1930s: the Surrealists. No major Surrealist artist, for example, received a commission for the 1937 exhibition. Under the circumstances it seems plausible to view the 'Exposition Internationale du Surréalisme' ('International Exhibition of Surrealism') of 1938 as, in part, a riposte to the official spectacle. Staged at the upmarket Galerie Beaux-Arts, the exhibition proved a great success with smart Parisian society. After encountering Salvador Dalí's elaborately staged *Rainy Taxi* (which included a mechanism that made it 'rain' on the mannequins and live snails inside the vehicle), visitors walked along a corridor lined with mannequins, each adorned (usually in a sexually provocative way) by the work of a different artist; mannequins, it may be noted, recur in Surrealist imagery as embodiments of the mysterious or uncanny.[10] Apparently full coal sacks hung from the ceiling of the main room, which also seemed (on the opening night) to be lit only by a burning brazier, making it difficult to see the works of art on the walls. Sound (recordings of hysterical laughter) and smell (roasting coffee) contributed to the disorientating effect. At once beguiling and frustrating, these displays defied conventional expectations of an art exhibition. At the same time, however, the element of spectacle (as with *Rainy Taxi* and the massed mannequins), the juxtaposition of word and image (a suggestive street sign hung beside each mannequin) and the publication of an accompanying book all recall the various techniques of promotion and persuasion that had been used in the exhibition of the previous year. As such, the Surrealists' show can be seen to blur the boundaries between modern art and mass culture.

Abstraction and figuration

Independent art

In France in the 1930s, modern art was also and, in fact, most often referred to as 'independent art', a term that since the late nineteenth century had served to differentiate progressive tendencies in contemporary artistic practice from the work of artists who received official support. By 1937, when, as we have seen, the state established a museum of modern art and numerous modern artists received official commissions, the term had lost much of its original significance. Nevertheless, it figured in the titles of both of the major exhibitions of modern art that took place in Paris that year: 'Les Maîtres de l'Art Indépendant', staged by the municipality of Paris at the Musée du Petit Palais, and 'Origines et Développement de l'Art International Indépendant' ('Origins and Development of International Independent Art'), staged at the state-run Musée du Jeu de Paume. According to the curator of the Petit Palais, Raymond Escholier, the term referred to those aspects of contemporary French art that, 'for thirty years, have made an impact abroad and have there raised the prestige of the School of Paris very high'.[11] Many artists of foreign origin whose careers had been based in Paris, such as Picasso and Lipchitz, were represented in the Petit Palais exhibition alongside French-born ones. Conversely, although the (much smaller) Jeu de Paume show was ostensibly devoted to modern foreign art, it actually included works by numerous French artists and most of the foreigners represented were Parisian residents. Thus, there was a certain degree of overlap between the two exhibitions, both of which presented modern art as a phenomenon at once Paris-based and internationally significant. However, the conception of independent art that each embodied also differed considerably. To discover what these differences were, let us start by looking at works from the 1930s by four of the dozen or so painters whose work was highlighted at the Petit Palais.

Please look at the following: Georges Braque, *The Duet* (Plate 1.7); André Derain, *Still Life with Oranges* (Plate 1.8); Pablo Picasso, *The Dream* (Plate 1.9); Henri Matisse, *Large Reclining Nude* (Plate 1.10). What do these works share, in terms of style, genre and theme? Does anything about them surprise you, given their authorship? What aspects of contemporary art are omitted?

All of these paintings are by artists who made their reputations in the first decades of the twentieth century, either as Fauves (Derain, Matisse) or as Cubists (Picasso, Braque). More recent aspects of contemporary art, notably abstraction and Surrealism, are omitted. All four belong to the traditional genres of art: still life, the nude, the interior scene, even portraiture if we count *The Dream*. As such, all of them can be defined as figurative and, to some extent at least, may be seen to represent a step backwards by comparison with the most innovative work of each artist's earlier career. The Derain still life, for example, employs a very traditional style; it is carefully painted in restrained, old-mastery tones that are quite unlike the bright colours and loose handling of his Fauve period. Braque's painting is structured as an almost symmetrical arrangement of light and shade, combined with patterned surfaces and curving outlines, but (in contrast to his earlier Cubist work)

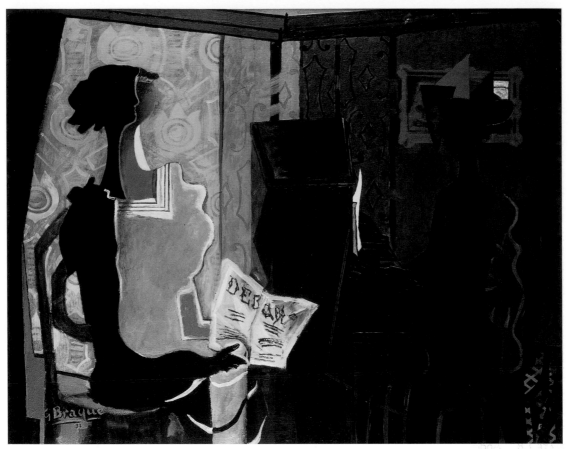

PLATE 1.7 Georges Braque, *The Duet*, 1937, oil on canvas, 131 × 163 cm. (Musée Nationale d'Art
Moderne, Centre Georges Pompidou, Paris. Photo: Bridgeman Art Library, London.
© ADAGP, Paris and DACS, London 2004.)

none of these effects disrupts the basic legibility of the scene. The paintings
by Matisse and Picasso present definite similarities to each other, which might
also surprise you; both use a flowing outline and vivid colour to convey the
erotic appeal of a naked or semi-naked woman, although Picasso has a stronger
sense of three-dimensionality than Matisse, where the figure forms part of
the overall surface design. What ultimately links all of these works is their
essentially private character, focusing as they do on domestic and erotic
themes. ∎

Like these paintings, the vast majority of exhibits at the Petit Palais were
both unproblematically figurative, even if many were inflected by Cubism to
some extent, and unchallenging in their subject matter (landscape also featured
prominently). The painters best represented in it included not only these
four canonical figures but also several who are now little regarded (such as
Maurice Utrillo and André Dunoyer de Segonzac). By contrast, the Jeu de
Paume exhibition conformed far more closely in the range of work it
represented to what we identify today as canonical modern art. The curator,
André Dezarrois, initiated the exhibition in collaboration with the Surrealist

PLATE 1.8 André Derain, *Still Life with Oranges*, 1931, oil on canvas, 89 × 117 cm. (Centre Pompidou-
MNAM-CCI, Paris. Photo: CNAC/MNAM Dist. RMN – Jacqueline Hyde. © ADAGP, Paris and
DACS, London 2004.)

poet Paul Éluard and Christian Zervos, editor of the magazine *Cahiers d'art*
('Journals of Art'): founded in 1926, this stood for a committed modernist
position. Éluard's involvement helps account for the presence of numerous
Surrealist paintings. Not only in its selection but also in its conception, this
exhibition differed significantly from its counterpart at the Petit Palais. Whereas
the latter consisted of an assemblage of individual masters, the layout of the
Jeu de Paume show presented a succession of major movements. Zervos's
catalogue essay was significantly titled 'De Cézanne à l'art non-figuratif' ('From
Cézanne to Non-Figurative Art'). As in the exhibition 'Cubism and Abstract
Art' held at the Museum of Modern Art, New York, in 1936, abstraction thus
appeared as the culminating point of the development of modern art. Abstract
art did not figure as prominently in the exhibition as this might suggest,
however; despite his having lived in Paris for many years, it included only
two works by Mondrian, for example. Delaunay wrote in protest at his own
poor representation, describing himself as 'the founder in France of abstract
art in colour'.[12] Evidently, it was only when it had a decorative function, as
with Delaunay's work for the 1937 'Exposition Internationale', that abstraction
was readily acceptable in France.[13]

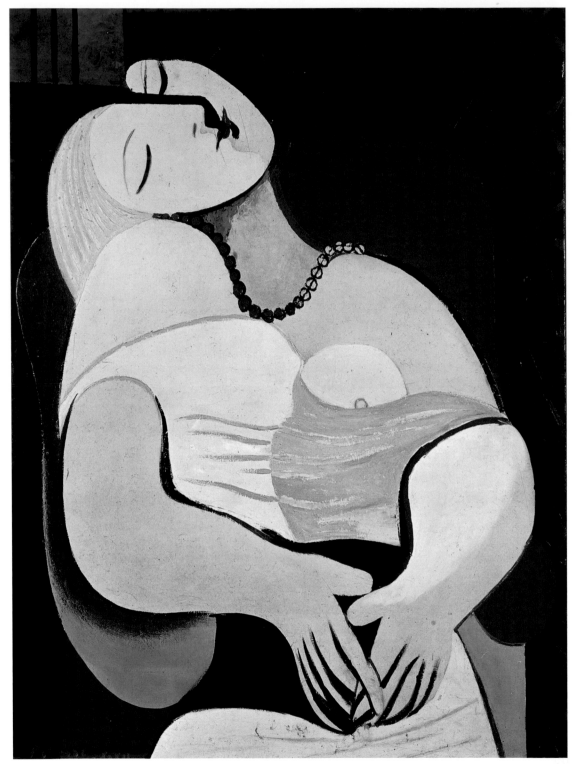

PLATE 1.9 Pablo Picasso, *The Dream*, 1932, oil on canvas, 130 × 97 cm. (Private collection.
Photo: Bridgeman Art Library, London. © Succession Picasso/DACS, London 2004.)

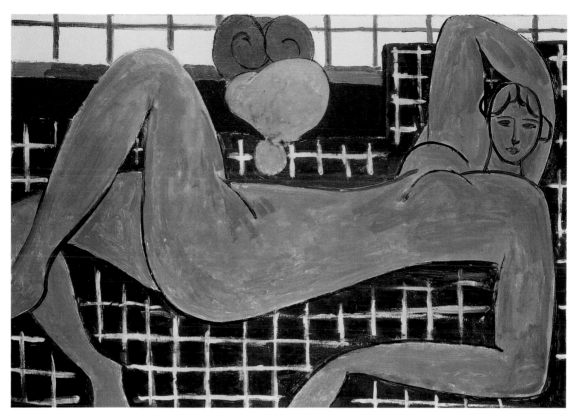

PLATE 1.10 Henri Matisse, *Large Reclining Nude* (*The Pink Nude*), 1935, oil on canvas, 66 × 93 cm. (Baltimore Museum of Art: The Cone Collection, formed by Dr Claribel and Miss Etta Cone of Baltimore, Maryland. Photo: Bridgeman Art Library, London. © Succession H. Matisse/DACS, London 2004.)

After Cubism

If modern art was officially consecrated in 1937, what effectively prevailed in that year (as evidenced by the state's purchases for the new museum dedicated to it) was 'independent art' as it was embodied in the Petit Palais exhibition. The 'independent' canon had already been established in the previous decade, as can be seen from the results of a 1925 survey by the art journal *L'Art vivant* ('Living Art'), asking readers to name their top ten artists. The two artists with the most works in the exhibition, Matisse and Maillol, came out top and the other painters named above all featured in the list. As Christopher Green has pointed out, there was a high correlation between the artists on the list and those who got the best prices.[14] The official triumph of modern art in the late 1930s owed much to the art market boom of the 1920s, which saw increasing numbers of collectors turning their attention to this kind of art; their ranks were well represented on the organising committee for the Petit Palais exhibition. Initially, commercial success was reserved for Matisse, Derain and other artists then usually identified as 'naturalists' (such as Dunoyer de Segonzac and Utrillo). However, as the presence of the names of Picasso and Braque on *L'Art vivant*'s list testifies, Cubism acquired a new respectability during the 1920s, gradually losing its avant-garde status and gaining acceptance as part of the history of 'independent art'. At the same time, the art market became more international, with American collectors playing an increasingly important role.

During this period, Matisse and Picasso were constantly being pitted against each other as the two most celebrated masters of modern art. Each had a large retrospective exhibition devoted to his work at the Galerie Georges Petit, in 1931 and 1932 respectively. Picasso's exhibition was notable both for its huge scale and for the stylistic variety of the works on display; as well as Matisse-influenced paintings like *The Dream*, it also included (to cite only his post-Cubist work) classicising compositions from around 1920 and works in which the legacy of Cubism was still apparent. To many commentators at the time, Picasso's eclecticism and his distortions of the human form seemed wilful and perverse, the sign of a great but ultimately destructive genius. Often, these qualities were attributed to his Spanish origins and contrasted with the work of Matisse, which was now seen as exemplifying distinctively French virtues such as moderation and clarity. This tendency is exemplified by the following passage, dating from 1933, by Jean Cassou, a committed modernist, who was to be a member of the organising committee of the Jeu de Paume exhibition:

> However spare the figures with which [Matisse] ends up, they
> could never topple over the edge into abstractions. His decorative
> genius safeguards him from these extremes. And also, no doubt,
> the taste for the *natural*, which is a quintessential facet of French
> culture. [By contrast] Picasso, the paradoxical and heroic Spaniard,
> is dragging painting into bizarre experiments and forced attitudes,
> towards the monstrous in fact.[15]

So abstracted a composition as *Large Reclining Nude* might be thought to belie this assertion. It was, however, the conception of Matisse as the living embodiment of French tradition, 'born under the sky of Poussin and Delacroix',[16] that accounts for his prominence in the Petit Palais exhibition of 1937. Significantly, the only work by Matisse that the state bought at this time was an odalisque in the Orientalist tradition of Eugène Delacroix and Jean-Auguste-Dominique Ingres.[17]

This kind of invocation of tradition in relation to modern art was nothing new. From around the time of the First World War, for example, attempts were made to legitimate Cubism by citing the authority of the past for its formal innovations. Whereas conservative opponents of avant-garde art denounced it as a foreign and, specifically, a Germanic phenomenon, Cubists and their defenders affirmed its indebtedness to the ordered compositions of such key figures in the French classical tradition as Nicolas Poussin and Ingres. These claims, together with the shift towards more figurative styles on the part of many Cubists around 1920, as exemplified by Picasso's classical phase, can be linked (as Kenneth Silver has shown) to the demands for a 'decadent' France to return to its native traditions that characterised the political rhetoric of the time. Whether or not the Cubists' 'call to order' should be equated with a capitulation to a right-wing political culture has been much debated.[18] With respect to the situation in the 1930s, the crucial point, as Cassou's remarks on Matisse reveal, is that continuing reservations about abstraction were bound up with the notion of French tradition as fundamentally naturalistic as well as classical. Artistic and political reaction coincided most strikingly in the criticism of Waldemar George, formerly an advocate of Cubism, who, in the 1930s, denounced modernism as a symptom of a civilisation in crisis and championed what he called 'Neo-Humanism'. He identified its leaders as Maillol and Derain, the latter being renowned for his respect for tradition.[19]

Around Abstraction-Création

The non-figurative art that was produced in Paris during this period was largely the work of foreigners. In addition to Mondrian and Kandinsky, they included many other artists who had settled there between the mid-1920s and the mid-1930s. All of them were confronted with a situation in which it was very difficult to attract interest in their work, on account both of the French emphasis on figurative art and of the runaway success of Surrealism. Abstract artists in Paris therefore constituted themselves as formal groups in order to make their presence felt, starting with Cercle et Carré ('Circle and Square'), which was founded in 1930 by the Belgian writer Michel Seuphor, in collaboration with Joaquín Torres-García, who was from Uruguay. Although Seuphor was committed to a strictly geometrical form of abstraction, the one exhibition that the group staged before collapsing included not only work by exponents of this tendency (most notably Mondrian), but also works that retained a figurative element and examples of non-geometrical abstraction by such artists as Jean (Hans) Arp and Kandinsky. A rival group, Art Concret ('Concrete Art'), founded by the Dutch artist Theo van Doesburg, represented a much more hard-line position, refusing any reference to the world beyond the art object itself. This involved a rejection both of Cubist-derived abstraction from reality and of Mondrian's 'Neo-Plasticism', in which abstract art was understood to embody an underlying spiritual order. By contrast, the one group that endured, from 1931 to 1936, Abstraction-Création, was conceived as a broad-based movement embracing a range of positions. The only criterion for inclusion in its exhibitions was simple: 'non-figuration'.[20]

The texts published in Abstraction-Création's annual journal reflect the diversity of positions held, but also testify to a shared commitment to abstraction as a universal, collective form of expression. (In this respect, this type of art differed fundamentally from mainstream 'independent art', with its focus on the distinctive sensibility of the individual master.) Jean Gorin, a French follower of Mondrian, for example, characterised Neo-Plasticism as 'the new art of the machine age', one whose means of expression were 'absolutely universal, mathematical and scientific. It is the impersonal art par excellence.'[21] Such assertions also served to demonstrate that abstract art was not arid and irrelevant, stuck in an 'ivory tower' while the world was in crisis, as was often claimed during the 1930s, but, on the contrary, in direct contact with objective reality and, moreover, helping to build the new and better world that (so the artists believed) was to follow. Already, in 1930, Mondrian had declared that Neo-Plasticism was '"real" because it expresses this reality', that is, the new reality of the future; in his writings of this period, these concerns are evinced in a new preoccupation with rhythm or 'dynamic equilibrium' as the crucial point of connection between art and life.[22] Just how much of a departure from Mondrian's previous emphasis on static harmony this represented is apparent from his work, which, beginning in 1932, when he first made use of a double line, becomes steadily more complex and more dynamic. In this respect, he can be seen to have been moving in the same general direction as a number of French abstract artists, including Auguste Herbin (president of Abstraction-Création) and Delaunay, who rejected the rectilinearity of Neo-Plasticism and instead made use of curves and spirals, forms in which a sense of movement is inherent (Plate 1.11).

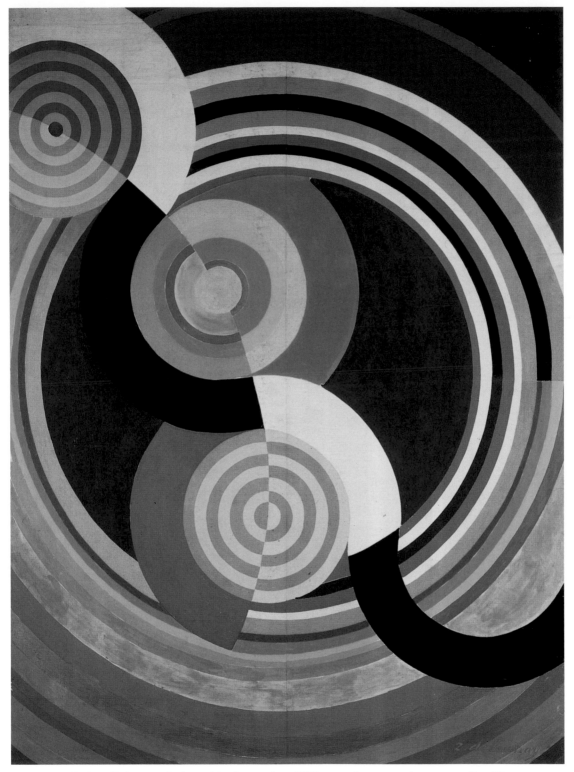

PLATE 1.11 Robert Delaunay, *Rythme No. 2, esquisse*, 1938, gouache on tracing paper, 43 × 35 cm. (Musée Nationale d'Art Moderne, Paris. © L. & M. Services B.V. Amsterdam 20030821.)

The work of these French artists can be aligned with a trend within abstraction towards 'life' in the organic rather than the social sense, towards nature in other words. Loose, curvilinear forms most obviously lend themselves to this kind of interpretation in the case of the work of Arp, who, in the early 1930s, combined membership of Abstraction-Création with continuing links with Surrealism. In the first issue of the group's journal, Hans Schiess wrote: 'the curve of his reliefs is like the curve of a leaf, a part of the totality, at the same time as the accomplishment of nature itself'.[23] While Arp had been concerned with natural forms and processes ever since his Dada period, the organic aspect of his work emerges particularly strikingly in the sculptures that he produced from around 1930. It has, moreover, been argued that part of the impetus behind the shift towards curvilinear forms in abstraction came from a new awareness of the complexity of the underlying structures of nature, which meant that the authority of science could be claimed for these forms as well as for rectilinear ones.[24] Tensions between the organic and geometric, man and the machine, underlie a questionnaire circulated to members of Abstraction-Création, which asked (for example): 'Why do you not paint nudes?', 'What do you think of the influence of trees on your works?' and 'Is a locomotive a work of art? Why? Why not?'[25] In general, artists responded to these concerns not by rejecting abstraction but rather by seeking (like Mondrian) to renew it in such a way as to make it more attuned to the actual complexity of the world. However, in the case of Jean Hélion, the struggle to reconcile art with 'the fundamental contradiction of life' gradually took him from geometrical abstraction (and membership of Abstraction-Création) in the early 1930s to a return to figuration at the end of the decade.[26]

Realism and commitment

Socialist Realism

'Realism' was a much-used term within artistic discourse of the 1930s. As we have seen, even Mondrian invoked the term in order to justify his own practice. For the most part, however, the idea of an art in touch with reality was defined in opposition to abstraction. In the first issue of the journal *Abstraction-création, l'art non-figuratif*, for example, Paul Vienney, a friend of Herbin's and (like him) a member of the French Communist Party (PCF), wrote: 'abstraction has no value for action … to act, it is … necessary to reach down into reality'.[27] As this indicates, realism was associated with political engagement, in contrast to the perceived 'ivory tower' stance of abstraction; thus, left-wing politics no less than the force of 'French tradition' provided a rationale for marginalising abstraction. The centrality of realist art to the cultural politics of the Left was confirmed by a series of debates on realism staged at the Maison de la Culture ('House of Culture') in May 1936, just as the Popular Front came to power. The Maison de la Culture had grown out of the Association of Revolutionary Writers and Artists (AEAR), which was founded in 1932. A communist initiative, AEAR increasingly welcomed fellow-travellers as well as Party members and thus played a crucial role in the formation of an anti-Fascist cultural alliance. Like the Popular Front itself, this

alliance was made possible by a reversal of policy on the part of the PCF, which, from 1934, abandoned its previous stance of refusing to ally with other parties of the Left, in order to rally the widest possible opposition to the menace presented by Nazi Germany. (In each case, the impetus for the policy was provided by directives from Moscow.)

Initially, the artist members of AEAR were a disparate array of figures brought together by a shared commitment to anti-Fascism rather than any common artistic practice. This inclusiveness proved unsustainable, however, especially after the official promulgation of Socialist Realism at the first Soviet Writers' Congress in Moscow in 1934. In his keynote speech, Andrei Zhdanov called upon writers (and, by implication, artists) to be, in Stalin's words, 'engineers of souls'. The fundamental point was that Socialist Realism was not simply a truthful depiction of reality but rather, in its optimistic vision, contributing to 'the building of a Communist society'. As such, it could be defined as a 'revolutionary romanticism'.[28] The PCF was represented at the congress by the former Surrealist Louis Aragon, now general secretary of AEAR and, in this capacity, the prime mover behind the debates at the Maison de la Culture. His book *Pour un réalisme socialiste* ('For a Socialist Realism') (1935) dutifully promoted the Soviet line. In a French context, the notion of Socialist Realism as revolutionary romanticism served as an endorsement of a national tradition of politically committed art exemplified by Jacques-Louis David and Gustave Courbet. The adoption of Socialist Realism can thus be aligned with a shift in cultural policy that accompanied the PCF's adoption of a new political strategy. From 1934, it abandoned its previous promotion of 'proletarian' culture in order to cast itself as the defender of the nation's 'high' culture, which it now claimed as the shared heritage of the entire French people. In 1937, Aragon went so far as to claim that the 'ensemble of realities that we call *a nation*' was the necessary basis of a 'truly human culture'.[29]

Concurrently with these theoretical developments, a number of young French exponents of Socialist Realism came to prominence. They included Boris Taslitzky, a PCF member who took part in the debates on realism at the Maison de la Culture. His painting *The Strikes of June 1936* (Plate 1.12) commemorates the wave of strikes that followed the Popular Front's electoral victory. With its bright colours and lively figures, the composition has an upbeat mood, which broadly accords with the prevailing representation of the strikes, both at the time and since, as festive and joyful.[30] In so far as it obscures the actuality of class conflict and instead looks forward to a better future, it seems appropriate to describe such an image as an example of revolutionary romanticism in the Soviet sense. More often, however, politically committed French artists, like previous generations of social realist painters, focused on the experience of labour and the suffering caused by the existing capitalist order, as, for example, in Édouard Pignon's *The Dead Worker* (Plate 1.13). Pignon was a PCF member active in the Maison de la Culture, as too was André Fougeron, who dealt with related themes (Plate 1.20). *The Dead Worker* is a 'revolutionary romantic' painting in the sense that it draws on the art of the past, specifically on traditional religious imagery of the dead Christ. Both Pignon and Fougeron, however, also differed from Soviet-style Socialist Realism in their use of distinctively modern effects of simplification and distortion. During the 1930s, they (and also Taslitzky) exhibited at the Galerie Billiet-Vorms, which staged an exhibition, 'Le Réalisme dans la Peinture' ('Realism in Painting') to coincide with the debates at the Maison de la Culture.

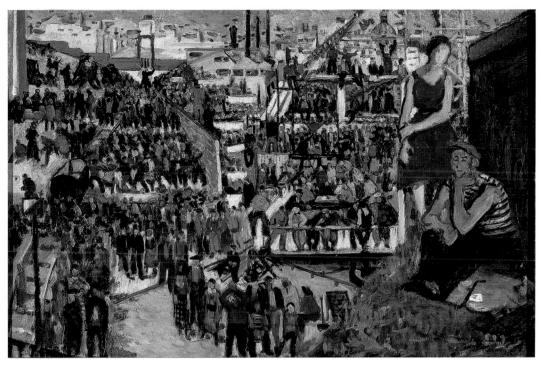

PLATE 1.12 Boris Taslitzky, *The Strikes of June 1936*, 1936, oil on board, support 40 × 60 cm (sketch for destroyed painting). (© Tate, London 2002. © ADAGP, Paris and DACS, London 2004.)

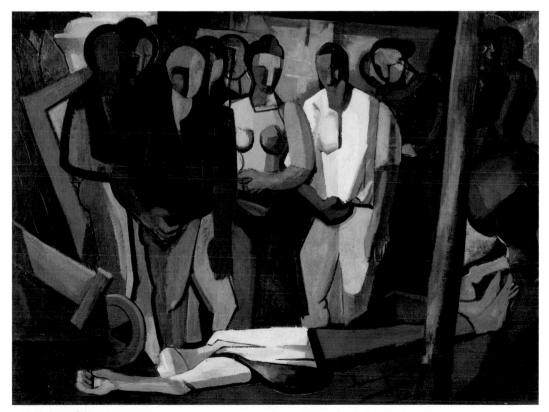

PLATE 1.13 Édouard Pignon, *The Dead Worker*, 1936, oil on canvas, 134 × 184 cm. (Centre Pompidou-MNAM-CCI, Paris. Photo: CNAC/MNAM Dist. RMN – Philippe Migeat. © ADAGP, Paris and DACS, London 2004.)

The 'new realism'

The speakers at the debates represented a range of positions. Besides Aragon, they included others heavily involved in AEAR and the Maison de la Culture (such as Cassou and Taslitzky), but also non-communist supporters of the Popular Front (such as Le Corbusier and Léger). The first debate (of three) was opened by the artist Jean Lurçat, who referred to 'this new realism of which it must be agreed that the art of painting is experiencing a very lively need'.[31] Let us now consider the arguments of Aragon and Léger with the aim of establishing what each of them understood by the 'new realism'.

Please read the following extracts, considering where the concerns of the two speakers overlap and how the aesthetics that they promote differ from each other.

Louis Aragon

[Painters] strayed to the point of abstraction. Nothing human remained in their canvases ... they ceased to paint for men and only painted for painters ... The financial resources of speculation ... dragged them each day further in this direction. They lost sight of life because, like grown-up children, they lived off their rich relations, the art dealers ... The social conditions that permitted this strange evolution, this flight from reality ... no longer exist today. However painters ... are very slow to revise their ideas ... They have not understood that the photographic experience is a human experience that they cannot neglect and that the new realism that will come, whether they want it or not, will see in photography not an enemy but an auxiliary of painting ... I here announce a new realism in painting. That is to say, I in no way imply a return to an old-style realism ... Realism will thus cease to be a realism dominated by nature, a naturalism, and become a realism that consciously expresses social realities and forms an integral part of the struggle that modifies reality. In a word, it will be a socialist realism ... You are going to build a new world, painters. That surely makes it worth revising your ideas.[32]

Fernand Léger

... the common reproach is that [modern pictures] have been snatched up by the dealers and the big collectors and that the people have no access to them. Whose fault is that? That of the present social order. If our works have not made their way among the people, the fault, I repeat, is that of the social order; it is not due to any lack of human quality on the part of the works in question. Under such a pretext as the latter, they would have us burn our bridges, coolly pass sentence of death upon that painting which brought us our freedom ... and turn our steps backward ... This is an insult to these men of a new world, who ask nothing better than to understand and go forward. It is officially to pronounce them incapable of rising to the level of that new realism which is their age – the age in which they live, in which they work, and which they have fashioned with their own hands ... The people themselves every day create manufactured objects that are

pure in tonal quality, finished in form, exact in their proportions …
It would require no great effort for the masses to be brought to
feel and to understand the new realism, which has its origins in
modern life itself, the continuing phenomena of life, under the
influence of manufactured and geometrical objects.[33]

Both Aragon and Léger are concerned about modern art's inaccessibility to
a non-specialist audience and both deplore its dependence on the support
of dealers and collectors. They also seem to agree with each other – and
with many of their contemporaries – in accepting that a human element is
desirable in art, while also characterising the 'new realism' as differing from
traditional figurative art in its relationship with technological/industrial
modernity – as represented by photography in Aragon's case and
manufacturing in that of Léger. However, where Aragon believes that modern
art's self-referentiality is inherently élitist and argues that the way forward is
for painters to develop a realism inspired by the example of photography
(the example he gave was the documentary photography of Henri Cartier-
Bresson), Léger insists that artists must keep faith with the tradition of modern
art and continue to innovate. He vehemently rejects the idea that a mass
audience is incapable of appreciating modern art, insisting that 'the people'
have a fundamental understanding of the modern aesthetic – defined in
characteristically formalist terms such as 'tonal quality' – because it is inherent
in their experience of modernity. Whereas the Socialist Realism promoted
by Aragon is centrally concerned with the representation of human life and
with the struggle to build a new world, Léger's 'new realism' is based on the
manufactured objects that are produced in the 'new world' that already exists:
geometric and standardised, it is a machine aesthetic. ∎

Léger's conception of a 'new realism' that was quite distinct from mere
imitation of reality had been formulated as early as 1913, in the context of
debates on Cubism, although it was only in 1925 that the actual term appears
in his writings.[34] It was during this decade that his work was most focused on
mechanisation and mass-produced objects. By the mid-1930s, he had returned
to the representation of the human figure and other organic forms but always
insisted that his painting nevertheless remained 'an object painting'
(Plate 1.14).[35] His attempt to reconcile realism and modernism, populism
and formalism, in his speech at the Maison de la Culture encountered strong
opposition. In his summing up of the debates, Aragon attacked Léger for
refusing to paint in a straightforwardly realist fashion and argued that his
aesthetic of objects merely endorsed the commodity fetishism of the existing
capitalist order: 'Slave, you paint your chains.'[36] This accusation may have
been provoked by the role Léger gives to shop-window display in his account
of how 'the man of the people' comes to have a sense of beauty: 'Seductive
shop windows where the isolated object causes the prospective purchaser
to halt: the new realism.'[37] Aragon was not, however, completely hostile to
avant-garde techniques that disrupted conventional realist representation.
His book *Pour un réalisme socialiste* contains an essay on John Heartfield,
although, admittedly, Aragon laid greater emphasis on the revolutionary
message of Heartfield's photomontages than on their technical innovation.[38]
Moreover, in the Maison de la Culture debates, Aragon argued that work of
this kind represented only a 'transitional position' rather than a valid form of
realism.[39] As we have seen, Léger too endorsed photomontage only up to a
point, although for very different reasons.

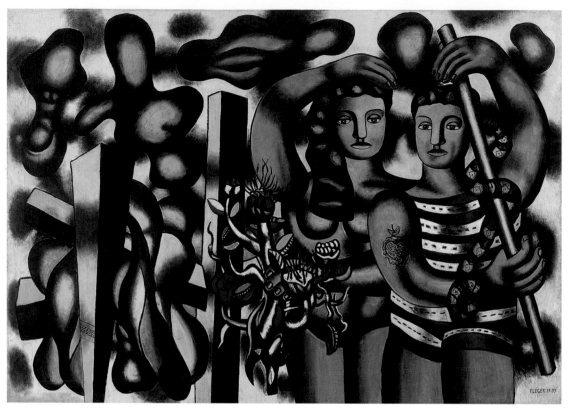

PLATE 1.14 Fernand Léger, *Adam and Eve*, 1935–9, oil on canvas, 228 × 334 cm. (Kunstsammlung Nordrhein-Westfalen, Düsseldorf. Photo: Walter Klein. © ADAGP, Paris and DACS, London 2004.)

Mural art

Despite the opposition between Aragon and Léger, it is possible to discern a broad consensus among French artists and left-wing critics. Rejecting what they saw as the twin extremes of Soviet propaganda art and purist abstraction, they sought to find some means of bridging the gap between the existing forms of French art practice and the proletariat whom they assumed would replace the bourgeoisie as the dominant force in the society of the future. In short, they wanted to make modern art accessible to a mass audience. A realism that combined politically resonant content with technically innovative form was widely seen as providing a solution to the problem.[40] Another solution that attracted widespread interest was mural painting, which Delaunay hailed as 'revolution on the walls' in a survey of artists' views on the future of painting staged by the AEAR journal *Commune* in 1935.[41] The great advantage of mural painting in public buildings was not only that it allowed artists to address a wider audience than their usual élite clientele, but also that it offered an escape from the tyranny of the art market, which was based on easel painting. In fact, much of the impetus behind the mural art movement of the 1930s came from the economic crisis, which drastically reduced private patronage; the commissions for the 1937 'Exposition Internationale' provided a welcome source of income for many artists, much as the public art projects of the New Deal did in the USA.[42]

Exemplary of these trends was the Association de l'Art Mural ('Association of Mural Art'), which was founded in 1935 and had links to the Maison de la Culture. Its fundamental objective was not the promotion of mural painting as such but rather the breaking down of the barriers separating painters, architects and sculptors, thereby enabling them to escape the isolation experienced by the artist in the modern capitalist order. Its members looked to the Middle Ages as a period in which artists were properly integrated into society and contributed as fellow-workers, as artisans, to the construction of a building. All of these concerns were shared by Léger, who was a member of the group and participated in its regular exhibitions. In 'The Wall, the Architect, the Painter' (1933), he cited as a precedent for the mural painting that he advocated 'the collective art that created immortal masterpieces before the Renaissance' and, in particular, the medieval cathedral, which he saw as the public (and popular) building par excellence.[43] (It was in the Renaissance, he argued, that art went astray and turned to the mere imitation of reality.) The combination of archaism and populism discernible in this text can also be seen in a painting such as *Adam and Eve* (Plate 1.14), in which the biblical couple appear as a man and woman of 'the people' (note Adam's tatoo). The most truly collective project that Léger was involved in was not, in fact, a mural, but rather the theatrical spectacle *La Naissance d'une cité* ('The Birth of a City'), staged in Paris on 18 October 1937, for which he designed the sets. A drama about the inauguration of a utopian society performed by a cast of hundreds in a sports stadium, it could lay claim to be the ultimate Popular Front work of art, as Léger suggested in describing it as 'a vast fresco, at once realist and lyrical'.[44]

Dreams and nightmares

Art and the Spanish Civil War

The Spanish Republic's contribution to the 'Exposition Internationale' of 1937 opened in July, one year after General Franco had launched a military insurrection against Spain's Popular Front government. The ensuing civil war became a defining cause for the European (and American) Left; outraged by the western powers' official neutrality towards the conflict, many joined the volunteer forces that were formed to fight for the Republic. The Spanish pavilion at the 1937 exhibition was a low-key modernist building entirely devoted to propaganda for the Republican cause, much of it in the form of works of art (although, as with other pavilions, extensive use was also made of photomontages documenting aspects of social, economic and cultural life). Many of these works testified to a commitment to modern art on the part of the Spanish government, which also commissioned a mural for the entrance hall of the pavilion from Picasso in January 1937. The unanticipated result was *Guernica*, not, in fact, strictly a mural but a vast canvas, on which Picasso started work after reading about the bombing of the ancient Basque town of Guernica by Nazi aeroplanes in April of that year. At the time, the aerial bombing of a civilian population was unprecedented and the action provoked international outrage. I will consider *Guernica* below, but for the

moment I want to note the diversity of Paris-based modern art, as it was represented in the Spanish pavilion. It ranged from the American sculptor Alexander Calder's non-figurative Mercury fountain to the forceful realism of Julio González's *La Montserrat* (Plate 1.15), a welded iron sculpture of a Spanish peasant woman with a sickle and a baby. The latter represents a striking departure from González's usual open-work constructions, no doubt in response to the requirements of propaganda.

A prominent place was also accorded in the pavilion to Surrealism, in the form of Joan Miró's vast mural *The Reaper* (now destroyed). In depicting an

PLATE 1.15 Julio González, *La Montserrat*, 1936–7, forged iron, height 165 cm. (Stedelijk Museum, Amsterdam. © ADAGP, Paris and DACS, London 2004.)

abstracted but still recognisable head of a peasant wielding a sickle as a weapon, Miró was modifying his usual practice in a similar fashion to González; iconographically, his mural had much in common with *La Montserrat*. In Miró's case, this 'plunge into the reality of things' in response to the 'terrible drama' of the civil war predates his work for the Spanish pavilion, as can be seen from *Still Life with Old Shoe* (Plate 1.16), painted in early 1937, which he came to see as an allegory of the war; humble objects here take on an eerie quality in the light of a burning sky.[45] Miró's ardent commitment to the Republican cause can be contrasted with the more ambiguous stance of Dalí, whose paintings dealing with the Spanish Civil War are not expressions of support for the Left but rather evocations of the horrific spectacle of a nation devouring itself (Plate 1.17). Both artists were themselves Spanish, or rather Catalan, but the war can also be seen to have had a significant impact on the work of other Surrealists, although less in terms of its effect on Spain than as a harbinger of general European war. Arguably, indeed, the combination of collective political engagement and exploration of the irrational forces underlying modern civilisation that characterised the movement meant that Surrealist art readily lent itself to pictorial reflections of (and on) the menacing international situation of the later 1930s. Certainly, although images of violence and disorder had long played a role in Surrealism, a new ominous mood is apparent in works painted at the time of the Spanish Civil War by such artists as Max Ernst (Plate 1.18) and René Magritte (Plate 1.19).

PLATE 1.16 Joan Miró, *Still Life with Old Shoe*, 1937, oil on canvas, 81 x 117 cm. (Museum of Modern Art, New York. Gift of James Thrall Soby. DIGITAL IMAGE © 2002 The Museum of Modern Art, New York/Scala, Florence. © Successio Miró/DACS, London 2004.)

PLATE 1.17 Salvador Dalí, *Autumnal Cannibalism*, 1936, oil on canvas, 65 × 65 cm. (© Tate, London 2002. © Salvador Dalí/Gala–Salvador Dalí Foundation/ DACS, London 2004.)

PLATE 1.18 Max Ernst, *The Fireside Angel*, 1937, oil on canvas, 113 × 144 cm. (Private collection. Photo: Peter Schälchli, Zurich. © ADAGP, Paris and DACS, London 2004.)

PLATE 1.19 René Magritte, *The Black Flag*, 1937, oil on canvas, 54 × 73 cm. (Scottish National Gallery of Modern Art, Edinburgh. © ADAGP, Paris and DACS, London 2004.)

More generally, it can be said that artistic responses to the Spanish Civil War tended to take a poetic and allegorical rather than literal and descriptive form. This is true even of treatments of the subject by a Socialist Realist like Fougeron, whose painting *Martyred Spain* (Plate 1.20) implicitly equates the country's sufferings with rape. Typically, the imagery of the war was informed by a romantic vision of Spain as a land of violent passions and exotic glamour, exemplified by the bullfight.[46] Here, Fougeron draws on the iconography of the bullfight in using a wounded horse as well as a violated woman to embody martyred Spain. Other works by him dealing with the civil war were included in the exhibition 'L'Art Cruel' ('Cruel Art'), which opened at the Galerie Billiet-Vorms in December 1937. Its curator, Jean Cassou, argued that, given the current state of the world, the 'return to reality' in contemporary art was inevitably 'full of rage, horror and indignation'.[47] Other artists represented in the exhibition included Dalí and one of his fellow-Surrealists, André Masson, whose existing fascination with ritual violence came to focus on the bullfight (Plate 1.21) in the mid-1930s, when he lived in Spain. Rather than relating directly to the civil war, these works by Masson evoke a timeless Spain of blood, cruelty and sacrifice. They are informed not only by romantic preconceptions about the country, but also by the ethnographic concerns of the dissident Surrealist group associated with the journal *Documents*.[48] The aestheticisation/mythologisation/eroticisation of violence that characterises 'cruel art' can be seen as politically problematic in so far as it compromises any clear-cut anti-Fascist message, in relation not only to the conflict in Spain but also (as discussed below) to the wider struggle.

PLATE 1.20 André Fougeron, *Martyred Spain*, 1937, oil on canvas, 110 × 154 cm. (© Tate, London 2002. © ADAGP, Paris and DACS, London 2004.)

PLATE 1.21 André Masson, *Tauromachy*, 1937, oil on canvas, 81 × 100 cm. (Baltimore Museum of Art: The Cone Collection, formed by Dr Claribel and Miss Etta Cone of Baltimore, Maryland. © ADAGP, Paris and DACS, London 2004.)

Surrealism and politics

I suggested above that Surrealism's particular combination of interests made it well suited to engaging pictorially with the international crisis of the late 1930s. However, fundamental tensions existed in practice between the movement's political commitments and its investigation of the unconscious.[49] In the early 1930s, the Surrealists' alliance with the PCF became increasingly difficult to sustain. In 1932, the impossibility of reconciling the free play of the individual imagination with the collective discipline imposed by the Communist International led Aragon to break definitively with Surrealism. Breton, by contrast, continued to affirm a commitment to revolution while also persistently criticising Soviet cultural policy. With the official promulgation of Socialist Realism, the Surrealists found themselves regarded with intensified suspicion by the PCF. After a speech given by Breton in 1935 at a conference of deeply hostile pro-communist intellectuals, in which he denounced the nationalistic bias of the PCF as a betrayal of Marxist doctrine and championed a truly revolutionary (as opposed to propagandist) art, the Surrealists severed their final links with the Party and started openly attacking Stalinism. Breton's concern to define an independent political position for Surrealism, combining revolutionary action with artistic freedom, drew him closer to the exiled Leon Trotsky, with whom he wrote the manifesto 'Towards a Free Revolutionary Art' (1938).[50] His firm opposition to Stalinism meant, however, that Surrealism became isolated from the rest of the Left; concern about this state of affairs eventually led even Éluard to defect.

The fundamental problem for the Surrealists was that, in the polarised political climate of the 1930s, their concern with liberating repressed desires made them vulnerable to accusations of complicity with Fascism. Admittedly, according to Breton and Trotsky, 'Every free creation is called "fascist" by the Stalinists.'[51] Nevertheless, these issues arose with particular force in the context of Surrealism. Aragon's speech to the 1935 conference, which was published in *Pour un réalisme socialiste* as 'Le Retour à la réalité' ('Return to Reality'), accused the Surrealists of having tried 'to bend Marxism to the theories of Freud' and, more damningly still, demanded:

> Do you not see just where this supposed freedom of experience that you so delight in leads you? Is there not among you any who have ended up by so loving 'experience' that they have seen even in the torture chambers of the S.A., in the hitlerian rods and axe, the *interesting* accessories of vice?[52]

Aragon may have intended this as a reference to Dalí, who had been condemned by the other Surrealists in 1934 for 'counter-revolutionary acts tending toward the glorification of hitlerian fascism'.[53] Dalí's fundamental contribution to Surrealism was to shift the balance towards the irrational: whereas Breton had identified its aim as the dialectical reconcilation of 'reality and unreality, reason and irrationality' and other apparently contradictory forces, Dalí's declared objective was 'to systematize confusion and thus to help to discredit completely the world of reality'.[54] He challenged the revolutionary commitment of his fellow-Surrealists (and enraged Breton) by employing his paranoiac–critical method to represent Lenin in a grotesque manner (Plate 1.22). It was one thing to subvert traditional patriarchal authority, as, for example, Ernst did in early paintings such as *Pietà or Revolution by Night* (1923), quite another to turn this kind of derision against the father figures of communism, as Dalí does in this work (the legendary figure of William Tell to whom the title refers was for him a highly negative symbol of patriarchal authority).

PLATE 1.22 Salvador Dalí, *The Enigma of William Tell*, 1933, oil on canvas, 202 × 346 cm. (Moderna Museet, Stockholm. © Salvador Dalí/Gala–Salvador Dalí Foundation/DACS, London 2004.)

If Dalí thereby exposed the underlying contradictions of Surrealism that Breton struggled to reconcile, his fascination with Hitler (manifested in a number of paintings and statements) was even more problematic in this respect. The artist himself denied the charge of 'Hitlerism', contending that it was necessary to try to understand the phenomenon as fully as possible and suggesting that Surrealism was uniquely well placed to do so. Subsequent commentators have often taken Dalí's Fascist tendencies for granted, but it has also been argued that he provided a psychoanalytically informed critique of Nazism as a sexual perversion (more specifically, as a form of sado-masochism).[55] What is undeniable is that many of his concerns were shared by Georges Bataille, editor of *Documents*, in whose case a passionate opposition to Fascism was combined with an exploration of themes of sexuality, violence and degradation. The affinity between the two is demonstrated by an essay Bataille wrote about Dalí's *The Lugubrious Game* (Plate 1.23); the shit-smeared pants of the man at the lower right had a particular significance for the writer, whom Breton derisively termed an 'excrement-philosopher'.[56] However, although Bataille was far more a man of the Left than the avowedly apolitical Dalí, his case too is problematic. In his essay 'The Psychological Structure of Fascism' (1933),[57] it has been argued, he tends towards an endorsement of Fascist violence and irrationalism even as he condemns its authoritarianism. Significantly, in 1936, the Bretonian Surrealists withdrew from Contre-Attaque ('Counter-Attack'), a political group of 'revolutionary intellectuals' that Breton had founded the previous year with his old antagonist Bataille, accusing the latter of 'sur-fascist' tendencies.[58] However, to reiterate, the crucial point is not whether or not such accusations were justified in any specific instance, but rather that, in the context of the 1930s, a Surrealist-inspired concern with the transgression of 'civilised' norms was likely to be seen by supporters of the Stalinised communist movement as a capitulation to the barbarism represented by Fascism.

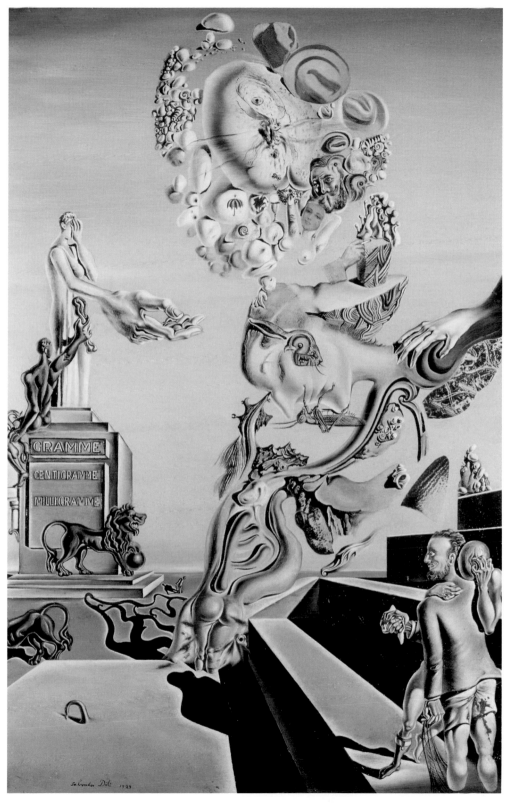

PLATE 1.23 Salvador Dalí, *The Lugubrious Game*, 1929, oil and collage on card, 44 × 30 cm.
(Photo: DESCHARNES/daliphoto.com. © Salvador Dalí/Gala–Salvador Dalí
Foundation/DACS, London 2004.)

Picasso and *Guernica*

Until the Spanish Civil War, Picasso had never produced an overtly political work of art. In an interview with Zervos published in *Cahiers d'art* in 1935, he suggested that art presented a 'danger to society', but located the source of the drama and danger of his own painting in his purely private 'passions'. An artist, he argued, should paint to unload his instincts, desires and feelings; the process of creating a picture he described as 'materializing a dream'.[59] Although the idea of art as self-expression was standard, Picasso's remarks can be seen to be informed by a distinctively Surrealist concern with the unconscious and the irrational. In fact, ten years earlier, Breton had claimed him as 'one of us', on account of his unwavering commitment to 'a purely interior model'.[60] In 1933, Picasso was invited to design a cover for the first issue of a lavishly produced, Surrealist-oriented journal, *Minotaure*. The minotaur, the bull-headed monster in the Cretan labyrinth from the myth of Theseus and Ariadne, was for the Surrealists a compelling symbol of the irrational desires and dark instincts of the unconscious. It appears frequently in Picasso's work around this time, notably in his etching *Minotauromachy* (Plate 1.24). For him, as for Masson, who was also fascinated by the myth, the minotaur was associated with a mythologised treatment of the bullfight

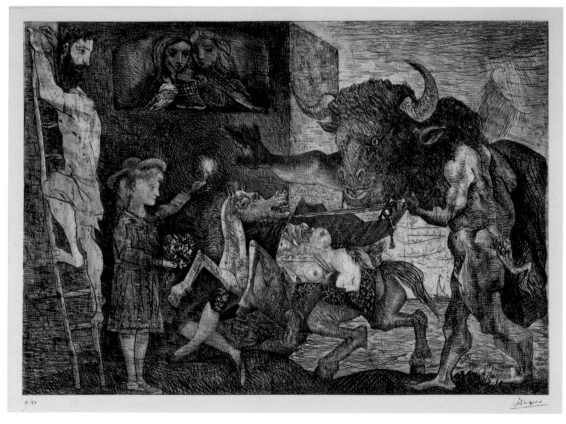

PLATE 1.24 Pablo Picasso, *Minotauromachy*, 1935, etching and engraving, plate 50 × 70 cm.
(Publisher: the artist. Edition: approx. 55. Museum of Modern Art, New York. Abby Aldrich Rockefeller Fund. DIGITAL IMAGE. © 2002 The Museum of Modern Art, New York/Scala, Florence. © Succession Picasso/DACS, London 2004.)

theme: note that the etching includes a wounded horse. Picasso projected onto it not some notion of Spain (as did Masson), but rather, it seems, the drama of his own inner life. In *Guernica* (Plate 1.25), this imagery of private obsession was harnessed to public political commitment; the painting thus embodies tensions similar to those that underlay the Surrealist movement as a whole.

Please compare *Guernica* (Plate 1.25) with *Minotauromachy* (Plate 1.24), considering how the painting both draws on and differs from the etching and to what extent the painting can be seen as a representation of the event to which the title refers. Also compare the following contemporary responses, considering how they differ in their interpretation of the painting.

Christian Zervos

Guernica … is undoubtedly the artist's most humane, most stirring work, engaging his most passionate feelings … From Picasso's paintbrush explode phantoms of distress, anguish, terror … And above so much sadness, the bird lifts up its song of life, and the bull – like the winged, mythological creatures of antiquity – contemplates man's work of destruction … A sense of permanence, of imperishable force emanates from him. His serene look convinces us that nothing essential is ever lost.[61]

Michel Leiris

The sun reduced to the shape of an electric bulb glaring in mean intimacy within an inch of our heads, the terrors of the horse writhing like Pegasus suddenly caught in some dreadful cut-throat place, the bull – the only victorious one – eternally thrusting up his horns, the convulsed human beings, … the bird shrieking itself hoarse … In the black-and-white rectangle of ancient tragedy, Picasso sends us our death notice: everything we love is going to die.[62]

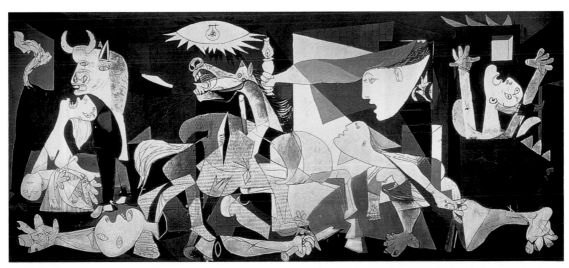

PLATE 1.25 Pablo Picasso, *Guernica*, 1937, oil on canvas, 349 × 777 cm. (Museo Nacional Centro de Arte Reina Sofía, Madrid. © Succession Picasso/DACS, London 2004.)

The etching prefigures the painting in several respects. In both works, a bull's head appears to one side and a wounded horse in the centre, while the little girl with the candle on the left in the etching relates to the woman holding up a lamp on the right in the painting. This woman looks down from a window – as do the two women at the back of the etching. But there are also fundamental differences: the poetic, mysterious mood of the earlier work is replaced by one of intense grief and horror; fine detail and subtle nuance give way to bold simplification and expressive distortion. Picasso also banishes any hint of eroticism: whereas the etching gives a central place to the beguiling figure of a female matador with bare breasts, the female figures in *Guernica* are wholly unalluring in their anguish. Overall, there is a shift away from allegory towards realism, exemplified by the replacement of the mythological minotaur by an actual bull. In particular, the screaming woman apparently trapped in her burning house at the far right can be seen as referring to the bombing of Guernica. Any literal reading of the scene as a representation of this historical event will not hold, however, in view of such elements as the incongruous light-bulb and the dead soldier in the foreground holding an anachronistic sword. A symbolic reading is needed to account for the presence of the horse and bull who, as we have seen, are drawn from the iconography of the bullfight. Both the importance of the animal symbolism and the overall complexity of the image are apparent from the antithetical interpretations put forward by Zervos and Leiris. Whereas the former sees the bull as a benign presence and contends that the painting offers a message of hope, the latter emphasises the beast's brute force (perhaps identifying it with triumphant Fascism) and interprets the painting in the bleakest possible terms. ■

Both of these responses were printed in a special issue of *Cahiers d'art* devoted to *Guernica*. Outside the milieu of committed modernists, however, the reception of the painting was rather less favourable. Even the officials who had commissioned it were concerned that it would 'be accused of being too abstract or difficult for a pavilion like ours which seeks to be above all … a popular manifestation'.[63] In his account of the 1937 'Exposition Internationale' by contrast, Ozenfant insisted that *Guernica* could and did speak to ordinary people. He applauded Picasso's refusal to make 'concessions to the dangerous tendency of Leftist groups who too often value only "subject matter" and … overlook the powerful social impact, always revolutionary in a way, of intensely beautiful things'.[64] Several of those who sought to defend the painting did so by affirming that it was an essentially realist work in the Spanish tradition, embodying the spirit of the Spanish people and revivifying the genius of Goya; in so doing, they implicitly identified *Guernica* as an example of revolutionary romanticism (even though it did not conform to Aragon's French-oriented definition of the term). When *Guernica* was exhibited in London the following year, it elicited comparable polemics between enthusiastic modernists, on the one hand, and hostile Socialist Realists, on the other. One of the former, the poet Stephen Spender, implicitly identified the painting as a form of 'new realism' by noting that its flickering monochrome and its flatness evoked the newsreels, photographs and newspapers to which Picasso owed his knowledge of the horror he depicted.[65]

Conclusion

During the 1930s, the Parisian art world underwent a remarkable process of politicisation. It became imperative for many, indeed most, artists and critics to embrace political engagement, and political concerns became central to artistic practice and discourse. As shown in this chapter, however, the marriage of art and politics did not take place in a tidy, univalent fashion. Oppositions between abstraction and realism, modernism and tradition, do not neatly translate into oppositions between Right and Left, autonomy and commitment. This is not to say that the situation was entirely fluid: even though modernism was moving towards official acceptance during this period, it still retained much of its original avant-garde credentials. In particular, abstract art remained a marginal phenomenon and, as such, the preserve of artists who did not accept the status quo. One of the more startling developments of the decade, however, was the embrace of artistic tradition by the major parties of the Left, although it might be argued, with the benefit of hindsight, that part of the reason for this was because the Communist International betrayed its historic commitment to the working class by appealing to the middle class in the name of 'humanity' and of the 'nation'. From such a perspective, the Trotskyist stance of the Surrealists is preferable but, at the same time, even if we disregard the Stalinist accusations of complicity with Fascism, it must be acknowledged that their commitment to social revolution was compromised by their embrace of fashionable success (for example, they can be seen to have pandered to public expectation by including Dalí in the 'Exposition Internationale du Surréalisme' of 1938, even though by this date he was largely estranged from the group).

As a coda, I would like to offer one final and especially telling example of just how complex the web of artistic affiliations, personal alliances and ideological commitments in 1930s Paris could be, by briefly considering the case of the sculptor Alberto Giacometti. During the first half of the decade, Giacometti's main ties were with the Surrealists; although invited to join Abstraction-Création, he refused. A crucial role in the conception of the Surrealist object was played by his work *Suspended Ball* (Plate 1.26), the imagined movement of which is suggestive of frustrated sexual desire. It was illustrated in the third issue of the journal *La Surréalisme au service de la Révolution* ('Surrealism at the Service of the Revolution') in 1931, in conjunction with Dalí's article introducing the idea of the Surrealist object, and also exhibited in the 1936 'Exposition Surréaliste des Objets' ('Surrealist Exhibition of Objects').[66] While such objects constituted a fundamental challenge to conventional aesthetic categories, Giacometti nevertheless remained primarily a sculptor. Equally, although he was associated with Bretonian Surrealism, he also had links to the group connected with *Documents*; his sculpture *Woman with her Throat Cut* (Plate 1.27) is close in spirit to Bataille in combining extreme violence with suggestions of erotic pleasure. At the same time, Giacometti maintained ties with Aragon and shared his political commitments; in response to the *Commune* survey of 1935, he sent in a drawing of a man waving a banner (presumably the red flag) with a crowd marching behind him. Giacometti's return to figuration in the mid-1930s led to his expulsion from the Surrealist group and, after this date, his closest artistic ties were with Derain, Hélion and young figurative painters, notably Balthus. As with Hélion, the new direction in Giacometti's work was motivated by a desire to embrace 'the totality of life'.[67] It also looks forward to the sculptures he produced in the postwar era.

PLATE 1.26
Alberto Giacometti,
Suspended Ball, 1930, plaster,
metal and string, height 61 cm.
(Kunsthaus, Zurich, Alberto
Giacometti Foundation.
© ADAGP, Paris and DACS,
London 2004.)

PLATE 1.27 Alberto Giacometti, *Woman with her Throat Cut*, 1932, bronze, 22 × 88 × 53 cm. (Scottish
National Gallery of Modern Art, Edinburgh. © ADAGP, Paris and DACS, London 2004.)

Notes

Where quotations from works in French are given in English, the translations are my own.

1 Ozenfant, 'Notes of a tourist at the exhibition' (1937), in Ades *et al.*, *Art and Power*, pp.115–16.

2 See Golan, *Modernity and Nostalgia*.

3 See Wilson, *Paris: Capital of the Arts 1900–1968*.

4 On the 'Exposition Internationale Coloniale' of 1931, see Chapter 2.

5 Quoted in Cowling and Mundy, *On Classic Ground*, p.149.

6 Quoted in *ibid.*, p.29.

7 Quoted in Lemoine, *Paris 1937: cinquentenaire de l'exposition internationale*, p.22.

8 On photomontage, see Chapter 13 in *Art of the Avant-Gardes*.

9 Interview of 1939, quoted in Affron, 'Léger's Modernism', p.145.

10 In the 1924 'Manifesto of Surrealism', for example; see Breton, *Manifestoes of Surrealism*, p.16.

11 Préambule ('Preface'), *Les Maîtres de l'art indépandant*, p.5.

12 Quoted in *Paris 1937: l'art indépandant*, p.26.

13 For further discussion of these issues, see Chapter 2 in *Art of the Avant-Gardes*.

14 Green, *Art in France*, p.60.

15 Quoted in Cowling *et al.*, *Matisse/Picasso*, p.377. On Picasso criticism of this period, see Cowling, *Picasso*, p.18.

16 Escholier, quoted in *Paris 1937: l'art indépandant*, p.32.

17 The painting in question was Matisse's *Decorative Figure on an Ornamental Ground* (1925–6), now in the Musée Nationale d'Art Moderne, Centre Georges Pompidou, Paris. By contrast, no work by Picasso entered the national collection during the Popular Front era.

18 Silver, *Esprit de Corps*. See also the texts in 'Neo-Classicism and the Call to Order', in Harrison and Wood, *Art in Theory 1900–2000*, IIIA, pp.226–49.

19 Green cautions, however, against identifying George, himself a Jewish immigrant, as anti-Semitic; see Green, *Art in France*, pp.224–5. He also argues that it is not clear that Derain was sympathetic to this interpretation of his work.

20 For an edited version of the group's manifesto, see Harrison and Wood, *Art in Theory 1900 2000*, IVA4, pp.374 5. For the history of the group, see Nobis and Rohrig, *Abstraction-Création 1931–1936*.

21 *Abstraction-Création, l'art non-figuratif*, no.1, 1932, p.16.

22 Mondrian, 'Realist and Superrealist Art' (1930), in *The New Art*, p.230. See also Bois, 'The Iconoclast', p.315.

23 *Ibid.*, p.2.

24 In this context, it has been noted that Ozenfant (who was critical of what he saw as Mondrian's extremism) illustrated his 1928 book, *Art*, with microscopic images of organic life and other natural forms; see Fabre, *Paris 1930*, pp.386, 396–7. For an extract from Ozenfant's book, see Harrison and Wood, *Art in Theory 1900–2000*, IVA2, pp.369–71.

25 *Abstraction-création, l'art non-figuratif*, no.2, 1933, p.1. The questionnaire is translated in Harrison and Wood, *Art in Theory 1900–2000*, IVA4, p.376.

26 Quoted in Fabre, 'L'Art abstrait-concret à la recherche d'une synthèse', p.74. On Hélion, see also Chapter 9 in *Art of the Avant-Gardes*.

27 *Abstraction-création, l'art non-figuratif*, no.1, 1932, p.46.

28 There is an extract from the speech in Harrison and Wood, *Art in Theory 1900–2000*, IVB15, pp.426–9.

29 Quoted in Michaud, 'Nationalisme et internationalisme', p.23. See also Ory, *La Belle Illusion*, pp.65–6.

30 For a discussion of the representation of the strikes, stressing how the emphasis on celebration served as a way of downplaying the workers' militancy, see Dell, 'Festival and Revolution'.

31 Quoted in Fauchereau, *La Querelle du réalisme*, p.45.

32 *Ibid.*, pp.94–7.

33 Léger, 'The New Realism Goes On' (1937), in *Functions of Painting*, pp.114–16. There is also an extract in Harrison and Wood, *Art in Theory 1900–2000*, IVC19, pp.502–5.

34 See Léger, 'The Origins of Painting and its Representational Value' (1913), in *Functions of Painting*, pp.3–10. There is also an extract in Harrison and Wood, *Art in Theory 1900–2000*, IIB8, pp.201–5. See also Lassalle, 'Art Criticism as Strategy', pp.199–204.

35 That is to say, it remained purely pictorial. Quoted in Conzen-Meairs, 'Revolution and Tradition', p.12.

36 Aragon, 'Le Réalisme à l'ordre du jour' ('Realism on the Agenda') (1913), quoted in Perrot, 'Impasse et seuil', p.134.

37 Léger, 'The New Realism Goes On' (1937), in *Functions of Painting*, p.117.

38 On Heartfield, see Chapter 13 in *Art of the Avant-Gardes*.

39 Aragon, 'John Heartfield et la beauté revolutionnaire' ('John Heartfield and Revolutionary Beauty') (1935), in *Pour un réalisme socialiste*, pp.35–47; Fauchereau, *La Querelle du réalisme*, p.94.

40 See Ory, *La Belle Illusion*, pp.238–49.

41 Fauchereau, *La Querelle du réalisme*, p.252.

42 On the New Deal, see Chapter 3.

43 Léger, 'The Wall, the Architect, the Painter' (1933), in *Functions of Painting*, pp.94, 98.

44 Quoted in Green, *Art in France*, p.177.

45 Miró, letter of January 1937, quoted in La Beaumelle, 'Les Surréalistes et la guerre d'Espagne', p.141.

46 For this argument, see Moulignat, 'Les Peintres face à la guerre d'Espagne'.

47 'L'Art cruel', catalogue essay, excerpted in *Paris–Paris*, p.49. Cassou cited Picasso's *Guernica* as an example; Picasso was represented in the exhibition by his satirical etchings *Dream and Lie of Franco*.

48 See Chapter 2. Masson was, in fact, represented in the exhibition by satirical drawings that did relate directly to the crisis.

49 See Chapter 14 in *Art of the Avant-Gardes*.

50 Breton, Rivera and Trotsky, 'Towards a Free Revolutionary Art' (1938), in Harrison and Wood, *Art in Theory 1900–2000*, IVD9, pp.532–5.

51 *Ibid.*, p.535.

52 Aragon, *Pour un réalisme socialiste*, pp.79, 82. (S.A. stands for Sturmabteiling, the political militia of the Nazi Party.)

53 Quoted in Maur, 'Breton et Dalí', p.201, as cited in Greeley, 'Dalí's Fascism', p.466.

54 Dalí, 'The Stinking Ass' (1930), in Harrison and Wood, *Art in Theory 1900–2000*, IVC14, p.487.

55 For this argument, see Greeley, 'Dalí's Fascism'.

56 Bataille, 'The Lugubrious Game' (1929), in *Visions of Excess*, pp.24–30. An edited version of the text, omitting the long footnote in which Bataille details his interpretation of Dalí's painting, is printed in Harrison and Wood, *Art in Theory 1900–2000*, IVC13, pp.484–6. For Breton's denunciation of Bataille, see *Manifestoes of Surrealism*, p.185. Bataille in his turn attacked Breton for his idealism; for a brief discussion of their differences, see Foster, *Compulsive Beauty*, pp.110–13.

57 Bataille, 'The Psychological Structure of Fascism' (1933), in *Visions of Excess*, pp.137–60.

58 Bataille, 'Introduction', in *ibid.*, p.xvii.

59 Zervos, 'Conversation with Picasso' (1935), in Oppler, *Picasso's Guernica*, pp.142–5. An edited version of the interview is included in Harrison and Wood, *Art in Theory 1900–2000*, IVD2, pp.507–10.

60 Breton, 'Surrealism and Painting' (1928), in Harrison and Wood, *Art in Theory 1900–2000*, IVC5, pp.457–63.

61 Zervos, 'The Story of a Painting' (1937), quoted in Oppler, *Picasso's Guernica*, p.210.

62 Leiris, 'Death Notice' (1937), quoted in *ibid.*, pp.206–7, 210.

63 Max Aub, 'Welcome to the Pavilion' (1937), quoted in *ibid.*, p.204.

64 Quoted in *ibid.*, pp.214–15; see also the fuller translation of Ozenfant's review cited in note 1.

65 'This kind of second-hand experience … is one of the dominating realities of our time' (quoted in Oppler, *Picasso's Guernica*, p.216). Among those who criticised Picasso's work from a Socialist Realist perspective was the art historian Anthony Blunt; for Blunt's criticism of abstract art, see Chapter 10 in *Art of the Avant-Gardes*.

66 As quoted in Ades, *Dalí*, p.152. The other exhibits included Marcel Duchamp's *Bottlerack* (see Chapter 2 in *Frameworks for Modern Art*) and Meret Oppenheim's *Breakfast in Fur* (see Chapter 14 in *Art of the Avant-Gardes*).

67 Quoted in Klemm *et al.*, *Alberto Giacometti*, p.120.

References

Abstraction-Création, l'art non-figuratif, 1932–6 (facsimile reprint), New York: Arno Press, 1968.

Ades, D., *Dalí*, London: Thames & Hudson, 1995.

Ades, D. *et al.* (eds), *Art and Power: Europe under the Dictators 1930–45*, exhibition catalogue, Hayward Gallery, London, 1995.

Affron, M., 'Léger's Modernism: Subjects and Objects', in C. Lanchner (ed.), *Fernand Léger*, exhibition catalogue, Museum of Modern Art, New York, 1998, pp.121–48.

Ameline, J.-P. (ed.), *Face à l'histoire, 1933–1996*, exhibition catalogue, Musée National d'Art Moderne, Paris, 1996.

Aragon, L., *Pour un réalisme socialiste*, Paris: Denoël et Steele, 1935.

Bataille, G., *Visions of Excess: Selected Writings, 1927–1939*, ed. and trans. A. Stoekl, Minneapolis: University of Minnesota Press, 1985.

Bois, Y.-A., 'The Iconoclast', in Y.-A. Bois, J. Joosten, A. Zander Rudenstine and H. Janssen (eds), *Piet Mondrian 1872–1944*, exhibition catalogue, Gemeentemuseum, The Hague, 1994.

Breton, A., *Manifestoes of Surrealism*, trans. R. Seaver and H.R. Lane, Ann Arbor: University of Michigan Press, 1969.

Conzen-Meairs, I., 'Revolution and Tradition: The Metamorphosis of the Conception of Realism in the Late Works of Fernand Léger', in *Fernand Léger: The Later Years*, exhibition catalogue, Whitechapel Art Gallery, London, 1987, pp.11–18.

Cowling, E., *Picasso: Style and Meaning*, London: Phaidon, 2002.

Cowling, E. and Mundy, J. (eds), *On Classic Ground: Picasso, Léger, de Chirico and the New Classicism 1910–1930*, exhibition catalogue, Tate Gallery, London, 1990.

Cowling, E. *et al.* (eds), *Matisse/Picasso*, exhibition catalogue, Tate Modern, London, 2002.

Dell, S., 'Festival and Revolution: The Popular Front in France and the Press Coverage of the Strikes of 1936', *Art History*, vol.23, no.4, November 2000, pp.599–621.

Edwards, S. and Wood, P. (eds), *Art of the Avant-Gardes*, New Haven and London: Yale University Press in association with The Open University, 2004.

Fabre, G., 'L'Art abstrait-concret à la recherche d'une synthèse', in Pagé and Vidal, *Les Années 30 en Europe*, pp.71–5.

Fabre, G., *Paris 1930: arte abstracto, arte concreto*, exhibition catalogue, with English translation, IVAM, Centro Julio González, Valencia, 1990.

Fauchereau, S. (ed.), *La Querelle du réalisme*, Paris: Cercle d'Art, 1987 (first published 1936).

Foster, H., *Compulsive Beauty*, Cambridge, MA: MIT Press, 1993.

Gaiger, J. (ed.), *Frameworks for Modern Art*, New Haven and London: Yale University Press in association with The Open University, 2003.

Golan, R., *Modernity and Nostalgia: Art and Politics between the Wars*, New Haven and London: Yale University Press, 1995.

Greeley, R.A., 'Dalí's Fascism; Lacan's Paranoia', *Art History*, vol.24, September 2001, pp.465–92.

Green, C., *Art in France 1900–1940*, New Haven and London: Yale University Press, 2000.

Harrison, C. and Wood, P. (eds), *Art in Theory 1900–2000: An Anthology of Changing Ideas*, Malden, MA and Oxford: Blackwell, 2003.

Klemm, C. *et al.* (eds), *Alberto Giacometti*, exhibition catalogue, Museum of Modern Art, New York, 2001.

La Beaumelle, A.A. de, 'Les Surréalistes et la guerre d'Espagne', in Ameline, *Face à l'histoire*, pp.137–42.

La Beaumelle, A.A. de *et al.* (eds), *André Breton: la beauté convulsive*, exhibition catalogue, Musée National d'Art Moderne, Paris, 1991.

Lassalle, H., 'Art Criticism as Strategy: The Idiom of "New Realism" from Fernand Léger to the Pierre Restany Group', in M. Gee (ed.), *Art Criticism since 1900*, Manchester: Manchester University Press, 1993, pp.199–218.

Léger, F., *Functions of Painting*, ed. and trans. E.F. Fry, London: Thames & Hudson, 1973.

Lemoine, B. (ed.), *Paris 1937: cinquentenaire de l'exposition internationale des arts et des techniques dans la vie moderne*, exhibition catalogue, Musée d'Art Moderne de la Ville de Paris, 1987.

Les Maîtres de l'art indépendant, 1895–1937, exhibition catalogue, Musée du Petit Palais, Paris, 1937.

Maur, K. von, 'Breton et Dalí, à la lumière d'une correspondance inédite', in La Beaumelle *et al.*, *André Breton*, pp.196–202.

Michaud, E., 'Nationalisme et internationalisme', in Pagé and Vidal, *Les Années 30 en Europe*, pp.23–5.

Mondrian, P., *The New Art – The New Life – Collected Writings*, ed. and trans. H. Holzman and M. St James, London: Thames & Hudson, 1987.

Moulignat, F., 'Les Peintres face à la guerre d'Espagne', in *L'Art face à la crise 1929–1939*, Université de Saint-Étienne, Centre interdisciplinaire d'étude et de recherche sur l'expression contemporaine, 1979.

Nobis, N. and Rohrig, H. (eds), *Abstraction-Création 1931–1936*, exhibition catalogue, Musée d'Art Moderne de la Ville de Paris, 1978.

Oppler, E.C. (ed.), *Picasso's Guernica*, New York: Norton, 1988.

Ory, P., *La Belle Illusion: culture et politique sous le signe du Front populaire*, Paris: Plon, 1994.

Pagé, S. and Vidal, A. (eds), *Les Années 30 en Europe: le temps menaçant 1929–1939*, exhibition catalogue, Musée d'Art Moderne de la Ville de Paris, 1997.

Paris 1937: l'art indépendant, exhibition catalogue, Musée d'Art Moderne de la Ville de Paris, 1987.

Paris–Paris, créations en France 1937–1957, exhibition catalogue, Musée Nationale d'Art Moderne, Paris, 1981.

Perrot, A., 'Impasse et seuil: figures du réalisme dans les années trente', in Ameline, *Face à l'histoire*, pp.133–6.

Silver, K.E., *Esprit de Corps: The Art of the Parisian Avant-Garde and the First World War 1914–1925*, Princeton, NJ: Princeton University Press, 1989.

Wilson, S. (ed.), *Paris: Capital of the Arts 1900–1968*, exhibition catalogue, Royal Academy of Arts, London, 2002.

CHAPTER 2

Surrealism's other side

Niru Ratnam

Revolution

In early December 1945, André Breton arrived in Port-au-Prince, Haiti, for a lecture tour that was scheduled to coincide with an exhibition of the paintings of the Cuban artist Wilfredo Lam, which was being held at the Centre d'Art. On 7 December, a banquet was held in Breton's honour, and there Breton spoke about Surrealism's fundamental principles. In the audience were the young editors of a Haitian journal, *La Ruche* ('The Beehive'), which at the time was known for its attacks on the island's reactionary government, headed by the dictator President Elie Lescot. After the banquet, the editors asked Breton if they could have exclusive rights to his address. Breton agreed. He was on the island to deliver three lectures, and the first of these took place in front of a crowd of 700 at the Rex Theatre on 20 December. The composition of the crowd was mixed. Haitian intellectuals were there but so were members of the military and the government, including President Lescot, all expecting a talk on 'the role of latinity in the Americas'.[1] Instead, Breton spoke about the history of Surrealism, Surrealism's encounter with Marxism, and what he conceptualised as the natural latent Surrealism in Haiti's culture and people. An eyewitness account compared the effect of the speech to the original, startling effect that Surrealism had had in Europe: 'The scandalous and subversive atmosphere that had characterized surrealism in the heroic period of its Parisian era was created at the Rex.'[2] Breton's speech was greeted by a standing ovation, but he left without paying the customary respects to the head of state.

In response to Breton's lecture, the editors of *La Ruche* decided to produce a special end-of-year issue devoted to Breton, Surrealism and Pierre Mabille. Mabille had been Breton's family doctor and was now the French cultural attaché in Haiti; it was he who had invited Breton to the island. The whole of the front page of the resulting issue was given over to Breton's speech. Inside, using Breton's words and Surrealism as a spur, the special issue called for rebellion against Lescot's government, or as one of the editors put it: 'a pure and simple call to national insurrection'.[3] The government reacted at once. Issues of the journal were confiscated, further publication was banned and two of the editors were imprisoned. In response, there were public demonstrations against the police. A student strike was called to demand the release of the two imprisoned editors and between 7 and 11 January 1946 this turned into a full-scale general strike. As unrest grew, the military intervened, not against the strike, but to remove Lescot's government. Dumarsais Estimé, a progressive black president, replaced the dictator Lescot.

PLATE 2.1 (facing page) Wilfredo Lam, detail of *The Jungle* (Plate 2.9).

The art historian Michael Richardson has written:

> For Europeans, the effect of Breton's lectures in Haiti may come as
> a surprise. We do not expect literary figures to make an intervention
> in the political arena ... What Breton said was hardly incendiary ...
> In interviews he was keen to play down the part he played in the
> revolution, pointing out that the social forces that caused it were all
> in place and would doubtless have become manifest if he had not
> visited the island. And yet, the revolution could not have taken the
> course it did without Breton's intervention.[4]

Richardson is one of a small number of art historians who have documented
Breton's trip to Haiti. It is often assumed that Surrealist activity was limited to
Europe in the interwar period of the twentieth century, but the work of
Richardson and other art historians such as Robert Linsley has shown that
this is not the case. Surrealism played an important, if scarcely documented,
role in the French-speaking Caribbean and was utilised by Caribbean
intellectuals in the struggle against colonialism.

This chapter is concerned with Surrealism's encounter with 'otherness', but
not the Surrealist interest in primitive art, which is well documented. Instead,
it focuses on Surrealism's anti-colonialist thrust, and how anti-colonial cultural
activities in the Caribbean were closely tied to Surrealism. But I will begin by
reviewing the better-documented phenomenon of ethnographic Surrealism
pursued by the dissident Surrealists who gathered around Georges Bataille
in Paris in the late 1920s and early 1930s.

It ought to be noted that the revolution in Haiti did not have a positive
outcome. The interim military junta of 1946 expelled Breton and successfully
demanded that Paris recall Mabille. The progressive government of Estimé
did not last long. He was overthrown in 1948 by a coup that ushered in the
long and greatly damaging reign of François 'Papa Doc' Duvalier. Despite this
unfortunate sequence of events, it should be recognised how and why
Surrealism was of such importance to Caribbean intellectuals and why the
Haitian poet Paul Laraque could later write: 'What Surrealism represented
to us above all was the leap into the unknown.'[5]

Ethnographic Surrealism

Ethnographic Surrealism is associated with the 'dissident' Surrealists, a number
of ex-Surrealists who were ousted from the group by Breton in March 1929,
and individuals such as Bataille who, although they never formally associated
with the group, shared many of the mainstream Surrealists' concerns. Bataille
was the focal point of the dissidents in a way that mirrors Breton's presence
within mainstream Surrealism. It is not surprising that some accounts of
Surrealism position Bataille as a dark counter-presence to Breton, but it would
be more accurate to recall Bataille's own opinion of himself as being 'at the
side of Surrealism',[6] a description that is more suggestive of a dovetailing of
interests than of simple opposition. Bataille's thinking is difficult to summarise
and is open to reductive readings, but James Clifford has drawn attention to a
phrase in Bataille's book *L'Erotisme* that states 'Transgression does not negate

an interdiction, it transcends and completes it'. Clifford argues that this claim offers a useful way of beginning to understand Bataille's project as a whole.[7] Bataille's words suggest that the function of taboos or interdictions is not to stop certain undesirable acts, but implicitly to invite their completion, and thus perversely these taboos and interdictions are dependent on the fulfilment of the acts they forbid. For instance, there would be no taboo on killing if murders did not take place, so murder 'completes' the interdiction against it. By extension, for Bataille all taboos in mainstream society exist only to be broken.

The forum for the views of the dissident Surrealists was the journal *Documents*. It was founded in 1929, a few weeks after Breton purged the Surrealist group because of perceived differences in belief about Surrealism's relationship to Marxism. The journal lasted less than two years before its financial backing was stopped. Bataille was one of the main forces behind the journal, along with its founder, Georges Wildenstein, and Georges-Henri Rivière, Carl Einstein and Michel Leiris. Rivière was the assistant director at the Museum of Ethnography at the Trocadéro (the museum in Paris where Pablo Picasso had seen African masks at the beginning of the twentieth century) and had been responsible for organising the first popular exhibition of pre-Columbian art in France. Leiris also worked at the museum and Einstein had written one of the first western analyses of African art.[8] This collective interest in non-western cultures and ethnography (the western academic discipline of observing, recording and analysing non-western cultures) goes some way to explain the presence of one of the subheadings of *Documents*. These were listed on the title page as being 'Doctrines', 'Archéologie', 'Beaux-Arts' ('Fine Art') and 'Ethnographie'. 'Variétés' was added from the fourth issue, in place of 'Doctrines' (Plate 2.2).

The presence of ethnography as one of its key interests was highly unusual for a journal ostensibly devoted to the arts, but *Documents* was a radical and strange journal. Central to an understanding of *Documents* is Bataille's concept of *la bassesse* ('baseness'). While Breton was aligning Surrealism closely to the historical materialism of Karl Marx, Bataille offered a different sort of materialism – one that was rooted in base matter itself and that rejected the hierarchies and ideals of other sorts of materialism. It has been described as 'a materialism which … acknowledges the actual diversity and untidiness of social and psychological experience'.[9] *La bassesse* orientated human existence downwards from the Platonic ideal towards the mud and the earth, the physical rather than the mental, extolling the virtues of bodily functions, sado-masochism and ritualistic activities such as sacrifice and cannibalism. For Bataille, *la bassesse* was famously exemplified in Jacques-André Boiffard's photograph of a big toe (Plate 2.3). Bataille argued that this previously disregarded digit was in fact the most human part of the body, in that it is the least like its counterpart in the body of the ape. Moreover, as it is the part of the body that is closest to the ground, for Bataille this meant that the most essential thing about humanity was that which was embedded firmly in the mud.

This reordering of the Platonic schemata was mirrored in a general drive towards reordering and reclassification in the journal. The contents of each issue were remarkably heterogeneous, with articles on 'high' art sitting next to descriptions of slaughterhouses. There were photographs of African masks and accounts of Cuban music. Clifford contends that the role of ethnography

within the journal can be understood in two ways. First, there is the fact that some of the contents of the journal were ethnographic photographs and accounts. Thus, the involvement of leading ethnographers such as Rivière, Leiris, Roger Callois, Marcel Griaule and André Schaeffner with *Documents* is unsurprising; for example, Rivière wrote an article on the Trocadéro for the first issue of the journal. However, there is a second, more subtle, role for ethnography within the journal. Clifford argues that there is an ethnographic attitude at work in the way the journal functions, particularly with respect to its layout:

> The journal's title, of course, is indicative. Culture becomes something to be collected, and *Documents* itself is a kind of ethnographic display of images, texts, objects, labels, a playful museum that simultaneously collects and reclassifies its specimens.[10]

PLATE **2.3** Jacques-André Boiffard, *Big Toe, Male Subject, 30 Years Old*, 1929, gelatin silver print, 31 × 24 cm. (Centre Pompidou-MNAM-CCI, Paris. © Photo: CNAC/MNAM Dist. RMN.)

The layout of issues of *Documents* borders on the anarchic, with no separate sections for the topics that the journal covers. At the time of *Documents*'s publication, the young discipline of ethnography was directed towards a questioning of western norms through the study of non-western cultures. It can be argued that the seemingly random layout of material implicitly critiques and deconstructs the received order of things as valued by bourgeois western society in a fashion that parallels the way ethnography was attempting to deconstruct western norms. There is also a parallel to be drawn between the startling juxtapositions of the layout of *Documents* and the deliberate jarring combination of subject matter within Surrealist art. *Documents* becomes less a journal in which ethnographic articles could be found (although there were a number of these) and more a *site* of ethnographic activity that made manifest the Surrealist view of culture as a series of artificial constructs that mask other realities. In short, we can understand *Documents* as performing ethnographic Surrealism. This idea of embodying an ethnographic attitude might explain why one of the subheadings on the cover page is 'Ethnographie' rather than the more common 'L'Art primitif' ('primitive art'); *Documents* was less interested in discrete articles on primitive art and more interested in an all-encompassing ethnographic mode of participant observation in international cultural life. This distinction becomes important when coming to defend *Documents* and ethnographic Surrealism against claims that each simply engaged in an unreflective celebration of the cultural 'other'.

Clifford characterises two key elements of ethnographic Surrealism that he argues are in operation within *Documents*: 'first, the corrosive analysis of a reality now identified as local and artificial; and second, the supplying of exotic alternatives'.[11] From this point of view, 'reality' is little more than just another construct masquerading as the norm. The foregrounding of other, non-western, realities thus becomes a crucial strategy that is clearly at play in many instances throughout *Documents* – for example, in volume 1, number 4, which came out in September 1929. One of the main subject strands of that issue was the appearance at the Moulin Rouge of a troupe of black performers from Harlem – Lew Leslie's Black Birds (Plate 2.4). Their appearance was not in itself unusual, for black musicians and performers, such as Josephine Baker, became increasingly fashionable in Paris throughout the 1920s. Yet what the Black Birds performed was very different from the usual mélange of comedy and light-hearted song. The Black Birds presented a dramatisation of DuBose Heyward's novel *Porgy* – a harsh, realistic story about the lives of liberated slaves working the cotton plantations, containing two murders, prostitution, suggestions of rape and allusions to drugs. For contributors to *Documents*, this was groundbreaking. An analysis of the play formed a key part of a general text by Leiris on civilisation, the human figure and voyeurism. The essay clearly displays the first element of ethnographic Surrealism that Clifford identifies: a corrosive analysis of a reality once taken for granted but now itself thought to be local and contingent:

> All our moral habits and polite customs, all that cloak of fresh colours, which covers the crudity of our dangerous instincts, all these beautiful forms of culture, of which we are so proud – for it is owing to them that we can claim to be civilised – are ready to fade away on being blown by the slightest whirlwind.[12]

There was also a review of *Porgy*, and immediately after that were four photographs of black people in different parts of the world (Plate 2.5): a juxtaposition that, typically for the journal, was left unexplained. It might be argued that the photographs are part of the attempt to focus on other realities.

PLATE 2.4
The arrival in France of Low Leslie's Black Birds, on the packet-ship *France*. (Photo: © Bibliothèque Nationale de France.)

Moreover, there seems little doubt that the placing of articles in such a disjunctive and unexpected order was radical. However, in retrospect, there has been academic disagreement about what this highlighting of non-western cultures, people and performers really achieved, and more generally about *Documents*'s ethnographic Surrealism.

Compare the following two late twentieth-century analyses of *Documents*'s ethnographic Surrealism. The first quotation is from Clifford, the second from Petrine Archer-Straw.

James Clifford

Documents poses, for the culture of the modern city, the problem facing any organizer of an ethnographic museum: What belongs with what? Should masterpieces of sculpture be isolated as such or displayed in proximity with cooking pots and ax blades? … The ethnographic attitude must continually pose these sorts of questions, composing and decomposing culture's 'natural' hierarchies and relationships. Once everything in a culture is deemed worthy in principle of collection and display, fundamental issues of classification and value are raised.[13]

Petrine Archer-Straw

Avoidance of blacks' realities and the perpetuation of certain violent tropes, were the most disturbing aspects of the *Documents* circle's agenda. The ethnography of the 'sousrealists' necessitated an interest in past rather than present cultures, and denied blacks any reality other than a historical one. Their confrontation with 'the other' required the stagnation of so-called primitive cultures in order to facilitate their 'sousrealist' contradictions. Further, their ethnographic practice of direct contact with these cultures was more a concern for self-exploration and colonial adventure, and was qualitatively little different from colonial voyeurism.[14]

Phot. Keyston

Petite fille noire à New York.

Bonne d'enfant à Nouméa (Albums Robin).

Phot. Nadar

Mademoiselle Lovzeski.

Sandouli, petit chef de Kanala (Albums Robin).

PLATE **2.5**
Four photographs of black people, from *Documents*, vol.1, no.4, 1929, p.224. (*Petite fille noire à New York* – photo: Keyston; *Bonne d'enfant à Nouméa* – photo: Albums Robin; *Sandouli, petit chef de Kanala* – photo: Albums Robin; *Mademoiselle Lovzeski* – photo: Félix Nadar. Photo: © Biblotheque Nationale de France, Paris.)

Archer-Straw suggests that *Documents* presents stereotypical views of blacks instead of considering the lived realities of black people at that time. Echoing critiques of primitivism, she argues that blacks are not granted a 'present' by *Documents*, but are seen as representing an almost lost past, supposedly recoverable only to those trained in ethnography, who then offer up these alternatives to European reality. Black people are still destined to remain the subjects of a white gaze rather than being allowed to articulate their own views and needs. The agenda of *Documents* is consequently self-centred, concerned only with the interests of a European intelligentsia behind the journal rather than taking any active interest in the problems faced by black

people. Clifford's argument has a different emphasis. He claims that through its layout and selection of material, *Documents* does attack and break down conventional European orders of things, questioning supposedly natural hierarchies (for example, between 'high culture' and 'low culture'). The implication of his argument is that it does not particularly matter if *Documents* does not concern itself with the material reality of blacks, or indeed if sometimes it reproduces certain unfortunate stereotypes, because the very ordering of *Documents* means that it embodies a progressive attitude of questioning cultural values. For Clifford, the project of *Documents* will inevitably lead to a space for minority voices to be heard. ∎

Not surprisingly, Archer-Straw does not view the four photographs of black people in a positive light: 'the selection of images … makes them appear like freaks. All wear the burden of assimilation, and it is ill-fitting and incongruous.'[15] A counter-argument drawing on Clifford might stress the mechanics of collage and juxtaposition at work in the presentation of these images. It is reductive to take them out of context. Instead, they must be seen as part of *Documents*'s wider ethnographic Surrealist undertaking predicated on the idea of a reordering of received categories of knowledge that ultimately leads to the defamiliarisation of everyday objects, theories and ideologies. The overall effect of the journal is to question western cultural orders, making the familiar perverse and emphasising the unusual. The haphazard structure of *Documents* is key here, as to focus on difference in a more straightforward and conventional publication would be to run the risk of fetishising difference. However, an argument against this defence is that since the concept of *la bassesse* acts as a unifying principle through *Documents*, the images of blacks are implicitly derogatory as they are inexorably linked to other manifestations of *la bassesse*, such as sado-masochism, sacrifice and so on.

Surrealism and anti-colonialism: Paris

The ethnographic Surrealist drive of those involved with *Documents* was confirmed by the participation of Leiris as 'secretary-archivist' in the famous Mission Dakar-Djibouti, a twenty-one month fieldtrip around Africa from the Atlantic to the Red Sea. The purpose of the trip was twofold: to collect ethnographic evidence and to take objects back to display at the Trocadéro. In these terms it was successful, for more than 3,600 objects were taken back.

The second issue of the glossy art magazine *Minotaure* (the first issue of which had appeared in February 1933, in the wake of *Documents*'s demise) was wholly devoted to the trip, and included a large number of photographs of sites and scenes from the trip. However, this was very much a one-off for the journal. There was to be little in the way of ethnography in issues that followed, despite its presence as one of the subtitles of the magazine. The fact that a whole issue was given over to the trip, in contrast to the collaged, fragmented approach of *Documents*, implied that ethnography was only suitable for a special issue, cut off from discussions about the wider cultural field. Bataille had little to do with *Minotaure*, and without his energy the anarchic editorial approach evident in *Documents* ebbed away.

While Leiris and the rest of the team were preparing to leave for Africa, the 1931 'Exposition Coloniale Internationale' ('International Colonial Exhibition') was taking place in the Bois de Vincennes on the outskirts of Paris. The exhibition was in effect a self-enclosed theme park devoted to France and its colonies. It consisted of pavilions representing each of France's colonies, such as Martinique, New Caledonia and Indochina, a number of which contained reconstructed tribal villages. Throughout the exhibition, visitors could see a great number of costumes, statues and masks, as well as some living 'natives'. These individuals had been shipped in for the event, incidentally causing outcry in the Parisian popular press, which feared a spread of imported tropical diseases such as leprosy. The function of the exhibition was clear: to celebrate France as an imperial power. As Jody Blake has put it: 'The Exposition's goal, expounded in official speeches and publications, was to instil patriotic pride in France's *mission civilisatrice* ["civilising mission"] and to promote the economic *mise en valeur* ["value"] of its colonies.'[16] The exhibition was, by and large, well received, but one of the few dissenting voices came

from the Surrealists. In May 1931, they issued a declaration entitled 'Don't Visit the Colonial Exhibition'.[17] Like their other declarations, this was a collective effort signed by a number of the group, including Breton, Louis Aragon, Yves Tanguy, Paul Éluard and Benjamin Péret. The Surrealists subsequently issued a second declaration, 'First Appraisal of the Colonial Exhibition',[18] and organised a counter-exhibition called 'La Vérité sur les Colonies' ('The Truth about the Colonies') (Plates 2.6 and 2.7).

'Don't Visit the Colonial Exhibition' contrasted the utopian world of the 'Exposition Coloniale Internationale' with reality, citing the fact that an 'Indo-Chinese' student had been deported from France two days prior to the opening. The declaration describes colonialism as the handmaiden of exploitative western capitalism blithely causing death and destruction in the colonies, and argues that the real purpose of the exhibition was to soften the reality of colonialism. For the Surrealists, it was little more than an exercise to ensure that manufacturers like Citroën and Renault, as well as

PLATE 2.6
Installation view of 'La Vérité sur les Colonies', 1931, reproduced from *Le Surréalisme au service de la Révolution*, December 1931. (Photo: © ACRPP, France.)

French citizens, 'can hear the echoes of faraway gunfire without flinching'.[19] This strand of criticism was continued in 'First Appraisal of the Colonial Exhibition', which argued that a fire at the exhibition that destroyed the Dutch East Indies pavilion was not an accident, but rather the logical continuation of a destructive capitalism wreaking havoc on the colonies, its peoples and their possessions. The counter-exhibition, 'La Vérité sur les Colonies', was organised by Aragon, Eluard and Tanguy in collaboration with the Anti-Imperialist League under a slogan of Marx's words: 'Un peuple qui en opprime d'autres ne s'aurait être libre' ('A people who oppress others cannot be free') (Plate 2.6). Visitors were greeted by another large banner with Lenin's words 'Imperialism is the last stage of capitalism.' There were exhibits of texts and visual materials, all offering a corrective to the 'Exposition Coloniale Internationale', as well as music events and primitive art from the collections of the Surrealists. Other exhibits included the figure of a black child holding a begging bowl with 'Merci' ('Thank you') inscribed on it, and a number of 'European fetishes', such as devotional figures (Plate 2.7). As Blake notes:

> The message of this exhibit was clear from the point of view of its organisers and supporters. The superstitious fetish-worshippers are not colonised peoples, but Christian missionaries with their gilded Madonnas and bleeding crucifixes. The superior artists are not Europeans, with their bad taste, gross sentiments, and mass production, but indigenous artists.[20]

The Surrealist response to the 'Exposition Coloniale Internationale' might initially seem surprising, as art-historical accounts tend to concentrate on the Surrealist interest in the 'other' by way of Oceanic art, which a number of the Surrealists collected, and the well-known Surrealist map of the world first published in the journal *Variétés* in 1929 (Plate 2.8). The map is somewhat misleading, for while it does point to some of the primitivist interests of the Surrealists at the time, it tells little about their long-standing anti-colonialism. The event that sparked

PLATE **2.7**
Installation view of 'La Vérité sur les Colonies', 1931, reproduced from *Le Surréalisme au service de la Révolution*, December 1931. (Photo: © ACRPP, France.)

this anti-colonialism was the intervention of the French government to help the Spanish suppress the Riff rebellion in Morocco. The Surrealists issued a declaration dated 16 October 1925 entitled 'To the Soldiers and Sailors', which called on combatants to put down their arms and fraternise with the rebels, and forcefully conveyed the Surrealist belief that the colonising 'mission' was simply driven by financial greed.[21] The Riff rebellion acted as a spur for Surrealist denunciations of France and its empire; it is noted as being of key importance in another declaration from 1925, 'The Revolution First and Always!', which focuses on the Surrealists' strong feelings of detachment from French and European values.[22] In the same year, Leiris was arrested, having denounced France to a crowd after a banquet held to honour the poet Saint-Pol-Roux descended into chaos, with the Surrealists shouting anti-French slogans.

It might be argued that the Surrealists' anti-colonialism was little more than an offshoot of a generalised protest against European bourgeois tastes and conventions, born out of the traumatic experiences of the First World War. Yet this is a reductive view. It is true that some declarations spilled over into exaggerated paeans of praise for a more spiritual and pure notion of the 'other', as in 'Address to the Dalai Lama',[23] which appeared in the third issue of the journal *La Révolution surréaliste*, but there was no wholesale automatic investment in anything non-European. Perhaps surprisingly, Mahatma Gandhi came under a long attack in the tract 'Mobilisation against War is not Peace' for his 'humanistic mysticism' and pacifism, which the Surrealists argued acted

to prop up imperialism and oppression.[24] More significantly, the Surrealists were among the first to analyse colonialism in terms of the cultural effects on the colonised, prefiguring later arguments by the Martiniquan-born psychoanalyst and writer Frantz Fanon and, subsequently, a number of post-colonial theorists. The 1932 declaration 'Murderous Humanitarianism' is strident in its opposition to colonialism, but crucially it also analyses colonial mechanisms.[25] There is an understanding of the rise of a small class of colonised black bourgeois who act as the middle-management of empire, and an early formulation of what the post-colonial theorist Edward Said would later term 'Orientalism' ('there is the call of some "mystic Orient" or other'[26]). There is also an awareness of the naive belief that the colonised want to live a more simple, uncultured existence ('A holy-saint-faced *international* of hypocrites deprecates the material progress foisted on blacks'[27]) and a realisation that the 1920s Parisian craze for all things black, such as jazz, is superficial. Instead of being an unfocused protest, Surrealism's anti-colonialism was both consistent and theorised.

Surrealism and anti-colonialism: the Caribbean

Wilfredo Lam's *The Jungle* (Plate 2.9) was painted in 1943, two years after his arrival back in his native Cuba. Lam had been in Europe since 1923, studying and working in Madrid for fifteen years. Towards the end of this stay, he was associated with the Surrealists, and was one of the large party (along with Breton, Marcel Duchamp, Max Ernst and Tristan Tzara) who decamped to Marseilles after the fall of France in 1940. In 1941, Lam and Breton (together with André Masson and Claude Lévi-Strauss) made their way to Martinique, and while the others subsequently went to New York, Lam continued on to Cuba. Lam is arguably the Caribbean artist who is most well known in the West, and *The Jungle* is probably his best-known painting. It operates on a number of levels, fusing the European avant-garde with particularly African-Caribbean forms and content, and is testament to the use and application of European ideas in the local circumstances of the Caribbean. By far the most important of these sets of ideas to take hold in the Caribbean was Surrealism.

Two of the signatories to the 1932 Surrealist declaration 'Murderous Humanitarianism' were Jules Monnerot and Pierre Yoyotte from Martinique, then a French colony. They were also part of the group of Caribbean students studying at the Sorbonne in Paris who published a single issue of a journal called *Légitime défense* ('Legitimate Defence') in 1932, which was at least in part inspired by Surrealist declarations against colonialism. The title was taken from a short book by Breton and there are overt references to both Marxism and Surrealism in the 'Declaration' at the start of the journal: 'we equally unreservedly accept surrealism, with which our destiny in 1932 is linked'.[28] There is also a reference to Salvador Dalí's paintings, and arguments about the repressions inherent within western civilisation are couched in Surrealist terms ('the extermination of love and confinement of dream'). However,

PLATE **2.9** Wilfredo Lam, *The Jungle*, 1943, gouache on paper mounted on canvas, 239 × 230 cm.
(Museum of Modern Art, New York. Inter-American Fund 1. DIGITAL IMAGE © 2002 The Museum
of Modern Art, New York/Scala, Florence. © ADAGP, Paris and DACS, London 2004.)

the 'Declaration' and the rest of the journal were specifically addressed to
'young French Caribbeans'. Richardson argues that the reason why the young
Martiniquans turned to Surrealism is clear:

> Surrealism was instrumental in providing the students with a point
> of departure for their critique of colonial society for, in breaking
> with the ethics of European culture, it offered them a sort of
> Trojan Horse in which to enter the previously impregnable white
> citadel. In surrealism they heard white masters with new voices,
> voices that renounced that mastery.[29]

In response to the publication of the journal, the French authorities suspended the grants of those responsible and stopped its distribution in the Caribbean. In retrospect, however, the single issue of *Légitime défense* can be seen as inaugurating a series of encounters between Francophone thinkers and writers from and in the Caribbean, and the French Surrealists. The key figure in this transatlantic conversation was a student at the École Normale Supérieure in Paris when *Légitime défense* was published: Aimé Césaire.

In 1939, Césaire chronicled his imminent return to France in a long poem, 'Notebook of a Return to My Native Land'. It was later reworked in Martinique and Breton would subsequently call it 'nothing less that the greatest lyrical monument of our time'.[30] The poem is now regarded as a landmark text in its attempt to convey a particular Caribbean sensibility. In the periods before and after the Second World War, black French-speaking writers, including Césaire and Leopold Senghor, developed the theory of 'Negritude'. Responding to what they felt were European racist dismissals of the abilities and aspirations of Africans, they attempted to define universal characteristics of all Africans. However, later post-colonialist commentators have criticised the implicit essentialism of the theory of Negritude.[31] They argue instead that to be Caribbean is to be always and already hybrid, drawing on African, Native American and the coloniser's (whether French or English) cultures, traditions and languages. Thus, the only essential thing about the Negritude of the Caribbean is its fundamental hybridity. Others, such as the writer Jean-Paul Sartre in his influential essay 'Black Orpheus', have noted the ironies of African writers finding their own voices through writing in the tongue of the ex-colonial master.[32] What is clear is that the interdependence between West and non-West militates against an easy understanding of a concept such as Negritude, and this also affected the ways in which Lam and other artists drew on western art. Writers like Césaire were using a toolbox comprising western arguments to articulate an African position in response to western racism, turning those arguments against a wider structure of neglect and oppression; perhaps this undermining of discourses from within in order to produce something new is the best way to begin to conceptualise Negritude. In this sense, Lam has been termed a 'painter of Negritude'.[33]

When he returned to Martinique, Césaire took up a teaching post and, along with his wife Suzanne Césaire and fellow-lecturer René Ménil, founded the journal *Tropiques*, which first appeared in 1941. *Tropiques* can be described as a Surrealist journal. Surrealism is present throughout the issues, and the debt to Surrealism is sometimes made overt, for example in Suzanne Césaire's essay published in issues 8 and 9, '1943: Surrealism and Us'.[34] As Césaire points out in that text, a Surrealist mode of address allowed the writers to avoid censorship by the Vichy-friendly authorities. Yet, as Richardson argues, *Tropiques* applied Surrealism to local Martiniquan realities and issues: '[*Tropiques*] is not influenced by surrealism; it *cannibalizes* it'.[35] Richardson chooses this verb very deliberately. He points out that Suzanne Césaire first used the notion of the cannibal, stating 'Martiniquan poetry will be cannibal or will not be',[36] and then the idea of cannibalising western culture became more widespread in anti-colonial, post-colonial and globalisation studies, in which it was used to convey something of the productive deformation of western ideas that arises from their application within the local specificities

of non-western cultures. There is, of course, a certain amount of irony at work here as well: 'canibales' was the European name for the Caribs in the Antilles, who Columbus claimed ate their fellow humans. After this claim was made, the term 'cannibal' replaced 'anthropophagus' as the description of those who eat human flesh, without any concrete evidence that this was a common practice among Caribs. Thus, we might understand Richardson's use of 'cannibalizes' as suggesting a misunderstanding from a European perspective. These Caribbean intellectuals were not simply digesting Surrealism; they were, in fact, making it Caribbean. The idea of the cannibal can therefore be used both to refer to the misunderstandings that have characterised many western conceptions of non-western cultures, and to highlight the creative distortion of western concepts that goes beyond simple assimilation. The idea is thus very closely related to the concept of the hybrid as theorised by writers such as Homi Bhabha.[37]

Looking back on *Tropiques*, Ménil pinpointed Césaire's poetry and Lam's paintings as being key manifestations of *Tropiques*'s aims,[38] and the twelfth issue of the journal contained a long appreciation of Lam's work by Mabille.[39] Lam and Césaire met in Martinique when Lam was on his way back to Cuba, and the artist's work can also be understood in terms of a return to a native land, applying the European avant-garde to local circumstances and also finding some of the ideals of Surrealism embodied in local practices. *The Jungle* is filled with imagery that can be linked not only to Surrealism and the work of Picasso, but also to the specifically Caribbean. For instance, the transformation of figure into plant can be seen as recalling the way discrete elements fuse together in Dalí's work, but it can also be understood in terms of Santería, the African-Cuban religion that, like Haitian voodoo, stresses the interdependence of people, spirits, ancestors and natural elements. The fertile mixes with the malign in the painting, and again this might be understood as typically Surrealist but can also be read in terms of the local. The tobacco leaves and sugar-cane were the primary plantation crops and consequently have connotations of slavery, but their abundance and potential as post-emancipation cash crops also lend an element of resistance and revival to their appearance. Moreover, as Linsley has pointed out, the motif of vegetation was repeated through *Tropiques* as its contributors understood the 'plant [as] a symbol of the patient defiance of the slave'.[40]

Unsurprisingly, art-historical accounts of Lam's work have attempted to articulate this idea of a Caribbean sensibility. In *Tropiques*, Mabille reads Lam's work with reference to voodoo, and the 'kind of universe, in which the trees, flowers, fruits and spirits cohabit',[41] which he compares with the 'mechanized cohorts' of Hitler assembled in Europe at that time. Mabille's reading is not simple primitivising, despite his running together of Santería and voodoo. It is possible to regard much of Lam's symbolism as indicative of an interest in Santería. Certainly Mabille's analysis may be understood in terms of *Tropiques*'s mission to articulate a distinctive Caribbean cultural and artistic spirit.

However, it is important to note that Lam, unlike the Haitian painter Hector Hyppolite, was not an initiate in either voodoo or Santería. As Dawn Ades

has pointed out, 'Although Lam did occasionally paint specific deities like Ogoun Ferraille, horned and with an iron horseshoe as head ... his figures are more often more generalized: horned or masked, set within a tropical world.'[42] Such works include *The Idol* and *The Reunion* (Plate 2.10). The imagery of both works seems recognisably Surrealist but it is also particular to the local situation that Lam discovered on his return to his native land. Moreover, Mabille's account of Lam's work might be understood as an attempt to articulate not only Lam's use of Surrealism within the particularities of the Caribbean but also the way local circumstances already embodied a number of concerns that the Surrealists valued.

This idea recalls part of the topic of Breton's incendiary first lecture in Haiti, when he spoke of what he saw as the latent Surrealism in the culture of Haiti. Indeed, Breton's writings on the Caribbean convey a sense of wonder as the Surrealist investment in a largely imagined 'other' finally discovers an actual 'other' that corresponds to those imaginings:

> You more than anyone else feel at home here, in fact. Everything has been like this for so long. In the end surrealist landscapes will be seen as the least arbitrary ones. It is inevitable that they should find a resolution on those lands where nature has not been tamed at all.[43]

PLATE 2.10 Wilfredo Lam, *The Reunion*, 1945, oil and white crayon on paper, 153 x 213 cm. (Centre Pompidou-MNAM-CCI, Paris. © Photo: CNAC/MNAM Dist. RMN. © ADAGP, Paris and DACS, London 2004.)

It must be granted that Breton slips into exoticism, but to restrict oneself to this would be to miss the point. For the editors of *La Ruche* and for those who joined the Haitian insurrection, for the editors of *Légitime défense* in Paris, for Aimé Césaire, Mabille and Suzanne Césaire in Martinique, for Lam in Cuba, and for many other Caribbean intellectuals, Surrealism provided a mode of revolutionary thinking that allowed a 'leap into the unknown'. Any dialogue between the West and the non-West will always run the risk of slipping into the occasional unthinking endorsement of a stereotype, but it is crucial to recover the importance of these dialogues from the blanket reductive accusation of exoticism. Breton realised this: 'Exoticism, one could mistakenly say, exoticism, a most careless word. But what does exoticism mean? The whole world is ours.'[44]

Notes

1 Depestre, 'André Breton in Port-au-Prince' (1991), in Richardson, *Refusal of the Shadow*, p.231.

2 *Ibid.*, p.232.

3 *Ibid.*

4 Richardson, 'Introduction', in Richardson, *Refusal of the Shadow*, p.21.

5 Laraque, 'André Breton in Haiti' (1971), in *ibid.*, p.223.

6 Bataille, quoted in Ades, *Dada and Surrealism Reviewed*, p.229.

7 Clifford, *The Predicament of Culture*, p.126.

8 I discuss this in *Art of the Avant-Gardes*, Chapter 6.

9 Editorial introduction to Bataille, from 'Critical Dictionary' (1929–30), in Harrison and Wood, *Art in Theory 1900–2000*, IVC12, p.483.

10 Clifford, *The Predicament of Culture*, p.132.

11 *Ibid.*, p.130.

12 Leiris, 'Civilisation', not paginated.

13 Clifford, *The Predicament of Culture*, p.132.

14 Archer-Straw, *Negrophilia*, p.152.

15 *Ibid.*, p.153.

16 Blake, 'The Truth about the Colonies, 1931', p.39.

17 Breton *et al.*, 'Don't Visit the Colonial Exhibition' (1931), in Richardson and Fijałkowski, *Surrealism against the Current*, pp.183–5.

18 Tanguy *et al.*, 'First Appraisal of the Colonial Exhibition' (1931), in *ibid.*, pp.185–8.

19 Breton *et al.*, 'Don't Visit the Colonial Exhibition' (1931), in *ibid.*, p.185.

20 Blake, 'The Truth about the Colonies, 1931', p.51.

21 Alexandre *et al.*, 'To the Soldiers and the Sailors' (1925), in Richardson and Fijałkowski, *Surrealism against the Current*, pp.181–3.

22 Altman *et al.*, 'The Revolution First and Always!' (1925), in *ibid.*, pp.95–7.

23 Artaud *et al.*, 'Address to the Dalai Lama' (1925), in *ibid.*, p.141.

24 Breton *et al.*, 'Mobilisation against War is not Peace' (1933), in *ibid.*, p.100.

25 Breton *et al.*, 'Murderous Humanitarianism' (1932), in *ibid.*, pp.190–3.

26 *Ibid.*, p.192. I discuss the work of Edward Said at more length in *Frameworks for Modern Art*, Chapter 5.

27 Breton *et al.*, 'Murderous Humanitarianism' (1932), in Richardson and Fijałkowski, *Surrealism against the Current*, p.192.

28 Lero *et al.*, 'Legitimate Defence: Declaration' (1932), in *ibid.*, p.188.

29 Richardson, 'Introduction', in Richardson, *Refusal of the Shadow*, p.5.

30 Breton, 'A Great Black Poet: Aimé Césaire' (1943), in *ibid.*, p.194.

31 Among contemporary post-colonialist theorists, the leading voices criticising the essentialism of 'Negritude' are those of Stuart Hall and Homi Bhabha. However, the concept of 'Negritude' was being criticised by Fanon as long ago as the late 1950s – see Fanon, 'On National Culture' (1959), in Harrison and Wood, *Art in Theory, 1900–2000*, VIA5, pp.710–15. The editorial introduction to the text on p.710 includes a short discussion of Senghor's theory of Negritude, and Fanon's criticism of it. See also Bhabha, on 'hybridity' and 'moving beyond' (1994), in Harrison and Wood, *Art in Theory, 1900–2000*, VIIIB17, pp.1110–16.

32 Sartre, 'Black Orpheus' (1948), in MacCombie, *'What is Literature' and Other Essays*.

33 See Linsley, 'Wilfredo Lam'.

34 Césaire, '1943: Surrealism and Us' (1943), in Richardson, *Refusal of the Shadow*, pp.123–6.

35 Richardson, 'Introduction', in *ibid.*, p.15.

36 Quoted in *ibid.*, p.15.

37 I discuss Bhabha's theorisation of hybridity in *Frameworks for Modern Art*, Chapter 5. See also Bhabha, on 'hybridity' and 'moving beyond' (1994), in Harrison and Wood, *Art in Theory, 1900–2000*, VIIIB17, pp.1110–16.

38 Ménil, 'For a Critical Reading of *Tropiques*' (1973), in Richardson, *Refusal of the Shadow*, pp.69–78.

39 Mabille, 'The Jungle' (1945), in *ibid.*, pp.199–212.

40 Linsley, 'Wilfredo Lam', p.294.

41 Mabille, 'The Jungle' (1945), in Richardson, *Refusal of the Shadow*, pp.211–12.

42 Ades, *Art in Latin America*, p.233.

43 Breton and Masson, 'Creole Dialogue' (1972), in Richardson, *Refusal of the Shadow*, p.185.

44 *Ibid.*, p.186.

References

Ades, D., *Art in Latin America: The Modern Era, 1820–1980*, exhibition catalogue, South Bank Centre, London, 1989.

Ades, D., *Dada and Surrealism Reviewed*, exhibition catalogue, Arts Council of Great Britain, London, 1978.

Archer-Straw, P., *Negrophilia: Avant-Garde Paris and Black Culture in the 1920s*, London: Thames & Hudson, 2000.

Blake, J., 'The Truth about the Colonies, 1931: Art indigène in Service of the Revolution', *Oxford Art Journal*, vol.25, no.1, 2002, pp.35–58.

Clifford, J., *The Predicament of Culture*, Cambridge, MA: Harvard University Press, 1988.

Edwards, S. and Wood, P. (eds), *Art of the Avant-Gardes*, New Haven and London: Yale University Press in association with The Open University, 2004.

Gaiger, J. (ed.), *Frameworks for Modern Art*, New Haven and London: Yale University Press in association with The Open University, 2003.

Harrison, C. and Wood, P. (eds), *Art in Theory 1900–2000: An Anthology of Changing Ideas*, Malden, MA and Oxford: Blackwell, 2003.

Leiris, M., 'Civilisation', *Documents*, vol.1, no.4, 1929, English supplement.

Linsley, R., 'Wilfredo Lam: Painter of Negritude', in K. Pinder (ed.), *Race-ing Art History: Critical Readings of Race and Art History*, London and New York: Routledge, 2002.

MacCombie, J. (ed. and trans.), *'What is Literature' and Other Essays*, Cambridge, MA: Harvard University Press, 1988.

Richardson, M. (ed.), *Refusal of the Shadow: Surrealism and the Caribbean*, trans. K. Fijałkowski and M. Richardson, London: Verso, 1996.

Richardson, M. and Fijałkowski, K. (eds and trans.), *Surrealism against the Current: Tracts and Declarations*, London: Pluto Press, 2001.

PART TWO

Art in America: from Realism to Abstraction

Realism and modernism

Pam Meecham

Introduction

This chapter considers art practice in the USA between the Wall Street Crash and resulting Great Depression of the 1930s and the Cold War of the 1950s. In particular, it explores issues related to the production and reception of art labelled 'realist' and 'abstract'. These terms are exceptionally problematic, but I am going to retain them because they were the terms most commonly employed in the historical debates I discuss. I will be using 'Realism' to refer to an art of significant subject matter, depicted in a range of styles – from a more or less 'photographic' naturalism to various kinds of 'expressive' distortion. In using 'abstract', I will be referring to art in which depicted subject matter is either absent or accorded less importance than the formal aspects of the painting: that is, the lines, shapes and colours themselves.

Histories of this period have been hotly contested. For many years, the international success of Abstract Expressionism led to neglect of the Realist art of the 1930s by critics and art historians. Later, with the emergence of the social history of art in the 1970s and 1980s, the pendulum swung, and the form of modernism produced in the USA from the 1940s to the 1960s was widely interpreted as a retreat from legitimate social concerns, even being condemned for its supposed complicity in the exercise of American power during the Cold War. In this chapter, I try to get away from the division that pitted Realism against abstraction on such terms, and to take note of aesthetic, iconographic and even political overlaps between the work of artists associated with the different styles. Throughout the chapter, I am going to stress similarities between the practices of Realist and abstract artists, but I want to begin by dramatising their differences.

Although better described as an attitude to art production than allegiance to any specific style, social realism, which dominated art practice during the 1930s, typically offered images of contemporary social concern in a naturalistic or quasi Expressionist form, as well as images that criticised American capitalism and big business. These tendencies can be represented by the work of Bernarda Bryson Shahn and William Gropper (Plates 3.2 and 3.3), respectively a poster for the farm resettlement administration and a satire on the rich and powerful held responsible for the Depression.

After the Second World War, advocates of abstraction offered theoretical support for what became variously known as Abstract Expressionism, 'action painting' or 'American-type painting': broadly speaking, a school of informal abstraction based on the expressive power of colour or of improvised gesture. The drive to assert the merits of abstraction over Realism tended to subordinate the art of the 1930s to the aesthetic achievements of the late 1940s and 1950s.

PLATE **3.1** (facing page) Ben Shahn, detail of *Democracies Fear New Peace Offensive* (*Spring 1940*) (Plate 3.6).

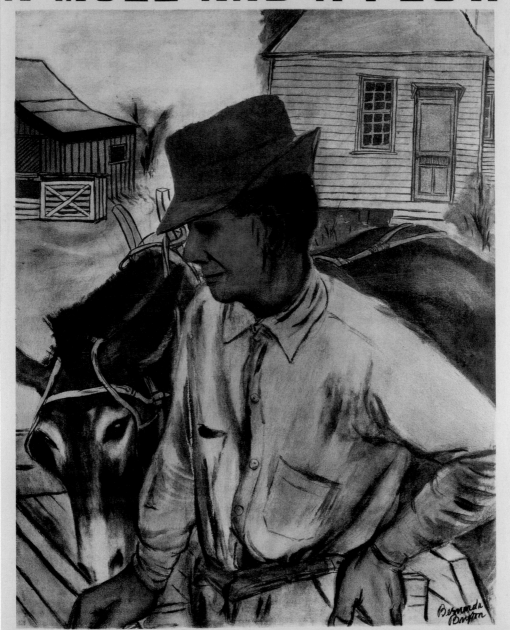

PLATE **3.2** Bernarda Bryson Shahn, *A Mule and a Plow*, 1935–6, colour photo-offset lithograph, 74 × 58 cm (excluding lettering). (Whitney Museum of American Art, New York; gift of Jake Milgram Wien in honour of the 95th birthday of Bernarda Bryson Shahn. 98.97.1. © Estate of Ben Shahn/VAGA, New York/DACS, London 2004.)

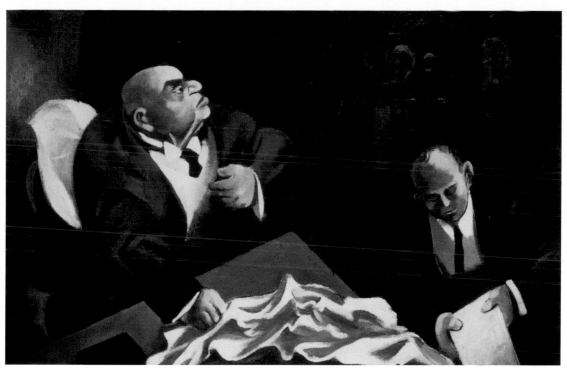

PLATE **3.3** William Gropper, *The Banker*, 1932, oil on canvas.

The 1950s in particular were often written about as a period of heroic struggle to divest American culture of an indigenous attachment to figurative realism, which held sway until Abstract Expressionism transformed the European origins of modernism and became the dominant international style. The overarching term 'Abstract Expressionism' does not adequately describe the diversity of practice in this period, but is conventionally used to cover two distinct technical and stylistic strands. The first is the 'action paintings' typified by Jackson Pollock's colossal paint-dripped canvases, the result of seemingly spontaneous gestural improvisation (Plate 3.4). The second is the 'colour-field paintings' or chromatic abstractions typified by Mark Rothko's large canvases of colour-saturated floating rectangles (Plate 3.5).

Plates 3.2–3.5 may thus be seen as representative of extremes of art practice during the period under discussion. The first two were typical products of the 1930s Depression era. One is a poster, designed for wide distribution and intended to inform and influence a broad public and put pressure on government policy makers. It is a naturalistic work depicting the plight of the powerless, typical of works produced for a relief agency, the farm resettlement administration. The other represents a satire on power as well as on financial corruption, which, for the Left, was the root cause of the breadlines in the Depression. The third image is an example of what the critic Harold Rosenberg called 'action painting'.[1] It is a monumental abstract work, painted in 1950, using industrial paint (aluminium and enamel) as well as conventional oil paint thrown or dripped across the surface of an unprimed canvas. The 'all-over'[2] application of entangled, scrawled skeins of paint with no apparent reference to a figurative tradition and no instantly recognisable subject matter shows scant regard for the conventions of perspective and central focal point familiar in work of the 1930s. The fourth image, Rothko's painting from the late 1950s, is not 'gestural' in the way that Pollock's is, but it is

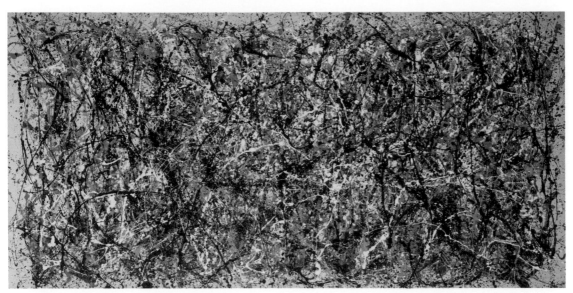

PLATE **3.4** Jackson Pollock, *One: Number 31, 1950*, 1950, oil and enamel on unprimed canvas, 270 × 531 cm. (Museum of Modern Art, New York. Sidney and Harriet Janis Collection Fund (by exchange). DIGITAL IMAGE © 2002. The Museum of Modern Art, New York. Scala, Florence. © ARS, New York and DACS, London 2004.)

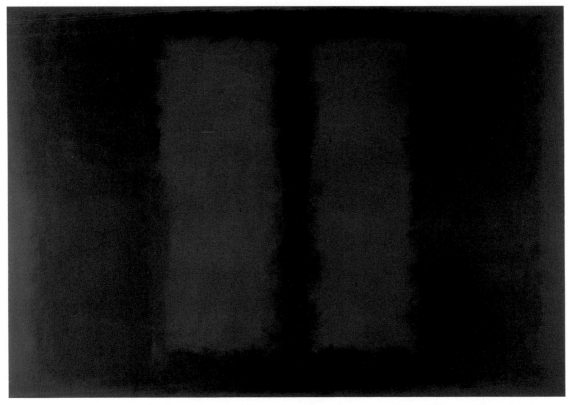

PLATE **3.5** Mark Rothko, *Black on Maroon*, 1958, oil on canvas, support 267 × 381 cm. (Tate, London 2003. © 1998, Kate Rothko Prizel and Christopher Rothko/DACS, London 2004.)

no less abstract. It is also monumental in scale compared with the easel works of the 1930s and its visual effect depends heavily on the combination of this scale with its field of sombre colour. *Black on Maroon* is part of a series of paintings for an aborted mural cycle in New York referred to as the 'Seagram project', some of which are now housed at Tate Modern in London. The painting's flat, saturated layers of luminous colour show no subject matter after the manner of the 1930s pictures, and not even the linear variation and complexity of the work by Pollock. In trying to recover meaning from Rothko's enterprise, the spectator is reliant on the painting's optical effects to the exclusion of any depicted social subject or narrative.

In what follows, I offer a discussion of the changes in art practice that took place between the 1930s and the 1950s. In attempting to explain the unprecedented acclaim of Abstract Expressionism by both critics and institutions such as museums, I relate back to the earlier part of the period. Despite the differences between the works I have just introduced, an inclusive – even untidy – cultural history will show that there was no seamless transition from prewar Realism to Abstract Expressionism in the 1940s and 1950s. Although the division between Realism and Abstract Expressionism for long seemed fixed, current interpretations are more likely to look at the continuities between one tendency and the other, and to draw out relationships *between* histories, rather than to assert that the work of the 1930s lacked aesthetic merit and that artists who clung to a figurative realism and art of social commentary were engaged in regressive practices. The reasons for the apparent hostility between advocates and practitioners of Realism and those of abstraction lie in the wider, complex cultural and political shifts that took place on either side of the Second World War, as much as in any objective qualities of the works themselves.

The case of Ben Shahn

I now want to turn to an image produced in the middle of the period under discussion, in 1940: *Democracies Fear New Peace Offensive* (*Spring 1940*) (Plate 3.6). The work is by Ben Shahn, often described as the quintessential 1930s artist, whose paintings, posters and magazine illustrations became emblematic of the struggle against social injustice. The inclusion of the date in the title of the work should alert you to the local and specific parameters of Shahn's painting. In many such respects it is compatible with the kind of 1930s social realist painting typified by the work of the committed left-wing artist Philip Evergood (Plate 3.7), that is to say, an art of social commentary representing contemporary inequality. In *American Tragedy*, Evergood represents a mixed-race couple confronting riot police, who are brutally suppressing a rally of strikers from the Republic Steel Corporation on Memorial Day in 1937.[3]

The terms of art history are often unstable and it is noteworthy that the prefix 'social' itself triggered considerable debate in the 1930s. For example, there was the distinction between a broad 'social realism' and a more doctrinaire, communist-sponsored 'Social*ist* Realism'. In addition, the term 'social commentary'

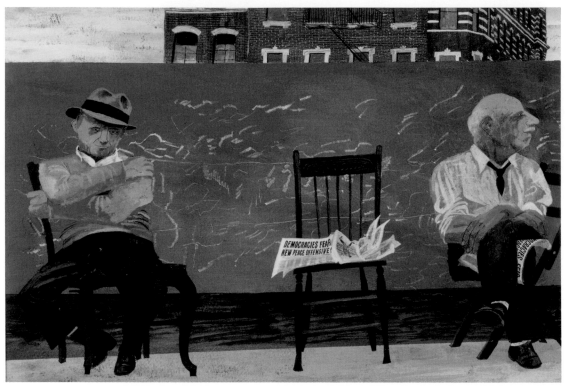

PLATE **3.6** Ben Shahn, *Democracies Fear New Peace Offensive* (*Spring 1940*), 1940, tempera on paper, 36 × 54 cm. (Museum of Contemporary Art, Chicago; promised gift of the Mary and Earle Ludgin Collection. Photo: © Museum of Contemporary Art, Chicago. Photo: Michal Raz-Russo. © Estate of Ben Shahn/VAGA, New York/DACS, London 2004.)

rather than 'social content' was advocated by Stuart Davis, a painter and theorist working throughout this period. Davis argued that

> the term 'social content' in art is ill chosen and destructive since it implies a lack of social content in art other than itself. The term should be changed to one which describes the intention, namely 'social comment'. There is a need for an art of social comment, and for an art of domestic naturalism, and for an art of generalized spatial equations – abstract art. The social need for any one of these does not negate the need for the others.[4]

Davis is an important voice, articulating the need for a plurality of art practices during a period in which tensions existed between artists who put their art into the service of social change and those who rejected what they considered to be propagandistic practices. His point is that it is a mistake to consider *any* work to be devoid of social ideas and aesthetics or to be lacking in content, however tenuous.

Shahn's figurative painting seemingly makes few concessions in the direction of abstract art. Instead, Shahn's work highlights the banality of the ordinary and the everyday. Indeed, its claim to Realism is inseparable from the particularity of its depiction of an urban scene, showing two unexceptional men, two newspapers and three chairs against the scratched surface of a wall. The newspapers bear the legend: 'Democracies Fear New Peace

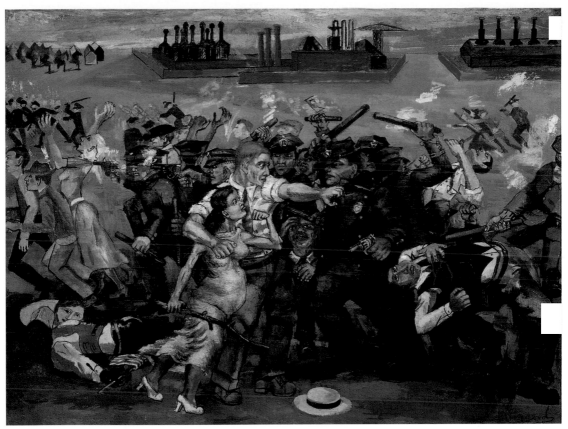

PLATE **3.7** Philip Evergood, *American Tragedy*, 1937, oil on canvas, 75 × 100 cm. (Private collection. Courtesy Terry Dintenfass Gallery.)

Offensive'. The newspaper on the chair also shows the sports page upside down, with perhaps a baseball player in action. Such attention to detail is part of the ethic of Shahn's realism, voiced in his dictum that 'there's a difference in the way a twelve-dollar coat wrinkles from the way a seventy-five-dollar coat wrinkles'.[5] This attention to detail seems to stand in stark contrast to Abstract Expressionism's subsequent rejection of the details of the world, for which it substitutes a concern with the act of painting itself. A closer look at Shahn's work, however, shows that the stylistic devices he employed carry the hallmarks of *both* the Realism of the 1930s *and* the formal innovations of the kind that we more readily associate with modernist art: distortion and simplification of form, the flattening of perspective evident in the buildings beyond the wall and the layers that make up the foreground of the work. Although figurative, it is not straightforwardly naturalistic. The dislocated, uncommunicative figures pressed to the edges of the picture, and the replacement of local colour in favour of a schematic use of browns and yellows, echo some of the formal devices we have come to expect of modernist art. Considerable attention has also been paid to painting the surface of the wall, which lies parallel to the picture plane and as such takes up an ambiguous relationship to the surface of the painting itself. Such interplay between literally marking the surface of the painting and illusionistically depicting a wall would become a major preoccupation of Abstract Expressionist artists working later in the decade.

Shahn's painting occupies an ambiguous position stylistically, in that it takes from Expressionism procedures that mark it out as modern and yet it remains stubbornly wedded to an art of overt social commentary. The picture shares, through thematic and stylistic devices, an affinity with the work of several artists that was, so to speak, on the border between Realism and modernism. These included the exiled German Dadaist/Expressionist George Grosz, who would have been familiar to New York artists through his teaching at the Art Students' League, and his compatriot Otto Dix, whose anti-war repertoire of dying soldiers, prostitutes and war-damaged amputees added a bitter social commentary to European art. Shahn had lived, for a time, in Europe, returning in 1929, and would have been aware of these and other vanguard tendencies, including the art of the Swiss-born Paul Klee (whom he acknowledged as having been influential[6]), which itself frequently hovered on the border of abstraction and figuration (Plate 3.8). Often producing graphic art and prints, these artists offered an established genealogy on which American artists attempting to use art as a social weapon could model their avant-garde activities. Situating him within the modern movement, Shahn's painting rejects unreflective illusionism. The work avoids simple description and mimetic verisimilitude, opting instead for ambiguity in both content and form.

Democracies Fear New Peace Offensive (*Spring 1940*) was painted at a particularly difficult moment for the American Left. In 1934, the unsigned editorial statement for the first issue of the Marxist journal *Partisan Review* had made an explicit commitment to communist politics in general, and to the USSR in particular:

> We propose to concentrate on creative and critical literature, but we shall maintain a definite viewpoint – that of the revolutionary working class. Through our specific literary medium, we shall participate in the struggle of the workers and sincere intellectuals against imperialist war, fascism, national and racial oppression, and for the abolition of the system which breeds these evils. The defense of the Soviet Union is one of our principal tasks.[7]

However, the intellectual commitments and forms of art practice that seemed secure in 1934 were cast into crisis by a series of events involving the USSR later in the decade. First, the adoption by the communist parties internationally of a so-called Popular Front against Fascism, which sought to defend culture by pursuing a policy of collaboration across the Left and Centre against the far Right, caused consternation among many committed advocates of a 'proletarian culture'.[8] Still more damaging, however, were the Stalinist purges of the army and the three show trials of opponents of the regime held in Moscow between 1935 and 1938. But the breaking point for many on the Left was the Hitler–Stalin Non-Aggression Pact of 1939, to which the newspaper headline in Shahn's painting alludes. The 'peace offensive' was effectively a coalition between the erstwhile ideological opposites of Nazi Germany and the communist USSR. It resulted in deep disillusionment for many artists and writers concerning their commitment to supporting international socialism and the USSR. Shahn's painting testifies, both in its subject matter and its technical means of representation, to the tensions experienced by artists as they sought ways to use their art in the service of democratic freedom or socialism, while shunning the idealised artforms of totalitarian regimes (see the Introduction to *Art of the Avant-Gardes*).

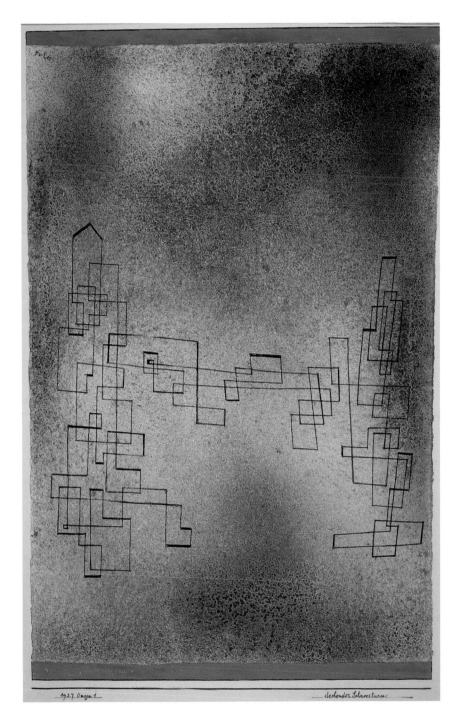

PLATE **3.8**
Paul Klee, *Threatening Snowstorm*, 1927, pen and coloured inks and watercolour on paper laid on card, 50 × 32 cm. (Scottish National Gallery of Modern Art, Edinburgh. © DACS, London 2004.)

As recently as 1998, the display of Shahn's painting in an exhibition at the Jewish Museum in New York incurred the wrath of the conservative critic Hilton Kramer, who suggested that Shahn, like many Leftists in the 1930s and 1940s, 'was a shameless apologist for the crimes of Stalinism', arguing that the 'content was designed to defend Stalin's collaboration with Hitler'.[9] Kramer attacked the painting on two distinct grounds. First, he criticised the supposed political affiliation of the artist. Secondly, he took issue with the form of the artwork itself, charging Shahn's painting with being 'little more than a colored cartoon' and lacking aesthetic merit.[10]

It is not the content of Kramer's art criticism that is important here. Indeed, the kind of objection raised by Kramer to socially committed art is not new. But, for all that, the historical record contains some surprises. For example, the Museum of Modern Art in New York has come to be identified with the 'triumph' of Abstract Expressionism, but as late as 1947 it hosted a major retrospective of Shahn's work. The curator, James Thrall Soby, drew attention to the challenge to a modernist aesthetic posed by art like that of Shahn. Writing in the catalogue of the exhibition, he referred to the English modernist critic Roger Fry's *Vision and Design* (1920), in which Fry made the claim that 'All art gives an experience freed from the disturbing conditions of actual life.'[11] Soby suggested that if this were so we would have to reject Shahn's work. Instead, he went on to defend Shahn's opposition to 'the "pure" painter, nourished in his studio by aesthetic faith'. He considered that Shahn's 'paintings, posters, murals, advertisements, proceed from the same steady eye and are informed by a relentless integrity. All *pace* Mr. Fry are art of uncompromising order.'[12] Here, then, is a curator at the Museum of Modern Art defending an artist against the hostility his work's engagement with the 'disturbing conditions of actual life' would encounter.

There are thus two problematic aspects to Shahn's work. First, there is the political matter of a supposed association with a Stalinist Left. Secondly, there is the aesthetic question raised by his work's depiction of a contemporary political crisis in the light of the claim that art could not be 'true art' if it engaged directly with actual life. The interesting thing about Soby's reflections is his implicit rejection, as long ago as the late 1940s, of the opposition that pitted the social painter against the 'pure' aesthetic painter. The separation of aesthetics from social painting and its removal to an abstract sphere was the basis of a major debate, which led to many artists engaged in an overtly political art practice being charged with neglecting art's aesthetic dimension, and with the production of mere illustration, where, as Shahn put it, content became a 'culprit'.[13]

The art and politics of the 1930s: art to effect social change

Soby's defence of the complexity of Shahn's practice indicates the open situation in American art after the end of the Second World War. 'Pure' painting had by no means completely eclipsed a sense of art's social role. Certainly, the economic conditions of the 1930s were by then a thing of the past. For all that, the debate about the most appropriate form that art should take during the 1940s had its roots in the social and political uncertainties of the preceding decade.

In 1929, the American stock market crashed and a period of worldwide economic instability ensued. In the USA, automobile output fell dramatically. When Henry Ford closed his River Rouge car plant in Detroit in 1931, over 75,000 workers lost their jobs and began the first hunger marches. In the mid-west the agrarian economy collapsed: a combination of dust bowls, poor

land management and mechanisation conspired to exacerbate the plight of tenant farmers and sharecroppers, impacting on migrant fruit pickers and canning factory workers. In 1933, President Franklin D. Roosevelt's administration ushered in the New Deal, which, to a previously unprecedented extent, accepted state responsibility for economic and social welfare. In response to the harsh economic realities of the Great Depression, many artists reformulated their working practices to make their art more explicitly relevant to contemporary conditions. Figures who had been attracted by the formal experimentation associated with the modern movement during the early decades of the twentieth century, exemplified by Georgia O'Keeffe and Arthur Dove, typically deserted their former artistic allegiances (Plates 3.9 and 3.10). Federal support of the arts resulted in public arts projects designed to elevate the mood of the nation. Under the New Deal, unemployed artists were being supported through relief projects such as the Public Works of Art Project (PWAP), Works Progress Administration (WPA) and later the Federal Art Project (FAP). The output from the FAP alone numbered well over 2,500 murals, 17,000 sculptures, 108,000 easel paintings and

PLATE **3.9** Georgia O'Keeffe, *Morning Sky*, 1916, watercolour on paper, 23 × 31 cm. (Whitney Museum of American Art, New York; purchase, with funds from The Lauder Foundation – Leonard and Evelyn Lauder, Gilbert and Ann Maurer and the Drawing Committee. 94.69. © ARS, New York and DACS, London 2004.)

11,000 designs, as well as a 20,000-piece Index of American Design.[14] Works such as Bryson Shahn's *A Mule and a Plow* (Plate 3.2) were typical products of the period, in both subject matter and mode of representation. Although no explicit stylistic guidelines were laid down, many artists chose, or were encouraged through commissioning agencies that dominated patronage, to work in a broadly 'realist' manner believed to be accessible and accountable to a wide range of people. Paradoxically, while borrowing the epithet 'realism', these images often celebrated a rather mythic, unitary vision of American values. This emphasis was seen as part of a return to a fundamentally American tradition that valued empirical fact as democratic.

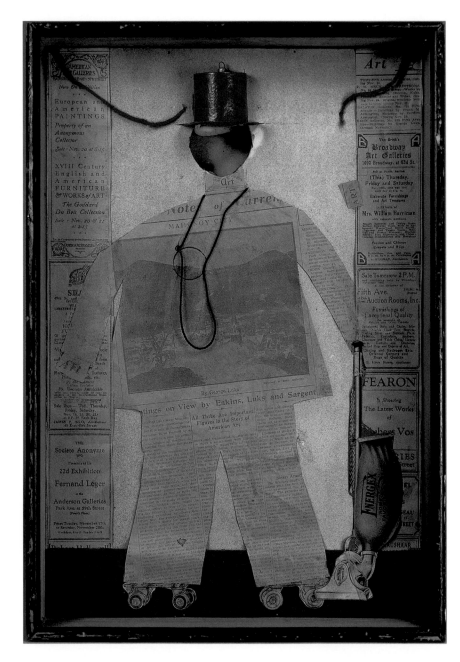

PLATE **3.10**
Arthur Dove, *The Critic*, 1925, collage of paper, newspaper, fabric, cord and broken glass, whole 50 × 34 × 12 cm. (Whitney Museum of American Art, New York; purchase, with funds from the Historic Art Association of the Whitney Museum of American Art. Mr and Mrs Morton L. Janklow, the Howard and Jean Lipman Foundation, Inc., and Hannelore Schulhof. 76.9.)

The association of Realism with democracy has a long and complex history in the USA. In part, democracy was identified with fidelity to appearance, the production of a likeness. Clearly, that view was threatened by the European modern movement: a situation that lay at the root of the charge against modern art that it was 'un-American'. During the nineteenth century, the American painter Thomas Eakins had developed an art guided by an emphatic commitment to empiricism: a reliance on observation and experience. In his quest for the depiction of an 'objective' appearance, he found his intellectual rationale in the methods and heroes of scientific enquiry (Plate 3.11). In a country with a pioneer past, realism in art was related to positivism and valued as if it were the artistic equivalent of science. Realism as truth to appearance became a democratic mantra. In 1943, for instance, a curator of the Museum of Modern Art, Dorothy Miller, mounted an exhibition under the title 'American Realists and Magic Realists'. In the catalogue, Miller named eighteenth- and nineteenth-century realists such as Eakins, Raphaelle Peale, John Audubon and Winslow Homer as

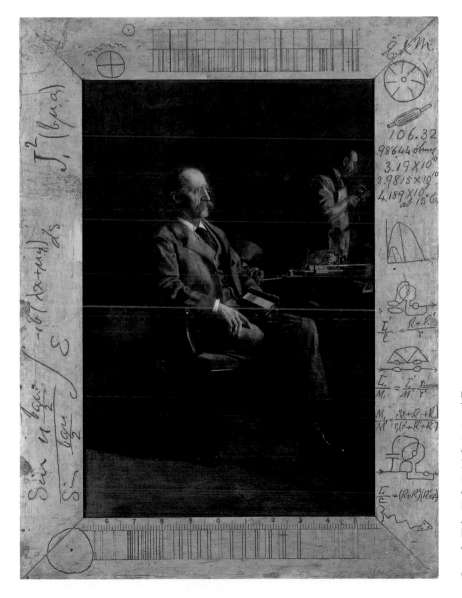

PLATE 3.11
Thomas Eakins,
*Professor Henry A.
Rowland*, 1897,
oil on canvas,
204 × 137 cm.
(© Addison Gallery
of American Art,
Phillips Academy,
Andover,
Massachusetts; gift
of Stephen C. Clark.
1931.5. Photo:
Greg Heins.)

progenitors for the contemporary artists in the exhibition, maintaining that 'no other style of painting appeals so naturally to a great majority of people, and in this sense it is a truly democratic style, offering no barrier of technique between the artists and the untrained eye'.[15]

Notwithstanding the centrality of the positivist tradition, there was a counter-balance in American culture to the sharply focused realism of instantaneous identification. This can be found in the nineteenth-century transcendentalist poets Ralph Waldo Emerson and Henry David Thoreau, whose idealism sought the 'essences' of reality beyond 'appearances' and emancipation in the individual rather than in social reform. In the visual arts, the impact of their powerful anti-positivism can be discerned in the paintings of the American romantic Albert Pinkham Ryder, whose art eschewed faithful transcriptions of nature and appealed to the imagination rather than the intellect (Plate 3.12). This counter-tradition to positivism, and Ryder's work in particular, were subsequently to prove influential to certain artists working towards an alternative to social realism in the 1940s.

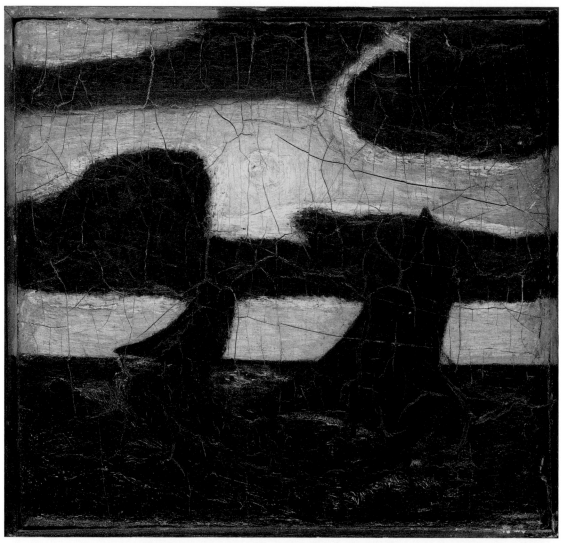

PLATE 3.12 Albert Pinkham Ryder, *Moonlight Marine*, 1870–90, oil and possibly wax on wood, 29 × 31 cm. (Metropolitan Museum of Art, New York; Samuel D. Lee Fund, 1934. 34.55. Photo: © 1989 The Metropolitan Museum of Art.)

Documenting the USA

Despite Ryder's example, however, during the 1930s – a period when American democracy itself appeared undermined – there was a widespread commitment to a realism that aspired to present a truthful picture of the world. The art of the 1930s was marked by several influential tendencies, which can be accommodated under the overarching title of 'cultural democracy'. Two important practices were photography and mural painting.

The 'realism' afforded by photography became a powerful tool for government relief agencies and this was one factor in the massive increase in art production during the period. In the popular imagination, the predicament of the rural USA was most successfully captured by photographs from the Farm Security Administration (FSA), set up in 1937 to document existing conditions and influence or add weight to government legislation and relief funding. For example, Dorothea Lange's iconic photograph of an 'Okie' mother and child in California (Plate 3.13) was widely reproduced.[16] It was used as the cover to John Steinbeck's classic of Depression literature, *Their Blood is Strong* (1938).

Lange's photograph and Bryson Shahn's poster (Plate 3.2) are evidence of a widespread use of documentary forms of practice across all the arts. The proliferation of graphic and photographic production during the New Deal was in part due to ideological debates regarding the desirability of cheaply reproducible media to reach a broader audience. Building on the work of photographers such as Jacob Riis and Lewis Hine, the photo-documentary

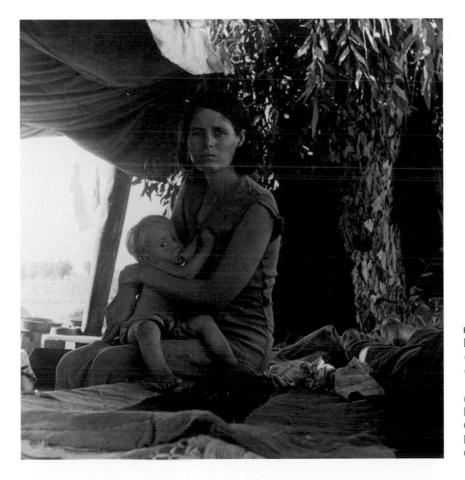

PLATE **3.13**
Dorothea Lange, *Okie Mother and Child in California*, 1936, photograph. (Courtesy the Dorothea Lange Collection, Oakland Museum of California.)

essay chimed with a national impulse to embrace measurement as a panacea in times of uncertainty. The country's media and administration invested in facts, data and true-life stories, autobiographical proletarian literature, eyewitness accounts and so on, as if to buttress through empiricism and factual authenticity the lived experience of a society whose self-respect had been badly shaken by the Depression.

The presentation of images was often accompanied by text in which ideological imperatives were made explicit so that the intended message could not be subordinated to aesthetic readings. For instance, captions were used on many photographs. Margaret Bourke-White's photograph *Maiden Lane Georgia: You Have Seen their Faces* was published with the caption 'A man learns not to expect much after he's farmed cotton most of his life' (Plate 3.14). In the highly emotive *You Have Seen their Faces*, a photo-essay book published in 1937, the novelist Erskine Caldwell and Bourke-White sought to narrate and visualise the plight of southern tenant farmers. As massive population resettlement and unemployment undermined social cohesion, facts offered a reassuring reconnection with local traditions, and recalled the founding history of the USA and its democratic idealism. A multiplicity of public works projects set about documenting American culture and society. These included enterprises such as the Index of American Design (1935), which produced an illustrated record, in drawings of exacting detail, of objects of American decorative art; the plans of old gardens drawn up by the Historic Gardens Unit of the New York Index; the Historical American Buildings Survey; and the Federal Music Project's recordings of indigenous folk music. The emphasis throughout was on the 'real'. Behind it all lay a reinvestment in American national unity. This ambitious reconstruction of national identity was accompanied by a significant resuscitation of the concept of 'the American Way', in which the Roosevelt administration reworked traditional ideas of the frontier and a pioneer past into what became redefined as the 'social frontier'.

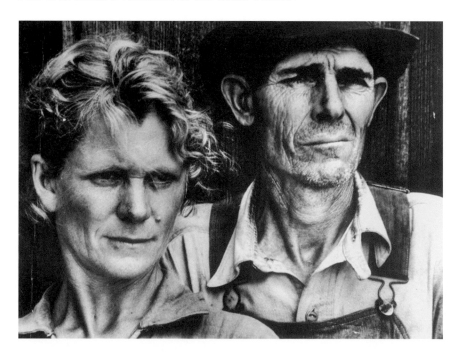

PLATE 3.14
Margaret Bourke-White, *Maiden Lane Georgia: You Have Seen their Faces*, c.1935. (Photo: Getty Images/Hulton Archive.)

The second aspect of 'cultural democracy' that I want to discuss is mural painting. Large numbers of murals were commissioned for public buildings as one of the most visible manifestations of the attempt to generate a sense of community and national self-awareness. The most important precedent for the FAP's mural programme lay in the work of a generation of Mexican artists who, during the 1920s and 1930s, had undertaken many major commissions, both in Mexico itself and in the USA. The Mexican Revolution sprawled through the second decade of the twentieth century, throwing up folk heroes of the stature of Pancho Villa and Emilio Zapata. Like the Russian Revolution, which it partly predated, the Mexican upheaval generated powerful impulses to seek and define a national identity. Most significantly for our present purposes, it stimulated the search for an art form that could both respond to and articulate these impulses.

Diego Rivera, José Clemente Orozco and David Alfaro Siqueiros were the leading figures in what became known as the Mexican Mural Renaissance. They had produced a state-sponsored art that celebrated socialism and mass emancipation for the revolutionary national government of Alvaro Obregon. The murals often depicted an idealised pre-Columbian past and a utopian socialist future to express narratives of national identity that had previously been repressed. Stylistically, the murals were a fusion of figuration and formal experimentation, of significant and accessible subject matter, with a measure of technical radicalism (Plate 3.15). Commissions were also undertaken in the USA for institutions as diverse as the San Francisco Stock Exchange, the Ford Motor Company in Detroit and the Rockefeller Center in New York.

Not surprisingly, there were occasional conflicts of interest between the militantly socialist painters and their capitalist patrons, the most notorious being in 1933, when the Rockefeller family obliterated Rivera's mural *Man at the Crossroads Looking with Hope and High Vision to the Choosing of a Better Future*, not because of the unlikely title but because of its inclusion of a portrait of Lenin. Nonetheless, in the climate of the Depression and the New Deal, the epic achievements of the Mexicans resonated with American artists in search of a socially relevant practice. Their influence could be seen in myriad public buildings, post offices, schools, hospitals and penitentiaries across the USA. The muralists aspired to a public art to counter the perceived individualism and commodification of easel painting. This position was voiced by Siqueiros in the manifesto 'A Declaration of Social, Political and Aesthetic Principles', drawn up in 1922 and signed by the membership of the Syndicate of Technical Workers, Painters and Sculptors: 'We *repudiate* so-called easel painting … because it is aristocratic, and we praise monumental art in all its forms, because it is public property … art must no longer be the expression of individual satisfaction … but should aim to become a fighting, educative art for all.'[17] Ten years later, Rivera affirmed that 'Mural art is the most significant art for the proletariat … But the easel picture is an object of luxury.' For him, there was no doubt that 'Art is a social creation', and no doubt either of his stated intention: 'to use my art as a weapon'.[18]

There were echoes of both the form and the politics of Mexican murals throughout the USA. For instance, a principal effect of the art projects of the New Deal was to decentralise practice and encourage regional centres, rather

than the traditional emphasis on east-coast cities. The nationwide murals often celebrated the achievements of democracy through Whitmanesque paeans to labour and trade. The impulse to celebrate vernacular culture was part of a reinvestment in everyman and marked a widespread turn to 'naturalism' across all the arts. In murals such as James Michael Newell's *Evolution of Western Civilisation* (Plate 3.16), there is a marked absence of any of the formal experimentation that we have come to expect from

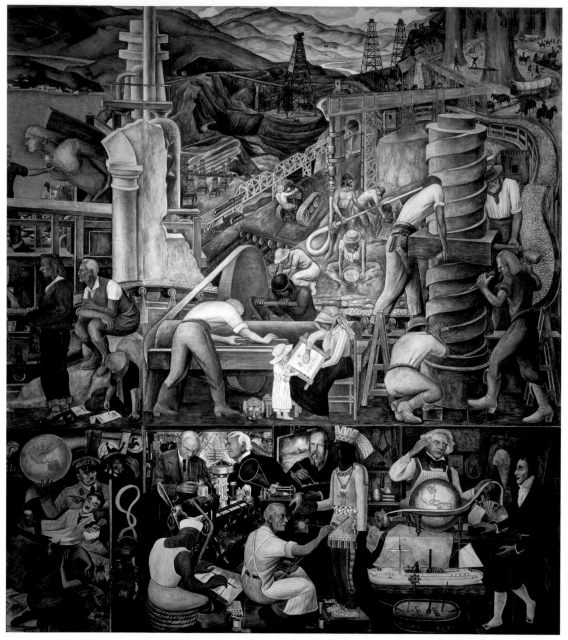

PLATE **3.15** Diego Rivera, detail of *Pan-American Unity*, 1940. (© City College of San Francisco. www.riveramural.com. © 2003 Banco de México Diego Rivera and Frida Kahlo Museums Trust. Av. Cinco de Mayo No.2, Col. Centro, Del. Cuauhtémoc 06059, México, D.F.)

modern art. It also took as its subject a narrative: the reassuring myth of the history of civilisation. There was not, however, a complete abandonment of modernist experimentation. The New York Works Progress (later Work Projects) Administration, under the direction of the abstract artist Burgoyne Diller, encouraged a diversity of practices. Arshile Gorky's mural *Aviation* of 1936 is an example of public art made for New York's Newark Airport that was a fusion of the machine aesthetic with abstract forms.[19] Gorky described his working process:

> The fourth panel is a modern plane simplified to its essential shape and so spaced as to give a sense of flight.

> In the other three panels, I have used arbitrary colors and shapes; the wing is black, the rudder is yellow, so as to convey the sense that these modern gigantic implements of man are decorated with the same fanciful yet utilitarian sense of play that children use in coloring their kites.[20]

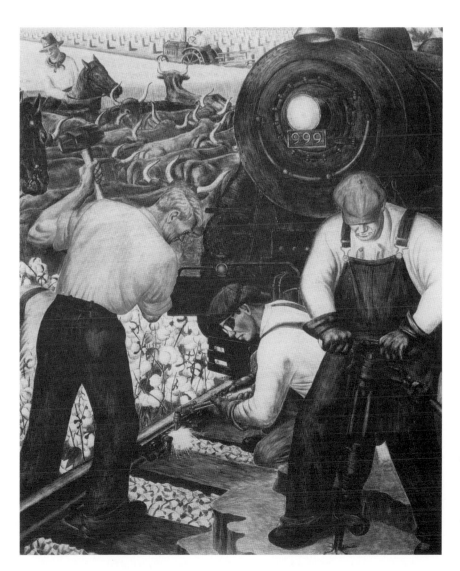

PLATE **3.16**
James Michael Newell, detail of *Evolution of Western Civilisation*, 1938, fresco mural panels in the library of Evander Childs High School, Bronx, New York.

Regional Realism

We have seen how one effect of the Depression was to stimulate many American artists to develop an art that was responsive to its immediate social context. But not all of the artists who responded through their art to the Depression era created works of social commentary or documentation. Some artists, collectively titled 'Regionalists', rejected not just formalist experimentation but modernity itself, abandoning the east-coast cities to return to the country. The best-known, and arguably the most complex, figure associated with Regionalism is Thomas Hart Benton. Benton had been active as an abstractionist in New York, but had come to regard abstract art as symptomatic of 'aesthetic drivellings and morbid self-concerns'.[21] By 1930, he had embarked on the extensive mural scheme *America Today*, which depicted the activities of the country, from docks and logging mills to cotton picking and mining. Pointedly set against the sturdy workers of the heartland were other scenes of sinful, alienated existence in the city. Benton's aim in *America Today*, and paintings such as *Agriculture and Lumbering* (Plate 3.17),

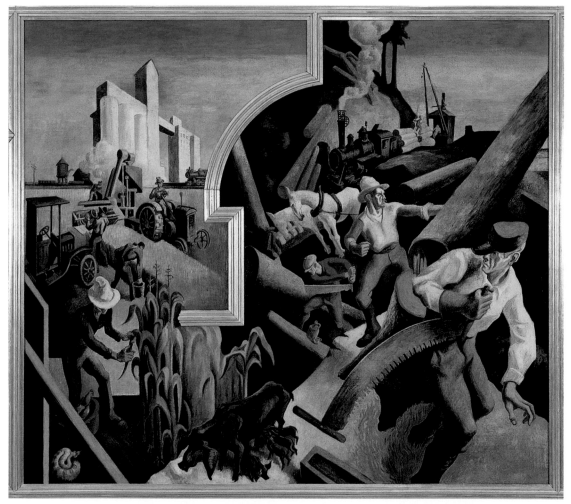

PLATE **3.17** Thomas Hart Benton, *Midwest*, detail of *Agriculture and Lumbering*, from *America Today*, 1931, distemper and egg tempera on gessoed linen with oil glaze. (© AXA Financial, Inc. © T.H. Benton and R.P. Benton Testamentary Trusts/VAGA, New York/DACS, London 2004.)

was ambitious, and consistent with the Depression era investment in documenting the lives and histories of 'ordinary folk'. But Benton's stance was not without its critics, particularly on the Left.

In a review of Benton's autobiography, *An Artist in America* (1937), the Marxist art historian and critic Meyer Schapiro objected to Benton's conversion from a 'formalising to a realistic art' on the following grounds:

> In turning from geometrical forms to objects, Benton imagines that he has entered fully into the life of his time. The mere representation of railroad trains and farmers gives him the illusion of a mystical rapport with a superior American reality. Just as he once assumed that geometrical forms brought the artist in touch with the inner structure of the world or the essence of art, so now he seems to believe that by depicting native objects he is grasping the essence of American life. But this essence is only an aspect or a segment, and its claim to permanence or inherence or primacy is refuted by its own history.[22]

Schapiro's argument, made more explicit in his earlier essay 'The Social Bases of Art' (1936), is clearly critical of the transhistorical claims made by some advocates of abstraction: 'if we examine attentively the objects a modern artist paints and the psychological attitudes evident in the choice of these objects and their forms, we will see how intimately his art is tied to the life of modern society'.[23] He casts doubt on the notion of essences, to argue that art has its own specific, temporal history that negates any claim to art being outside history. But more to the point, in his book review Schapiro seems to recognise that a kind of formalism that had permeated Benton's earlier abstract paintings somehow carried over into his figurative work. For Schapiro, Benton's supposed 'objectivity as a painter, limited to buildings and machines and the picturesqueness of native "types", exacted no deeper insight into American life'.[24] Reinforcing Schapiro's sense that Benton's 'populist realism' remained limited to recording the external features of American life, rather than the essence he hoped for, was the fact that Benton had disavowed 'social ideas', stating explicitly that 'social understanding usually hurts the artist'.[25] Schapiro saw a weakness in the fact that Benton criticised 'a realism guided by radical values and a desire for change', and instead 'poses the stable, unpolitical everyday world and the corresponding historical past as the proper subjects for art'.[26] Schapiro argued that Benton's opposition to both major contemporary currents in art practice, namely abstraction on the one hand and a radical realism with aspirations to effect social change on the other, rendered his work 'conservative'. He believed that ultimately Benton failed to address political differences and the contradictions of lived social reality. As far as Schapiro was concerned, to enter 'fully into the life of his time'[27] had to involve an actively political and social realism. It was his disavowal of the political realities of the period that rendered Benton's work regressive.

Another left-wing figure who found Benton's 'populist realism' unpalatable was Stuart Davis, who was both an abstract painter and secretary of the communist-dominated Artists' Union. In a significant exchange with Clarence Weinstock, editor of the journal *Art Front*, Davis had defended his politically committed abstraction against Weinstock's advocacy of Socialist Realism as the only art appropriate to the times. In the USA, few artists worked within the strictures

of communist-sponsored Socialist Realism, preferring instead a social realism that tended to be less optimistic and more critical of contemporary realities. For Davis, abstraction was 'the result of a revolutionary struggle relative to the bourgeois academic traditions of the immediate past and even the present'.[28] In his view, Benton's supposed 'populist realism' was nothing of the kind. In 'Rejoinder to Thomas Benton', Davis ridiculed his 'dime novel American history'.[29] For Davis, as we saw earlier, social meaning was inseparable from *all* artwork, including abstraction. Contrary to Benton's claims about getting at the truth through the avoidance of an overt social or political perspective, for Davis Regionalism in general and Benton's approach in particular *were* suffused by a register of values and these were entirely negative: chauvinism, anti-Semitism and homophobia. Benton's greatest crime was to lay claim to being an American painter representing the mid-west and yet simultaneously asserting 'there is no revolutionary tradition for the American artist in the political sense'.[30]

Despite Benton holding views readily associated with Fascism, by the early 1940s and the entry of the USA into the Second World War, he had produced the colossal eight-canvas series *The Year of Peril* as part of the government's propaganda exercise to call the country to arms. In this anti-Fascist, allegorical work, Benton tried to reconcile Regionalism with a commitment to internationalism. Several of the canvases were set in the mid-west, depicting the rape of women and the destruction of homesteads in melodramatic scenes drawing on a clichéd repertoire of stereotypes. Although widely published as stamps and posters, Benton's work received little critical acclaim. Rather, Davis's and Schapiro's criticism seemed vindicated. Benton's attempt to universalise from the specific context of the mid-west, at the moment of the USA's entry into the Second World War, resulted in, to use Benton's own words, 'swift and superficial representation of combat and production scenes' (Plate 3.18).[31]

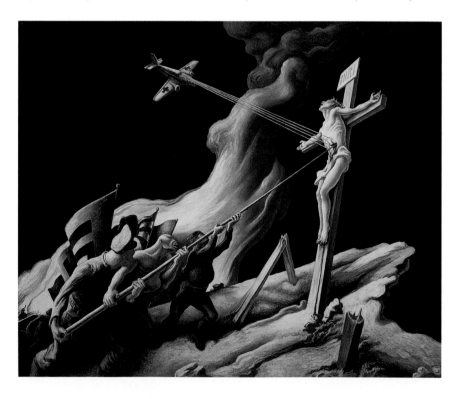

PLATE **3.18**
Thomas Hart Benton, *Again*, from the *The Year of Peril* series, 1941/2, egg tempera and oil on canvas mounted on panel. (State Historical Society of Missouri, Columbia. © T.H. Benton and R.P. Benton Testamentary Trusts/ VAGA, New York/ DACS, London 2004.)

Davis advocated an art practice that avoided the pitfalls of propaganda by maintaining that modern art (even abstract art) was inherently opposed to Fascism and thus innately political. In his exchange with Weinstock, he spoke of 'the revolutionary history of abstract painting', going on to claim that 'In the materialism of abstract art in general, is implicit a negation of many ideals dear to the bourgeois heart.'[32] During the New York World's Fair of 1939, Davis produced a mural extolling the virtues of American democracy associated with a commitment to rational scientific progress as opposed to the irrationality of Fascism (Plate 3.19). For Davis, the advanced technical nature of both its *content* and its *form* gave this work its radical credentials in opposing Fascism. Davis's plea for tolerance of most artforms was a legacy of the aims of the Popular Front, which had mobilised western democracies in the fight against Fascism and crossed most ideological and artistic boundaries, under the banner of 'freedom of expression'. However, Schapiro cautioned that even traditional 'democratic individualism' – that is, the individualism of bourgeois society – was not a secure bulwark against Fascism. Although he thought it would be 'premature' to characterise Benton's Regionalism as Fascist, he warned against any appeal to 'natural sentiment … whatever its source'.[33] For Schapiro, bourgeois individualism and rationalism offered no protection against being conscripted to extremist political agendas. In the very different context of the Cold War, Schapiro's warning would be relevant to a generation of American artists – many 1930s social realists – who found themselves aligned with the 'American Way' in the name of individualism.

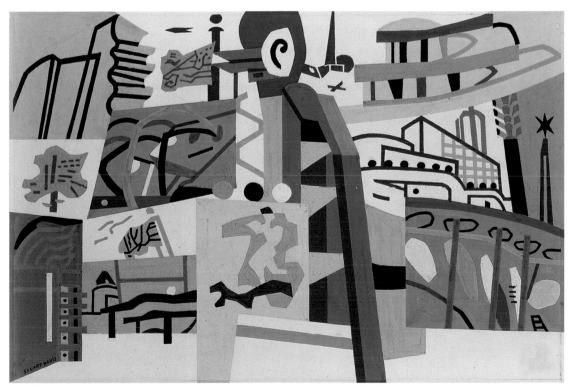

PLATE **3.19** Stuart Davis, *Impression of New York World's Fair* (mural study), 1939. (Smithsonian American Art Museum, Washington © 2003. Photo: Smithsonian American Art Museum/Art Resource/Scala, Florence. © Estate of Stuart Davis/VAGA, New York/DACS, London 2004.)

Rethinking the avant-garde

The need to identify new aesthetic ambitions, as confidence in the values of the 1930s waned, acquired a greater sense of urgency as war took hold in Europe and the USA became involved. Most notably, the widespread adherence by American artists to social realism lessened. The reasons are various, but among the more obvious is the fact that a commitment to social realism tended to be bound up with other commitments – to the Popular Front and for radical social action against the conditions of the Depression. Even though American artists generally distinguished between social realism and Social*ist* Realism, there was still the difficult issue of support for the USSR. All of these allegiances were eventually either redrawn by the evolution of historical events or even came to seem suspect in the increasingly conformist culture of the wartime and postwar USA. But this transition was not an easy one, and neither is it enough to characterise it as a conservative response to the war, a simple retreat from social commitment. The shift in artists' priorities from the late 1930s to the late 1940s was complex.

The late 1930s had witnessed a considerable rise in support for *un*orthodox communism, that is to say, Trotskyism. Leon Trotsky was based in exile in Mexico, and key ideas of his – such as the fact that the USSR was not a genuinely socialist society, and that art should be free to develop its own revolutionary forms rather than be constrained by the straitjacket of Socialist Realism – found a significant audience. Particularly in New York, this included writers and artists across a wide spectrum, which was by no means restricted to the avant-garde. *Partisan Review* was the main site for the circulation of these and related ideas. In 1938, the journal published the manifesto 'Towards a Free Revolutionary Art', co-authored by André Breton and Trotsky. The manifesto condemned the USSR as 'a twilight of filth and blood'. Significantly, it also equated 'free art' with revolution, while enforcing a crucial distinction between such a 'free revolutionary art' and 'so-called pure art', which, as the essay put it, 'generally serves the extremely impure ends of reaction'.[34] This, it goes almost without saying, is a very grey area. Precisely where the lines were to be drawn between a 'pure art', in the sense of 'art for art's sake', serving the ends of reaction, and a 'free art', walking in step with the revolution, was not going to be easy to determine in practice. At the very least, it would depend on the nature of the ideas informing the art, as much if not more than on any features of the art itself. The impact of Trotskyism is easier to gauge in theoretical and literary work than it is in the visual arts. As one might expect, once the fake optimism of Soviet fellow-travelling was gone, pessimism was hard to avoid: Victor Serge called this period 'the midnight of the century'.[35] In articles such as 'Proletarian Literature: An Autopsy' and 'Twilight of the Thirties', the *Partisan Review* editor, Philip Rahv, struck a note of elegiac despair as he observed: 'There are still remnants, but no avant garde movement to speak of exists any longer.' He went on,

> Everywhere the academicians, the time-servers, the experts in accommodation, the vulgarisers and the big-money adepts are ruling the literary roost, and those few whose conscience in such matters is still awake have begun to look back at the nineteen twenties as a golden age ... exceedingly alive with experiment and innovation.[36]

The crux of these debates was the notion of 'independence'. Thus, Rahv had written in an unsigned *Partisan Review* editorial in 1937 that 'Any magazine, we believe, that aspires to a place in the vanguard of literature today will be revolutionary in tendency; but we are also convinced that any such magazine will be unequivocally independent.'[37] By this he meant independent of the Communist Party; this in turn, in the circumstances of the time, signalled an allegiance to Trotskyism. In tandem with the manifesto 'Towards a Free Revolutionary Art', Breton and Rivera set up an organisation grandly titled the International Federation of Independent Revolutionary Art (FIARI). *Partisan Review* published Trotsky's letter of support for this 'international federation of truly revolutionary and truly independent artists'. Trotsky asserted that 'truly independent creation cannot but be revolutionary by its very nature … not relying upon orders from outside, but rejecting such orders and heaping scorn upon all who submit to them'.[38] This is a criticism of Socialist Realism and of artists who, whether with misgivings or not, toed the party line. However, the significant outcome of this attempt to preserve the compatibility of political and artistic vanguardism, in the face of the subordination of art to politics by Stalinism, was an inescapable disarticulation of the two. What tended to happen was that, once artists felt free from political diktat, other questions such as those of originality or self-expression came to the fore, and the pursuit of these ends had unpredictable consequences for the old left-wing shibboleths of popularity and accessibility.

The decisive intellectual intervention in these debates came in the form of Clement Greenberg's essay 'Avant-Garde and Kitsch', which was published by *Partisan Review* in the fall issue of 1939. This provided much of the theoretical support for the subsequent development of the American avant-garde. The stance it embodied meant that the practical developments undertaken by artists seeking a way out of the impasse of the late 1930s had an overarching justification, which simultaneously secured *both* the credentials of the ongoing enterprise of radical art *and* complete freedom to innovate technically. Emerging from a Trotskyist milieu, even if his own Marxist credentials were less than robust, Greenberg seemed to some to square the circle between committed avant-gardism and its erstwhile opposite, art for art's sake. The essay pitted what he saw as a debased mass culture corrupted by commodification ('kitsch') against an inward-looking avant-garde culture for which 'subject matter or content becomes something to be avoided like a plague'.[39] Greenberg cut through the political imperative that held sway during the 1930s, severing the connection between culture and society by maintaining that art could only survive by disengaging itself from 'ideological confusion and violence'.[40] He argued that avant-garde art should be protected from mass culture, as kitsch produces ersatz emotions and is a commodified art fed back to an unthinking public. For Greenberg, only an autonomous art, free from doctrinaire political strictures and from the products of capitalist consumerism alike, held out hope for emancipation: the possibility of a form of aesthetic expression that could overcome nationalism and chauvinism. Greenberg's argument pointed the way forward for a transformed sense of avant-garde art practice. But his dual rejection of what he classified as subject matter in art, and of what he saw as the passive form of consumption encouraged by commercial popular culture, continued to put him at odds with many artists of the prewar generation.

There was no easy transition from a prewar art of social commitment and shared values to a postwar situation of rampant individualism and formalism. Easy or not, though, transition there was; avant-garde art was responding to deeper currents of change in the American outlook: from the left-wing culture of the New Deal to the right-wing paranoia of McCarthyism; from Popular Front to Cold War; from isolationism to global power. This is not to say that art was directly swept along as the political tide ebbed from the social radicalism of the 1930s. Much of the art of the 1930s had involved a critique of capitalism, and even after the Second World War artists tended to remain distant from the materialism and consumerism of the American Dream. But once the wider radicalism of the prewar period had been tempered by increased prosperity, artists' distance from the core values of society tended increasingly to be expressed in social alienation rather than shared commitment. The poverty of the 1930s was now ghettoised rather than spread through society, and the USA was economically strong and internationally powerful. In a situation where they were no longer on the collective breadline, many, although by no means all, artists tended to get on with making art and talking to the few who wanted to listen. Moreover, under McCarthyism the articulation of social issues and collective goals had become problematic, and whether a rationalisation or not, for many the pressing needs of the despairing individual eclipsed broader social agendas. Greenberg maintained that it became impossible: 'you couldn't dissolve your own anxieties, your own aspirations and so forth, in larger ones. It was your own art, it was your own writing.'[41]

'Avant-Garde and Kitsch' had appeared on the eve of the Second World War, and over the next twenty years its author refined his argument in support of what he termed 'American-type painting'. By 1960, American abstraction had become internationally dominant, and it was in that year that Greenberg essayed an ambitious synopsis of his views in a radio broadcast titled 'Modernist Painting'. As well as charting a century-long process of evolving artistic autonomy from the art of Édouard Manet up to his own contemporaries in the New York School, Greenberg articulated his insistence on the primacy of the formal features of an artwork, and his belief in quality defined through the experience of an artwork alone. By the 1960s, however, his views had hardened into an imperative of self-criticism: 'The essence of Modernism lies … in the use of the characteristic methods of a discipline to criticize the discipline itself – not in order to subvert it, but to entrench it more firmly in its area of competence.' For Greenberg, it was the stressing of the 'ineluctable flatness of the support' that remained 'most fundamental in the processes by which pictorial art criticized and defined itself under Modernism'. He concluded that 'flatness alone was unique and exclusive to that art'.[42] According to this theory, the challenges necessary to guarantee avant-garde status came from the artist's concentration on the medium itself and an increasing recognition of the 'flatness' of the painting's surface: a concentration that has been interpreted as a plea for art that responds only to predetermined formal issues. It was these factors that became widely identified as the key characteristics of postwar American vanguard art, whose achievement of international pre-eminence was subsequently dubbed, not without chauvinism, 'the triumph of American painting'.[43]

Even so, the substitution of social concerns by a concentration on individualism and formal values was not without its critics. For some artists on the Left,

there was no conflict between continuing to work in a narrative, realistic and accessible manner that experimented with new forms of expression without moving into complete abstraction. Indeed, artists not committed to Abstract Expressionism continued to find support in the idea of an independent art free from party political allegiance and doctrinaire formulations, while maintaining a commitment to art in the service of social change. In the postwar period, although artists who still emphasised the social, political and economic foundations of their work found it increasingly difficult to find critical acceptance, some, including Shahn, Gropper and Evergood, continued to follow their own aims in the face of critical hostility. Likewise the African American Jacob Lawrence still pursued a figurative practice that made use of sequential narrative similar to cartoons, at the same time as emphasising the *historical* in art: familiar strategies during the 1930s and in popular culture. The young Lawrence had taught children's art classes in Harlem, New York, as part of the WPA-sponsored Harlem Art Workshop, and the passing of the 1930s did not significantly alter his practice. For him, storytelling was a crucial element in art that abstraction could not accommodate. In order to tell the historical narratives of the African American diaspora and black community aspirations, Lawrence's works often contain explanatory texts in their titles, a strategy that runs directly counter to the Abstract Expressionist predilection for leaving works untitled, thereby forcing concentration on the visual configurations alone. Celebrating the heroes and heroines of the Civil Rights movement, such as Harriet Tubman, Toussaint L'Ouverture, Frederick Douglass and the abolitionist John Brown, Lawrence preferred to take from modernism what he regarded as appropriately modern formal devices, rooted in Cubism and Expressionism, as a vehicle with which to communicate his subjects to a contemporary audience. Moreover, working in hybrid forms, Lawrence could integrate folk and African motifs into his art. Although he was clearly concerned with formal values in art, formalism as such was not adequate for Lawrence's purpose; in fact, for him, formalism remained something to be resisted or subverted through a continuing use of narrative (Plate 3.20: race riots were numerous; white workers were hostile towards the migrants who had been hired to break strikes). Lawrence's racially conscious art challenged Greenberg's insistence on an 'escape from ideas which were infecting the arts with the ideological struggles of society ... to a greater emphasis upon form'.[44]

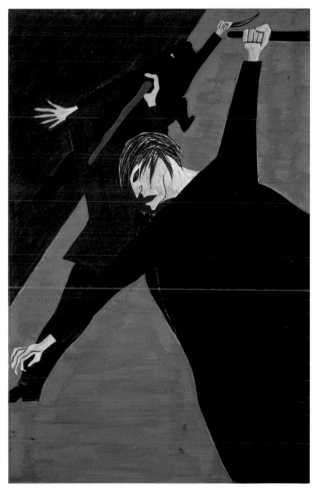

PLATE 3.20
Jacob Lawrence, *The Migration of the Negro*, later renamed *The Migration Series*, 1941, panel 50 of the series. (© Gwendolyn Knight Lawrence, courtesy of the Jacob and Gwendolyn Lawrence Foundation.)

Mythmakers: rethinking primitivism

What emerges is a complex picture. Virtually all artists working during the 1930s who later became members of the Abstract Expressionist group had expressed left-wing sympathies and produced socially committed art or taken part in other activities: ranging from Pollock's time in Siqueiros's mural painting workshop to Barnett Newman running for mayor of New York on an anarchist ticket. Given their prior political commitments, it seems reasonable to assume that for such artists the new forms of abstract art nonetheless represented a continuing engagement with a wider political and social reality. To take only a few of the most overt examples: Pollock referred to his art as 'the expression of contemporary aims of the age that we're living in';[45] Newman wrote of the atomic bomb as 'this new fate [which] hangs over us';[46] and Adolph Gottlieb wrote of his abstracted, pictographic paintings as 'the expression of the neurosis which is our reality'.[47]

We should be wary of claims for a 'transitional' period in the early 1940s leading to a culmination in fully realised abstraction. That kind of teleological history can fail to do justice to the work in question, regarding it as 'merely experimental', as being on the way to something else. Nonetheless, it is true that many of the artists who were subsequently central to Abstract Expressionism did enter a so-called 'mythic' period in the early 1940s, between the more overtly realist practice of the 1930s and the 'all-over' abstract works of the late 1940s and 1950s. During this period, we can identify attempts to adjust or reconfigure previous European modernist traditions: principally the legacies of Expressionism, abstraction and Surrealism.

An interest in pre-history, the spiritual and mythology permeated the culture of the period and influenced the work of figurative and abstract artists alike. Painters such as Shahn and Evergood, who still worked in a socially committed figurative idiom, frequently incorporated mythic elements into their imagery. It is the function of the mythic within avant-garde culture that I want to concentrate on here. Collectively ascribed the title 'mythmakers', many American avant-garde artists responding to the wartime crisis took up again the earlier European Expressionist preoccupation with primitive and archaic forms. However, as well as the obvious similarities with previous Expressionist tendencies, there were significant differences. In addition to maintaining an interest in the formal properties of the African mask, the proto-Abstract Expressionist 'mythmakers' drew on the iconography of the archaic forms found in pre-Columbian and Native American art. They were also stimulated to pursue other forms of the 'pre-cultural' laid bare by the exiled Surrealists present in New York: irrationalism and the unconscious (see Chapter 14 in *Art of the Avant-Gardes*). There was a further difference in the adaptation of European Surrealism to a New World environment. The preoccupation with repressed sexuality that had been a hallmark of European Surrealism was of less concern to the Americans than the meaning of human existence itself.

The elevated intentions of the 'mythmakers' can be read out of their stated ambition to achieve a more direct expression using 'only that subject matter ... which is tragic and timeless'.[48] That alone, they felt, would give their work

a more profound quality, which the reforming, regenerative social and political art of the 1930s – through its very historical specificity – could not give. In order to accomplish this, in his work of the early 1940s Rothko drew on mythological sources, principally archaic and Hellenic in origin, including fragments of columns, pottery and so forth. Beyond the literal assimilation of archaic motifs into his work, Rothko also used less literal transcriptions of archaic cultures, as in his *Tiresias* of 1944 (Plate 3.21). In this particular case, the conscious incorporation of elements of Greek myth (the title refers to the seer of Sophocles' Oedipus trilogy) should alert us to problems with the notion of unmediated expression and the 'timeless'. However, *Tiresias* also suggests an important modern reference. Tiresias is all seeing but blind, and the unseeing eye was an important leitmotif of Surrealism as a metaphor for a culture in crisis. Rothko thus combined in his work elements of memory, Greco-Roman imagery, ancient rites and rituals, and Surrealist experimentation.

In his pictographic work of the 1940s, Gottlieb also utilised motifs familiar in Surrealism. In *Masquerade* (Plate 3.22), images are located across a plane parallel with the surface of the painting, framed in boxes. These serve to integrate the composition into a whole, and, along with a relatively equal lateral emphasis and shallow pictorial space, they achieve a unity of effect that might have been thought incompatible with the serialisation of disparate motifs. The scratched forms of ancient symbols such as the spiral and the fish are combined with schematic rendering of the eye and the figure. In the statement already quoted, Gottlieb, Rothko and Newman asserted a kind of transhistorical 'spiritual kinship with primitive and archaic art'. They declared, 'We favor the simple expression of the complex thought. We are for the large shape because it has the impact of the unequivocal. We wish to reassert the picture plane. We are for flat forms because they destroy illusion and reveal truth.'[49] It is open to debate how far one sees this return to the past as an absolute rejection of the present, or as related to ideas circulating in contemporary popular literature and culture: part of a wider field of conjecture about the human psyche and what the art historian Michael Leja has referred to as 'modern man' discourse.[50]

It is noteworthy, however, that all these artists firmly rejected 'illustration'. In an interview with Seldon Rodman in the late 1940s, Rothko claimed, 'I'm interested only in expressing basic human emotions, tragedy, ecstasy, doom, and so on.' And, interestingly, from the point of view of our comparison of social realism with more abstract forms of expression, Rothko added: 'I communicate them more directly than your friend Ben Shahn, who is essentially a journalist.'[51] Rothko's ambition was for direct expression, unmediated by the demands of an art of 'social commentary', which for him was closer to journalism than to art as such. For Rothko, a state of critical self-awareness was only possible through direct expression: he disdained what he believed to be mediated illustration. 'Illustrative manner' was increasingly used as a pejorative term during the 1950s. The art historian Barbara Rose maintained that in the absence of an American academy to reject, for those aspiring to 'critical' status a rejection of illustration was necessary – in imitation of the European avant-garde.[52]

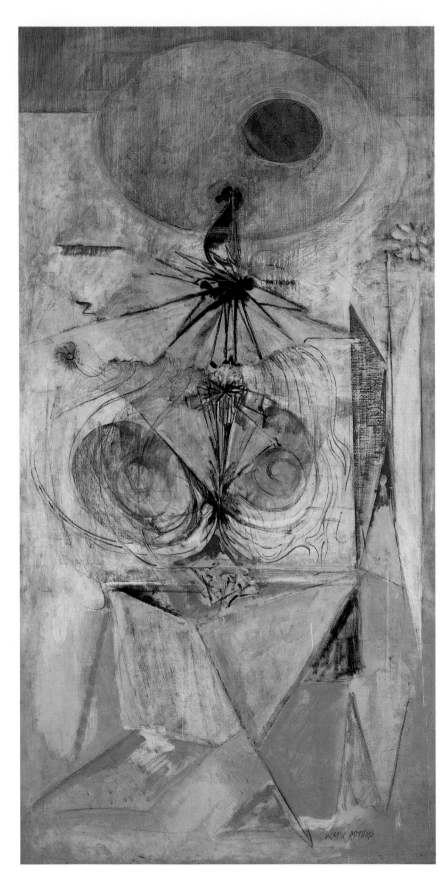

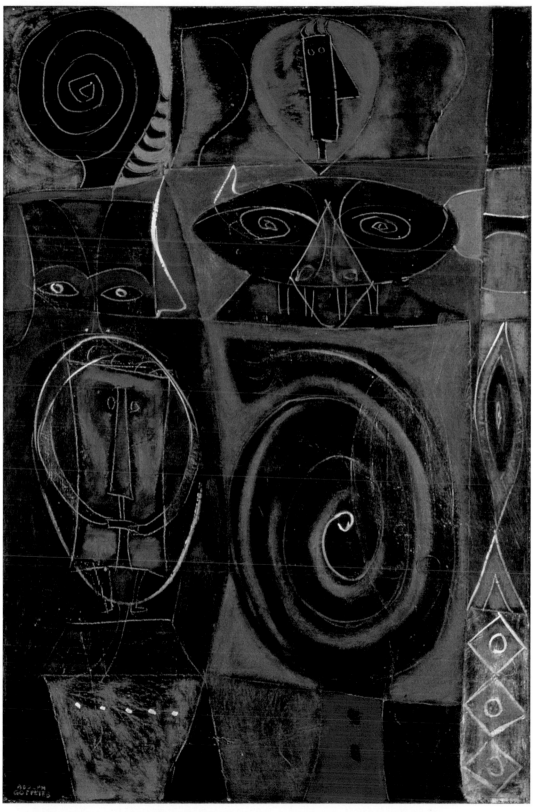

PLATE **3.22** Adoph Gottlieb, *Masquerade*, 1945, oil and tempera on canvas, 91 × 61 cm. (Adolph and Esther Gottlieb Foundation/VAGA, New York/DACS, London 2004.)

Pollock and the artist as hero

The situation in the USA after the Second World War gave rise to a strong sense of individualism and a related political philosophy known as the 'new liberalism', which rendered redundant the concept of the artist as citizen. The postwar USA contained contradictory ideologies. There was the hysterically conservative anti-communism of Senator Joseph McCarthy and the House Un-American Activities Committee. This was represented in the field of art by Senator George Dondero, who saw modern art as 'Shackled to Communism'. For Dondero, the entire range of modern art – 'Cubism', 'Futurism', 'Dadaism', 'Expressionism', 'Abstractionism', 'Surrealism' – amounted to a communist plot to destroy 'real American art'.[53] But, simultaneously with this, an alternative perspective arose out of the section of the American establishment known as the 'business liberals'. Their leading spokesman, Arthur Schlesinger, articulated a vision of 'the vital center'.[54] In stark contrast to the conservatives, the new liberals regarded the individualism of modern art as a bulwark against totalitarianism. For Schlesinger and others of a similar persuasion, it was the very 'intricacy and ambiguity' of modern art that safeguarded it against manipulation; 'mystery', 'anxiety', and 'complexity'[55] were interpreted as positive values for the art of an open society. All of this amounts to a significant reconceptualising of the figure of 'the artist', and a shift away from the social commentary agendas of the 1930s to a new kind of subjectivity termed the 'first-person aesthetic'.

A look at broader cultural issues, however, reveals that in a troubled era there were significant forces in play that served to relate the individualistic imperatives of the Abstract Expressionist painters to wider networks of social and political concerns. Thus, notions of primitivism and the irrational were key concepts that locate the New York School enterprise (see Chapter 4) within American popular and literary culture. So, too, was the heroic language and posture adopted by early critical supporters and painters alike. Nowhere is this more vividly demonstrated than in Hans Namuth's photographs of Pollock working in his studio in East Hampton on Long Island outside New York. Showing him wearing jeans and a T-shirt, the hallmark of the American construction worker or farm labourer, a world away from the smock and palette of the traditionally conceived 'fine artist', these images of Pollock helped to fix in the public's mind the existential figure of the American 'action painter' (see Plate 5.5). The photographs give us some insight into the production of Pollock's large-scale, 'all-over' canvases such as *Lavender Mist: Number 1, 1950* (Plate 3.23), *One: Number 31, 1950* (Plate 3.4), *Number 1A, 1948* and *Autumn Rhythm: Number 30, 1950* (see Plates 4.3 and 4.8).

A vocabulary that emphasised self-discovery and direct expression marked much of the contemporary writing relating to the New York School. It is not difficult to regard this as resulting from a dissatisfaction with the political art of the 1930s: the emphasis on collective, human-interest narratives giving way to a personal voyage of self-discovery. For instance, in an interview with William Wright in 1950, Pollock maintained, 'The thing that interests me is that today painters do not have to go to a subject matter outside of themselves. Most modern painters work from a different source. They work from within.'[56] The widespread use of Jungian and Freudian psychoanalysis and depth psychology were significant factors in American culture, and this is important in accounting for the shift from the collective during the 1930s to the individualism of the 1940s and 1950s.

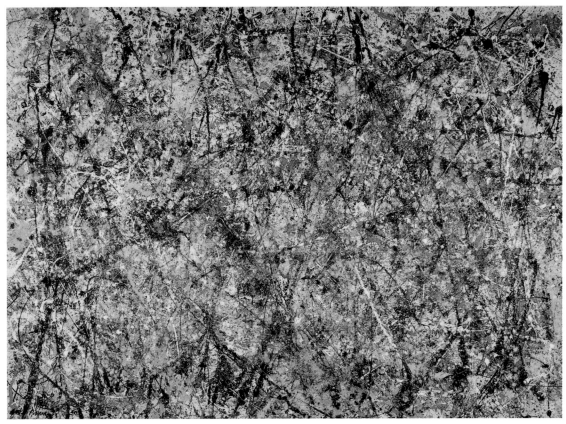

PLATE **3.23** Jackson Pollock, *Lavender Mist: Number 1, 1950*, 1950, oil, enamel and aluminium paint on canvas, 221 × 300 cm. (Ailsa Mellon Bruce Fund, Image © 2003 Board of Trustees, National Gallery of Art, Washington. © ARS, New York and DACS, London 2004.)

Pollock reiterated the rejection of illustration and the importance of the unconscious in art production. Writing in 1947 in a draft statement for *Possibilities*, one of a number of 'little magazines' that promoted Abstract Expressionism and other avant-garde experiments, Pollock remarked, 'the source of my painting is the unconscious'.[57] In the same magazine, the painter Robert Motherwell and the critic Harold Rosenberg further captured the lack of determinism in contemporary debate in the title of their essay, 'The Question of What Will Emerge Is Left Open'. This text marks a move away from the 1930s sense of an art of social commentary to a much more open-ended, unplanned enquiry – even as it sits with the new liberalism's sense of an art that could avoid conscription to political ends. The paradox, of course, is that it was precisely the new liberalism itself that was able to enlist 'free art' and 'dissenting art' as emblematic of its own supposedly 'free' political system. Rosenberg and Motherwell had come to see overt political choice – out of the options on offer in the early Cold War – as inimical to the practice of art, rather than as the condition of its ethical conduct. In a statement that articulates this dilemma, they write, 'If one is to continue to paint or write as the political trap seems to close upon him he must perhaps have the extremest faith in sheer possibility.'[58] They cite with approval a dictum of the Cubist painter Juan Gris, 'You are lost the instant you know what the result will be.'[59] Little could be further from the meticulous planning involved in the production of a mural cycle for a public building.

By 1952, Rosenberg had apparently answered his own open question about what would emerge with the concept of 'action painting'. He also swiftly distanced art practice from a dependence on forms of illustration, but, going beyond even that, he wrote of the new painting as an *activity* rather than as a way of making bounded formal compositions, abstract no less than figurative. In a famous passage, he claimed that:

> At a certain moment the canvas began to appear to one American painter after another as an arena in which to act – rather than as a space in which to reproduce, redesign, analyse or 'express' an object, actual or imagined. What was to go on the canvas was not a picture but an event.[60]

Within Rosenberg's rubric, painting was a process not a product. I argued at the outset of the chapter that, despite appearances – and art-historical accounts – to the contrary, there were actually some features of a shared political perspective between ostensibly different Realist and abstract artists. Rosenberg was a deeply committed Marxist during the 1930s and active in the politics of the period. When, after the Second World War, his view of art became seasoned with the fashionable existentialist rhetoric of 'The Act', it did not signify any divorce between art and politics in his view. Whereas Greenberg's formalist theory had stressed the separation of art from politics, or at least claimed that political issues were irrelevant to the aesthetic quality of the work of art, by which it should alone be judged, Rosenberg continued to claim a radical agenda for avant-garde practice. In developing the concept of the 'American action painters', Rosenberg was in essence maintaining that, if the act of painting was given primacy rather than the product of the act (open as it was to ideological appropriation), to approach the canvas with nothing fixed in mind became an act of resistance, a means of challenging dangerous conformity. Therefore the *act* of making art itself, through *gesture*, was a social and political act. Moreover, his championing of the individual's removal or alienation from mainstream culture was in stark contrast to the 1930s conception of the 'artist as citizen'. Rosenberg seems, in fact, to have regarded 'action painting' as a way out of the impasse represented by both politically overt Realism and its opposite, namely an abstract, formalist art for art's sake. Writing in 1952, he remarked that while the 'reborn' action painter may, as a human being, be in his forties, that is to say, may well have been active before the Second World War, *as a painter* he would be 'around seven': produced by the new post-1945 configuration of circumstances. As Rosenberg put it:

> most of the artists of this vanguard found their way to their present work by being cut in two …

> Many of the painters were 'Marxists' (WPA unions, artists' congresses); they had been trying to paint Society. Others had been trying to paint Art (Cubism, Post-Impressionism) – it amounts to the same thing.

> The big moment came when it was decided to paint … just TO PAINT. The gesture on the canvas was a gesture of liberation, from Value – political, aesthetic, moral.[61]

In effect, Rosenberg reworked his Marxism with postwar French existentialism to buttress the idea of a continuing, radical avant-garde through the concept of the artist's heroic encounter with the canvas. Rosenberg turned the crisis of the prewar project of a social art into a virtue, stating explicitly that

> the foundering of Art and Society was not experienced as a loss. On the contrary, the end of Art marked the beginning of an optimism regarding himself as an artist.
>
> The American vanguard painter took to the white expanse of the canvas as Melville's Ishmael took to the sea.
>
> On the one hand, a desperate recognition of moral and intellectual exhaustion; on the other, the exhilaration of an adventure over depths in which he might find reflected the true image of his identity.[62]

In postwar Paris, the writers Jean-Paul Sartre and Simone de Beauvoir had argued for the need to take responsibility for one's own existence, at the same time as acknowledging the unpredictable and anxiety-producing state that a rejection of any sense of determinism might have produced. Although a direct analogy between existentialist philosophy and the act of painting is unstable, the *language* of existentialism informed both the production and the reception of the art and the reconceptualised image of the postwar artist. In Rosenberg's 'act-painting', a supposedly more 'direct' and unmediated expression could take place, in which the outcome for what he termed the 'anxious object' was not predetermined.[63] Writing in 1955, Motherwell also related to art as a form of action: as 'an activity of bodily gesture serving to sharpen consciousness'. He reasoned that the 'act of painting is a deep human necessity, not the production of a hand-made commodity'.[64] In brief, it may be seen that, by the late 1940s, notions of community, art schemes and programmes of social renewal had for many artists given way to problems of individual identity.

Spontaneous art in an age of scientific management

Greenberg had insisted that Abstract Expressionist paintings were the outcome of the artist's confrontation with predetermined formal problems, the legacy of the work of the previous generation of modernist painters. During the same period, however, Schapiro offered quite a contrary defence of avant-garde art. In his 1957 essay 'The Liberating Quality of Avant-Garde Art', Schapiro, like Rosenberg, also championed the political dimension of the course taken by 'independent' artists.[65] In the aftermath of war and the atom bomb, many artists expressed a generalised scepticism about the use of technology and science and repudiated the mechanolatry that had permeated the machine aesthetic of the interwar period. After the Second World War, the USA witnessed a consolidation of industrial practices, against a backdrop of weakened union movements, giving rise to widespread doubt

about the increased use of dehumanising, technological processes. In his writing, Schapiro evoked the inclination in American culture that sought anti-rationalist alternatives to the alienation caused by an increasingly standardised, automatised, technocratised and scientific society. For many, this alienation was typified by the repetitive work practices associated with F.W. Taylor's 'time and motion' studies, and most notoriously implemented in the assembly-line procedures of the motor industry.

The radicalism of Schapiro's defence of Abstract Expressionism lies in his perception of the contradictions and ambiguities of the processes at work in paintings such as Pollock's *One: Number 31, 1950* (Plate 3.4). There is a contradiction between Pollock's use of industrial paints, thrown or dripped rhythmically across unstretched, unprimed canvas, and the normal expectations one has for the 'pre-ordered' precision and control of industrial procedures. Schapiro's point is that the accidental and the random in painting could be used to register the human element in opposition to technological control. Moreover, for Schapiro, the freely made mark, drip and handprint on the surface of the canvas were signs of the artist's active presence that could be interpreted as a repudiation of capitalist wage labour. In a comparable acceptance of the human element in the production of artworks, Rothko referred to himself and other Abstract Expressionist artists as 'craftsmen'.[66] The alienation caused by what were seen as assaults on the uniqueness of the individual through automation could be countered by spontaneity and attempts to access a pre-rational mind. An important precursor for this in the interwar avant-garde was the range of 'automatist' practices evolved by the Surrealists. Furthermore, the notion of 'spontaneity' itself had a strong presence in the lexicon of anarchism. Following Schapiro's line of thought, the Surrealist attraction to automatism can be seen to play a significant part in Abstract Expressionist practices. Moreover, automatism or 'controlled experiment' was also a legacy of the WPA and Mexican mural painting. What we are left with is a kind of radical history or pedigree for the forms of improvisation that Abstract Expressionism placed at centre stage. In this way, despite the fact that Abstract Expressionist paintings do not *depict* anything of the world of machinery and mass production, it is possible to read the improvised practices out of which they are made as affirming by implication a non-regulated form of labour in a world of increasing regimentation. For Schapiro, as the title of his 1957 essay 'The Liberating Quality of Avant-Garde Art' implies, the practice in itself is a statement of liberation.

In this connection, I want to return to a point left hanging earlier: the significance of the nineteenth-century romantic Albert Pinkham Ryder for the generation of postwar artists. Many artists turned to Ryder, whose work provided one of the few American historical precedents for modernist aesthetics, to counter the positivism and literalism discussed above. In 1963, Frederick Fairchild Sherman observed of Ryder's marinescape (such as that shown in Plate 3.12):

> They have practically no actual semblance of truth … being deliberate inventions incorporating in designs of studied simplicity ideas of movement and space … Obviously unreal in themselves, they embody the very reality of the tragedy of the sea, and by appealing to the imagination rather than to the intellect release

subconscious presentiments of indescribable verisimilitude that are no more truthful mental images of remembered scenes than the paintings themselves are faithful transcripts of nature.[67]

Pollock maintained that Ryder was the only American artist who interested him. Ryder advocated a rejection of detail in painting in favour of a more essential quest: the concentrated simplified shape. He stated that 'The artist should fear to become the slave of detail. He should strive to express his thought and not the surface of it. What avails a storm cloud accurate in form and color if the storm is not therein?'[68]

The concentration on the 'essence' of a scene rather than on a detailed examination of empirical evidence resonated with painters who aspired to a truth beyond appearances. Ryder's own description of his working practices makes striking reading when compared with what we know of those of the Abstract Expressionists: 'I threw my brushes aside; they were too small for the work in hand. I squeezed out big chunks of pure, moist color and taking my palette knife, I laid on blue, green, white and brown in great sweeping strokes.'[69] Moreover, in addition to this apparent precedent for the 'gestural' Abstract Expressionists, some art historians have noted parallels between Ryder's concentration on the 'in betweenness' of 'geometry and formlessness', his quest for simplified forms and the work of Rothko.[70] Like some of the generation of Abstract Expressionists, Ryder's work echoed with Gothic references and a mysticism borne out of an engagement with eastern philosophies as well as the *Sturm und Drang*[71] and irrational subjectivity of European Romanticism.

Conclusion

In this chapter, I have discussed developments and changes in American art from the 1930s to the 1950s. Many art-historical accounts have tended to emphasise the differences between the pre- and postwar periods. Indeed, the priorities of the two periods were distinctive, as is neatly summed up by the art historian Francis Pohl's description of the later career of Shahn as 'a New Deal artist in a Cold War climate'.[72] For all that, there were some significant continuities underlying the apparently very different styles of social realism and Abstract Expressionism. Histories are inevitably shaped by the teller, and changing priorities certainly affect historical narratives. Interpretations have to be measured against both relatively objective historical evidence and relatively subjective judgements of value. The editors of a short-lived 1950s periodical, *Reality: A Journal of Artists' Opinions*, objected to the 'fast spreading doctrine that non-objectivism [a contemporary term for Abstract Expressionism] has achieved some sort of aesthetic finality that precludes all other forms of artistic expression'.[73] Abstract Expressionism did become the new academy and the dominant style that gained international status: the benchmark for the next generation of artists and critics. However, in the bleak reality of postwar reconstruction, artists of differing aesthetic persuasions continued to make works in a plurality of art forms with which to distance themselves from the conformism and censorship of American culture in general and its embrace of technology and scientism in particular.

Notes

I would like to thank Paul Wood for his substantial contribution to this chapter.

1 Rosenberg, from 'The American Action Painters' (1952), in Harrison and Wood, *Art in Theory 1900–2000*, VA16, pp.589–92.

2 The term 'all-over' refers to compositions in which each part of the surface is accorded a comparable intensity, with no specific area of focus.

3 Memorial Day is a national holiday in the USA, held on the last Monday in May to remember those who have died in the nation's service.

4 Quoted in O'Connor, *Art for the Millions*.

5 Soby, *Ben Shahn*, p.5.

6 Shahn, 'Paul Klee'.

7 (Rahv), Editorial Statement (1934), p.1.

8 The Popular Front represented a rejection of the previous period of communist policy. This had advocated a militantly 'proletarian' opposition to Fascism, whereas the Popular Front involved a series of cross-class alliances with intellectuals, social democrats, liberals and even anti-Fascist conservatives.

9 Kramer, 'Ben Shahn Can't Escape his Place in History', p.31.

10 *Ibid.*

11 Quoted in Soby, *Ben Shahn*, p.3.

12 *Ibid.*, pp.3–4.

13 Shahn, *The Shape of Content*, p.56.

14 McKinzie, *The New Deal for Artists*, p.xi.

15 Miller, *American Realists and Magic Realists*, p.3.

16 'Okie' is contemporary slang for the refugees who fled the dust bowls of Oklahoma and other agricultural states for the promise of a new life in California.

17 Siqueiros *et al.*, 'A Declaration of Social, Political and Aesthetic Principles' (1922), in Harrison and Wood, *Art in Theory 1900–2000*, IVB4, pp.406–7.

18 Rivera, 'The Revolutionary Spirit in Modern Art' (1932), in *ibid.*, IVB13, pp.424, 421.

19 Gorky was quick to point to the social aspects of his form of abstraction, commenting during the 1930s, 'mural painting does not only serve in a decorative capacity but an educational one as well. By education, I do not mean in a descriptive sense, portraying cinema-like the suffering or progress of humanity, but rather the plastic forms, attitudes and methods that have become the heritage of the art of painting' (Gorky, 'My Murals for the Newark Airport: An Interpretation' (unpublished manuscript, 1936), printed in O'Connor, *Art for the Millions*, p.73).

20 *Ibid.*

21 Benton, *An Artist in America* (1937), quoted in Schapiro, 'Populist Realism', p.55.

22 Schapiro, 'Populist Realism', p.54.

23 Schapiro, 'The Social Bases of Art' (1936), in Harrison and Wood, *Art in Theory 1900–2000*, IVD4, p.515.

24 Schapiro, 'Populist Realism', p.55.

25 Quoted in Davis, 'Rejoinder to Thomas Benton', p.12.

26 Schapiro, 'Populist Realism', p.55.

27 *Ibid.*, p.54.

28 Davis and Weinstock, 'Abstract Painting in America', 'Contradictions in Abstractions' and 'A Medium of 2 Dimensions' (1935), in Harrison and Wood, *Art in Theory 1900–2000*, IVB17, p.434.

29 Davis, 'Rejoinder to Thomas Benton', p.12.

30 *Ibid.*

31 Benton, 'American Regionalism', p.76.

32 Davis and Weinstock, 'Abstract Painting in America', 'Contradictions in Abstractions' and 'A Medium of 2 Dimensions' (1935), in Harrison and Wood, *Art in Theory 1900–2000*, IVB17, p.434.

33 Schapiro, 'Populist Realism', p.57.

34 Breton, Rivera and Trotsky, 'Towards a Free Revolutionary Art' (1938), in Harrison and Wood, *Art in Theory 1900–2000*, IVD9, pp.532–5; quotes pp.533, 534.

35 Serge, *S'il est minuit dans le siècle* ('Midnight of the Century').

36 Rahv, 'Twilight of the Thirties', p.5.

37 (Rahv), Editorial Statement (1937), p.3.

38 Trotsky, open letter to André Breton, dated 22 December 1938.

39 Greenberg, 'Avant-Garde and Kitsch' (1939), in Harrison and Wood, *Art in Theory 1900–2000*, IVD11, p.541.

10 *Ibid.*

41 Clement Greenberg, interview with T.J. Clark, in 'Greenberg on Pollock', video for the Open University course A315, *Modern Art and Modernism*, 1983.

42 Greenberg, 'Modernist Painting' (1960–5), in Harrison and Wood, *Art in Theory 1900–2000*, VIB5, pp.774, 775.

43 Sandler, *The Triumph of American Painting*.

44 Greenberg, 'Towards a Newer Laocoon' (1940), in Harrison and Wood, *Art in Theory 1900–2000*, VA1, p.564.

45 Pollock, Interview with William Wright (1950), in Harrison and Wood, *Art in Theory 1900–2000*, VA13, p.583.

46 Newman, 'The New Sense of Fate', unpublished typescript quoted in Hess, *Barnett Newman*, p.27.

47 Gottlieb, Statement (1947), in Harrison and Wood, *Art in Theory 1900–2000*, VA7, p.573.

48 Gottlieb, Rothko and Newman, Statement (1943), in *ibid.*, VA2, p.568.

49 *Ibid.*, p.569.

50 Leja, *Reframing Abstract Expressionism*.

51 Rodman, *Conversations with Artists*, p.93.

52 Rose, *American Art since 1900*, p.12.

53 Dondero, from *The Congressional Record* (1949), in Harrison and Wood, *Art in Theory 1900–2000*, VC15, pp.667, 668.

54 Schlesinger, *The Vital Center*.

55 Schlesinger, from *The Politics of Freedom* (1950), in Harrison and Wood, *Art in Theory 1900–2000*, VC16, p.669.

56 Pollock, Interview with William Wright (1950), in *ibid.*, VA13, p.583.

57 Pollock, Two Statements (1947 and 1947/8), in *ibid.*, VA4, p.571.

58 Motherwell and Rosenberg, 'The Question of What Will Emerge Is Left Open' (1947–8), in *ibid.*, VC10, p.659.

59 *Ibid.*

60 Rosenberg, from 'The American Action Painters' (1952), in Harrison and Wood, *Art in Theory 1900–2000*, VA16, p.589.

61 *Ibid.*, pp.590–1.

62 *Ibid.*, p.591.

63 Rosenberg, *The Anxious Object.*

64 Motherwell, Statement in the journal *The New Decade* (1955), reprinted in Johnson, *American Artists on Art*, p.29.

65 Schapiro, 'The Liberating Quality of Avant-Garde Art' (1957), reprinted as 'Recent Abstract Painting', in *Modern Art*, pp.213–16.

66 Quoted in Robert Goodnough (ed.), 'Artists' Session at Studio 35' (1950), in Motherwell and Reinhardt, *Modern Artists in America*, p.16.

67 Quoted in Lipman, *What is American in American Art*, pp.81–2.

68 Ryder, 'Paragraphs from the Studio of a Recluse' (1905), in Harrison and Wood, *Art in Theory 1900–2000*, IB2, p.62.

69 *Ibid.*, p.63.

70 Novack, *American Painting of the Nineteenth Century*, p.219.

71 Literally, 'storm and stress'. *Sturm und Drang* was an anti-rationalist precursor of German Romanticism in the 1770s. The young Johann Wolfgang Goethe and Johann Gottfried Herder opposed classicism in the name of spontaneity and genius.

72 A reference to Pohl's history of Shahn's transition from the 1930s to the 1950s, *Ben Shahn: New Deal Artist in a Cold War Climate (1947–1954).*

73 Bishop *et al.*, *Reality*, p.2. Among the forty-six signatories to a letter sent to the Museum of Modern Art, New York through *Reality* were many artists who had high-profile careers during the 1930s, including Milton Avery, Philip Evergood, William Gropper, Edward Hopper, Jacob Lawrence and Reginald Marsh.

References

Benton, T.H., 'American Regionalism: A Personal History of the Movement', *University of Kansas City Review*, vol.18, fall 1951, pp.75–6.

Benton, T.H., *An Artist in America*, New York: University of Kansas City Press-Twayne, 1951 (first published 1937).

Bishop, I., Dobkin, A., Levine, J., Varnum Poor, H., Solman, J., Soyer, R. and Wilson, S. (eds), *Reality: A Journal of Artists' Opinions*, vol.1, no.1, spring 1953.

Caldwell, E., *You Have Seen their Faces*, New York: Modern Age Books, 1937.

Davis, S., 'Rejoinder to Thomas Benton', *Art Digest*, 1 April 1935, pp.12–13, 26–7.

Edwards, S. and Wood, P. (eds), *Art of the Avant-Gardes*, New Haven and London: Yale University Press in association with The Open University, 2004.

Fry, R., *Vision and Design*, Oxford: Oxford University Press, 1981 (first published 1920).

Harrison, C. and Wood, P. (eds), *Art in Theory 1900–2000: An Anthology of Changing Ideas*, Malden, MA and Oxford: Blackwell, 2003.

Hess, T.B., *Barnett Newman*, exhibition catalogue, Tate Gallery, London, 1972.

Johnson, E. (ed.), *American Artists on Art: 1940–1980*, New York: Harper & Row, 1982.

Kramer, H., 'Ben Shahn Can't Escape his Place in History', *New York Observer*, 23 November 1998, p.31.

Leja, M., *Reframing Abstract Expressionism: Subjectivity and Painting in the 1940s*, New Haven and London: Yale University Press, 1993.

Lipman, J. (ed.), *What is American in American Art*, New York: McGraw-Hill, 1963.

McKinzie, R.D., *The New Deal for Artists*, Princeton, NJ: Princeton University Press, 1973.

Miller, D., *American Realists and Magic Realists*, exhibition catalogue, Museum of Modern Art, New York, 1943.

Motherwell, R. and Reinhardt, A. (eds), *Modern Artists in America*, New York: Wittenborn Schultz, 1951.

Novack, B., *American Painting of the Nineteenth Century: Realism, Idealism, and the American Experience*, New York: Harper & Row, 1979.

O'Connor, F., *Art for the Millions: Essays from the 1930s by Artists and Administrators of the WPA Federal Art Project*, Boston: New York Graphic Society, 1973.

Pohl, F.K., *Ben Shahn: New Deal Artist in a Cold War Climate (1947–1954)*, Austin: University of Texas Press, 1989.

(Rahv, P.), Editorial Statement, *Partisan Review*, vol.1, no.1, February–March 1934, p.1.

(Rahv, P.), Editorial Statement, *Partisan Review*, vol.4, no.1, December 1937, pp.3.

Rahv, P., 'Twilight of the Thirties', *Partisan Review*, vol.6, no.4, summer 1939, pp.3–15.

Rodman, S., *Conversations with Artists*, New York: The Devin-Adair Co., 1957.

Rose, B., *American Art since 1900: A Critical History*, New York: Praeger, 1975.

Rosenberg, H., *The Anxious Object: Today and Its Audience*, New York: Horizon Press, 1964.

Sandler, I., *The Triumph of American Painting*, New York: Praeger, 1970.

Schapiro, M., *Modern Art: Selected Papers*, New York: George Braziller, 1978.

Schapiro, M., 'Populist Realism', *Partisan Review*, vol.4, no.2, January 1938, pp.53–7.

Schlesinger, A.M., Jr, *The Vital Center: The Politics of Freedom*, London: Deutsch, 1970 (first published 1949).

Serge, V., *S'il est minuit dans le siècle*, Paris: B. Grasset, 1939.

Shahn, B., 'Paul Klee', in J.D. Morse (ed.), *Ben Shahn: Documentary Monographs in Modern Art*, New York: Praeger, 1972, pp.167–70.

Shahn, B., *The Shape of Content*, The Charles Eliot Norton Lectures 1956–7, Cambridge, MA: Harvard University Press, 1957.

Soby, J.T., *Ben Shahn*, The Penguin Modern Painters, Harmondsworth: Penguin, 1947.

Steinbeck, J.E., *Their Blood is Strong*, San Francisco: Simon J. Lubin Society of California, 1938.

Trotsky, L., open letter to André Breton, *Partisan Review*, vol.6, no.2, winter 1938, pp.126–7.

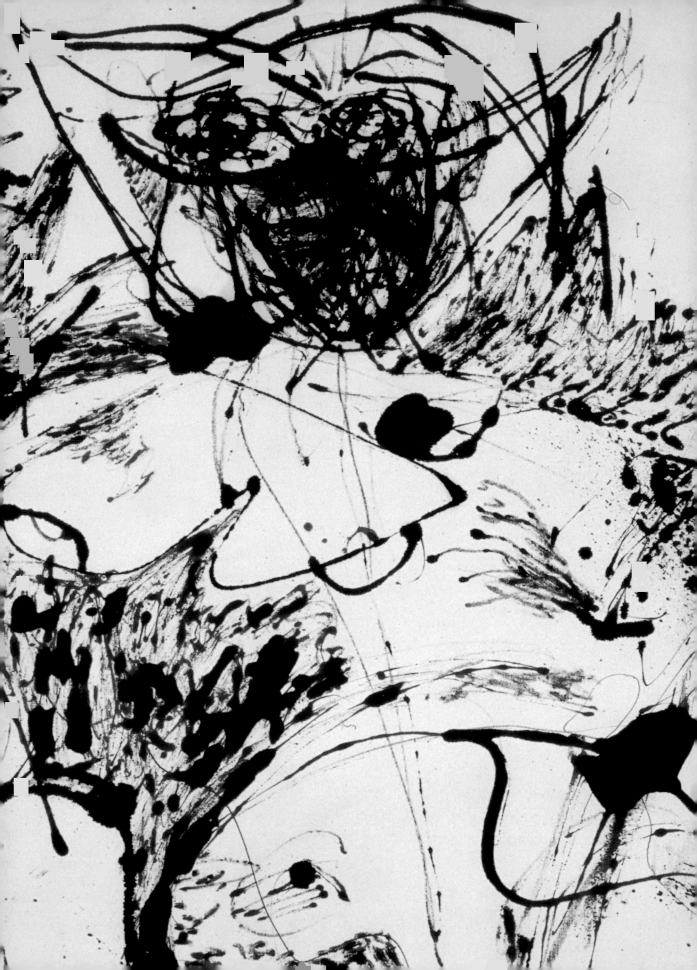

CHAPTER 4

Jackson Pollock

Charles Harrison

Introduction

The aim of this chapter is to consider the significance of the work of Jackson Pollock, both in the context of American art from the late 1930s to the early 1950s, and as a focus for some subsequent concerns of art and criticism. Particular attention is paid to his all-over abstract paintings of 1947–50, and to their relevance for arguments about the decline of easel painting. The chapter concludes, however, with discussion of Pollock's return to pictorial imagery in some remarkable works of the early 1950s.

Pollock and the New York School

Born in 1912, Pollock was significantly younger than the other major artists in the loose grouping known variously as the New York School, the American First Generation and the Abstract Expressionists. Mark Rothko, Barnett Newman, Clyfford Still and Willem de Kooning were all born between 1903 and 1905. Pollock was nevertheless one of the first of these five to make a name for himself in New York. His first solo show in 1943 attracted the attention of the critic Clement Greenberg and led to the purchase of a painting, *The She-Wolf*, by the Museum of Modern Art in New York (Plate 4.2). But it was with a later series of all-over abstract paintings, made from 1947 to 1950, that he established himself as a considerable figure in the international development of modernist art (for example, Plate 4.3).

This same period was also a moment of significant development for other artists of the New York School. In the late 1940s, both Rothko and Newman established their own very different mature styles (for example, Rothko's *Magenta, Black, Green on Orange* of 1949, Plate 4.4), while de Kooning painted a number of remarkable near-abstract canvases loosely based on a repertoire of figures in interiors and outdoors (Plate 4.5). Still had formed his own distinctive abstract style in comparative isolation during the mid-1940s, but he became associated with the New York School after his first solo show at Peggy Guggenheim's gallery, Art of this Century, in 1946 (see Plate 5.17). Among the other notable artists of the same generation working in the USA were the sculptor David Smith (Plate 4.6) and the Armenian painter Arshile Gorky, who killed himself in 1948, a year after achieving a noticeably individual style (Plate 4.7).

PLATE **4.1** (facing page) Jackson Pollock, detail of *Portrait and a Dream* (Plate 4.21).

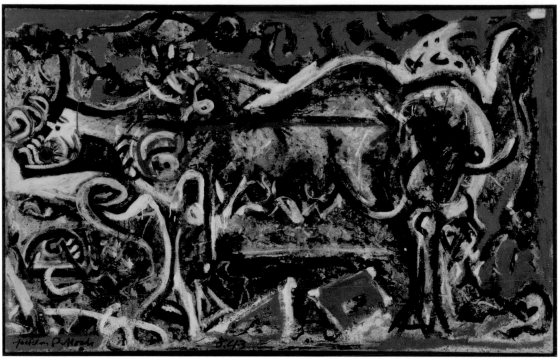

PLATE **4.2** Jackson Pollock, *The She-Wolf*, 1943, oil, gouache and plaster on canvas, 106 × 170 cm.
(Museum of Modern Art, New York. Purchase. DIGITAL IMAGE © 2002 The Museum of Modern
Art, New York/Scala, Florence. © ARS, New York and DACS, London 2004.)

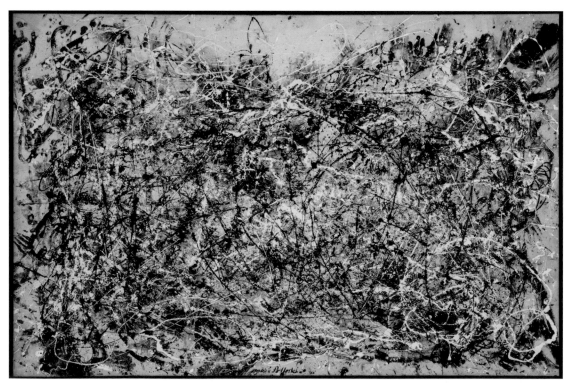

PLATE **4.3** Jackson Pollock, *Number 1A, 1948*, 1948, oil and enamel on unprimed canvas, 173 × 264 cm.
(Museum of Modern Art, New York. Purchase. DIGITAL IMAGE © 2002 The Museum of Modern
Art, New York/Scala, Florence. © ARS, New York and DACS, London 2004.)

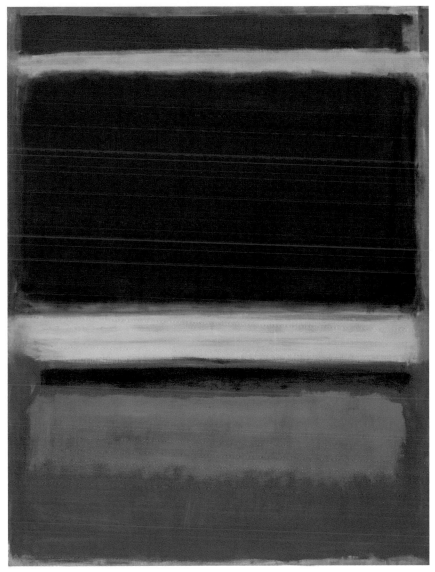

PLATE **4.4** Mark Rothko, *Magenta, Black, Green on Orange*, 1949, oil on canvas, 217 x 165 cm. (Museum of Modern Art, New York. Bequest of Mrs Mark Rothko through The Mark Rothko Foundation, Inc. DIGITAL IMAGE © 2003 The Museum of Modern Art, New York/Scala, Florence. Kate Rothko Prizel and Christopher Rothko/DACS, London 2004.)

During the Second World War, New York had attracted a number of émigrés from the European avant-gardes of the 1920s and 1930s. But while their presence had certainly contributed to the development of American interest in the modern tradition, the predominant avant-garde of the 1940s was composed of artists who were citizens of the USA, even if several of them had been born elsewhere. As early as 1948, the shift of initiative was noted by Greenberg in an article published in the journal *Partisan Review*. Never sympathetic to Surrealism, he confirmed what he saw as 'the decline of art that set in in Paris in the early thirties'[1] – a decline he associated with the isolation of Cubism in a Europe grown resistant to new insights:

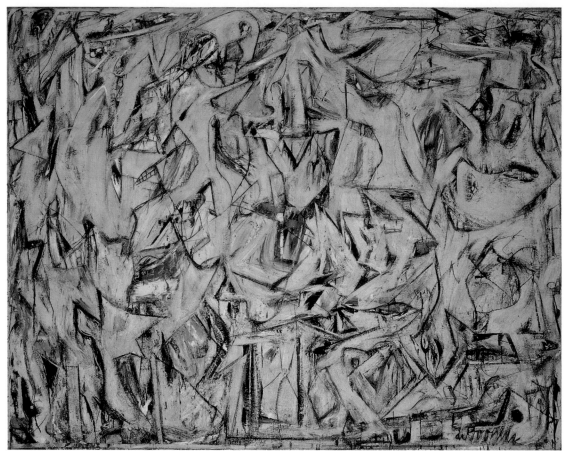

PLATE **4.5** Willem de Kooning, *Excavation*, 1950, oil and enamel on canvas, 204 × 254 cm. (Art Institute of Chicago, Mr and Mrs Frank G. Logan Purchase Prize. Gift of Mr Edgar Kaufmann, Jr, and Mr and Mrs Noah Goldowsky. © Willem de Kooning Revocable Trust/ARS, New York and DACS, London 2004.)

If artists as great as Picasso, Braque, and Léger have declined so grievously, it can only be because the general social premises that used to guarantee their functioning have disappeared in Europe. And when one sees, on the other hand, how much the level of American Art has risen in the last five years, with the emergence of new talents so full of energy and content as Arshile Gorky, Jackson Pollock, David Smith … then the conclusion forces itself, much to our own surprise, that the main premises of Western art have at last migrated to the United States, along with the center of gravity of industrial production and political power.[2]

In a review published in the journal *The Nation* in the following year, Greenberg referred to Pollock as 'one of the major painters of our time'.[3] Three years after that, again in *Partisan Review*, he was admonishing 'the museum directors, the collectors, and the newspaper critics' of the USA to accept that 'we have at last produced the best painter of a whole generation'.[4]

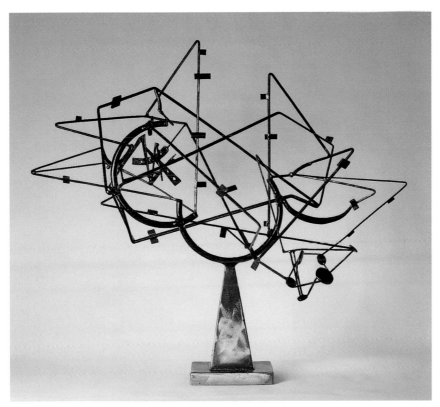

PLATE **4.6** David Smith, *Star Cage*, 1950, various metals, welded and painted, 114 × 130 × 66 cm. (Collection Frederick R. Weisman Art Museum at the University of Minnesota, Minneapolis. John Rood Sculpture Collection Fund. © Estate of David Smith/VAGA, New York/DACS, London 2004.)

Though Pollock did not live to profit greatly by the widespread acclaim given to the New York School, his work was central not only to the international establishment of an American avant-garde, but to modernist painting in general in the middle of the twentieth century. That statement can be justified whether we conceive of modernist painting as a developing mainstream of practice emanating from the nineteenth century, as the theoretical construct of a particular critical tendency, as a specifically American component in the competitive international culture of the postwar years, or as an amalgam of all of these.

Crucial to the establishment of Pollock's reputation was the one-man show of his abstract work held at the Betty Parsons Gallery in New York late in 1950. All the thirty-two paintings in the exhibition had been completed during this, the artist's thirty-ninth year. Several of them were very large. The two largest, *Autumn Rhythm: Number 30, 1950* (Plate 4.8) and *One: Number 31, 1950* (see Plate 3.4), were both over two and a half metres high and over five metres wide. *Number 32* was as high and almost as wide, while *Lavender Mist: Number 1, 1950* (see Plate 3.23) was over two metres by three metres.

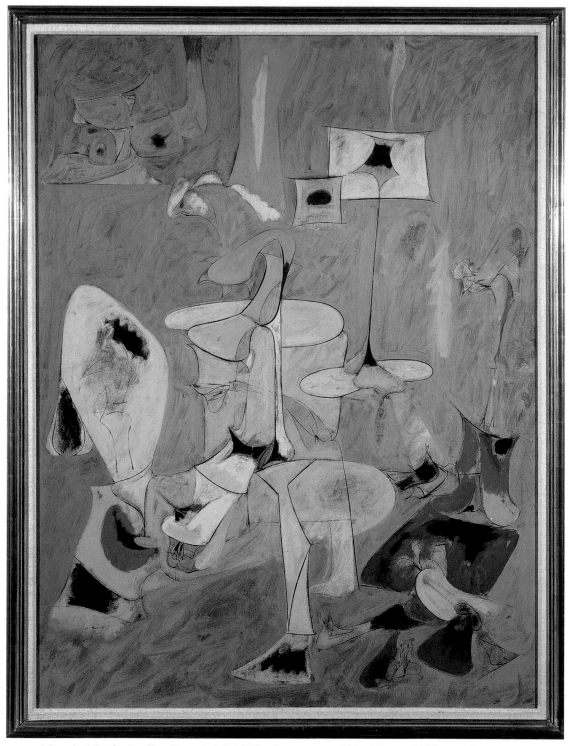

PLATE **4.7** Arshile Gorky, *The Betrothal II*, 1947, oil on canvas, 129 x 97 cm. (Whitney Museum of American Art, New York. Purchase 50.3. Photo: Geoffrey Clements. © ADAGP, Paris and DACS, London 2004.)

Number 7, 1950 was a frieze-like painting 59 cm high by 278 cm long (Plate 4.9). Each of these works was markedly non-figurative and was painted in an apparently all-over style that resulted from a combination of cursive traceries of fluid paint, rhythmically applied, with a varied texture of more staccato spots and spatters. Though Pollock had worked with recognisable pictorial imagery before 1947, and was to do so again after 1950, the exhibition has been widely seen as the culminating event of an intense and continuous phase in his work. In the autumn of 1945, he and the painter Lee Krasner had married and moved out of New York to a farmhouse in East Hampton on Long Island, where Pollock converted a barn into a studio. The first paintings in his all-over drip-and-spatter style were painted there before the end of 1947. Though he was plagued by alcoholism almost continuously from his teenage years until his death in 1956, between the autumn of 1948 and the end of November 1950 he abstained altogether from alcohol.

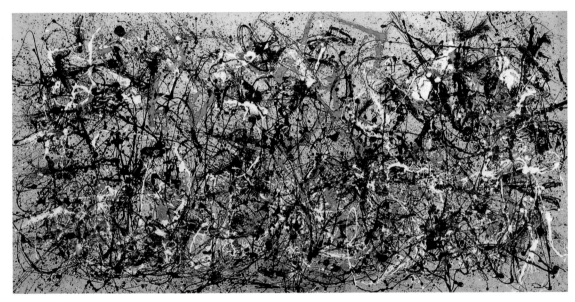

PLATE **4.8** Jackson Pollock, *Autumn Rhythm: Number 30, 1950*, 1950, oil on canvas, 267 × 526 cm. (Metropolitan Museum of Art, New York, George A. Hearn Fund, 1957 (57.92). Photo: © 1988 The Metropolitan Museum of Art. © ARS, New York and DACS, London 2004.)

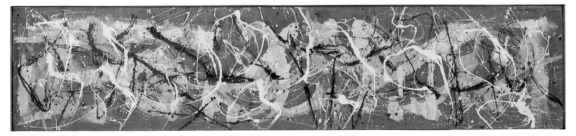

PLATE **4.9** Jackson Pollock, *Number 7, 1950*, 1950, oil, enamel and aluminium paint on canvas, 59 × 278 cm. (Museum of Modern Art, New York. Gift of Mrs Sylvia Slifka in honour of William Rubin. DIGITAL IMAGE © 2003 The Museum of Modern Art, New York/Scala, Florence. © ARS, New York and DACS, London 2004.)

Abstraction and literalism

However varied the conclusions of criticism and interpretation, there are two aspects of Pollock's paintings of 1947–50 that writers on his work have generally needed to take into account. The first is their compositional and optical character: the distinctive nature of their appearance. On the one hand, they present a continuous screen-like surface parallel to the wall and to the orientation of the standing spectator; on the other, they appear as surfaces we do not simply look *at*, but also look *into*, albeit the depth in question is relatively shallow. Greenberg wrote in 1955 of the need the painters of the New York School had felt to 'loosen up' the shallow box-like space of Pablo Picasso's synthetic Cubism (for example, Plate 4.10):

> With this went that canon of drawing in faired, more or less simple lines and curves that Cubism imposed and which had dominated almost all abstract art since 1920. They had to free themselves from this too.[5]

The kind of shallow space that Greenberg had in mind can be observed in Pollock's *The She-Wolf* of 1943 (Plate 4.2). The busy activity of the painting's surface might be seen as driven by an impulse to 'loosen up' the rectilinear mode of composition that tended to accompany Cubist styles. In *The Key* of three years later, while the rhythmic character of Pollock's line has become more pronounced, and the colour more markedly independent of any descriptive function, the composition can still be seen as contained within a box-like area (Plate 4.11). In the works of 1947–50, however, the illusory depth is no longer in any real sense *pictorial*; that is to say, it is not such a space as might contain scenes or objects or figures. Rather, it is a direct product of the way the paint is put on: in distinct stages and layers, darker or lighter, one colour and texture laid over another, not so much worked together as meshed in places where paint runs wet into wet, with the last phase of application generally serving to establish a nearest optical level – a kind of picture plane – beyond which all else reads as relatively further back and further in. Within this shallow space a distinct sense of atmosphere – or emotional quality – is conveyed through the particular character and

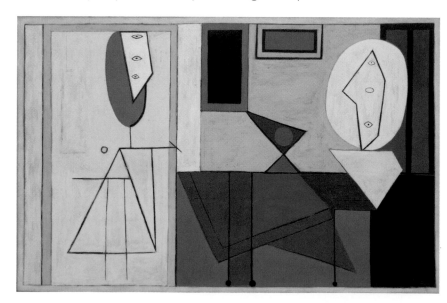

PLATE 4.10
Pablo Picasso,
The Studio, winter
1927–8 (dated
1928), oil on canvas,
150 × 231 cm.
(Museum of Modern
Art, New York. Gift of
Walter P. Chrysler, Jr.
DIGITAL IMAGE © 2002
The Museum of
Modern Art, New
York/Scala, Florence.
© Succession
Picasso/DACS,
London 2004.)

movement of line and stroke, through the relations and distribution of colours, and through effects of opacity and transparency.

The second notable aspect of Pollock's abstract works is the idiosyncratic manner in which they are made. All the paintings in question were executed on unstretched canvas laid out on the studio floor, with the artist working from above and from all four sides, pouring, dripping and spattering comparatively liquid paint, typically working in bursts of rapid and continuous activity, punctuated by periods of reflection. These latter periods might last for minutes or – if a canvas was pinned up to be thought about or temporarily set aside – for months. There is little in these paintings that could be called brushwork. In his work of 1947–50, Pollock tended to apply the paint by dripping it or flicking it from a stick or dried-out brush, rarely making direct contact with the canvas, and if he did, then it was usually by applying the paint directly from the tube or with a palette-knife, or occasionally by using his hands or fingers. By the late 1940s, dripping paint was not an entirely unprecedented way to make a painting, but Pollock's work is remarkable for the sheer explicitness of its facture. The technique is altogether readable and recoverable from the visible surface of the painting, upon which everything is just what it appears to be. Interest in this aspect of Pollock's painting was to receive considerable impetus from pictures published by the photographer Hans Namuth, whose several visits to East Hampton in 1950 resulted in a large number of still images and a 20-minute colour film, together providing a compelling representation of the artist at work (see Plate 5.5).

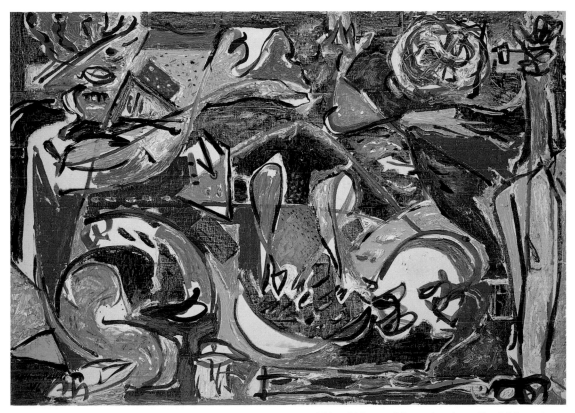

PLATE 4.11 Jackson Pollock, *The Key*, 1946, oil on canvas, 150 x 213 cm. (Through prior gift of Mr and Mrs Edward Morris, 1987.261, reproduction, The Art Institute of Chicago. © ARS, New York and DACS, London 2004.)

In the critical interpretation of Pollock's work, there has been a tendency for these two aspects to be held apart, or at least for responses to be predominantly governed by either one at the expense of the other. The explanation for this, I believe, is largely to be found in developments in American art and criticism during the 1960s. Twenty years after Pollock's exhibition at the Betty Parsons Gallery, Philip Leider wrote that 'Both abstraction and literalism look to Pollock for sanction; it as if his work was the last achievement of whose status every serious artist is convinced.'[6] At the time he was writing, Leider was editor of the influential journal *Artforum*, which had moved its editorial offices to New York from the West Coast three years previously. The passage quoted forms the opening to his review of another exhibition: a retrospective of the work of 34-year-old Frank Stella, held at the Museum of Modern Art in New York. The early critical acclaim given to Stella's work was in large part a consequence of the climate of interest – and the eager market – that had been established by the American First Generation. In Leider's account, the issue that Stella was bound to address was how to make 'abstract pictures that could survive as post-Pollock art'. By 'abstraction', Leider meant to refer not simply to an abstractionist tendency in art, but to a 'modernist' tendency in practice and theory for which Pollock's art, or rather a particular interpretation of Pollock's art and of its development up to 1950, had been central. Leider cited the criticism of Greenberg and its extension in the writing of Michael Fried. (It was Fried who had first introduced the term 'literalism', to refer to the range of anti-illusionistic three-dimensional objects produced by Donald Judd, Robert Morris and others during the mid-1960s.[7]) In the modernist tendency as thus attributed, it was the first of the two aspects I have outlined – the paintings' optical character – that was given priority when Pollock's work was considered:

> how his art broke painting's dependence on a tactile, sculptural space; how the all-over system transcended the Cubist grid; how it freed line from shape, carried abstract art further from the depiction of *things* than had any art before; how it created 'a new kind of space' in which objects are not depicted, shapes are not juxtaposed, physical events do not transpire. In short, the most exquisite triumph of the two-dimensional manner.[8]

'That view is now so thoroughly a part of the literature', Leider claimed, 'that students run it through by rote.'[9] And yet already by 1970, this view was subject to challenge by those artist-writers that Leider, following Fried, designated 'literalists' – Judd and Morris foremost among them. In their view of Pollock, it was the second of the two aspects noted above – the mode of fabrication – that was accorded priority. 'Pollock's paint is obviously on the canvas', Judd wrote in 1965, 'and the space is mainly that made by any marks on a surface, so that it is not very descriptive and illusionistic.'[10] Leider represented the literalist position in the following terms:

> *You could visualize the picture being made* – there were just no secrets. It was amazing how much energy was freed by this bluntness, this honesty, this complete obviousness of the process by which the picture was made. Another thing about Pollock was the plain familiarity with which he treated the picture as a *thing*. He left his handprints all over it; he put his cigarette butts out in it. It is as if he were saying that the kind of objects our works of art must be derive their strength from the directness of our attitudes toward them ...

> Literalism thus sees in Pollock the best abstract art ever made deriving its strength from the affirmation of the *objectness* of the painting and from the directness of the artist's relations to his materials.[11]

I do not mean to suggest that Leider offers an exhaustive account of the different ways in which Pollock's art might be regarded. As you will see, the artist's interest in Picasso and in Surrealist theories of automatism suggests another type of reading, in which greater emphasis is placed on emotional and psychological content. My point is that in 1970, it made sense to divide Pollock's work in this way because the art world was itself divided, as the authority of modernist protocols for the criticism of art broke down. This process had begun hard on the heels of the most articulate formulation of those very protocols in Greenberg's criticism, and had accelerated with the rapid and widespread development of kinds of art to which modernist criticism seemed unresponsive, or inadequate, or downright hostile. In 1967, *Artforum* had published a four-part essay on 'Jackson Pollock and the Modern Tradition' written by William Rubin, then curator of painting at the Museum of Modern Art in New York.[12] Yet at the very moment when Pollock's work was thus being firmly inscribed in a kind of modernist history of painting, a younger generation of artists was already claiming his licence for work that was predicated on the very redundancy of painting: for a new kind of anti-illusionistic sculpture, for 'happenings', for 'three-dimensional work', for 'environments'. In the first of a series of 'Notes on Sculpture', published in *Artforum* in February 1966, Robert Morris claimed that 'Clearer distinctions between sculpture's essentially tactile nature and the optical sensibilities involved in painting need to be made.'[13] In a further essay of 1969, Morris asserted that his own 'anti-form' floor pieces made of felt, cotton waste, mirrors and metals had 'ties to Pollock through emphasis in the work on gravity and a direct use of materials' (Plate 4.12).[14]

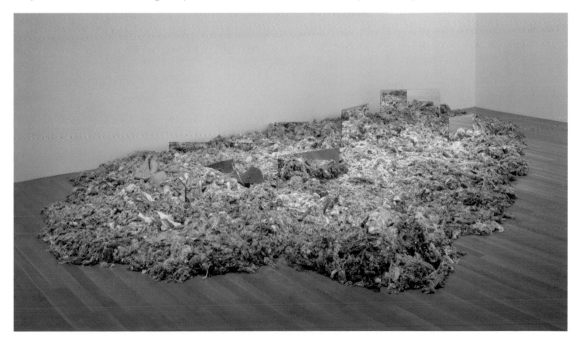

PLATE **4.12** Robert Morris, *Untitled* (*Floor Piece*), 1968, felt, asphalt, mirrors, wood, copper tubing, steel cable and lead, 55 × 668 × 511 cm, variable. (Museum of Modern Art, New York. Gift of Philip Johnson. DIGITAL IMAGE © 2002 The Museum of Modern Art, New York/Scala, Florence. © ARS, New York and DACS, London 2004.)

The implication of Leider's claim about Pollock's canonical status was that the conditions of art had changed in his wake, in such a manner that it was now harder for consensus to be established about the basis on which art might proceed, and thus about the outcomes most deserving of attention. What seemed to have been lost, in other words, was that sense of a mainstream of development that had been central to modernist criticism and art history. If there was agreement on the significance of Pollock's work, there was considerable division as to the grounds on which that significance was to be established – a division that was largely focused from both sides on interpretation of the abstract work of 1947–50. On the one hand, it was as though that work had served more clearly than any other to extend the tradition of modern painting. On the other hand, when combined with the uncompromising character of his abstraction, the palpably physical character of Pollock's process seemed to point towards some form of three-dimensional work, and thus to indicate the implausibility of painting maintaining a central role in the continuing development of art. And yet Pollock produced a significant body of paintings in the years 1951–3, and these were works in which pictorial motifs were decidedly, if often ambiguously, in evidence.

Autumn Rhythm

The debates and divisions of the late 1960s cast a long shadow over the subsequent criticism of art. They have also been much revisited in the light of more recent enquiries into the art-historical origins of the postmodern. Pollock's work has, in turn, been the subject of an intensifying interest, marked by the mounting of a major survey of his work that opened at the Museum of Modern Art in New York late in 1998 and travelled to the Tate Gallery in London in the spring of 1999. Now, some half a century after the end of his career as a painter, we can perhaps attempt to reconcile the divergent views of Pollock's work that served for so long to condition its interpretation and to mark out its place in contested histories of art.

I would like to return to an observation made earlier: that Pollock's paintings convey a distinct sense of atmosphere or emotional quality. If this is true, it seems we must allow some qualification of the assertion that everything on the surfaces of these paintings is just what it appears to be. While the majority of Pollock's paintings of 1947–50 may neither be nor contain pictures of other things, to say of any given painting that it conveys a distinct sense of atmosphere or emotional quality is to allow that it is endowed with some significant kind of content – a content that a description of its literal physical properties, however exhaustive, will still fail to catch. It is at this point, I think, that the two aspects of Pollock's work may be brought together. The paintings are made in the way they are *so as to have content* – and thus so as to be more than the mere 'wallpaper designs' to which they were sometimes disparagingly compared in the late 1940s and 1950s. It is true, however, that the content of the works of 1947–50 is not of a descriptive or allusive kind. It cannot be identified pictorially, by matching the appearance of the painting

against the appearance of some scene or object in the real world, or iconographically by noting the effective transformation of some conventional image or motif. So what is the nature of this content, how could it have been instilled and how is it to be recovered? It is to that cluster of questions that the remainder of this chapter is principally addressed.

I have referred elsewhere to the problems that earlier abstract artists had in justifying the claim that their abstract works deserved to be compared to the major pictorial paintings of the past. I have also discussed claims that Pollock's near-contemporary Barnett Newman made for the meaning of his painting.[15] Like Newman's work, Pollock's depends very heavily upon the direct encounter with the actual object, with its scale, its particular colour and texture, and its sheer physical presence. It is in this encounter – and only in this encounter – that the work is designed to disclose such content as it may have. As in the case of Newman's work, study of Pollock's painting in reproduction requires a considerable exercise of imagination so that the probable character of this encounter can be entertained in the mind. We should not pretend, however, that any such exercise of imagination can fully replace experience of the original work.

Look now at the illustration of _Autumn Rhythm_ (Plate 4.8). The painting filled an end wall at Pollock's exhibition in 1950 (Plate 4.13). Imagine yourself standing in front of the work, concentrating on its appearance in an open and critical spirit, and note down the particular aspects of the painting that you think might be especially remarkable in a face-to-face encounter.

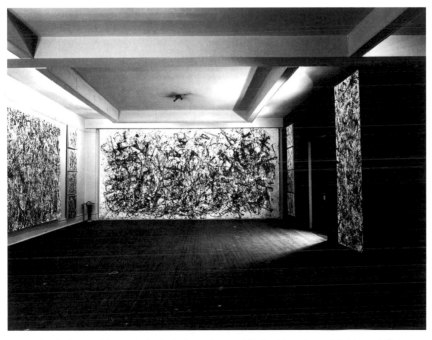

PLATE **4.13** Hans Namuth, installation view of Pollock's solo exhibition at Betty Parsons Gallery, New York, 1950, photograph. (© Estate of Hans Namuth, courtesy Pollock–Krasner House and Study Center, East Hampton, New York. © ARS, New York and DACS, London 2004.)

One point to register at the outset is that you would be immediately conscious of the physical distinctness of the painting. Its framing edge would mark off an actual change of surface and level relative to the wall. And within that perimeter, changes of tone and colour would involve changes in texture – say between bare canvas and glossy enamel paint – in ways that a reproduction can only hint at. Secondly, if you have reminded yourself of the dimensions of the work as given in the caption, it should be clear that its sheer size would be a major consideration. A natural question is: just what specific effects do the painting's size and scale produce? To put this question another way, does it *justify* its size? Factors to consider here include its height relative to your own and its breadth as a possible cause of movement from side to side, either of your head or of your entire body, depending on how close to the painted surface you saw yourself as standing. This last point might lead you to consider just where it would be appropriate to position yourself relative to the canvas on the wall. Should you be far enough back to take in the whole composition at a glance, or so close that you could examine the weave of the canvas? My own view is that the best place to start would be the point at which the painting filled your entire visual field, so that you could see all of its surface but little beyond its edge. (This is closer than you might think. You can try it out by measuring out a five-metre span of wall and seeing how far back you need to stand to see both ends without moving your head.) From here you would still be able to discern even the smallest paint mark on *Autumn Rhythm*, while the larger puddles and splatters of black enamel would register in all their density. Crucially, in face of the actual work it would be far easier to relate the graphic properties of the work – the dynamic aspects of painted stroke and line – to the series of varied human movements of which they must be the outcome. Even though you would be seeing the painting hung on the wall, it would be easier to sense the different kinds of physical movement involved in trickling a line out over a wide area (the thin S-shaped trail of black at the upper centre), in making a more contained and puddled series of almost-figurative marks (the group of white motifs at the bottom right-hand corner), and in casting down one single emphatic stroke after another (the brown marks along the top). What is *not* easily imagined, supposing that the reproduction leaves you cold, is whether you would in the end find the painting any more engaging: whether it would appear to you as more than a mere decorative – or messy – tangle of marks and lines; whether, in other words, it would appear so internally motivated and directed as to sustain a sense of intentional character or meaning. ∎

The problem with abstract art – and indeed with much illustrative or pictorial art as well – is that we do not always know what to look *for*. I mean this in much the same sense that one might speak of knowing or not knowing what to listen for in a piece of music in order to appreciate the different elements of its structure. It helps, in other words, to know what the components are that are being put in play, what principles and precedents lie behind their organisation, what techniques have been used in their animation, and what the factors are that might lead to success or failure in the end result. It is not easy to find meaning or content in a painting such as *Autumn Rhythm* unless we have some sense of what it is that it is *made out of*.

The easel picture and the mural

This is where we may be assisted by a wider acquaintance with Pollock's work. In the autumn of 1947, at about the time when he painted his first all-over drip-and-spatter paintings, he made an unsuccessful application for a Guggenheim fellowship. He stated his project as follows:

> I intend to paint large movable pictures which will function between the easel and mural. I have set a precedent in this genre in a large painting for Miss Peggy Guggenheim which was installed in her house and was later shown in the 'Large Scale Paintings' show at the Museum of Modern Art … [This exhibition took place in April–May 1947.]

> I believe the easel picture to be a dying form, and the tendency of modern feeling is towards the wall picture or mural. I believe the time is not yet ripe for a *full* transition from easel to mural. The pictures I contemplate painting would constitute a halfway state, and an attempt to point out the direction of the future, without arriving there completely.[16]

In the summer of 1943, Peggy Guggenheim had signed a contract with Pollock, paying him $150 per month as an advance against sales, and scheduling a one-man show for the autumn. The painting Pollock mentions was commissioned at the same time for the entrance hall of her New York house. It is known as *Mural* and is now in the collection of the University of Iowa Museum of Art (Plate 4.14). It measures almost two and a half metres by six metres. Guggenheim's original intention was that the work should be painted directly on the wall, but she was persuaded by Marcel Duchamp – who was a supporter of Pollock – that this would mean she would lose the painting if she were to move house,[17] as she was indeed to do in 1947. Accordingly, Pollock worked on a large canvas mounted upright. *Mural* was clearly an important work for him, both on account of its considerable size and, perhaps, because it led him to believe that the limits of the easel painting might be overcome through a move towards abstraction.

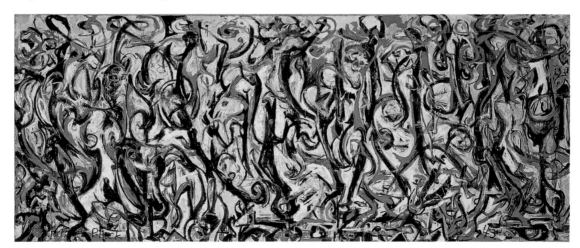

PLATE **4.14** Jackson Pollock, *Mural*, 1943, oil on canvas, 243 x 603 cm. (© 1986 The University of Iowa Museum of Art. Gift of Peggy Guggenheim, 1959.6. Photo: Ecco Hart. © ARS, New York and DACS, London 2004.)

Just what did Pollock understand an 'easel picture' to be, and why should he have thought it 'a dying form'? Considered literally, an easel picture or easel painting is one painted on a stretched canvas on some form of upright support, with the expectation that it will subsequently be framed and hung on a wall. But the concept of the easel painting had become inseparable from the modes of consumption and of social life that such things tended to evoke. The easel painting was first and foremost a transportable kind of *picture*, something to be looked *into*, its self-contained content in principle insulated by its frame against whatever distractions might issue from the varying contexts of its installation.

> Traditionally, the Western easel painting subordinates decorative to dramatic effect, cutting the illusion of a boxlike cavity into the wall behind it and organizing within this cavity the illusion of forms, light, and space, all more or less according to the current rules of verisimilitude.[18]

That was written by Greenberg in an essay on 'The Crisis of the Easel Picture' published in April 1948, at a time when he was close to Pollock, and when his writing was strongly affected by his response to the painter's work. Greenberg suggested that easel painting as thus characterised was being undermined by the recent tendency of painters to

> render every element, every part of the canvas equivalent ... [and to] weave the work of art into a tight mesh whose principle of formal unity is contained and recapitulated in each thread, so that we find the essence of the whole work in every one of its parts ...

> This very uniformity, this dissolution of the picture into sheer texture, sheer sensation, into the accumulation of similar units of sensation, seems to answer something deep-seated in contemporary sensibility. It corresponds perhaps to the feeling that all hierarchical distinctions have been exhausted, that no area or order of experience is either intrinsically or relatively superior to any other ...

> the future of the easel picture as the vehicle of ambitious art has become very problematical; for in using the easel picture as they do – and cannot help doing – these artists are destroying it.[19]

As Greenberg's essay made clear, to consider easel painting a dying form was not simply to observe changes in a specific artistic medium; it was also to imagine a different mode of *use* for art – a different kind of relationship between the painted object and the rest of the world. I suggest that there were two related conditions – a relatively consistent political disposition on the one hand and a changing set of artistic precedents on the other – that had led Pollock to the views he stated in 1947 regarding the practice he was engaged in. To explain them and to show how they were connected it is necessary briefly to review the previous stages of his development as an artist.

Pollock spent most of his childhood in California. In 1930, he travelled to New York, where he enrolled at the Art Students League under Thomas Hart Benton, then established as a painter of distinctively American themes, who was to be his principal mentor for the next five or six years (see Plate 3.17). Attendance at communist meetings in California had introduced Pollock to the work of the revolutionary Mexican muralists Diego Rivera and José Clemente Orozco. In the spring of 1930, he had gone with his brother to see a large fresco by Orozco

commissioned for Pomona College in Claremont, California (Plate 4.15), and later in the same year both Benton and Orozco were working on murals in the New School for Social Research in New York. Benton gave classes in mural painting, and Pollock enrolled for these in the early 1930s. In 1936, he took part in a workshop conducted by another of the Mexicans, David Alfaro Siqueiros, to whom he had been introduced in 1932 on a trip back to California. Among the Mexican muralists, Siqueiros was at the time perhaps the most forceful exponent of a position consistent with the Stalinist policy of Socialist Realism (Plate 4.16). In a paper of 1934, he declared, 'We will be preparing ourselves for the society of the future, in which our type of art will be preferred to all others, because it is the effective daily expression of art for the masses.'[20] Under Siqueiros's direction, Pollock experimented with various non-traditional techniques and assisted in the production of displays for parades and demonstrations.

The evidence is that Pollock's ambition up to this point was directed at the possibility of a public mural art – one that could engage explicitly with social issues and that would serve as a motivating force for progressive political change. His surviving work from the 1930s shows roughly painted, romantic landscape themes giving way to emphatically rhythmic compositions containing one or more abstracted figures (Plate 4.17). Yet while his style is clearly indebted to the work of Orozco and Siqueiros, the figures that stand at the centre of his subject matter tend to be more thoroughly fragmented – or more evidently composed of painted marks and patches – than would have suited the ends of their basically narrative and didactic art. It seems that Pollock's aspirations involved contradiction of a kind from an early stage. The prevailing expectations of public mural art were that its modes of representation should be relatively transparent and graspable. Yet the tendency of Pollock's technique was towards opacity – his pictorial imagery becoming inexorably transformed and veiled by an individualistic absorption in the *processes* of painting.

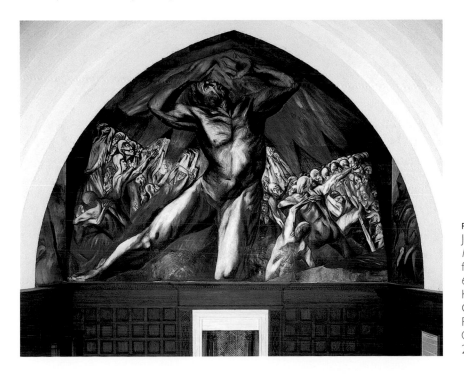

PLATE 4.15
José Clemente Orozco, *Prometheus*, 1930, fresco (central panel), 610 × 869 cm. (Frary Hall, Pomona College, Claremont, California. Photo: Jeffrey Nintzel. © DACS, London 2004.)

Plate 4.16
David Alfaro Siqueiros, *Proletarian
Victim*, 1933, enamel on burlap,
206 x 121 cm. (Museum of Modern
Art, New York. Gift of the estate of
George Gershwin. DIGITAL IMAGE
© 2002 The Museum of Modern Art,
New York/Scala, Florence. © DACS,
London 2004.)

This tendency had been gaining impetus since Pollock had established himself
in New York and was able to inform himself of modernistic developments in
European painting, then better represented in American collections than in
any centre outside Paris. In the Cubist and post-Cubist work of Picasso and
in the Surrealist painting of Max Ernst, Joan Miró and André Masson, there
was little to support an interest in the highly modelled figurative styles that
Benton and the Mexicans pursued in common, whatever might have been
the differences in their political standpoints. On the other hand, there was
much to encourage an association of artistic modernism with a breakdown
of the traditional techniques of pictorial modelling and with an inventive
complication of the painted surface. The contemporary world was by no
means absent from such work, but it tended to be evoked either through
relatively private and personal scenarios or by means of signs and symbols
incorporated into formally complex compositions.

PLATE **4.17**
Jackson Pollock,
*Untitled (Composition
with Figures and
Banners)*, c.1934–8,
oil on canvas,
27 × 30 cm.
(Museum of Fine
Arts, Houston.
Museum purchase
with funds provided by
the Brown Foundation
Accessions
Endowment Fund.
© ARS, New York
and DACS, London
2004.)

Pollock was particularly drawn to the Surrealist concept of automatism. The Surrealists' understanding of automatism was derived from psychoanalytic theory, where it refers to actions performed involuntarily, without conscious intention. Associating traditional principles of artistic decorum with a repressive social order, the Surrealists adopted a variety of literary and artistic strategies by means of which habitual controls over composition were deliberately evaded, with the intention of provoking apparently chance associations and of releasing inhibited or suppressed material from the unconscious. The precedent of Surrealist painting provided Pollock with a justification for what seems in any case to have been his natural disposition – to work fast and impulsively. It also served to suggest that an impulsive manner of working might be the means to release a more authentic kind of content – authentic in the sense of being uncensored by restrictive conditions of taste and propriety. Though it was clearly in conflict with the populist stance of Socialist Realism, the idea that a critically significant form of art might be made by bringing the private out into the public had a powerful lineage in the Romantic movement of the late eighteenth and early nineteenth centuries. It was given an added impetus in the late 1930s and early 1940s by the belief, supported by the theories of Carl Jung and prevalent in avant-garde circles in New York, that certain archetypal motifs were to be found in common in classical mythology, in tribal art and in the contents of the subconscious as revealed through psychoanalysis. It should be borne in mind that from 1937 onwards, Pollock was engaged in a number of different forms of psychiatric therapy for his chronic alcoholism, psychoanalysis among them.

The various strands in his work were brought together in dramatic form in the spring of 1939, when Picasso's *Guernica* was shown at the Valentine Gallery in New York as part of an attempt to raise money for the Republican cause in the Spanish Civil War (see Plate 1.25). The painting had a profound effect on Pollock, as it did on many artists at the time. In a later televised interview, Lee Krasner testified that she visited the work every day during the month of its exhibition in New York and that when it travelled on to the Museum of Modern Art in Boston, she followed it there. At that time, Pollock was attending sessions of therapy with a Jungian psychoanalyst. It was suggested that he should take his drawings to the sessions so that their supposedly unconscious motifs could be interpreted. Eighty-three surviving sheets were published in 1970.[21] Over half of these contain images that can be related to *Guernica* (for example, Plate 4.18). The implication is that the painting had so thoroughly got under Pollock's skin that his preoccupation with it surfaced even in drawings that were supposed to be automatistic.

There are many reasons why Picasso's painting should have exerted so great a fascination on Pollock in particular. Here was the most highly respected of

PLATE **4.18**
Jackson Pollock, untitled drawing, *c.*1939–40, pencil on paper, 36 × 28 cm. (Museum of Art, Rhode Island School of Design, Providence, Rhode Island. Gift of Polly and Erwin Strasmich in memory of Ida Malloy. Photo: Michael Jorge. © ARS, New York and DACS, London 2004.)

modern artists – as one of Pollock's artist friends said, 'Picasso was God'[22] – working on a large-scale mural designed for public display; he was apparently using a repertoire of motifs previously associated with his personal deliberations upon sexual and emotional themes in order to register a sense of outrage at an event of current political significance; and in the process he was employing a stylistic vocabulary derived from Cubism, which was still the paradigmatic modernist movement. I suspect that Pollock saw *Guernica* as a demonstration that the contradictory strands of his own ambition were at least in principle capable of reconciliation: that an engaged and topical public art might be made out of personally resonant pictorial materials, and without the need to resort to Realist styles that had come to seem conservative in the light of modernist interests.

Even as he responded to Picasso's example, the persisting nature of Pollock's dilemma can be read out of a few of the paintings he produced in the late 1930s and early 1940s. *Naked Man with a Knife* (Plate 4.19) shows him applying a broadly Cubist style to a dramatically expressive theme, while attempting to retain the densely modelled treatment of his figures that was a remaining legacy from his Realist commitments (there is a strong echo of the muscular figure style of Orozco). The result is a work that for all the potency of its theme appears uncomfortably over-stuffed within its relatively shallow pictorial space. The individual character of Pollock's work at this time is more successfully pursued in a remarkable series of small works on paper, in pencil, crayon and ink, that he made during the same period, many of them included among the so-called 'psychoanalytical drawings' that he presented for discussion with his therapist (for example, Plate 4.18). In an interview published in 1969, Krasner describes Pollock's notebooks and drawings from this period:

> a great body of work that most people didn't see until years later …
> For me, all of Jackson's work grows from this period; I see no more
> sharp breaks, but rather a continuing development of the same themes
> and obsessions.[23]

The notable feature of these drawings is that each tends to be treated as a decorative whole. Their rich and varied texture results from a combination of often disturbing imagery, laid down with apparent rapidity, with graphic marks that have no discernible depictive function.

The progressive developments in Pollock's painting through the 1940s were those that enabled him to work in a similar manner, and at a similar pace, with the more substantial and intractable materials of paint on canvas. The more practised he became in the relevant techniques, the more confident he seems to have been that the persisting imagery of his work – a characteristic repertoire of expressive heads, struggling figures, animals and 'primitive' decorative motifs – could be relied on to maintain a more or less submerged life in the busy surfaces of his paintings. Krasner again:

> I saw his paintings evolve. Many of them, many of the most abstract, began
> with more or less recognizable imagery – heads, parts of the body,
> fantastic creatures. Once I asked Jackson why he didn't stop the painting
> when a given image was exposed. He said 'I choose to veil the imagery.'[24]

Mural (Plate 4.14) was painted before Pollock had quite reached this stage. Look again at the illustration of this painting and see if you can see elements in common with *Naked Man with a Knife* (Plate 4.19) on the one hand, and with such later works as *Autumn Rhythm* (Plate 4.8) on the other.

PLATE **4.19** Jackson Pollock, *Naked Man with a Knife*, c.1938–40, oil on canvas, 127 x 91 cm.
(© Tate, London 2002. © ARS, New York and DACS, London 2004.)

What I have in mind first is the effect of almost sculptural relief that tends to be produced by dense compositions of human figures. If you look closely at *Mural*, you may be able to read it as an extended frieze of figures, their vestigial modelling still just discernible beneath the increasingly rhythmical swirls of paint. Secondly, though, there is clear evidence that the accelerating process of application is tending towards the all-over abstract surface that the artist would arrive at over the next few years. ∎

Four years after he painted *Mural*, the pictures that Pollock 'contemplated painting' would finally depart from the figurative and spatial conventions that had governed the traditional easel painting. The resulting surfaces would have the uniformity, the sheer sensation and the absence of hierarchical distinctions that Greenberg was to observe (Plates 4.3, 4.8 and 4.9). Yet in the laying down of line and colour there would still be the same degree of psychological investment that had always accompanied the establishment of Pollock's imagery. The intensity of that investment would guarantee the kind of emotional content that I see as present in paintings such as *Autumn Rhythm*. And perhaps the results would serve to mark out a new kind of potential in mural art.

Pollock after 1950

In the overall interpretation of Pollock's work, a significant question remains to be addressed. Are *Autumn Rhythm* and the other large abstract paintings of 1950 appropriately seen as fulfilments of the project that he announced in 1947; that is to say, as works that 'constitute a halfway state' between easel and mural and that 'point out the direction of the future, without arriving there completely'? Or might we rather regard the four-year period of his drip-and-spatter paintings as a transitional phase in a continuing career, bracketed at either end by works in which an evocative pictorial imagery, if not always easily readable, is certainly vividly exposed?

Had Pollock continued to work consistently in an abstract vein after 1950, or had he died then rather than in 1956, there would be little incentive to consider the second alternative. At the end of 1951, however, he held a show of paintings in black enamel paint on canvas, in which imagery related to the 'psychoanalytical drawings' is openly, if ambiguously, exposed, free from overlay by any build up of coloured skeins and splotches. In June 1951, he had written to a friend, 'I've had a period of drawing on canvas in black – with some of my early images coming thru – think the non-objectivists will find them disturbing – and the kids who think it simple to splash a Pollock out.'[25] In most of the paintings in the series, colour is used sparingly, if at all, and several of them take the form of complex semi-abstract compositions that seem to be based on single or multiple figures (Plate 4.20).

In a review of early 1952, Greenberg was obliged to reconsider his earlier forecast. He acknowledged that the works in the 1951 exhibition hinted 'at the innumerable unplayed cards in the artist's hands. And also, perhaps, at the large future still left to easel painting.'[26] Three years later, however, he wrote that having achieved a considerable technical control, Pollock 'found

himself stranded between the easel picture and something else hard to define, and in the last two or three years he has pulled back'.[27] Fried, writing on Pollock a crucial ten years later in 1965, was critical of what he saw as a 'strong tendency … to revert to traditional drawing at the expense of opticality'. In his view, the black-and-white paintings of the early 1950s 'probably mark Pollock's decline as a major artist'.[28] The long essay from which this quote is taken was written to introduce the work of three younger artists, Stella among them, whose thoroughly non-figurative work Fried saw as continuing a tendency to abstraction that Pollock had largely determined. As for the literalist artist-writers of the 1960s and early 1970s, with their concern for 'three-dimensional work' and for 'the concrete physicality of matter rather than images',[29] they seem not to have engaged with Pollock's post-1950 work at any point.

PLATE **4.20** Jackson Pollock, *Echo: Number 25, 1951*, 1951, enamel on unprimed canvas, 233 × 218 cm. (Museum of Modern Art, New York. Acquired through the Lillie P. Bliss Bequest and the Mr and Mrs David Rockefeller Fund. DIGITAL IMAGE © 2002 The Museum of Modern Art, New York/Scala, Florence. © ARS, New York and DACS, London 2004.)

In the years after 1950, Pollock combined painting rich in elusive imagery with a certain amount of abstract work. His production dropped off markedly after 1952, however. It seems that his ability to work was increasingly impaired by the drinking he had resumed late in 1950 – at the very moment when Namuth finished filming him at work. He was to die in a car accident in 1956, in which one of his two female passengers was also killed. What is arguably his last successful work, now known as *Portrait and a Dream*, was painted in 1953 (Plate 4.21). It was first shown – as *Portrait with a Dream* – at the Sidney Janis Gallery in New York the following February. Though Pollock probably did not set out to paint a work with such a title, the title is one that he seems to have chosen for himself at a certain stage in the development of the painting – possibly after he had decided that it was finished.

Look now at *Portrait and a Dream* (Plate 4.21). Paying attention to the details of size and medium, write a brief description. Note the different techniques that you think the artist would have used, any evidence of different stages in its development and anything that you find remarkable in the composition. Do not be too concerned if you find the left half of the picture difficult to interpret.

This is a comparatively large painting in a broad landscape format, slightly wider than two adjacent squares. I would expect you to have remarked on its clear division into two separate halves, with apparently different scales. The left-hand portion is painted fluently, with paint stained into the unprimed canvas. It looks like a large, rapidly executed drawing, which is in a sense just what it is. The medium is a liquid black enamel paint, which produces an effect rather like a greatly enlarged drawing in ink on paper. The trickling and pooling of the black paint indicate that it must have been applied from above, and that at that stage the canvas was lying on a horizontal surface. (In fact, in order to maintain the control necessary to develop complex imagery at speed, and at the same time to get the paint flowing smoothly over such a large area, Pollock would sometimes use a basting-syringe. This worked, as his widow remarked, 'like a giant fountain pen'.[30]) The outline drawing of the

PLATE 4.21 Jackson Pollock, *Portrait and a Dream*, 1953, oil on canvas, 149 x 342 cm. (Dallas Museum of Art. Gift of Mr and Mrs Algur H. Meadows and the Meadows Foundation, Inc. © ARS, New York and DACS, London 2004.)

head at the right is painted using the same technique, but here Pollock has filled in areas with coloured oil paint: the yellow and reddish brown areas applied quite thinly, the blue-grey areas thickly painted. The portrait may well have been conceived as a *self*-portrait. The title may have encouraged you to think of the left-hand component as a dream that the head is dreaming, though if that is what it is, it is far from easy to decide just what is represented. I make out the traces of a semi-reclining figure: the left leg with bent knee occupying the bottom left corner of the painting, the right leg bent above it, the belly more or less at the centre of the painting's left-hand section. Beyond this point it gets harder. I might see the figure's weight as carried on its left arm, with the bent elbow forming the bottom right-hand corner of the 'dream', but if so, it is lacking a head. The dark patch at the top right can be read as a head, with two eyes and a vestigial mouth, but it seems disconnected from what I see as the reclining torso. Perhaps two separate figures are represented. But whatever depicted forms we may be able to identify, there will remain many areas of the drawing that are hard to assimilate into a coherent pictorial scheme. ■

Pollock's practice at the time was to buy large bolts of cotton canvas — 'remnants … anywhere from five to nine feet high, having maybe fifty or a hundred yards left on them',[31] and to paint in succession on unprimed lengths unrolled on the studio floor, dividing them subsequently into separate works and only stretching them when they were to leave the studio for exhibition. In the case of *Portrait and a Dream*, Krasner records that the two halves were painted in separate phases of work, and the decision to incorporate them as one painting was made subsequently.[32] The likeliest succession of events, I think, is that Pollock cut his canvas at the left-hand edge of the 'dream' and at the right-hand edge of the 'portrait', and that he then tacked the resulting double image up onto the studio wall so that he could measure its effect. It may have been at this point, and following a final decision not to divide the two parts, that he added colour to the right-hand side, working upright in a less liquid medium with brush and perhaps palette knife. The effect is to give the head a greater solidity and to emphasise its nearness to the picture plane, thus increasing the contrast with the 'dream', which seems now to occupy a less clearly defined and more recessive pictorial space. These measures would have been consistent with a feeling on Pollock's part that what he had more or less adventitiously produced in the two juxtaposed images was something that might justifiably bear the title 'Portrait and a Dream', and that could be improved by being pushed in that direction.

Krasner was both a witness to the making of much of Pollock's mature work and a contributor to his deliberations over it. In the interview already cited, she recorded that he had discussed *Portrait and a Dream* with two visiting friends:

> In response to their questions, Jackson talked for a long time about the left section. He spoke freely and brilliantly … The only thing I remember was that he described the upper right-hand corner of the left panel as 'the dark side of the moon'.[33]

This is the detail I have interpreted as a head. I could well be wrong, or Pollock could have been improvising to entertain his visitors, or the two readings could be allowed to coincide.

Conclusion

While Pollock's abstract works of 1947–50 attracted immediate, diverse and copious comment, less attention was devoted to the primarily black-and-white works of 1951–3. They have remained relatively resistant to successful critical interpretation among those concerned to trace a consistent and progressive tendency in modernist art. This may be because they have appeared conservative, at least in their suggestive recapitulation of themes from the long history of painted imagery. It may also be because a high degree of risk attaches to any attempt to resolve their combination of resonant imagery with ambiguity – an extreme ambiguity that follows from the virtual suppression of spatial hierarchy.[34] But perhaps these paintings may in time come to be seen as worthy fulfilments of the project that Pollock had set himself in 1947, 'to paint large movable pictures which will function between the easel and mural', and to point out *a* (if not *the*) 'direction of the future, without arriving there completely'. At the least they can be seen as fascinating resolutions of the dilemma to which Pollock's enterprise was largely addressed from the late 1930s onwards: how to make technically modern painting out of imaginative materials that were immediately personal, even at times paranoid – painting that was entirely free from didacticism, but that nevertheless achieved the presence, scale and resonance of an engaged public art.

Notes

1 Greenberg, 'The Decline of Cubism' (1948), in Harrison and Wood, *Art in Theory 1900–2000*, VA10, p.577.

2 *Ibid.*, p.579.

3 Greenberg, 'Review of Exhibitions of Adolph Gottlieb, Jackson Pollock and Joseph Albers' (1949), in O'Brian, *Clement Greenberg*, vol.2, p.286.

4 Greenberg, 'Feeling is All' (1952), in O'Brian, *Clement Greenberg*, vol.3, p.106.

5 Greenberg, '"American-Type" Painting' (1955), in *ibid.*, pp.219–20.

6 Leider, 'Literalism and Abstraction', p.44.

7 Fried, 'Art and Objecthood' (1967), in Harrison and Wood, *Art in Theory 1900–2000*, VIIA7, p.836.

8 Leider, 'Literalism and Abstraction', p.44.

9 *Ibid.*

10 Judd, 'Specific Objects' (1965), in Harrison and Wood, *Art in Theory 1900–2000*, VIIA5, p.826.

11 Leider, 'Literalism and Abstraction', p.45. Pollock's handprints can be seen in *Number 1A, 1948* (Plate 4.3).

12 Rubin, 'Jackson Pollock and the Modern Tradition'.

13 Morris, 'Notes on Sculpture' (1966), in Harrison and Wood, *Art in Theory 1900–2000*, VIIA6, p.829. Morris seems to have been responding to modernist support for the constructed work of the English sculptor Anthony Caro, which Greenberg saw as having its roots in Cubist collage – and thus in painterly concerns with the optical *rather than* the tactile.

14 Morris, 'Notes on Sculpture 4: Beyond Objects' (1969), in Harrison and Wood, *Art in Theory 1900–2000*, VIIB4, p.884. See also Morris, 'Anti Form'.

15 In Chapter 3 of *Frameworks for Modern Art*.

16 Pollock's statement is printed in O'Connor, *Jackson Pollock*, pp.39–40.

17 As reported in Varnedoe with Karmel, *Jackson Pollock*, p.320.

18 Greenberg, 'The Crisis of the Easel Picture' (1948), in O'Brian, *Clement Greenberg*, vol.2, p.221.

19 *Ibid.*, pp.224, 225.

20 Siqueiros, 'Towards a Transformation of the Plastic Arts' (1934), in Harrison and Wood, *Art in Theory 1900–2000*, IVB16, p.430.

21 The 83 sheets of drawings had remained in the possession of Pollock's analyst, Dr Joseph Henderson. They were published in 1970 in Wysuph, *Jackson Pollock*, and concurrently with the launch of the book were exhibited at the Whitney Museum of American Art in New York. Their appearance provoked a number of Jungian interpretations of Pollock's work, though Henderson has testified 'I did not consciously discuss Jung or Jungian theories with him' (see Varnedoe with Karmel, *Jackson Pollock*, p.80 n.47).

22 Peter Busa interviewed with Roberto Matta by Sidney Simon, originally published as 'Concerning the Beginnings of the New York School 1939–1943', in *Art International*, summer 1967, quoted in Harrison, 'Abstract Expressionism', p.175.

23 Friedman, 'An Interview with Lee Krasner Pollock', p.7.

24 *Ibid.*

25 Letter of 7 June 1951 to Alfonso Ossorio, quoted in O'Connor, *Jackson Pollock*, p.59.

26 Greenberg, 'Feeling is All' (1952), in O'Brian, *Clement Greenberg*, vol.3, p.105.

27 Greenberg, '"American-Type" Painting' (1955), in *ibid.*, p.226.

28 Fried, quoted in Harrison, 'Abstract Expressionism', p.207 n.31.

29 Morris, 'Notes on Sculpture 4: Beyond Objects' (1969), in Harrison and Wood, *Art in Theory 1900–2000*, VIIB4, p.884.

30 Friedman, 'An Interview with Lee Krasner Pollock', p.10.

31 *Ibid.*, p.8.

32 *Ibid.*, p.10.

33 *Ibid.*, p.8.

34 For an illustration of the kinds of risk involved, see E.A. Carmean's 'The Church Project'. The author of this extensive article notes that in the summer of 1950 Pollock had been engaged in discussions with the architect Tony Smith concerning a project for the design of a Catholic church, argues that the black-and-white paintings were related to this project, and reads a number of them as versions of traditional Christian themes envisaged as cartoons for windows. A robust counter-argument was offered by Rosalind Krauss in her 'Contra Carmean', published in the same issue of the journal. She notes, 'Not only does Carmean presuppose a working method absolutely at odds with the technique of poured line as an index of the spontaneous and the improvisatory … but it pictures Pollock *consciously*, deliberately, doing the one thing he was adamantly against; illustration' (p.125).

References

Carmean, E.A., Jr, 'The Church Project: Pollock's Passion Themes', *Art in America*, vol.70, no.6, summer 1982, pp.110–22.

Fried, M., *Three American Painters*, exhibition catalogue, Fogg Art Museum, Harvard University, 1965.

Friedman, B.H., 'An Interview with Lee Krasner Pollock', in *Jackson Pollock: Black and White*, exhibition catalogue, Marlborough–Gerson Gallery, New York, March 1969.

Gaiger, J. (ed.), *Frameworks for Modern Art*, New Haven and London: Yale University Press in association with The Open University, 2003.

Harrison, C., 'Abstract Expressionism', in N. Stangos (ed.), *Concepts of Modern Art*, London: Thames & Hudson, 1974, pp.169–211.

Harrison, C. and Wood, P. (eds), *Art in Theory 1900–2000: An Anthology of Changing Ideas*, Malden, MA and Oxford: Blackwell, 2003.

Krauss, R., 'Contra Carmean: The Abstract Pollock', *Art in America*, vol.70, no.6, summer 1982, pp.123–31, 155.

Leider, P., 'Literalism and Abstraction: Frank Stella's Retrospective at the Modern', *Artforum*, vol.8, no.8, April 1970, pp.44–51.

Morris, R., 'Anti Form', *Artforum*, vol.6, no.8, April 1968, pp.33 5.

O'Brian, J. (ed.), *Clement Greenberg: The Collected Essays and Criticism*, vol.2: *Arrogant Purpose, 1945–1949*, Chicago: University of Chicago Press, 1986.

O'Brian, J. (ed.), *Clement Greenberg: The Collected Essays and Criticism*, vol.3: *Affirmations and Refusals, 1950–1956*, Chicago: University of Chicago Press, 1993.

O'Connor, F.V., *Jackson Pollock*, exhibition catalogue, Museum of Modern Art, New York, 1967.

Rubin, W., 'Jackson Pollock and the Modern Tradition: Parts I–IV', *Artforum*, vol.5, no.6, February 1967, pp.14 22; no.7, March 1967, pp.28–37; no.8, April 1967, pp.18–31; no.9, May 1967, pp.28–33.

Varnedoe, K. with Karmel, P., *Jackson Pollock*, exhibition catalogue, Tate Gallery, London, 1999.

Wysuph, C.L., *Jackson Pollock: Psychoanalytic Drawings*, New York: Horizon Press, 1970.

CHAPTER 5

Abstract Expressionism and masculinity

Fionna Barber

Introduction

In this chapter I will examine the construction of gender roles in Abstract Expressionism. These are commonly perceived to involve highly polarised definitions of masculinity and femininity, in keeping with the context of postwar reconstruction and the conservatism of the Cold War period. Perhaps inevitably, this has resulted in a focus on the work of male artists such as Jackson Pollock (see Chapter 4), Willem de Kooning and Clyfford Still, but women also played significant roles in the evolution of Abstract Expressionism. They included artists such as Lee Krasner (Plate 5.2), Elaine de Kooning and Joan Mitchell (Plate 5.3), and also the collector Peggy Guggenheim and the gallery owner Betty Parsons, who were vital to the promotion of radical painting in New York in the 1940s and 1950s. As I will explain, the predominance of forms of masculinity within the culture of Abstract Expressionism has had considerable repercussions for the ways in which the work of these women has subsequently been regarded. In the feminist reading of Abstract Expressionism that I want to apply here, categorisations of gender are as much a feature of the artist's social identity as they are of the work produced. The public machismo associated with Pollock or Franz Kline is seen to be echoed by attributes of their paintings identified with masculinity, such as the size and scale of their work, or even their use of gesture and certain types of brushstroke. The identification of Abstract Expressionism's gendered associations is, however, far from recent. In the late 1940s and 1950s, the popularity of Jungian notions of the unconscious, with an emphasis on polarised masculine and feminine archetypes, also helped to encourage the gendered discourse surrounding the work of these artists, although in a form somewhat different from more recent revisions.

One of the most interesting features of some recent debates about gender has been a tendency to regard the categories of masculinity and femininity as less stable than they were previously considered. This is linked to the interpretation of identity as fundamentally *performative*, and is primarily associated with the work of the American feminist philosopher Judith Butler. These theories have an important application in facilitating a more nuanced analysis of a range of contemporary gender identities. They also enable us to re-read historical constructions of masculinity and femininity, such as those underpinning Abstract Expressionism. Yet despite the reductivism of the Jungian understanding of gender that predominated at the time, it is important to try to maintain a sense of the multiplicity of meanings that may be attached to a type of painting. The 'meaning' of a work of art is not determined by a single discourse that may have influenced its production.

PLATE **5.1** (facing page) Willem de Kooning, detail of *Woman I* (Plate 5.20).

PLATE **5.2** Lee Krasner, *Prophecy*, 1956, oil on cotton duck, 148 × 86 cm.
(Courtesy Robert Miller Gallery, New York. © ARS, New York and
DACS, London 2004.)

PLATE **5.3** Joan Mitchell, untitled painting, 1958, oil on canvas, 101 × 91 cm. (Collection Ulster Museum, Belfast. Photograph reproduced with the kind permission of the Trustees of the National Museums and Galleries of Northern Ireland. © Estate of Joan Mitchell.)

The gendering of the gesture: Jackson Pollock and Abstract Expressionist masculinity

With this in mind, I want to preface a discussion of some aspects of paintings by Pollock with a comparison of the views of the two main critics who promoted radical painting in postwar New York: Clement Greenberg and Harold Rosenberg. Greenberg emerged as the dominant advocate of modernism, but it is Rosenberg's emphasis on the *act* of painting that has a particular value in the light of more recent readings that stress the performative aspect of Abstract Expressionism.

Now read the following extracts from Greenberg's '"American-Type" Painting' and Rosenberg's 'The American Action Painters'. How would you characterise the different interpretations they construct for Abstract Expressionism?

Clement Greenberg

Within a notion of shallow space generalized from the practice of Miró and Masson as well as of Picasso, and with some guidance from the early Kandinsky, [Jackson Pollock] devised a language of baroque shapes and calligraphy that twisted this space to its own measure and vehemence. Pollock remained close to Cubism until at least 1946, and the early greatness of his art can be taken as a fulfilment of things that Picasso had not brought beyond a state of promise in his 1932–1940 period. Though he cannot build with color, Pollock has an instinct for bold oppositions of dark and light, and the capacity to bind the canvas rectangle and assert its ambiguous flatness and quite unambiguous shape as a single and whole image concentrating into one the several images distributed over it. Going further in this direction, he went beyond late Cubism in the end.[1]

Harold Rosenberg

At a certain moment the canvas began to appear to one American painter after another as an arena in which to act – rather than as a space in which to reproduce, re-design, analyse or 'express' an object, actual or imagined. What was to go on the canvas was not a picture but an event ...

The new American painting is not 'pure' art, since the extrusion of the object was not for the sake of the aesthetic ... In this gesturing with materials the aesthetic, too, has been subordinated. Form, colour, composition, drawing, are auxiliaries, any one of which – or practically all, as has been attempted logically, with unpainted canvases – can be dispensed with. What matters always is the revelation contained in the act. It is to be taken for granted that in the final effect, the image, whatever be or be not in it, will be a *tension*.[2]

Both of these extracts are concerned with the identification of the main features of American avant-garde painting. One obvious difference is that Rosenberg is talking in general terms, whereas Greenberg discusses the work of one particular artist – Pollock. Apart from this distinction, there are considerable differences in their understanding of contemporary painting. For Greenberg, it is the artist's engagement with pictorial space that is dominant. The shape and support of 'the canvas rectangle' provide a static format for the assertion of what Greenberg sees as a fluctuating sense of space in Pollock's paintings. These formal qualities also provide the artist with a means of resolving relationships between different 'images' dispersed across the surface of the work, resulting in a coherent fusion. Greenberg, however, is also concerned here with Pollock's engagement with spatial issues in the work of earlier European modernists – up to the point, in 1946, where he broke with them.

By comparison, Rosenberg's account emphasises action, and the dramatisation of the process of production in an encounter with the surface on which the artist works. The canvas area (identified by Greenberg as a means of containing a resolution of spatial tensions) is seen in very different terms, as defining the boundaries within which some kind of event could be enacted. Yet for Rosenberg, the artist's gesture is also of prime importance in a dynamic process of painting. Rather than a disinterested assessment of the resolution of formal relationships, I would suggest that this involves the viewer's awareness of painting as a physical act. Rosenberg's use of the word 'revelation', however, helps to give meaning to the artist's gesture by its connection with some deeper purpose. ■

These two critics were, in fact, fiercely opposed to each other's viewpoint; Rosenberg's essay 'The American Action Painters' was produced at least partly as a challenge to Greenberg's account of contemporary painting that was gaining precedence through his regular publication in journals such as *The Nation* and *Commentary*. Both critics had been Trotskyists in the 1930s; however, in contrast to Greenberg's Cold War repudiation of his former politics, Rosenberg maintained a tenuous connection to Marxism throughout the 1950s.[3] Rosenberg's essay from which the extract above is taken also had strong links to Existentialism in its stress on painting as a decisive, meaningful act. This causes problems for explanations of the work of painters such as Barnett Newman, Mark Rothko and Clyfford Still, which is characterised by broad planes of colour rather than the play of individual brushstrokes – although 'artistic revelation' does imply their concern with the metaphysical category of the 'sublime'. As Greenberg pointed out elsewhere in '"American-Type" Painting', Rosenberg's position is applicable to the work of only some Abstract Expressionist artists, such as Pollock, Kline and de Kooning.[4] It does, however, have considerable explanatory power if we consider a painting by Kline, who was described posthumously by the poet Frank O'Hara as 'the action painter *par excellence*'.[5] In *Painting Number 2* (1954), colour is pared down to the interaction of black and white on bare canvas (Plate 5.4). Together with the painting's large size, this has the effect of drawing attention to the delineation of an almost architectural structure; it is not too difficult to see Kline's sweeping black brushstrokes in relation to the movement of the artist's body and the decisions he made in front of the canvas.

The primacy of the *gesture* can also be seen in other works, such as Pollock's *Number 1A, 1948* (see Plate 4.3). The skeins of paint covering the canvas become legible as the trace of an engagement between artist and canvas – marks made by Pollock's specific method of painting, involving his whole body in a dynamic, gestural act as he moved along the surface and back again. The handprints at the top right can also be seen as signs of the event that has taken place – a mark of the artist's presence in the 'arena' of the canvas, rather than, say, the remains of a 'picture' of a body, the rest of which has been obscured by the skein of lines. Similar handprints appear in another of Pollock's drip paintings, *Lavender Mist: Number 1, 1950* (see Plate 3.23). However, if we look more closely at *Number 1A, 1948*, it is possible to discern areas that *can* be read in terms of figuration, such as the skull-like ellipse of white paint at the bottom right. Pollock's attitude to figuration was quite ambivalent. In discussions with an interviewer from *Life* magazine in 1949,

PLATE **5.4** Franz Kline, *Painting Number 2*, 1954, oil on canvas, 204 × 272 cm. (Museum of Modern Art, New York. Mr and Mrs Joseph H. Hazen and Mr and Mrs Francis F. Rosenbaum Funds. DIGITAL IMAGE © 2003 The Museum of Modern Art, New York/Scala, Florence. © ARS, New York and DACS, London 2004.)

he stated that, despite his attempts to avoid imagery as unnecessary to the meaning of the painting, 'recognisable images are always there in the end'.[6] Indeed, the question of Pollock's attitude to 'subject matter' and figuration has been the cause of considerable debate. And, although admittedly this may be hard to discern from a reproduction, in some areas of *Number 1A, 1948* it is clear that Pollock had initially mapped out areas of black, either by brush or rubbed in with rags, prior to the dynamic layering of paint trails across the surface.

Rosenberg's arguments concerning the 'enactment' of painting also have applications to the formation of artistic identity in other areas. This becomes increasingly clear if we look at the photographs of Pollock taken by Hans Namuth between July and November 1950. These depict Pollock at work in his studio in the barn behind the house that he shared with his wife, the painter Lee Krasner, in East Hampton, Long Island. There are other published images of Pollock at work. In April 1949, *Life* magazine included Martha Holmes's and Arnold Newman's photographs of his demonstration of the drip technique, while Rudolph Burckhardt had also taken photographs of Pollock in his studio with the painting *Number 1, 1950*. Namuth's photographs and the films he made of Pollock at work, however, provide the most extensive record of the artist's methods, and have themselves

PLATE **5.5** Hans Namuth, Jackson Pollock painting *One: Number 31, 1950*, with Lee Krasner watching, 1950, photograph. (Courtesy Pollock–Krasner House and Study Center, East Hampton, New York. © Estate of Hans Namuth. © ARS, New York and DACS, London 2004.)

acquired a canonical status in their representation of Pollock at work on two paintings, *One: Number 31, 1950* (Plate 5.5) and *Autumn Rhythm: Number 30, 1950*. They have also formed the basis for the attempted reconstruction of the artist's working method in a Hollywood feature film, *Pollock*. The photographs demonstrate his use of gesture and the swiftness of his balletic movements across the floor in the gradual evolution of these paintings; in the background stand other paintings waiting to be reworked. Indeed, the photographs also show the significance of two stages, production and gestation, as indicated in Pollock's statement published in the journal *Possibilities*, edited by Rosenberg and Robert Motherwell: 'When I am *in* the painting, I'm not aware of what I'm doing. It is only after a sort of "get acquainted" period that I see what I have been about.'[7] To some extent, these images reinforce Rosenberg's interpretation by lending themselves to an imaginative reconstruction of what went on during Pollock's sessions with Namuth in the barn: the smell of oil paint and cigarette smoke, the sound of Pollock's heavy boots scuffling across the floor, the dull splash of arcs of paint hitting the surface, the click of the photographer's shutter. However, we also need to set such seductive reconstructions in the wider context of the contemporary construction of masculinity in the USA in the early 1950s.

During the Second World War, women in the USA had begun to occupy many of the jobs left vacant by men who had enlisted; they were particularly encouraged to move into heavy industry, historically a male domain, as a means of supporting both the domestic economy and the war effort. With the end of the war in 1945, the workforce became remasculinised; women lost their jobs and their independence, increasingly being pushed back into domesticity as part of a regressive redefinition of gender identity. The Cold War also reinforced the polarisation of gender roles and an enforced heterosexuality. The FBI's attentions were directed to uncovering not only closet communists but also homosexuals, in an attempt to root out 'sex perverts' who posed a threat to national security. In the postwar context of polarised gender roles, any deviation by men from macho toughness could be suspect, as the following anecdote reveals. On one occasion in 1949, Pollock and Rosenberg visited the cinema with Elaine and Willem de Kooning to watch Greta Garbo in *Camille*. Pollock, allegedly moved to tears by the love scenes, was mocked by Rosenberg with the words 'If you don't stop bawling we'll need a rowboat to get out of this place.' Normative masculinity was soon restored – the two began brawling and were thrown out of the cinema.[8]

The primitive and the unconscious

Assertions of virility became identified with the USA's founding mythologies: those of the pioneer and the frontiersman. These emerged regularly in the themes of mass culture, for example in the John Ford film *The Searchers* (1956), but they also informed the ways in which artistic identities could be enacted, frequently appearing in Rosenberg's writings about both Pollock and other Abstract Expressionists. In 1967, he described Pollock as 'prefer[ring] to play the laconic cowboy – a disguise that both protected him from unwanted argument and hid his shamanism beneath the legendary he-man of the West'.[9] Pollock fitted the description – he was born in Wyoming (although he only lived there for a few months) and had trained with the Regionalist painter Thomas Hart Benton. Conflated with this, however, was the notion of artist as shaman, derived from the widespread avant-gardist discourse of the 'primitive'. Yet the construction of the 'primitive' itself is related to a category that was important not just for Pollock, but for the ways that other Abstract Expressionist artists thought of their work: the psychoanalytic category of the unconscious. We need to consider the effects of these two related categories on the gendering of Abstract Expressionist painting.

The notion of the primitive has played a major role in the development of modernism from the late nineteenth century onwards. It was a defining feature of Picasso's *Les Demoiselles d'Avignon*, in addition to being an extremely important category for German Expressionist artists such as Ernst Kirchner and Emil Nolde. The availability of artefacts from colonised African and Polynesian cultures in European ethnographic museums was central to the work of these and other painters. The interest of later American artists in primitivism was evidence of a similar fascination with the artefacts of tribal societies; frequently these were the products of Native American cultures. Ironically, these were cultures that were being eradicated in the interests of economic and political expansionism within the USA, which was similar to

the fate of the colonised cultures that had fascinated earlier European artists. Jackson Pollock, Adolph Gottlieb and Theodoros Stamos were just some of the painters who were deeply interested in Native American mythology and image making. On a trip to New Mexico in 1947, Stamos had himself photographed in front of a rock covered in Native American petroglyphs (Plate 5.6); representations of the worn surfaces of these stones appeared in works such as his *Archaic Sentinel* of 1947 (Plate 5.7). In Gottlieb's painting *Labyrinth No. 2* (Plate 5.8) the grid-like composition, which is a recurrent feature of his work, contains a range of imagery reminiscent of Tlingit blankets from Alaska (Plate 5.9). Gottlieb was fascinated by these, and appropriated their organic representation of animal bodies in his fragmented and abstracted human forms. Barnett Newman, in addition to developing his own practice as a painter, curated exhibitions such as 'Pre-Columbian Stone Sculpture' (Wakefield Gallery, New York, 1944) and 'Northwest Coast Indian Painting'

PLATE 5.6
Lloyd Lozes Goff, Theodoros Stamos at Santia Mountain, New Mexico, in front of petroglyphs, 1947, photograph. (Photo: Lloyd Lozes Goff, 1947.)

(Betty Parsons Gallery, New York, 1946). He also claimed that 'we feel a bond of understanding with the primitive artist's intentions, problems and sensibility'.[10]

It is important to locate this interest in the primitive in the wider historical circumstances. As Michael Leja has suggested, in the USA during the Second World War, notions of the primitive played a significant role in the mass media as much as in other more specialised discourses, such as anthropology.[11] In the context of the war, the category of the primitive encouraged the recognition of dark irrational forces lurking beneath the veneer of civilisation. Gottlieb's painting *The Eyes of Oedipus (Alphabet of Terror)* of 1941 (Plate 5.10) was one example of the attempt to link modern experience to more archaic categories; here the pictographic grid contains grimacing Expressionistic faces reminiscent of tribal masks. The name *The Eyes of Oedipus* refers to the Greek myth used by Freud as an allegory for the trauma that, he believed, inaugurated the male child's acquisition of gendered subjectivity.

PLATE **5.8** Adolph Gottlieb, *Labyrinth No. 2*, 1950, oil on canvas, 91 × 122 cm. (© Tate, London 2002, photo: John Webb. © Adolph and Esther Gottlieb Foundation/VAGA, New York/DACS, London 2004.)

PLATE **5.9**
Chilkat Tlingit blanket cloak, late nineteenth century, mountain goat wool and caribou skin. (Werner Forman Archive, Field Museum of Natural History, Chicago, USA.)

PLATE 5.10 Adolph Gottlieb, *The Eyes of Oedipus* (*Alphabet of Terror*), 1941,
oil on canvas, 91 x 71 cm. (© Adolph and Esther Gottlieb
Foundation/VAGA, New York/DACS, London 2004.)

Yet the significance of the primitive for Abstract Expressionists was bound
up more closely with a specific interest in *Jungian* psychology, in which
practices of myth making have been given a particular status. Myths can be
defined as forms of narrative that attempt to explain events through the
search for underlying meaning related to divine or supernatural phenomena.
Rather than directly describing what has happened, they function through
often very striking images whose original historical meanings have become
lost as they pass into collective memory. The ability of myths to stand in for
knowledge that has become lost or somehow repressed made them deeply
attractive to both Freud and Jung in the development of their very different
theories of the unconscious. Rothko, Gottlieb and Stamos were all drawn

towards the mythology of archaic Greek culture, while Barnett Newman frequently used biblical narratives as a catalyst for his continued engagement with the sublime. Yet the biblical associations of works such as *Adam* (1951–2), *The Word II* (1954) and *Day One* (1951–2) can also be understood as part of an authoritarian, patriarchal discourse in Newman's work – even though this conflicted considerably with his political allegiances to anarchism.[12]

Many artists, including Rothko, had become disillusioned with the politics of the Left following the pact signed by Adolf Hitler and Joseph Stalin in 1939 over the annexation of Poland. The deep, intuitive forces evoked by mythology offered a different way of interpreting the cataclysm in Europe. Several paintings by Rothko from the early 1940s use themes from Greek tragedy to convey the horror of contemporary events, although he clearly regarded these works not as illustrations but as allegories. One of these, *The Omen of the Eagle* of 1942 (Plate 5.11) was described by Rothko in 1944 in terms that evoke the combination of the mythic and the primitive:

> The theme here is derived from the Agamemnon Trilogy of Aeschylus. The picture deals not with the particular anecdote, but rather with the Spirit of Myth, which is generic to all myths of all times. It involves a pantheism in which man, bird, beast and tree – the known as well as the knowable – merge into a single tragic idea.[13]

Unlike Freud, Jung perceived myths in quite holistic terms, bound up with a belief in the presence of archetypes in the unconscious. These archetypes, Jung believed, are deeply rooted in the psyche and cannot be explained by the experience of the individual alone, but are derived from the collective experience of humanity. According to Jung, they are found across different cultures and manifested in shared dream imagery and mythological symbolism.[14] Furthermore, the awareness of this knowledge has become largely repressed within western civilisation; 'primitive' cultures, allegedly lacking the West's sophistication, are, by comparison, much closer to the experience of the collective unconscious. There are problems with this universalising of cultural experience and the subordination of non-western cultures to Eurocentric systems of interpretation. Jung's archetypes also involve highly essentialised views of gender – male as active, female as passive, fertile and identified with nature and, by extension, with the unconscious. Jungian belief systems were important for many artists during this period; Pollock, for example, affirmed in an interview towards the end of his life, 'I've been a Jungian for a long time.'[15] Although he first encountered Jungian ideas when studying with Benton, Pollock also underwent a period of analysis with Dr Joseph Henderson, a Jungian psychotherapist, as treatment for alcoholism during 1939 and 1940. Henderson actively encouraged Pollock to produce images as representations of his dreams, many of which also incorporated his interest in Native American imagery. One example (Plate 5.12) includes a shaman-like male figure surrounded by three animal forms – a bird, a horse and a snake; in his hands he holds a globe and a sickle moon, a symbol closely associated with femininity in Jungian discourse. Symbolic imagery also began to appear in Pollock's paintings, such as *Moon Woman Cuts the Circle* (1943), which uses a similar combination of Jungian and Native American sources (Plate 5.13).

PLATE 5.11 Mark Rothko, *The Omen of the Eagle*, 1942, oil and graphite on canvas, 66 × 45 cm. (Gift of the Mark Rothko Foundation, Inc. Image © 2003 Board of Trustees, The National Gallery of Art, Washington. © 1998, Kate Prizel Rothko and Christopher Rothko/DACS, London 2004.)

PLATE **5.12** Jackson Pollock, untitled drawing, c.1939–42, coloured pencil on paper, 36 × 28 cm. (Jackson Pollock catalogue raisonné archives, courtesy Pollock–Krasner House and Study Center, East Hampton, New York. © ARS, New York and DACS, London 2004.)

Yet masculinity and femininity were not as actively polarised in Pollock's work as might be imagined. In *Male and Female* of 1942 (Plate 5.14), the vertical totem shapes would imply the oppositional gender characteristics of Jungian archetypes; they also co-exist with an engagement with Picasso's work of the early 1930s in that the three diamonds in the space between the two figures suggests an allusion to Picasso's *Girl before a Mirror* (1932), in which the background comprises a similar geometric patterning (Plate 5.15). Despite the left-hand figure's curving eyelashes, suggestive of a feminine identification, both figures possess male and female sexual characteristics. In Jungian terms, this ambivalence can be interpreted as recognition by the male artist of his own femininity in the interests of a more holistic identity. However, the play of ambiguity between the two figures opens up the possibility of regarding gender identities in Abstract Expressionism as less stable than they might otherwise have appeared.[16]

PLATE **5.13** Jackson Pollock, *Moon Woman Cuts the Circle*, 1943, oil on canvas, 110 × 104 cm. (Centre Pompidou-MNAM-CCI, Paris. © Photo: CNAC/MNAM Dist. RMN. © ARS, New York and DACS, London 2004.)

Finally, a case can also be made for the existence of this instability of gendered identity in some of Pollock's later drip paintings. In the case of *Lavender Mist: Number One, 1950* (see Plate 3.23), the use of colour can be seen to raise questions of gender. The title (proposed by Greenberg) is suggestive of a gender ambiguity in the association of lavender with male homosexuality, while the delicate pastel surface of the painting itself is shot through with skeins of pink, a colour more closely associated with femininity, especially in the polarised gender roles of the postwar period. Yet this becomes contradictory when set against the gestural production of the painted surface – an activity encoded as masculine. As Ann Gibson has observed of another slightly later painting by Pollock, *Unformed Figure* of 1953, 'a textural maze

PLATE 5.14 Jackson Pollock, *Male and Female*, 1942, oil on canvas, 186 × 124 cm. (Philadelphia Museum of Art. Gift of Mr and Mrs H. Gates Lloyd. Photo: Graydon Wood, 1994. © ARS, New York and DACS, London 2004.)

PLATE 5.15
Pablo Picasso,
Girl before a Mirror,
1932, oil on canvas,
162 × 130 cm.
(Collection, Museum
of Modern Art, New
York. Gift of Mrs
Simon Guggenheim.
Photo: Saichi Sunami.
© 2002 DIGITAL IMAGE,
The Museum of
Modern Art, New
York/Scala, Florence.
© Succession
Picasso/DACS,
London 2004.)

of poured lines of paint suggests both an ejaculatory (stereotypically masculine) method of applying paint and a "decorative" (stereotypically feminine) pattern of threadlike lines'.[17] A further issue is how we regard Pollock's views of the genesis of his work, given his claim in 1947 that 'the source of my painting is the unconscious'.[18] Although Jungian references to universal, trans-historical archetypes permeated the work of the Abstract Expressionists, we need to remember that these were beliefs produced within a specific historical context. We must look elsewhere in order to explain the drip paintings as something other than a validation of Pollock's view of the unconscious. One suggestion draws on Freud's ideas about language and subjectivity. Rather than becoming visible through preformed symbols, the presence of the unconscious is revealed in its ability to erupt into conscious thought and break open any sense of a seamless, uncontradictory experience of reality. Maybe, in the case of at least some of these paintings, it is the embedded evidence of gender instability itself that is the most explosive, given the rhetoric of heroic masculinity by which the figure of Pollock has been enveloped.

Identity and the performative

I now want to develop the discussion of gender identity as performative, as a means of further understanding the operation of notions of masculinity in Abstract Expressionism. The category of the performative has emerged in recent cultural theory, not just in relation to ideas of the theatrical, but with regard to more inclusive concepts of meaning as something that is enacted rather than pre-given.[19] This also needs to be seen in relation to debates about identity, in which notions of subjectivity are increasingly recognised as both fluid and contingent. In this context, the notion of performance may be usefully defined as:

> conventionally something constructed, something with a gap between what we see and what we think might be its, invisible, origin. However, the theorising of performance … calls into question any such boundary between 'staged' performances as a separate sphere and everyday enactment or performance of self, and in so doing problematises authenticity, identity and origins.[20]

We can then begin to understand the various identities taken up by artists as constructed not just through representational features of their painting, but also through their enactment, as individuals, of certain fantasies of gender in their daily lives. These 'enactments' can be seen to contribute to the formation of their subjectivity as artists at a given historical moment, frequently reinforcing identities that, I would argue, are also in a sense performed within the art they produce. The advantage of theories of performativity is that they allow us to challenge notions of gender, sexuality and identity as fixed and predetermined. Because of this, they have become a major component of what in the 1990s became known as 'Queer Theory', which calls into question the stability of both heterosexual and homosexual identities. Judith Butler has developed the concept of the performative from the work of Michel Foucault to argue that ideas of gender and the experience of our bodies are liable to change according to the discursive formations – systems of meaning – that they encounter. These, in turn, provide stability for our gendered identity, albeit only temporarily. What it is to be male or female, in other words, is framed within a certain set of historical conditions and given meaning in relation to them through the enactment of certain ideas of masculinity or femininity, often at an unconscious level. In Butler's words, 'there is no gender identity behind the expressions of gender … identity is performatively constituted by the very "expressions" that are said to be its results'.[21]

Because it allows us to question notions of identity as 'authentic' and signified through a predetermined set of characteristics, the concept of performativity also enables us to reassess issues of gender in Abstract Expressionism. The performance of the self is closely bound up with ideas about our bodies, and how they acquire specific meanings in different contexts. One example here would be the way that some male Abstract Expressionist artists acquired connotations of masculinity through their style of dress. A photograph taken by Namuth during the summer of 1953 depicts Elaine and Willem de Kooning in Willem de Kooning's studio at the dealer Leo Castelli's house on Long Island (Plate 5.16). We should be aware that it actually shows two artists,

one male and one female. What can be seen as Willem de Kooning's aggressive, macho pose, with arms folded across the body and muscles tensed, is also enacted in front of two very different female bodies – that of the woman painted on the canvas and of Elaine de Kooning seated beside it. The significance of her dress should not be overlooked – the pedal pushers and man's shirt help to construct her identity as a Bohemian female artist. Nevertheless, my main focus here is on the enactment of masculinity through a significant feature of Willem de Kooning's clothing: the T-shirt.

As a versatile garment enabling the performance of masculinity in a range of social spaces, from factory to studio to bar, the T-shirt was an important agent in the construction of postwar gender roles. The T-shirt became popular after the USA entered the war in 1942, when it became the standard issue undergarment for the American Navy. After the war, it acquired a range of different uses; its lightweight cotton jersey construction encouraged sweat absorption, making it ideal for workers in heavy industry. At the same time, a number of, sometimes conflicting, signifiers of masculinity became attached to the garment – although identified with the remasculinised workforce, the T-shirt simultaneously acquired more subversive meanings as it moved into gay cultures and Bohemia. The way the T-shirt defined the body's muscularity implicated it in the performance of an eroticised masculinity; publicity stills for the film *A Streetcar Named Desire* (1951) notably featured Marlon Brando in a T-shirt. Its adoption by Abstract Expressionist painters such as Pollock, de Kooning and Kline helped to reinforce their identification with working-class masculinity, suggesting thereby that their paintings were produced through hard labour. It also simultaneously served to secure their identity as

PLATE 5.16
Hans Namuth, *Elaine and Willem de Kooning*, 1953, photograph. (© 1991 Hans Namuth Estate, Courtesy Center for Creative Photography, The University of Arizona. © Willem de Kooning Revocable Trust/ARS, New York and DACS, London 2004.)

Bohemian and anti-bourgeois. Such constructions of identity were not universal among male painters at the time. The construction of other Abstract Expressionist masculinities was also signified by dress. Photographs of Rothko and Newman frequently show them wearing a suit or a shirt and tie, in a performance of the self that may be regarded as continuous with the profound intellectual engagement with the sublime in their paintings.

We also need to consider the issue of representational strategies as performative: in other words, the constitution of Abstract Expressionist identities through the themes and practices incorporated in picture making. It can be quite challenging to apply these types of reading to the abstract paintings of an artist such as Still, who is relatively marginalised by comparison with, say, Pollock or Rothko, but whose practice engaged with similar concerns to those of other Abstract Expressionist painters. In a large untitled painting from 1951 (Plate 5.17), Still used a palette that was mainly restricted to mottled black and purple, with highlights of a tonal range including white, cream, ochre and orange. Even in a reproduction it should be possible to get a sense of the textural qualities of the surface – Still tended to apply his pigment with a palette knife instead of a brush. There is also a strong emphasis on vertical elements of the composition, with pools of colour overlapping and leaking into each other. Absence of figuration, increased size, a simplification of pictorial elements, and an emphasis on their verticality within the composition, were all features that had come to characterise Still's work from the late 1940s. Like Rothko and Newman, Still was interested in the development of a pictorial language capable of evoking the sublime; his abandonment of titling from as early as 1938 also served to direct the viewer's response towards the more expressive attributes of his paintings.

Throughout his life, Still was notoriously secretive, and almost fanatical about controlling access to his paintings. Very few left his studio, and he preferred them to be exhibited as an autonomous entity, in isolation from the work of other artists. With this in mind, he made two substantial bequests of his work during his lifetime. In 1964, he gave thirty-one paintings to the Albright-Knox Gallery in Buffalo, and in 1974, he donated a further twenty-eight to the San Francisco Museum of Modern Art. Six years after his death in 1980, Still's widow gave a further ten works to the Metropolitan Museum of Art in New York, where they are currently displayed in a separate gallery. Still was also highly suspicious of the critical discourse surrounding art, particularly art history – somewhat ironic in the light of his master's thesis on Cézanne submitted to Washington State University in 1935. What is more, he was not above making fantastical death threats against anyone who challenged his work; in a letter of May 1951 he claimed 'I will feed any man, give him a bed or my shirt. But let him touch my work, my spirit, and his blood will be on his own hands.'[22] Clearly, Still went to great lengths to attempt to control the meanings of his paintings – his version of the sublime had a basis in specific experiences and cultural references that, I want to suggest, also informed the enactment of identity.

Far more than either Rothko or Newman, Still's references to the sublime were specifically American. Like Pollock, he spent part of his childhood in the north-west of the USA. Soon after his birth, in 1904 in North Dakota, his

PLATE 5.17 Clyfford Still, untitled painting, 1951, oil on unprimed canvas, 239 × 208 cm. (Museum of Modern Art, New York. Blanchette Rockefeller Fund. DIGITAL IMAGE © 2003 The Museum of Modern Art, New York/Scala, Florence.)

family, who were farmers, moved to Spokane in Washington state before settling in Alberta when he was six years old. Both the inhospitable terrain of the badlands and the vastness of the Canadian prairies can be seen as informing the scale and surface of Still's works, in addition to their engagement with pictorial space.[23] The contradiction inherent in the human struggle to survive in these conditions – the need both to dominate nature and to recognise a dependence on it – also informed his preference for highly contrasting and frequently jarring colour combinations. A sense of identity as defined by the

PLATE **5.18**
Clyfford Still, untitled painting,
1934, oil on canvas,
150 x 84 cm. (San Francisco
Museum of Modern Art.
Gift of the artist.
Photo: Ben Blackwell.)

land itself became embedded in Still's practice from early on – a painting
from 1934, for example, depicts an earth-coloured male figure striding across
a barren landscape (Plate 5.18). Even at this stage there is a concern with the
verticality that became a predominant formal characteristic of his later work.
Still made this clear in a later statement that linked the human relationship
with the flatness of the prairies to his interests as a painter: 'For in such a land
a man must stand upright, if he would live … And so was born and became
intrinsic this elemental characteristic of my life and work.'[24]

However, in our understanding of gender identity in relation to Still's practice
we should be wary of reducing vertical elements to phallicity alone; what is
more important is the way that an upright masculinity, emerging from the
ground of the painting, can be regarded as an organising principle throughout
his work. As an excerpt from a letter by the artist to the writer Ed Cahill and
his wife in 1954 makes clear, verticality for him was identified with survival in
a hostile universe:

> Scream of the child kicking out of the womb, shriek of a madman
> challenging the mountains. But somewhere in a crack between fate
> and the categorical imperatives a man's hand, or will, or cry rises, and
> in that moment is born that from which I would not turn away – that
> which gave you the courage and will to write … and for me to put
> forth my visions on canvas … And on to the next, and the next –
> A frightening infinity isn't it? That of 'the life,' rather than the symbol.
> The vertical rather than the horizontal; the single projection, instead of
> polarities; the thrust of the flame instead of the oscillation of the wave.[25]

By the early 1950s, the relationship between figure and ground in Still's work
had become less distinct. This was closely related to his particular engagement
with the primitive, which, from about the mid-1940s onwards, began to emerge
in his paintings in a very different form from how it appeared in the work of
Pollock or Rothko. Still's earlier work drew on Native American imagery in
a manner similar to Pollock's, but in the mid-1940s the concept of the primitive
in his paintings underwent a significant change: rather than being a source of
imagery, it became more closely identified with pictorial structure and the
use of colour. In the rich earthy tones that characterise many of his works,
the physical presence of layered pigment becomes a metaphor for the
geological features of the rough terrain so central to the frontiersman identity
enacted in his work. Landscape becomes ground, and in Still's works of the
mid-1940s, such as *1945–H* (Plate 5.19), it becomes increasingly difficult to
differentiate the figure from the paint that surrounds it. Stephen Polcari has
suggested that this fusion of signs of the human and the organic in Still's practice
is closely related to the interests of the anthropologist Lucien Lévy-Bruhl,
who argued that 'primitive' cultures considered human and nature as
inseparable within a spiritual continuum.[26] In Still's work, probably even more
than in Pollock's, the primitive is closely linked to a conflation of frontiersman
and shaman. The concepts of psychic and physical regeneration derived from
his awareness of Native American cultures of the north-west were important
for Still. Within these cultures it was the figure of the shaman – usually male
– who stood apart from society and between material and spirit worlds.
It was his role to manipulate and interpret the primordial forces of the natural
world in psychic terms, and an important part of shamanic training was the
development of the inner resources necessary to avoid being overwhelmed
by the powers he had to confront. There is evidence that Still saw his practice
in similar terms. Not only did he own a large collection of tribal art, but in a
letter to the dealer Sidney Janis he stated:

> The forces I generate and externalize can be used to many ends.
> My concern is that they be not so turned against me that I cease to be
> able to extend their intensity and clarity, or that I be made a victim of
> the tensions and complexes that lash or impale so many others.[27]

PLATE **5.19**
Clyfford Still, *1945–H*, 1945, oil on canvas, 229 × 176 × 4 cm. (San Francisco Museum of Modern Art. Gift of the artist. Photo: Ben Blackwell.)

In his performance of an identity appropriated from Native American culture, Still appeared to displace the shaman's magical powers from prairie to picture plane. This was a process that continued in his work of the 1950s and beyond. By this stage, Still, like many other Abstract Expressionists, had considerably increased the size of his paintings, a move that began to allow the full play of relationships of colour in his work. In Still's paintings of this period, such as the untitled work from 1951 considered previously (Plate 5.17), the apparent indeterminacy of meaning, I would suggest, allows compositional features to be read as sites of the enactment of a masculine identity on different levels. The texture and colour of Still's thickly layered surfaces are evocative of the remote geological terrain. Upright forms suggest spatial ambiguity, but in reference to Still's earlier work they can also signify the absorption of the male figure in the vast landscape. Areas of black open up the suggestion of a void beyond, an interpretation strongly associated with the sublime, encoded

as masculine within Abstract Expressionism. Yet there is also a degree of ambiguity here. Black was a colour that Still strongly associated with fertility; the lacerations of white and orange in the top right of the painting also evoke penetration, in turn suggestive of the primordial drama of fertilisation and rebirth. The strategies of Abstract Expressionist painters that Rosenberg identified as existential dramas fought out in the arena of the canvas, in Still's hands were stripped of their reference to contemporary philosophy and transposed to a domain of the primitive, as a representation of shamanic conflicts on a universal plane.

Still's work demonstrates just one example of the enactment of various forms of masculine identity within Abstract Expressionist painting. But representation was also the site of the male artist's engagement with fantasies of femininity, and the depiction of women by men generally corresponded to terms established in Jungian discourse. The focus on the Jungian-identified primitive encouraged a plethora of images of mythical and mystical female figures, such Gottlieb's *The Sorceress* (1947). Rather than being idealised, however, these are seen as destructive, evoking the archetypal horror of the devouring mother. In many ways they reiterate a fear of women current in postwar American culture, displaying an ambivalence similar to that in *film noir*, in examples such as Barbara Stanwyck's role as the seductive but murderous Phyllis Dietrich in *Double Indemnity* (1944). Much discussion of the construction of woman as 'other' to Abstract Expressionist forms of masculinity has focused on paintings by Willem de Kooning, particularly *Woman I* of 1950–2 (Plate 5.20). This was one of the works shown by de Kooning in his exhibition entitled 'Paintings on the Theme of the Woman' at the Sidney Janis Gallery, New York, in 1953. It was preceded by a series of depictions of single female figures that he produced throughout the 1940s. Significantly, some of these figures are less explicitly identified with mythological themes of femininity; in early paintings such as *Seated Woman* of c.1940 (Plate 5.21) they wear contemporary dress, although clothing is less clearly defined in examples from the late 1940s. The exercise below should begin to provide a sense of the extent to which the critical discourse about Abstract Expressionism has been permeated by Jungian theory.

Please read the following extracts from critical responses to de Kooning's *Women* paintings of the 1950s. What kinds of reading do they provide for the painting *Woman I*?

Clement Greenberg

… in any case, he remains a late Cubist. And then there is his powerful, sinuous Ingresque line. When he left outright abstraction several years ago to attack the female form with a fury greater than Picasso's in the late '30s and the '40s, the results baffled and shocked collectors, yet the methods by which these savage dissections were carried out were patently Cubist. De Kooning is, in fact, the only painter that I am aware of at this moment who continues Cubism without repeating it.[28]

PLATE **5.20** Willem de Kooning, *Woman I*, 1950–2, oil on canvas, 193 × 147 cm. (Museum of Modern Art, New York. Purchase. DIGITAL IMAGE © 2002 The Museum of Modern Art, New York/Scala, Florence. © Willem de Kooning Revocable Trust/ARS, New York and DACS, London 2004.)

Robert Rosenblum

Confronted with the hurricane force of de Kooning's 'Women' series of 1950–53, we … feel that the spirit of the Stone Age Venuses of Willendorf or Lespugue … lies at the root of this art, as do many ancient Mesopotamian figures, which, with their bug-eyed stare and threatening frontality, de Kooning has acknowledged … as influences. … And as for painterly mutilation, there is always the example of Chaim Soutine, whose 1950 retrospective at the Museum of Modern Art would have supported de Kooning's audacity in handling pink and red paint as if he were a wrestler or a rapist attacking resistant flesh.[29]

Carol Duncan

De Kooning's *Women* are exceptionally successful ritual artifacts and masculinize the [Museum of Modern Art's] space with great efficiency … The ambiguity of the figure, its power to resemble an awesome mother goddess as well as a modern burlesque queen, provides a fine cultural, psychological, and artistic field in which to enact the modern myth of the artist-hero – the hero whose spiritual ordeal becomes the stuff of ritual in the public space of the museum.[30]

Michael Zakian

Even his great *Woman* images of the 1950s – often interpreted as fierce bitch-goddesses – lack character … He was troubled that 'woman' has no clear meaning, no firm identity in our culture. He painted schematic images of the female figure to grasp a fleeting impression that was captivating but which had no real substance.[31]

Greenberg's account establishes a formalist agenda for de Kooning and situates him primarily in relation to European painting – both the shallow space and the ambiguous relationship between figure and ground could be seen as inviting comparisons with Cubism. However, Greenberg's modernist priorities still contain a sense of violence done to the figure, which is even more apparent in Rosenblum's essay, written some thirty years later. Rosenblum makes explicit a dominant view of de Kooning's *Women* images, which conflates the deconstruction of the represented body with the enactment of violence on the bodies of actual women. Both Rosenblum and Duncan indicate what may be seen as the ambivalent construction of femininity in these images with reference to the female deities with which the Jungian female archetype is associated, although in somewhat different terms. Rosenblum's account seems to articulate what Freud identified as an ambivalent relation to the maternal body, both as idealised and as a source of horror. Duncan's statement, meanwhile, recognises these meanings invested in the female body but moves beyond the terms of idealisation and abasement. *Woman I*, in her account, becomes recognisable both in terms of its contemporaneity, and as having a further cultural significance in the construction of gendered narratives within the institution of the museum. Zakian, finally, points to the instability of meaning in these paintings. He appears to imply that their meanings only seem to settle when they are anchored in some particular identity out of the variety on offer for 'woman' in our culture. ∎

PLATE 5.21
Willem de Kooning,
Seated Woman,
c.1940, oil and
charcoal on masonite,
137 × 91 cm.
(Philadelphia Museum
of Art. The Albert M.
Greenfield and
Elizabeth M.
Greenfield Collection.
© Willem de Kooning
Revocable Trust/ARS,
New York and DACS,
London 2004.)

What is interesting about this sample of the critical discourse surrounding the *Women* paintings is the emergence of key themes of violence and horror. In fact, there was little difference between Rosenblum's response and those of some of de Kooning's earlier reviewers. In 1954, for example, Andrew Ritchie clearly identified the terms of reference at that time: 'De Kooning's Eves, Clytemnestras, Whores of Babylon, call them what you will, have universality, an apocalyptic presence that is rare in the art of any time or any country.'[32] What is it about a painting such as *Woman I* that has prompted this type of response ever since it was first exhibited? The female figure's staring eyes, exposed teeth and prominent breasts confront the viewer in a

manner reminiscent of Picasso's *Les Demoiselles d'Avignon*, while the body appears further distorted by the extended shoulders and foreshortening of the lower torso. The relationship between figure and ground introduces a further consideration of gender; the classic grid structure that surrounds the figure is recognisably encoded as masculine, in contrast to the grotesque, uncontrolled female body that erupts within it. Such a representation disturbs conventional paradigms of female beauty. The point is, however, that in the context of Abstract Expressionism, this anti-idealism has become fixed and given a stability of meaning, primarily through Jungian discourse, as the 'other' side of the female archetype – an interpretation that has proved to be remarkably durable in reading de Kooning's *Women* images. It is these anti-idealistic attributes of the universal female ('Eve, Clytemnestra …') that become the main terms of reference for these works, despite de Kooning's inclusion of elements legible in terms of their contemporaneity – the wedge-heeled shoes with ankle straps in *Woman I*, or the subject matter of *Woman and Bicycle* of 1952–3. In fact, Jungian interpretations of the *Women* images have been further stabilised through statements by the artist: for example, he retrospectively compared them to the Mesopotamian statues cited by Rosenblum,[33] and, more enigmatically, he said 'Maybe I was painting the Woman in *me*', referring to the Jungian notion that identity is composed of both male and female principles, animus and anima.[34]

So, the enactment of masculine identities in Abstract Expressionism took place within what could be thought of as two main sites: social and pictorial. The construction of a social identity was dependent on a range of different factors. These included the meanings of clothing, such as the T-shirt as a highly mobile signifier of postwar masculinity, and the enactment of certain forms of macho behaviour and the proscription of others, for example the display of vulnerability. These aspects of masculinity need to be seen in conjunction with the articulation of masculine identity in pictorial practice, which could also take a variety of forms. These range from, on one hand, the appropriation of the primitive in Still's large abstract works to, on the other, the painting as the site of projection of male fantasies of femininity corresponding to Jungian archetypal definitions in de Kooning's *Women* paintings. All of these factors would have consequences for the position of women Abstract Expressionist painters.

Women artists, identity and the gendered gesture

The emphasis on polarised, archetypal gender roles in Abstract Expressionist practice combined with the more conservative cultural climate of postwar USA made the situation of women artists quite problematic. The identification of Abstract Expressionist painting with the enactment of masculinity meant that women painters such as Lee Krasner, Elaine de Kooning and Joan Mitchell had to develop strategies for dealing with their position. As with the male artists, we need to consider both social constructions of artistic identity and pictorial practice.

Both Krasner and de Kooning were married to Abstract Expressionist painters – Krasner married Pollock in 1945. The problem encountered when dealing with Krasner's work is that in critical terms she seems, in Anne Wagner's words, 'certainly to have been unable to escape identification with Pollock'.[35] One issue has been her representation in biographical accounts, such as the sensationalist misogyny of S. Naifeh and G.W. Smith's *Jackson Pollock: An American Saga* (1989), on which the Hollywood feature film *Pollock* (2001) was largely based. Here she frequently appears as a jealous manipulative wife, rather than as a productive artist in her own right. By the early 1940s, however, Krasner was increasingly establishing a reputation as a radical abstract painter in New York. She was a friend of both Willem de Kooning and Rosenberg, having met the latter when they both worked on a Works Progress Administration (WPA) scheme in the late 1930s and she was studying at Hans Hofmann's School, where Hofmann had praised her paintings with the dubious accolade that 'this is so good you wouldn't know it was painted by a woman'.[36] In 1942, though, after visiting Pollock's studio to view his work for the first time, Krasner began to promote his career at the expense of her own, even to the extent of addressing envelopes for his shows with Peggy Guggenheim from 1943 onwards. In 1945, after the couple moved to East Hampton, Krasner's supportive role continued as she helped Pollock deal with his alcoholism. Pollock needed this support even more after the 1949 article in *Life* magazine asked 'Is he the greatest living painter in the United States?', and he was thus subjected to considerable pressure to maintain this position. Something of this homely nurturing identity is present in the photographs of the woman in the unflattering plaid dress pictured with Pollock in some of Namuth's photographs (Plate 5.5). Yet Krasner's appearance in these photographs can also be seen as related to the staging of an identity in response to Pollock's belief in the Jungian view of the unconscious; Krasner seems to have acted out the Jungian female archetype to some degree, as the nurturing, supportive Earth Mother. Certainly her work from shortly before and for a period after Pollock's death engaged with Jungian mythical themes, with titles such as *Prophecy* (1956) (Plate 5.2) and *Gaiea* (1966), named after a Greek Earth Goddess.

Despite his comment that 'she's talented plenty, but great art needs a pecker',[37] in private Pollock valued Krasner's opinion; on one occasion he famously asked her 'Is this a painting?'[38] Much of Krasner's own work from the mid-1940s until the end of the following decade involved some kind of dialogue with Pollock's practice, although consistently in the interests of the production of her own position as an artist. At some points during the 1950s, this engagement could be confrontational: her *Collage* of 1955 (Plate 5.22) includes sections of Pollock's discarded canvas worked into the spatial ambiguity of the composition. This dialogue first appeared in what Krasner entitled the *Little Image* paintings from the late 1940s. Although employing the same all-over format as Pollock's work, many of these utilise a grid system to organise the composition, derived from Krasner's interest in both Piet Mondrian and the contemporary Uruguayan painter Joaquín Torres-García.

Despite the considerable differences in size, scale and priorities, when a selection of the *Little Image* paintings were exhibited for the first time at a show significantly entitled 'Artists: Man and Wife' at the Sidney Janis Gallery

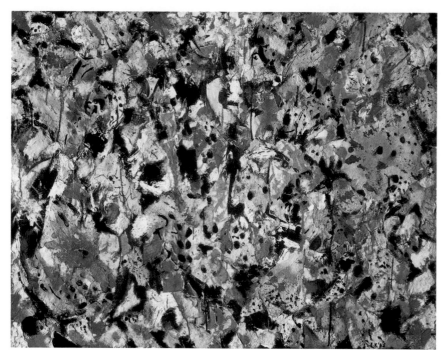

PLATE **5.22**
Lee Krasner, *Collage*,
1955, oil and paper on
board, 77 × 103 cm.
(Courtesy Robert
Miller Gallery. © ARS,
New York and DACS,
London 2004.)

in 1949, Krasner's work was reviewed in the journal *Art News* in terms
that firmly reinstated her subordination to Pollock: 'There is a tendency among
some of these wives to "tidy up" their husband's styles. Lee Krasner
(Mrs Jackson Pollock) takes her husband's paints and enamels and changes
his unrestrained, sweeping lines into neat little squares and triangles.'[39] Yet it
is important to retrieve Krasner from this restrictive categorisation, in order
to provide a sense of the subtlety of her work. Many of the *Little Image*
paintings, such as *White Squares* (*c.*1948) (Plate 5.23), incorporate
hieroglyphic signs, similar to the primitivism of Gottlieb's work of the early
1940s. However, there are other possible meanings; as a child of Russian
Jewish immigrants, Krasner was taught to read Hebrew, although she
subsequently lost the ability to interpret Hebraic script. Its encoded assimilation
into works such as *White Squares*, I would suggest, invites more complex
readings in terms of other aspects of Krasner's identity, of a hybridised
engagement with a diasporic Jewish culture. Krasner, therefore, begins to
emerge as an artist involved in a relationship not just with Pollock's work,
but with a range of other representational strategies in the dynamic generation
of her own distinctive form of practice and identity.

Other women artists, such as Elaine de Kooning, developed different strategies
for negotiating the hegemony of masculinity in Abstract Expressionism. For
several, this involved the blurring of gender identity in the public act of naming.
Krasner, who had already changed her name from Lenore to the more
androgynous Lee, went through a period in the late 1940s of signing her
work 'L.K.'; Elaine de Kooning showed her work as E. de Kooning at this time,
while Grace Hartigan's first exhibition, at the newly formed Tibor de Nagy
Gallery, New York, in 1951, was under the name of George. Although she
subsequently claimed that this was because of her interest in the nineteenth-
century women writers George Eliot and George Sand, the effect was still
one of negating her gender within the public domain, at a time when this

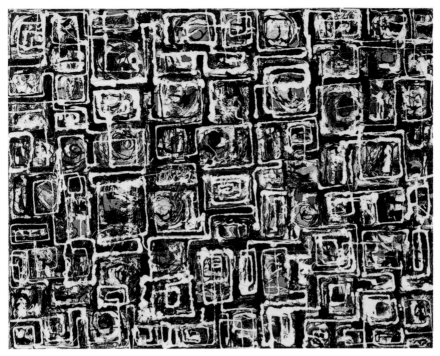

PLATE 5.23 Lee Krasner, *White Squares*, c.1948, oil on canvas, 61 x 76 cm. (Whitney Museum of American Art, New York. Gift of Mr and Mrs B.H. Friedman 75.1. Photo: Geoffrey Clements; photographic copyright: The Whitney Museum of Modern Art, New York. © ARS, New York and DACS, London 2004.)

space was highly masculinised.[40] Elaine de Kooning was active as an artist and as an art critic from the late 1940s. Some aspects of her practice in both areas were similar to that advocated by Rosenberg; her artist's statement of 1959 claimed 'A painting to me is primarily a verb, not a noun – an event first and only secondarily an image.'[41] However, from 1949, de Kooning's regular reviews and essays published in *Art News* and elsewhere helped to map out a position distinct from the increasingly polarised stances of Greenberg and Rosenberg. Her closely observed, accessible accounts of contemporary painting – such as her requiem for Kline after his death in 1962 – were also informed by her awareness as a painter of the work involved in the studio.[42] For de Kooning, the gesture was fundamental to her understanding of contemporary art practice and to her own work. In the 1950s, much of her practice involved the depiction of male figures, such as the painting *High Man* of 1956 (Plate 5.24). However, making masculinity the subject of her painting also involved her in the appropriation of paradigmatically masculinist painting strategies: as when her use of gesture (which was initially identified with the body of the male artist) is turned back upon the depiction of male bodies. In discussing similar works, such as the portrait of Willem de Kooning, *Bill at St. Marks*, she later stated: 'I see everything as possessing or possessed by gesture. I've often thought of my paintings as having an axis around which everything revolves … When I painted my seated men, I saw them as gyroscopes.'[43]

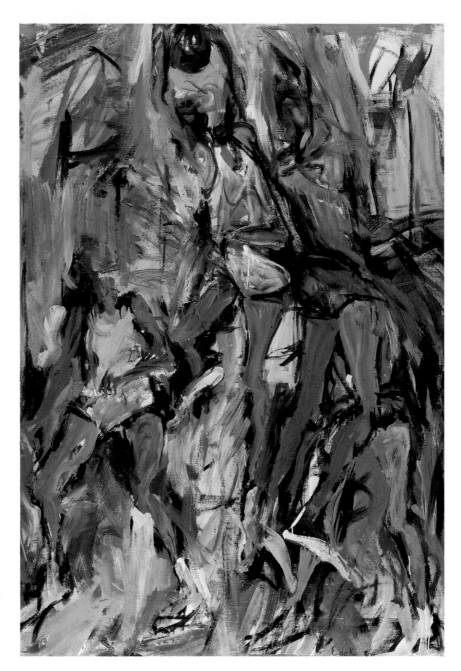

The appropriation of the masculine-encoded gesture was a strategy also adopted by Mitchell. Like Elaine de Kooning, she avoided any engagement with the mythic and Jungian connotations that anchored women to reductive archetypes. Mitchell's abstract painting *Maize* of 1955 (Plate 5.25) shows evidence of a knowledge of the work of Wassily Kandinsky, Arshile Gorky and Willem de Kooning in its all-over approach to the surface, from which organic forms seem to emerge. This is not the de Kooning of the *Women* paintings, already in formation in the late 1940s; instead, she had looked closely at his more abstract works, for example *Attic* of 1949 (Plate 5.26)

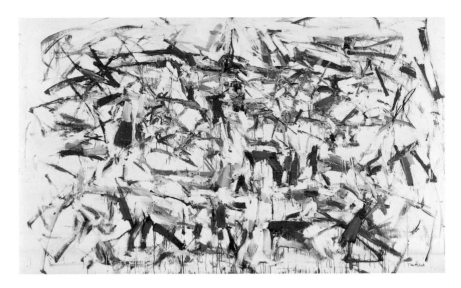

and *Excavation* of 1950 (see Plate 4.5), which downplay such reductive views of femininity.[44] In *Attic*, figuration has been largely reduced to a kind of biomorphism, dispersed across a surface that appears to be deceptively underworked, but is actually built up from oil, enamel and newspaper transfer. Mitchell's incorporation within her work of features of a masculine discourse continued during the 1950s with a more overt appropriation of the gesture, derived from her understanding of Kline's black-and-white paintings. In the monochrome works such as *Painting Number 2* of 1954 (Plate 5.4), Kline's draining of colour focuses attention on the brushstroke; in the context of sexual difference, the exaggerated gesture seems almost hyper-masculine, excessive and barely contained within the picture frame. Significantly, it was Kline's use of the gesture, rather than Willem de Kooning's or Pollock's, that Mitchell appropriated. Incorporated into her own practice, as in an untitled painting from 1958 (Plate 5.3), this becomes legible, I would suggest, as a kind of 'drag act'. This implies a process whereby the female artist performs a more ambiguous identity, signified through assumption of the exaggerated characteristics of the male. Indeed, such a reading is continuous with the social identity enacted by Mitchell as an Abstract Expressionist painter. In the Cedar Tavern or the Artists' Club (where she was one of the few female members), Mitchell notoriously adopted the macho postures more commonly associated with the male artists: hard-drinking, belligerent and non-monogamous.[45]

Mitchell's acceptance by her male counterparts was, of course, not just a result of her ability to hold her own in a bar-room. As a resolutely abstract painter she was also working in a form that, in the early 1950s, was encoded as masculine not just through the associations of the gestural brushstroke but because of its supposed ability, as in Rothko's engagement with the sublime, to address the underlying tragic themes of western culture. Women artists whose work was more figurative experienced problems in addition to more overt prejudices relating to gender, in that their work was seen as incapable of engaging with such grand meta-narratives. Hartigan, for example, had initially

PLATE **5.26** Willem de Kooning, *Attic*, 1949, oil, enamel and newspaper transfer on canvas, 157 × 206 cm. (Muriel Kallis Steinberg Newman Collection, jointly owned by The Metropolitan Museum of Art and Muriel Kallis Newman, in honour of her son, Glenn David Steinberg, 1982. 1982.16.3. Photo: 1986 The Metropolitan Museum of Art. © Willem de Kooning Revocable Trust/ARS, New York and DACS, London 2004.)

shown abstract paintings at the 1950 'New Talent' show at the Sam Kootz Gallery, New York; when her work subsequently became more figurative, she lost the support of such figures as Pollock and Rothko. In the masculine space of the New York art world of the early 1950s, the supportive friendships that existed between women artists were very important, though relations between them were frequently competitive. Hartigan's later description of her relationship with Frankenthaler gives an indication of the contradictions involved:

> Helen's argument with me was that I was using imagery and I should be abstract. My argument with her was that her paintings looked as though she had painted them between cocktail time and dinner … There was bitchery in this wonderful world that we were living in, but we needed each other. Your best friend would put a knife between your shoulder blades.[46]

Conclusion

Regarding Abstract Expressionism in gendered terms throws light on a range of key themes and practices in the work of these artists. The most obvious is probably the significance of the gesture, primarily associated with the work of Pollock. As a signifier of masculinity, the gesture helped to establish dominant readings of masculinity, which, in turn, had to be negotiated by women artists such as Krasner and Mitchell in relation to their own practice. Gendered identities in Abstract Expressionism, however, were formed at other levels as well. The pervasiveness of Jungian ideas conflated the unconscious and the primitive, providing a basis for the articulation of polarities of gender in different ways. In the work of Still, for example, these became stabilised around a kind of existential masculinity, enacted within his large abstract paintings; de Kooning's *Women* paintings, by comparison, can be seen as the site of the production of male fantasy, with the female image as the embodiment of an ambivalent archetypal 'other'. Increasingly, masculinity is regarded by cultural theorists as a relatively fluid construct, a gendered identity enacted at levels of which people are not necessarily conscious, but which help to provide meaning for a range of different contexts. Despite the Jungian claims to universality that helped to give form to a range of Abstract Expressionist masculinities, one of the final ironies is that these now appear to have been historically contingent.

Notes

1 Greenberg, ' "American-Type" Painting' (1955), in O'Brian, *Clement Greenberg*, vol.3, p.225.

2 Rosenberg, 'The American Action Painters' (1952), in Harrison and Wood, *Art in Theory 1900–2000*, VA14, pp.581–2.

3 Orton, 'Action, Revolution and Painting'.

4 Greenberg, ' "American-Type" Painting' (1955), in O'Brian, *Clement Greenberg*, vol.3, p.217.

5 Quoted in Anfam, *Franz Kline*, p.10.

6 Quoted in Naifeh and Smith, *Jackson Pollock*, p.591.

7 Pollock, 'My Painting', p.79.

8 Lieber, *Willem de Kooning*, p.33.

9 Rosenberg, 'The Mythic Act', p.131 (originally published as 'The Art World: The Mythic Act').

10 Newman, 'The New Sense of Fate' (1948), in O'Neill, *Barnett Newman*, p.165.

11 Leja, *Reframing Abstract Expressionism*, p.57.

12 Leja, 'Barnett Newman's Solo Tango'.

13 Quoted in Ashton, *About Rothko*, p.45.

14 See, for example, Jung, 'Approaching the Unconscious'.

15 Pollock (1956), quoted in Rodman, *Conversations with Artists*, p.82.

16 There have been at least two major essays arguing against the validity of Jungian analysis of Jackson Pollock's work: Gordon, 'Pollock's "Bird"' and Rubin, 'Pollock as Jungian Illustrator'.

17 Gibson, *Abstract Expressionism*, p.55.

18 Pollock, 'Draft of *Possibilities I* Statement' (1947), in Harrison, *Such Desperate Joy*, p.23.

19 Jones and Stephenson, *Performing the Body*.

20 Brook, 'Performance and Spectacle', p.113.

21 Butler, *Gender Trouble*, p.25.

22 Still, from a letter to a friend (May 1951), in *Clyfford Still*, pp.119–20.

23 Anfam, 'Clyfford Still's Art', pp.31–2.

24 Quoted in *ibid.*, p.24.

25 Still, from a letter to Dorothy and Ed Cahill (1954), in *Clyfford Still*, pp.121–2.

26 Polcari, *Abstract Expressionism and the Modern Experience*, p.103.

27 Still, from a letter to Sidney Janis (1954), in *Clyfford Still*, p.121.

28 Greenberg, '"American-Type" Painting' (1955), in O'Brian, *Clement Greenberg*, vol.3, p.222.

29 Rosenblum, 'The Fatal Women of de Kooning and Picasso', p.100.

30 Duncan, 'The MoMA's Hot Mamas' (1989), in *The Aesthetics of Power*, pp.194, 198–9.

31 Zakian, 'A Critic of Modernist Idealism', p.11.

32 Quoted in Cateforis, *Willem de Kooning's 'Women' of the 1950s*, p.146.

33 Willem de Kooning, quoted in Sylvester, 'de Kooning's Women: Interview with Willem de Kooning' (1969), in Shapiro and Shapiro, *Abstract Expressionism*, pp.226–8.

34 Conversation with de Kooning, in Rodman, *Conversations with Artists*, p.102.

35 Wagner, 'Krasner's Presence', p.223.

36 Hofmann, quoted in Wagner, *Three Artists (Three Women)*, p.115.

37 Potter, 'Jackson Pollock: Fragments of Conversations and Statements 1949–1956', in Harrison, *Such Desperate Joy*, p.91.

38 Friedman, 'An Interview with Lee Krasner Pollock', unpaginated.

39 Quoted in Wagner, 'Krasner's Presence', p.224.

40 Hartigan, quoted in Nemser, *Art Talk*, p.129.

41 Elaine de Kooning, 'Statement' (1959), in *The Spirit of Abstract Expressionism*, p.175. This essay is reprinted in Gaiger and Wood, *Art of the Twentieth Century*.

42 Elaine de Kooning, 'Franz Kline – Painter of his Own Life' (1962), in *The Spirit of Abstract Expressionism*, pp.189–99.

43 Elaine de Kooning, 'Statement' (1959), in *The Spirit of Abstract Expressionism*, p.176.

44 *Attic* does not avoid them completely. Although it is practically impossible to see this in reproduction, the bottom left corner contains a transfer from a newspaper image of a swimsuit-clad pin-up imprinted on the canvas; her face is partially obscured, drawing more attention to her body.

45 Kertess, *Joan Mitchell*, p.21.

46 Hartigan, quoted in Nemser, *Art Talk*, pp.145–6.

References

Anfam, D., 'Clyfford Still's Art: Between the Quick and the Dead', in J.T. Demetrion (ed.), *Clyfford Still Paintings 1944–1960*, Washington: Hirshhorn Museum and Sculpture Garden in association with Yale University Press, 2001, pp.17–42.

Anfam, D., *Franz Kline: Black and White 1950–1961*, exhibition catalogue, The Menil Collection, Houston, 1994.

Ashton, D., *About Rothko*, New York: Da Capo Press, 1996.

Brook, B., 'Performance and Spectacle', in *Feminist Perspectives on the Body*, Harlow: Pearson Education, 1999, pp.111–35.

Butler, J., *Gender Trouble: Feminism and the Subversion of Identity*, London and New York: Routledge, 1990.

Cateforis, D., *Willem de Kooning's 'Women' of the 1950s*, Ann Arbor, MI: UMI Press, 1993.

Clyfford Still, exhibition catalogue, Museum of Modern Art, San Francisco, 1976.

de Kooning, E., *The Spirit of Abstract Expressionism: Selected Writings*, New York: George Braziller, 1994.

Duncan, C., *The Aesthetics of Power: Essays in Critical Art History*, Cambridge: Cambridge University Press, 1993.

Friedman, B.H., 'An Interview with Lee Krasner Pollock', in B. Rose (ed.), *Pollock Painting*, New York: Agrinde, 1980, unpaginated.

Gaiger, J. and Wood, P. (eds), *Art of the Twentieth Century: A Reader*, New Haven and London, Yale University Press, 2003.

Gibson, A.E., *Abstract Expressionism: Other Politics*, New Haven and London: Yale University Press, 1997.

Gordon, D.G., 'Pollock's "Bird" or How Jung Did Not Offer Much Help in Myth-Making', *Art in America*, vol.68, no.8, October 1980, pp.45–53.

Harrison, C. and Wood, P. (eds), *Art in Theory 1900–2000: An Anthology of Changing Ideas*, Malden, MA and Oxford: Blackwell, 2003.

Harrison, H.A. (ed.), *Such Desperate Joy: Imagining Jackson Pollock*, New York: Thunders Mouth Press, 2000.

Jones, A. and Stephenson, A. (eds), *Performing the Body: Performing the Text*, London and New York: Routledge, 1999.

Jung, C.G., 'Approaching the Unconscious', in C.G. Jung and M.-L. von Franz (eds), *Man and his Symbols*, London: Aldus Books, 1964, pp.18–103.

Kertess, K., *Joan Mitchell*, New York: Harry N. Abrams, 1997.

Leja, M., 'Barnett Newman's Solo Tango', *Critical Inquiry*, spring 1995, pp.556–80.

Leja, M., *Reframing Abstract Expressionism: Subjectivity and Painting in the 1940s*, New Haven and London: Yale University Press, 1993.

Lieber, E., *Willem de Kooning: Reflections in the Studio*, New York: Harry N. Abrams, 2000.

Naifeh, S. and Smith, G.W., *Jackson Pollock: An American Saga*, London: Barrie & Jenkins, 1989.

Nemser, C., *Art Talk: Conversations with Fifteen Women Artists*, New York: Icon Books, 1995.

O'Brian, J. (ed.), *Clement Greenberg: The Collected Essays and Criticism*, vol.3: *Affirmations and Refusals, 1950–1956*, Chicago: University of Chicago Press, 1993.

O'Neill, J.P. (ed.), *Barnett Newman: Selected Writings and Interviews*, Berkeley: University of California Press, 1990.

Orton, F., 'Action, Revolution and Painting', in F. Orton and G. Pollock (eds), *Avant-Gardes and Partisans Reviewed*, Manchester: Manchester University Press, 1996, pp.177–203.

Polcari, S., *Abstract Expressionism and the Modern Experience*, Cambridge: Cambridge University Press, 1991.

Pollock, J., 'My Painting', *Possibilities*, vol.1, winter 1947–8, pp.78–83.

Rodman, S., *Conversations with Artists*, New York: Devin-Adair, 1957.

Rosenberg, H., 'The Mythic Act' (1967), in Harrison, *Such Desperate Joy*, pp.129–35.

Rosenblum, R., 'The Fatal Women of de Kooning and Picasso', *Art News*, vol.84, October 1985, pp.98–103.

Rubin, W., 'Pollock as Jungian Illustrator: The Limits of Psychological Criticism: Parts I and II', *Art in America*, vol.67, no.7, November 1979, pp.104–23; no.8, December 1979, pp.72–91.

Shapiro, D. and Shapiro, C. (eds), *Abstract Expressionism: A Critical Record*, Cambridge: Cambridge University Press, 1989.

Wagner, A., 'Krasner's Presence, Pollock's Absence', in W. Chadwick and I. de Courtivron (eds), *Significant Others: Creativity and Intimate Partnership*, London: Thames & Hudson, 1996, pp.222–43.

Wagner, A., *Three Artists (Three Women): Modernism and the Art of Hesse, Krasner and O'Keeffe*, Berkeley and Los Angeles, University of California Press, 1996.

Zakian, M., 'A Critic of Modernist Idealism: de Kooning and Modernism', *Artweek*, 28 March 1991, p.11.

3

PART THREE

American Modernism
in the 1960s

The critical terrain of 'high modernism'

Gail Day and Chris Riding

Introduction

Looking back from 1987, the art critics Barbara Rose and Michael Fried reflected on the debates of the 1960s:

Barbara Rose

If I could sum up the shift that occurred in art and criticism in 1967, it would be the widespread assault on the dogma of modernism as an exclusively optical, art-for-art's sake, socially detached, formalist phenomenon that inevitably tended toward abstraction.[1]

Michael Fried

… the point is that these were issues to fight over, so that if we historicise that moment now we have to see it as a conflictual time, a time when different possibilities were entertained, when the same body of work was seen in different ways, when the future – our now – was in doubt, when you entered the debate in an active way and you fought for what you saw as the truth.[2]

This chapter introduces the painting, sculpture and associated critical paradigm now collectively known as 'high modernism'. High modernism is associated with certain American east-coast art from the late 1950s and 1960s: the paintings of Helen Frankenthaler, Morris Louis, Kenneth Noland, Jules Olitski, Frank Stella, Larry Poons and the sculptures of Anne Truitt (Plates 6.2, 6.3 and 6.4). The work of the English sculptor Anthony Caro is also incorporated, along with the so-called 'New Generation' of sculptors, most of whom, with Caro, taught or studied at St Martin's School of Art, London, in the same period.[3] High modernism is primarily aligned with the later writings of Clement Greenberg and, especially, with the essays of the young art critic Michael Fried. It has been called 'high' because it involves some of the most developed articulations arising from the protocols and preferences established in Greenberg's theorisations of modern art, views that achieved a particular prominence from 1961 when Greenberg published a collection of essays in *Art and Culture*. At its peak, when it had attained its most complex formulations, there coalesced a wave of challenges to high modernism's sense of what the practices of art making, criticism and theory entailed. By the mid-1960s, already simmering disputes crystallised, and 1967 – the year acknowledged in Rose's comment above – marks the watershed.[4] Thereafter, high modernism was, as Fried notes, 'beleaguered' and 'eclipsed', and no longer held the critical summit.[5]

PLATE 6.1 (facing page) Jackson Pollock, detail of *Number 32* (Plate 6.6).

PLATE **6.2** Kenneth Noland, *17th Stage*, 1964, acrylic on canvas, 238 x 205 cm. (Virginia Museum of Fine
Arts, Richmond. Gift of Sydney and Frances Lewis. © Virginia Museum of Fine Arts. © Kenneth
Noland/VAGA, New York/DACS, London 2004.)

The debates that emerged took place in a period when the conditions of art's
production, reception and exchange were perceived to have become
thoroughly institutionalised and commodified. In this respect, a number of
issues are alluded to: the expansion of the art market, the growth of the gallery–
dealer system, the multiplication of galleries, museums and art publications, the
extension within university curricula of art-historical studies and degree-level
programmes in fine art. The increasingly varied approaches to art that developed
through the late 1950s and 1960s could be seen as reflecting the rivalry of
competing niches in a rapidly expanding market. However, reducing matters

PLATE **6.3** Anne Truitt, installation, photograph, André Emmerich Gallery, New York, 1965.
(© Anne Truitt.)

PLATE **6.4** Jules Olitski, (*Twice*) *Disarmed*, 1968, acrylic on canvas, 234 × 540 cm. (Metropolitan Museum
of Art. Gift of Mr and Mrs Eugene M. Schwartz, 1986. 1986.364. Photo: Lynton Gardiner.
Photograph © 1987 The Metropolitan Museum of Art. © Jules Olitski/VAGA, New York/
DACS, London 2004.)

simply to the reflexes of commercial interests does not seem an adequate explanation; as writings from the period convey, there were also strong intellectual, political, moral and aesthetic values at stake.

Fried, in 1987, saw his younger self as defending 'the truth' and artistic values that were 'truly important';[6] Rose, who had once been sympathetic to the sorts of values espoused by Greenberg and Fried, subsequently saw Fried's 'truth' as a dogma. Greenberg's insistence on art as an autonomous process of self-criticism did not gel with the sensibilities that developed later in the 1960s. The radicalisation of opinion generated in the context of the Civil Rights Movement, anti-war protests and an emerging Women's Movement also generated new ambitions for artistic practices. Unable and unwilling to engage sympathetically with much new work – 'far-out' or 'novelty art', as Greenberg called it disparagingly[7] – the high modernist paradigm, as espoused by Greenberg and Fried, was increasingly seen by others to be inflexible and irrelevant. Over the following decades, the challenge to high modernism was substantial and far-reaching. It was criticised for its optical bias (and for downplaying the role of 'tactility' or that of human embodiment in the experience of art, and for its preference for the medium of painting); for its historicism (that is, the assumption that art progresses through a constant process of renewal); for its formalism, its advocation of art's autonomy and its criticism of historical and social interpretation; for its opposition to the analysis of 'content', narrative, symbolism and metaphor in contemporary art; and for presuming that the beholder of modernist art was an undifferentiated universal human subject whose judgements were disinterested. Many art practices and alternative approaches to art history and criticism have since developed on the basis of these critiques.[8]

Yet, almost half a century later, despite being widely perceived as irrelevant, the work of Greenberg and Fried can still elicit hostility. So forceful and successful have the criticisms of them been that it can sometimes be difficult to encounter this body of writing for any purpose other than to set up high modernism's fall from grace. The understanding of the work that Greenberg and Fried supported – the practical and intellectual parameters of which were developed in complex dialogues with the critics' writing and studio visits – has, accordingly, also suffered. As Fried put it: 'I unquestionably, overwhelmingly lost.'[9] Yet high modernism's much-criticised commitment to autonomy forced upon its best representatives certain rigours of thought, and its commitment to charting and explaining artistic development demanded close visual analysis. Unquestionably, high modernism had limitations, but these very limitations also generated highly perceptive explorations of painting and sculpture, which, at their best, opened up a critical language capable of finely nuanced distinctions; at their worst, their category distinctions became simplistic and dichotomous. In this short chapter, our task is to outline some of the specific knowledge and critical language that were developed in the high modernist aesthetic, and, in doing so, we will be staying pretty much within its terms. Focusing on the work of Frankenthaler, Louis, Stella and Caro, we will explore paintings and sculptures that, for many people, are all too often encountered as unapproachable and mute, recovering something of the charge that made this field so disputed.

Illusively intangible: the figurative possibilities of optical space

In a number of articles throughout his career, starting with 'Avant-Garde and Kitsch' (1939) and culminating in the formulations of the notorious 'Modernist Painting' (1960), Greenberg argued that, since the onset of society's modernisation and secularisation, the arts had lost their ritual function and established role in society. As a consequence, art was in constant danger of being subsumed into the modern industries of entertainment.[10] The only way to avert this danger and to defend art's quality – indeed, to *guarantee its value* and survival – he continued, was for each art to engage in an ongoing process of self-definition. This process proceeded by means of self-criticism, and involved the pursuit by each art of its cardinal norms: the conventions that were specific to its medium. In the case of painting, those norms were identified as colour, the shape of the support and, most particularly, the flatness or two-dimensionality of the surface – the last being, in Greenberg's view, the only factor that was utterly unique to painting.[11]

Although high modernist theory has come to be identified with the idea of 'flatness', this did not mean that modernist paintings were to be seen in non-spatial terms. On the contrary, such painting – we will discuss sculpture later – was centrally involved with the complexities of spatial relations. In the 1930s, the painter Hans Hofmann, for instance, had discussed the 'push–pull' effect, the capacity of different colours, tones, forms or textures to appear to advance or recede either within a painting's illusory terrain or, in some cases, even to advance forwards and outwards from the surface of the canvas.[12] Modernist paintings could also complicate the distinction of figures from ground. In this context, the role of the drawn, poured or accidentally produced line also took on fresh implications: its role in delineating form was called into question. In addition, the picture plane might be set loose and appear to hover in front of or behind the literal canvas surface. Painterly composition, focused on these questions, explores various spatial articulations, balancing elements, playing with visual tensions, and attending to their interrelations and mutual inflections. A typical painting puts numerous relations and contrasts into play, making for a complex array of spatial modulations and perceptual ambiguities.

Greenberg argued that all paintings have to deal with the *relation between* three-dimensional spatial illusion (whether through traditional mimetic resemblance to the world or, in modernist work, through the interplay of colours, forms etc.) and the two-dimensionality of their surface (the physicality – or facture – of paint achieved through the various techniques of its application and the quality of the supporting canvas or board). He argued that whereas painting had traditionally weighted that relation towards three-dimensional illusion, modernist painting switched the emphasis, and increasingly drew attention to the canvas's two-dimensional surface. This is what high modernists mean by the 'acknowledgement of' a painting's 'flatness' – and, note, this is not the same as saying that modernist paintings are, or should be, flat. Indeed, possibilities of spatial illusion were, it was argued, operative from the moment the 'first mark' was applied to a fresh canvas. Moreover, modernist painting, Greenberg stated, is not necessarily 'abstract',

or 'non-figurative', and 'has not abandoned the representation of recognisable objects in principle. What it has abandoned in principle is the representation of the kind of space that recognisable objects can inhabit.'[13]

This abandoned kind of space was often referred to with the adjectives 'sculptural', 'tactile' and 'tangible'. The new kind of space, in contrast, was 'optical'. Fried also emphasised that spatial relations in modernist work were 'accessible to eyesight alone, not to touch'.[14] What seems to be at stake is a distinction between two ways of *seeing* paintings and the spaces *represented* in them: one that understands sight as a suspension of, and another that understands it as a means to, an empathic relation with tactility or, as Greenberg put it: 'purely optical experience against optical experience as revised or modified by tactile associations'.[15] Seeing, in this sense, meant that while a painting's surface materiality – its materiality as such – may be important, it must not come to supplant the pictorial whole, and must be subsumed within a painting's illusory space.

Let us examine these issues further. Frankenthaler's *Mountains and Sea* (1952) (Plate 6.5) occupies a canonical place in the high modernist narrative. Frankenthaler saw Jackson Pollock's work (on a visit to his studio with the painter Larry Rivers), and, in turn, Louis and Noland saw her painting (on a studio visit with Greenberg in 1953). Louis credits Frankenthaler with being the crucial bridge between Pollock and the possibilities implied by his paintings.[16] She exploited the use of staining thinned oil paint into unsized and unprimed canvas that was evident in some of Pollock's work (see Plate 6.1 for a detail showing the staining in Pollock's *Number 32* (Plate 6.6)). However, it has also been said that Frankenthaler and Rivers were influenced by what they saw on the back of Pollock's canvases – by the way that the paint had seeped through the fabric to form images on the reverse side of the canvas. The permeation of the cotton-duck's weave by the pigment creates, as Greenberg noted, a new relation between the paint and the supporting surface: the paint no longer sits *on* the canvas; rather it seeps *into* it and they become a single entity.[17]

Louis adapted Frankenthaler's staining technique using new acrylic resin paints (Magna paint), which, when thinned, proved better suited to achieving the degrees of transparency that we see in his *Veil* paintings, such as *Golden Age* (1958) (Plate 6.7).[18] In these paintings, Louis applied a sequence of overlapping coloured waves across and into the canvas, unifying them with a final overarching brown-green wash. According to Fried, however, Louis did not just draw on Frankenthaler's technique, nor did he simply develop her use of colour. He had recognised other potentials in *Mountains and Sea*: Louis had seen that staining was a medium for both *colour* and *figuration*. Most viewers of *Mountains and Sea* feel that they can identify elements of a landscape, especially the sea, which seems to be registered by the blue on the right, which suggests a shoreline and distant horizon. Other elements are less readily identifiable but – in contrast to Pollock's classic drip paintings – Frankenthaler's painting conveys a stronger sense of mimetic figuration. Louis's handling of figuration was, Fried argues, more like Pollock's than *Mountains and Sea*; it is not deployed, say, to describe or imply a landscape but, in Fried's view, to articulate different optical densities. As he saw it, Louis reconciled figuration with (non-tactile) opticality. Staining was 'the means to *a kind of figuration* capable of sustaining a broad gamut of internal articulations all of which are experienced as *illusively intangible*'.[19]

PLATE **6.5** Helen Frankenthaler, *Mountains and Sea*, 1952, oil on canvas, 220 × 298 cm. (Collection of the artist, on loan to the National Gallery of Art, Washington DC. © 2003 Helen Frankenthaler. Image © 2003 Board of Trustees, National Gallery of Art, Washington DC.)

PLATE **6.6** Jackson Pollock, *Number 32*, 1950, enamel on canvas, 269 × 457 cm. (Kuststammlung Nordrhein-Westfalen, Düsseldorf. Photo: Walter Klein. © ARS, New York and DACS, London 2004.)

The overlapping waves of Magna created spatial modulations that registered *transitions* between individual colour washes. 'One might say', wrote Fried, 'that the perception of such a change *is* the perception of figuration.' This was not, to re-emphasise, figuration in the sense of seeing 'some kind of tangible thing' – even the word 'veil' might be misleading if we think of *Golden Age* as mimicking an actual gauze. It is, rather, a new kind of illusively intangible figuration, one that acknowledges the configurations of colour while forestalling our wish to see these configurations as tangible, holding their tactility in aesthetic suspension.

For Greenberg and Fried, the tradition of modernist painting up to this point – and Louis's practice was taken to be exemplary in this respect – had explored the cardinal norm of flatness through optical attention to colour and *abstract* figuration. The acknowledgement of the character of the picture support now took another twist: instead of focusing on the features of the canvas's painted surface, attention turned to the role of the canvas as shape. For Noland, Olitski and Stella – according to the narrative of high modernism – the *shape* of a painting's support was to become of crucial importance, and specifically its role in the structure of pictorial illusion. We will focus on the case of Stella.

Radically illusive: the shape of Stella's soul

Stella had caused a stir in 1959 when, as a twenty-three year old, he presented a series of works, known collectively as the *Black Paintings* (Plate 6.8). Stripes of black enamel paint were applied in various symmetrical configurations, and each stripe was separated by a thin strip of unpainted raw canvas. Stella used not only the materials but also the techniques of commercial painters and decorators – repetitive actions conducted with a house-painter's 2½ inch brush – and he publicly rejected some keystones from the art of painting: personal expression and compositional complexity.[20] As one commentator later put it, the paintings were seen as 'insolently static,

PLATE **6.8** Frank Stella, *Die Fahne hoch!*, 1959, enamel on canvas, 309 × 185 cm.
(Whitney Museum of American Art, New York. Gift of Mr and Mrs
Eugene M. Schwartz and purchased with funds from the John I.H. Baur
Purchase Fund, the Charles and Anita Blatt Fund, Peter M. Brant,
B.H. Friedman, the Gilman Foundation Inc., Susan Morse Hilles, the
Lauder Foundation, Frances and Sydney Lewis, the Albert A. List
Fund, Philip Morris Inc., Sandra Payson, Mr and Mrs Albrecht Saalfield,
Mrs Percy Uris, Warner Communications Inc., and the National
Endowment for the Arts. 75.22. Photo: Geoffrey Clements.
© ARS, New York and DACS, London 2004.)

intractably simple-minded', which 'with one blow, seemed to wipe the slate clean of all earlier habits of picture-making'.[21] Hostile critics interpreted the work as blank, empty and nihilistic: this was further compounded by Stella's titles – for example, *Die Fahne hoch!* (Raise High the Flag) and *Arbeit macht frei* (Work Brings Freedom) – which were references to Nazi Germany.

Stella produced further series of striped painting using various metallic or synthetic paints. Supported by unusually thick stretchers – as in *Six Mile Bottom* (Plate 6.9) – the paintings protruded noticeably from the wall, and the stretchers' depth was echoed by the stripes. Stella also introduced unusually shaped canvases, notching the edges, corners or centre. These adjustments and the stripes echoed one another, introducing a dynamic in which the latter seemed to ripple or 'jog' (Plate 6.10). In 1966, Stella exhibited the *Irregular Polygons*, a series of paintings comprising more complex and eccentric shapes, where the shapes of the canvases echoed the arrangements of interlocking coloured forms painted onto the picture surface (Plate 6.11). As we discuss later, much turns on what we have here, for simplicity's sake, referred to as 'echoing': the relation between the shape of the canvas and the shapes painted onto the canvas surface. Stella's paintings were, more than any other, the 'body of work' that was fought over in the 1960s. As Fried wryly put it in 1987, the competing aesthetic pulls on Stella's work represented a battle 'for his soul'.[22] It is to this struggle that we now turn.

Look at the installation photograph of Stella's *Aluminium Paintings* exhibited at the Leo Castelli Gallery, New York, in 1960 (Plate 6.10), and at *Six Mile Bottom*, one of the series (Plate 6.9). Carefully study the following passage from Donald Judd's 'Specific Objects' and the two extracts from Fried's essays 'Three American Painters' (1965) and 'Art and Objecthood' (1967) below. With regard to the competing claims of Judd and Fried on Stella's work, try to identify both the similarities and the differences in their accounts. (Be prepared to spend some time puzzling over these extracts; they are by no means straightforward. Identifying the differences may prove especially difficult.)

Donald Judd

The main thing wrong with painting is that it is a rectangular plane placed flat against the wall. A rectangle is a shape itself; it is obviously the whole shape; it determines and limits the arrangement of whatever is on or inside of it. In work before 1946 the edges of the rectangle are a boundary, the end of the picture. The composition must react to the edges and the rectangle must be unified, but the shape of the rectangle is not stressed; the parts are more important, and the relationships of color and form occur among them. In the paintings of Pollock, Rothko, Still and Newman, and more recently of Reinhardt and Noland, the rectangle is emphasised. The elements inside the rectangle are broad and simple and correspond closely to the rectangle ... The parts are few and so subordinate to the unity as not to be parts in an ordinary sense. A painting is nearly an entity, one thing, and not the indefinable sum of a group of entities and references ... The plane is also emphasised and nearly single. It is clearly a plane one or two

inches in front of another plane, the wall, and parallel to it. The relationship of the two planes is specific; it is a form.

... Stella's shaped paintings involve several important characteristics of three-dimensional work. The periphery of a piece and the lines inside correspond. The stripes are nowhere near being discrete parts. The surface is farther from the wall than usual, though it remains parallel to it. Since the surface is exceptionally unified and involves little or no space, the parallel plane is unusually distinct ... A painting isn't an image. The shapes, the unity, the projection, order and color are specific, aggressive and powerful.[23]

Michael Fried

Like Newman and Noland, Stella is concerned with deriving or deducing pictorial structure from the literal character of the picture support; but his work differs from theirs in its exaltation of deductive structure as sufficient in itself to provide the substance, and not just the scaffolding or syntax, of major art.

... The Cubists appear to have built their paintings out toward the edge, and the nearer to it they came the less consistent with their treatment of the main motif their handling seems to have become. Whereas in Stella's paintings structure is generated from the framing edge in toward the center of the canvas – with the result that if any portion of his pictures tends to be problematic it is the center, rather than, as in Cubist works, the perimeter.

... his use of metallic paint, rather than seeming to signify 'thingness' or materiality pure and simple, seems instead to be his way of achieving something like the opticality brought about by staining and color in the work of Louis, Noland, and Olitski. More precisely, the gentle play of finely granulated reflected light off the metallic stripes has the effect of dissolving one's awareness of the picture surface as a tactile entity in a more purely visual mode of apprehension.[24]

... the success or failure of a given painting has come to depend on its ability to hold or stamp itself out or compel conviction as shape – that, or somehow to stave off or elude the question of whether or not it does so.

... What is at stake in this conflict is whether the paintings or objects in question are experienced as paintings or as objects, and what decides their identity as painting is their confronting of the demand that they hold as shapes. Otherwise they are experienced as nothing more than objects.[25]

These passages can be elusive, but are rich with material for consideration. Judd and Fried note a shift from the legacy of prewar painting to postwar American work. Each establishes a lineage for Stella: 'Pollock, Rothko, Still and Newman ... Reinhardt and Noland' (Judd); 'Newman and Noland' (Fried). Both authors identify the edge of the canvas as of special significance, and argue that it is Stella's work that makes this edge, the canvas's shape, a pressing issue for contemporary art. Judd and Fried make arguments upon which,

PLATE **6.9** Frank Stella, *Six Mile Bottom*, 1960, metallic paint on canvas, 300 × 182 cm. (© Tate, London 2003. © ARS, New York and DACS, London 2004.)

PLATE **6.10** Frank Stella, installation shot of *Aluminium Paintings*, 1960. (Leo Castelli Gallery, New York. Photo: Rudolph Burckhardt. © Estate of Rudy Buckhardt/VAGA, New York/DACS, London 2004 and © ARS, New York and DACS, London 2004.)

PLATE **6.11** Frank Stella, installation shot of *Irregular Polygons*, 1966. (Leo Castelli Gallery, New York. Photo: Rudolph Burckhardt. © Estate of Rudy Buckhardt/VAGA, New York/DACS, London 2004 and © ARS, New York and DACS, London 2004.)

they imply, the power of an artwork rests. Judd aims to identify what it is about shape that is 'specific, aggressive and powerful', whereas Fried attempts to account for the ability of a painting to 'compel conviction as shape'. They differ fundamentally, however, in how to interpret this significance. Fried puts it succinctly: what is at stake is whether artworks – and we can think here of *Six Mile Bottom* – 'are experienced as paintings or as objects'. Judd, who conveys his growing impatience with the practice of painting, understands the importance of a canvas's shape as leading logically to an interest in objects-in-the-world ('A painting is nearly an entity, one thing'). He sees Stella's canvases not as surfaces for the exploration of painterly problems (composition, colour, spatial relations) but more as 'slabs'.[26] Thus, in *Six Mile Bottom*, Judd would see a development towards an object-like entity, which would be implied by a number of factors: the simplification of composition and colour, and the clear relation established between the canvas shape and the shapes marked on the canvas in aluminium paint (not to mention the suggested 'materiality' of metal). Fried sees most of the same factors as demonstrating an issue *for painting*: the stripes are deduced from the shape of the stretcher, a reinforcement that enables shape to hold convincingly as a pictorial issue. Crucially, he perceives the metallic paint not as aluminium, but as an optical shimmer that works to suspend our awareness of the tactility and materiality of the painting's surface. Where, for Judd, artistic interest turns on the specific relations established externally between the canvas-object and the wall on which it is displayed, for Fried, it resides in a painting's internal pictorial issues. ∎

Fried makes the distinction between 'depicted shape' (the shapes painted onto a picture surface) and 'literal shape' (the shape of the canvas itself), but refuses to abandon pictorial concerns.[27] He refuses to make an *absolute* separation between the 'depicted' and the 'literal'; 'literal shape' is always an issue *for painting*, and is always *experienced as* painting. Judd, we might say, sees Stella's interest in the edge of the canvas as the culmination of a process that led *from* depicted *to* literal shape. As far as Fried is concerned, Judd's way of seeing destroys the state of suspension that he so values, killing off, in one blow, the role of depicted shape, the tensions within pictorial illusion, and the tensions between pictorial illusion and the literal shape of the canvas. Judd, Fried argues, by projecting Stella's paintings as 'nothing more than objects', 'hypostatises' literal shape.[28] As a consequence, Fried dubs Judd and the other artists associated with minimalism 'literal*ists*', and their work, he argues, had degenerated into the 'literal*ism*' of objects, or what he calls the condition of 'objecthood'.[29]

The issue of shape was pushed further in Stella's 1966 series of irregular polygons. In order to explore this, let us examine one of the series, *Moultonboro III* (Plate 6.12). The intensity of the paint itself (a combination of epoxy and alkyd) is initially striking, particularly the two-tone yellow triangle (the inner segment in fluorescent Day-Glo) that seems to slice into a square support. The painting is deceptively simple, but the more we look, the more difficult it is to unravel the spatial relations between the red, turquoise and yellow elements. It is possible to see the turquoise 'Z'-shape, and specifically the relationship established between its bevelled ends and the red area, as implying perspectival recession. There seem to be contrary possibilities:

PLATE 6.12 Frank Stella, *Moultonboro III*, 1966, fluorescent alkyd and epoxy paint on canvas, 279 × 305 cm. (Private collection. Photo/Copyright: Malcolm Varon, New York, © 2003. © ARS, New York and DACS, London 2004.)

(a) the space retreats towards both the left- and the right-hand sides of the red 'square' (as if we imagine ourselves looking onto an open box-form from above); (b) the space retreats inwards from the sides (as if, through a perceptual flip, we instead imagine ourselves looking upwards from within the box towards a ceiling). Yet even these options are confounded, because the perceived boxiness of the red-turquoise components fails to add up; its aspects at top-left and at bottom-right seem inconsistent, as though the space has twisted or warped. Even without the metaphor of the 'box' (far too tangible!), depending upon how we grasp the illusionistic recession, the red area can be seen as folding either towards the wall or towards the beholder. Possible interpretations abound; is there a 'real Z' that is being depicted, and, if so, is its depiction to be seen as 'flat or warped, regular or irregular, partly or wholly parallel or oblique to the picture surface'?[30]

We have here summarised and extemporised a discussion of *Moultonboro III* from Fried's challenging essay 'Shape as Form' (1966). With patience, it is possible to follow – and extend – 'the extreme ambiguity, indeterminacy, and multivalence of the relations' in this and other irregular polygon paintings.[31] It is, however, a little more difficult to grasp the nub of Fried's argument.

In his account, Stella's irregular polygons provide a special limit case: they push the distinction of depicted and literal shape to the point where the difference all but collapses. The central ambiguity of a painting like *Moultonboro III* is the difficulty in distinguishing the roles played by literal and depicted shape. The yellow triangle, for instance, is suggested partly by depiction and partly by the shaping of the stretcher. But, argues Fried – and here is the tricky bit – the painting's ability to convey the triangle's 'literalness', or the way the triangle almost appears to be an object in the world (*appearing as if* real), seems not to be carried by the stretcher's shape so much as by the yellow configuration itself. The element that we might expect to be most real – the stretcher's shape – is not the element that carries the effect of literal reality. Rather, it is conveyed by the pictorial effect of the whole: the yellow triangle that is *both* literal *and* depicted shape, and reducible to neither. Hence, Fried arrives at an apparently paradoxical formulation: in the irregular polygons, 'literalness itself' is 'radically illusive'.[32]

Commentators often see Fried as engaged in little more than a conservative, defensive action to maintain painting, and wanting simply to defeat the literal aspects of painting (the 'tangible', the 'tactile' or 'literalness as such'). Indeed, there are times when his writing is marked by a dogged preservation of (a certain notion of) 'art' against the threat of 'objecthood'. At such moments, a high moral tone dominates his argument, and his category distinctions can lose their productive tension and dissolve into simplistic oppositions. Yet, there are also subtler, more dialectical, moments to his argument. Fried's purpose is not just (by way of a counter to Judd) to destroy literal qualities. Rather, he values their force, and wants to maintain their property for pictorial illusion. In other words, of central importance are the dialectical dynamics *within* the contrast of literal and illusive, a contrast which demands that literal qualities remain alive and active. As his introduction to 'Shape as Form' makes explicit, shape, as an issue for painting, is neither literal nor depicted; instead, we encounter a wider conceptual–aesthetic frame: '*shape as a medium* within which choices about *both* literal *and* depicted shapes are made, and made *mutually responsive*'.[33] What Fried at his best tries to convey may be understood, then, as an extreme state of suspended, quivering, aesthetic tension.

Thus far, our attention has focused on aspects of high modernism's account of painting. We have moved, within its aesthetic terms, from an experience of painting defined by the suspension of tangible figuration (in the case of Louis's veils) to one defined by the suspension of literalness itself (Stella's irregular polygons). But how, within high modernist terms, could a sculpture provide a successful aesthetic experience? Surely sculpture – being intractably a tangible object – is inescapably plagued by literalness itself, with sheer material, three-dimensional 'thingness'? In fact, both Greenberg and Fried saw sculpture as posing the most pressing and advanced artistic questions. The test case was the work of Anthony Caro.

The efficacy of gesture: Caro and embodiment

In 1959, Caro, who had been Henry Moore's studio assistant earlier in the decade, travelled to the USA, where he saw the paintings of Pollock and Louis and met Frankenthaler and Noland, and the sculptor David Smith. The trip was to prove decisive in changing his attitude towards sculpture. Smith's late work, Caro noted, 'showed me how to get away from found objects, patinas and the rest'.[34] Caro's transition from the 'old look' entailed a move within his practice: from figurative to abstract modes, and from an expressionistic modelling of plaster (to make bronze casts), to a compositional–constructive approach, which involved bolting or welding together metal elements (for example, I-beams, T-beams, tubes and, later, oil-tank ends). Like Smith, Caro developed work in the abstract and constructive tradition of large-scale sculpture, and used the methods of improvisation.[35] If we look at *Early One Morning* (1962) (Plate 6.13), we can see that, even in relation to the more advanced tendencies of modernist sculpture such as Smith's, Caro's welded forms look remarkably open and airy; the work's steel and aluminium components are dispersed, creating multiple nodes of focus; and volume, such as it is, is suggested and delineated rather than conveyed through the volumetrics of solid masses or relatively contained forms. In making this contrast, it would be unfair and inaccurate to represent Smith's *Cubi* (Plate 6.15) as weighty, solid, stable monoliths, yet, *relative* to *Early One Morning*, the *Cubi* seem much more cohesive and contained. Although the *Cubi* effect a precarious resistance to gravity, their very verticality necessarily asserts the 'compacting' produced by gravity's downward pressure. Caro's new sculptures were unusual for deploying most of their material below eye level, and their low-lying and lateral orientation lent them an anti-monumental quality. Despite the amount of metal employed, Caro's *Prairie* (1967), in particular, struck critics as achieving a remarkable weightlessness (Plate 6.14). The fact that Caro's sculptures are painted is also important (although Greenberg regarded their colour as 'secondary' and 'provisional').[36] It unifies components that might otherwise be experienced as *too* dispersed to register as a coherent work, and ensures that there are no visual disjunctions caused by the elements' material texture. Fried sees the use of monochromatic colour, moreover, as contributing to the suspension of gravity.[37]

Rather than being mounted on plinths, Caro's sculptures are situated directly on the floor, further adding to their anti-monumental appearance. The removal of the plinth also redefines the sculptural 'frame' or 'field', and was seen to have striking consequences. First, instead of just functioning as a work's base, the ground becomes a significant and active sculptural component. Secondly, the lack of plinth and the open, extending constructions were seen to have changed the relation between sculptural space and the viewer, breaking down the distinction where a viewer looks into a sculpture's space, and making spectator and space coextensive. Like many (although not all) sculptures, Caro's work demands to be seen in the round, which further involves the viewer's body within the sculpture's spatial field. The sculptures' very openness, lacking the

PLATE **6.13** Anthony Caro, *Early One Morning*, 1962, steel and aluminium painted red, 290 × 620 × 333 cm. (Tate, London 2003. Courtesy of the artist.)

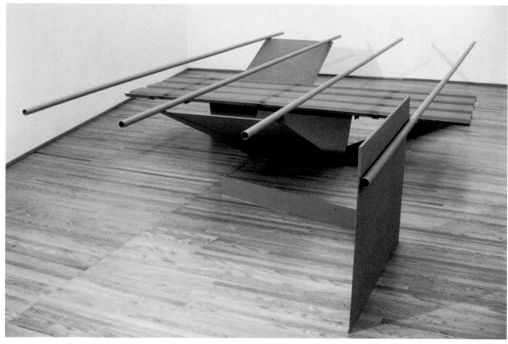

PLATE **6.14** Anthony Caro, *Prairie*, 1967, steel painted matt yellow, 96 × 582 × 320 cm. (Private collection, on loan to the National Gallery of Art, Washington DC. Courtesy of the artist.)

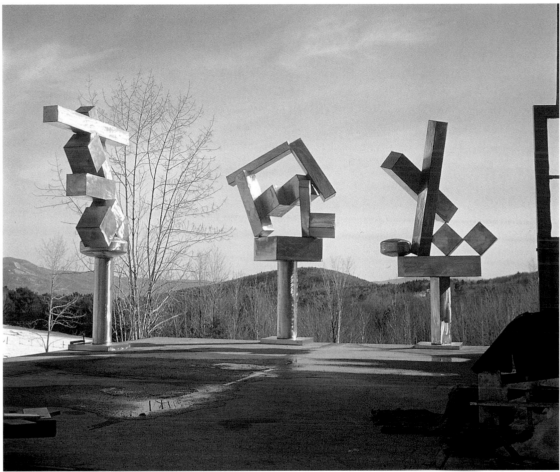

PLATE **6.15** David Smith, *Cubi*, photo of three sculptures installed outside the artist's workshop at Bolton Landing, including (left) *Cubi XVIII*, 1964, polished stainless steel, 294 × 154 × 55 cm (Museum of Fine Arts, Boston. Gift of Susan W. and Stephen D. Paine 68.280), (centre) *Cubi XVII*, 1963, stainless steel, 274 × 165 × 97 cm (Dallas Museum of Art, no.1965.32.MCD) and (right) *Cubi XIX*, 1964, stainless steel, 286 × 148 × 102 cm (Tate Gallery, London. T00891). (Photographed by the artist at Bolton Landing. © Estate of David Smith/VAGA, New York/ DAC, London 2004.)

mass that is associated with the human form, may make them seem disembodied; yet, despite this, and despite their 'radical abstractness', these works were seen as intimately related to human embodiment through their means of eliciting aesthetic experience.[38] We will pursue this further in a moment.

First, it is worth noting that Smith's sculptures belonged to the contested body of work of the period, and were increasingly being understood to have minimalist or 'literalist' implications. Fried, fearing the drift into minimalist hypostatisation of the literal ('literalism' or 'objecthood'), was anxious to differentiate Caro's work from this association.[39] We have already seen that Caro suppresses the materiality of steel and aluminium through paint, contrasting with the strong material textures of Smith's sculptures, as well as with that of minimalist works like those of Andre or Judd. Secondly, in contrast to the simple units and serial repetition of minimalist work, and in contrast

to the totemic and potentially object-like implications of Smith's work, Fried points to the relatively dispersed or fragmentary quality of Caro's work. Multiple spatial juxtapositions emerge when viewing a Caro structure from a series of angles, which Fried sees as a syntactical structure. 'The mutual inflection of one element by another' constantly makes and remakes the work.[40] Moreover, as Fried emphasises, it is not the elements themselves to which our attention is drawn (to focus on the individual components would, in his view, render the work into no more than an assemblage of discrete objects). He highlights, in contrast, the relations and dynamic interplay between the elements, or, as Greenberg puts it: 'Caro's sculptures invade space in a quite different way [from Smith or Gonzales] … and they are more integrally abstract. Caro is far less interested in contours or profiles than in vectors, lines of force and direction.'[41]

Thirdly, Fried pursues his argument through a discussion of the role of human gesture, which picks up the discussion of embodied experience. Caro's sculptures: 'defeat, or allay, objecthood by imitating, not gestures exactly, but the *efficacy* of gesture … they are possessed by the knowledge of the human body and how, in innumerable ways and moods, it makes meaning'.[42]

The syntax of the various metal elements alludes to the human body's expressive capacities, but not by depicting or mimicking bodily gestures. Rather, Caro's works imitate 'the efficacy of gesture': the *power* of a gesture's effect or intention.[43]

> [Caro] has been able *to render wholly abstract* various actions and states that are themselves paradigmatically situational: e.g. being led up to something, entering it, perhaps by going through or stepping over something else, being inside something [and] looking out from within.[44]

For a work like *Deep Body Blue* (1967) (Plate 6.16) to provide an abstract experience of everyday actions – Fried's idea of 'being led up to something, [and] entering it' – the spectator must conceive of the sculpture in a particular way. It is not that Fried wants us to see this sculpture as a door; nor does he (or Caro) expect us to walk through it as if it were a door. Rather, within the articulations of its syntax, especially the play of its two vertical elements which exist in the same spatial plane, *Deep Body Blue* generates a radically abstract experience: we feel the *efficacy* of approaching and crossing a threshold, the essence, so to speak, of 'threshold-ish' actions. It is the way the spectator understands a Caro sculpture in relation to his or her own experience of embodiedness that, for Fried, makes these sculptures aesthetically meaningful. In contrast, Minimalist Art, he thought, provides a 'sure-fire', 'heightened perceptual experience', displayed through a powerful *mise-en-scène* that in many ways prefigures the installations that have been successful in late twentieth- and early twenty-first century art.[45] But, according to Fried, 'literalism theatricalised the body, put it endlessly on stage, made it uncanny or opaque to itself, hollowed it out, deadened its expressiveness, denied its finitude and in a sense its humanness'.[46] Caro's sculptures – their 'radical abstractness' and their 'efficacy of gesture' – he argues, are 'a fountainhead of antiliteralist and antitheatrical sensibility'.[47]

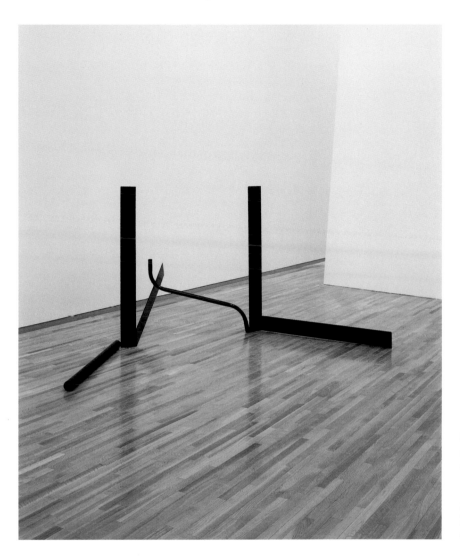

PLATE **6.16**
Anthony Caro,
Deep Body Blue,
1967, steel, painted,
149 × 257 × 315 cm.
(Private collection.
Reproduced courtesy
of the artist.)

Conclusion

In the argument that we encountered earlier from 'Specific Objects' (1965), Judd advanced an account of a new three-dimensional art that was identified as 'neither painting nor sculpture'. In 'Art and Objecthood' (1967), Fried argued that *'The concepts of quality and value – and to the extent that these are central to art, the concept of art itself – are meaningful, or wholly meaningful, only within the individual arts. What lies between the arts is theater.'*[48] In this respect, the theoretical terrain of minimalism marked a profound shift from the ideas and values of medium-specificity that both Greenberg and Fried advocated. You will recall that, for Greenberg, modernism's process of self-definition was crucial to the very survival of art. From a high modernist perspective, the new practices evaded the question of value altogether, thereby risking art's existence.

Notes

1 Rose, 'Remembering 1967' (1987), quoted in Gudis, Jacob and Goldstein, *A Forest of Signs*, p.129.

2 Fried, 'Theories of Art after Minimalism and Pop' (1987), in Foster, *Discussions in Contemporary Culture, Number One*, p.79.

3 The principal figures associated with Caro were David Annesley, Michael Bolus, Phillip King, Tim Scott, William Tucker, William Turnbull and Isaac Witkin. See the exhibition catalogues Dunlop, *The New Generation* and Annesley, *The Alaister McAlpine Gift*.

4 An issue of the magazine *Artforum*, published in June 1967, has been frequently cited as the 'litmus test' of the moment, containing essays from contesting positions. In particular, Fried's essay 'Art and Objecthood' (1967), reprinted in *Art and Objecthood*, pp.148–72, raised the stakes, both clarifying and further exacerbating divisions by launching a full-scale critique of the writings and aesthetic preferences of artists associated with minimalism.

5 Fried, 'An Introduction to my Art Criticism' (1996), in *Art and Objecthood*, pp.14, 15.

6 Fried, 'Theories of Art after Minimalism and Pop' (1987), in Foster, *Discussions in Contemporary Culture, Number One*, p.78.

7 Greenberg, 'Recentness of Sculpture' (1967), in O'Brian, *Clement Greenberg*, vol.4, pp.250–6.

8 These critiques include social–historical approaches to art, from Marxism and feminism, and also 'postmodern' structural and poststructural analyses.

9 Fried, 'Painting Present: Michael Fried', lecture delivered at Tate Modern, Tuesday 15 October 2002.

10 Greenberg, 'Avant-Garde and Kitsch' (1939), in O'Brian, *Clement Greenberg*, vol.1, pp.5–22 (extract reprinted in Harrison and Wood, *Art in Theory 1900–2000*, IVD11, pp.539–49) and 'Modernist Painting' (1960), in O'Brian, *Clement Greenberg*, vol.4, pp.85–93 (reprinted in Harrison and Wood, *Art in Theory 1900–2000*, VIB5, pp.773–9). 'Modernist Painting' was originally a radio broadcast in 1960. See also Greenberg, 'After Abstract Expressionism' (1962), in O'Brian, *Clement Greenberg*, vol.4, pp.121–34.

11 Greenberg, 'Modernist Painting' (1960), in O'Brian, *Clement Greenberg*, vol.4, pp.85–93. Elsewhere, Greenberg notes two prime conventions: 'flatness and the delimitation of flatness', namely, the picture surface and the framing edge (Greenberg, 'After Abstract Expressionism' (1962), in *ibid.*, p.131).

12 Hofmann, 'On the Aims of Art' (1931), extracts reprinted in Harrison and Wood, *Art in Theory 1900–2000*, IVA3, pp.371–4.

13 Greenberg, 'Modernist Painting' (1960), in O'Brian, *Clement Greenberg*, vol.4, p.87, reprinted in Harrison and Wood, *Art in Theory 1900–2000*, VIB5, pp.773–9.

14 Fried, 'Morris Louis' (1971), in *Art and Objecthood*, p.106.

15 Greenberg, 'Modernist Painting' (1960), in O'Brian, *Clement Greenberg*, vol.4, p.89, reprinted in Harrison and Wood, *Art in Theory 1900–2000*, VIB5, pp.773–9.

16 Fried, 'Morris Louis' (1971), in *Art and Objecthood*, p.105.

17 Greenberg, 'Louis and Noland' (1960), in O'Brian, *Clement Greenberg*, vol.4, pp.94–100.

18 The New York based paint manufacturer Leonard Bocour introduced Louis and Noland to Magna paint. Earlier, in the 1940s, Bocour had made 'big tubes for big paintings', and from 1956, he had marketed acrylic polymer emulsion. He supplied Louis and Noland with free 'ends-of-batch' paints, eventually producing paint specifically for them in gallon cans. When diluted to the same liquid consistency – to a wash, as used in the technique of staining – acrylic paint (which is thinned with water) maintains a higher density of colour saturation than oil paint (thinned with turpentine). It is worth stressing that these specific differences in the quality of acrylics and oils contribute to the different painterly effects in the work of Louis and Frankenthaler. See Gage, *Colour and Culture*, p.267.

19 Fried, 'Morris Louis' (1971), in *Art and Objecthood*, p.109; our emphases.

20 See Andre, 'Preface to Stripe Painting' (1959), in Harrison and Wood, *Art in Theory 1900–2000*, VIIA2, p.820; Stella, 'Pratt Institute Lecture' (1959–60), in *ibid.*, VIIA3, pp.820–1. Cf. Glaser, 'Questions to Stella and Judd'.

21 Rosenblum, *Frank Stella*, pp.16, 17.

22 Fried, 'Theories of Art after Minimalism and Pop' (1987), in Foster, *Discussions in Contemporary Culture, Number One*, p.79. Fried's comment specifically refers to his 'battle' with the sculptor Carl Andre, who shared Stella's studio in the early 1960s. Stella, Andre and the photographer Hollis Frampton were old schoolfriends. Andre had provided a statement and Frampton a photograph for Stella's entry in the exhibition catalogue for *Sixteen Americans*. Fried was also a close friend of Stella's (and was best man at the wedding of Stella and Barbara Rose in 1961).

23 Judd, 'Specific Objects' (1965), extracts reprinted in Harrison and Wood, *Art in Theory 1900–2000*, VIIA5, pp.825, 827.

24 Fried, 'Three American Painters' (1965), in *Art and Objecthood*, pp.251, 253, 256; the opening section of the essay is in Harrison and Wood, *Art in Theory 1900–2000*, VIB9, pp.787–93.

25 Fried, 'Art and Objecthood' (1967), in *Art and Objecthood*, p.151, extracts reprinted in Harrison and Wood, *Art in Theory 1900–2000*, VIIA7, pp.835–46.

26 Judd, in Glaser, 'Questions to Stella and Judd', p.60.

27 Fried, 'Shape as Form: Frank Stella's Irregular Polygons' (1966), in *Art and Objecthood*, pp.77–99; an extract of the first section of this essay is reprinted in Harrison and Wood, *Art in Theory 1900–2000*, VIB10, pp.793–5.

28 Fried, 'Shape as Form' (1966), in *Art and Objecthood*, p.92.

29 Fried, 'Art and Objecthood' (1967), in *ibid.*, pp.148–72.

30 Fried, 'Shape as Form' (1966) in *ibid.*, p.94.

31 *Ibid.*, p.93.

32 *Ibid.*, p.94.

33 *Ibid.*, p.77; extract reprinted in Harrison and Wood, *Art in Theory 1900–2000*, VIB, pp.793–5.

34 Caro, quoted in Rubin, *Anthony Caro*, p.30.

35 Smith's position is articulated in his lecture 'Tradition and Identity' (1959), in Harrison and Wood, *Art in Theory 1900–2000*, VIB2, pp.766–7.

36 Greenberg, 'Contemporary Sculpture: Anthony Caro' (1965), in O'Brian, *Clement Greenberg*, vol.4, p.208.

37 Fried, 'Anthony Caro' (1963), in *Art and Objecthood*, pp.273–5.

38 Fried, 'Two Sculptures by Anthony Caro' (1968), in *Art and Objecthood*, p.181. Ideas on human embodiment found favour with Fried and also with Robert Morris, who were both concerned with the spectator's bodily relation to the art object. Both Fried and Morris drew on the phenomenological philosophy of Maurice Merleau-Ponty, but drew from it contrasting aesthetic resources.

39 The word 'hypostatise' is much used by Fried. In this context, it suggests the simultaneous isolation and elevation of 'literal shape', the effect of which is to over-value the quality being hypostatised while destroying it by 'fixing it in stone'. A related way of putting this might be to say that Judd 'fetishises' or 'reifies' literal shape.

40 Fried, 'Art and Objecthood' (1967), in *Art and Objecthood*, p.161.

41 Greenberg, 'Contemporary Sculpture: Anthony Caro' (1965), in O'Brian, *Clement Greenberg*, vol.4, p.205.

42 Fried, 'Art and Objecthood' (1967), in *Art and Objecthood*, p.162.

43 Rubin describes Smith's *Cubi* as 'semaphoric "gestures"', suggesting that they were anthropomorphic forms making abstract signage with their 'arms'. This is very different from Fried's point, where embodiment is understood as the relation of spectator to sculpture, and where the latter imitates 'not gestures' (not even semaphoric ones), but the efficacy – or modality – of gestures (Fried, 'An Introduction to my Art Criticism' (1996), in *Art and Objecthood*, p.29).

44 Fried, *Anthony Caro*, p.14; our emphasis. See also Fried, 'Two Sculptures by Anthony Caro' (1968), in *Art and Objecthood*, pp.180–4.

45 Fried, 'An Introduction to My Art Criticism' (1996), in *Art and Objecthood*, p.40.

46 *Ibid.*, p.42.

47 Fried, 'Art and Objecthood' (1967), in *Art and Objecthood*, p.162; extract in Harrison and Wood, *Art in Theory 1900–2000*, VIIA7, p.844.

48 *Ibid.*

References

Annesley, D., *The Alaister McAlpine Gift*, exhibition catalogue, Tate Gallery, London, 1971.

Dunlop, I., *The New Generation: 1965*, exhibition catalogue, Whitechapel Gallery, London, 1965.

Foster, H. (ed.), *Discussions in Contemporary Culture, Number One*, Seattle: Bay Press, 1987.

Fried, M., *Anthony Caro*, exhibition catalogue, Hayward Gallery/Arts Council, London, 1969.

Fried, M., *Art and Objecthood*, Chicago: University of Chicago Press, 1998.

Fried, M., 'Painting Present: Michael Fried', lecture delivered at Tate Modern, 15 October 2002.

Gage, J., *Colour and Culture: Practice and Meaning from Antiquity to Abstraction*, London: Thames & Hudson, 1993.

Glaser, B., 'Questions to Stella and Judd', *Art News*, September 1966, pp.55–61.

Greenberg, C., *Art and Culture*, Boston: Beacon Press, 1965.

Gudis, C., Jacob, M.J. and Goldstein, A. (eds), *A Forest of Signs: Art in the Crisis of Representation*, Cambridge, MA: MIT Press, 1989.

Harrison, C. and Wood, P. (eds), *Art in Theory 1900–2000: An Anthology of Changing Ideas*, Malden, MA and Oxford: Blackwell, 2003.

Judd, D., 'Specific Objects', *Arts Yearbook*, no.8, New York, 1965, pp.74–82.

O'Brian, J. (ed.), *Clement Greenberg: The Collected Essays and Criticism*, vol.1: *Perceptions and Judgments 1939–1944*, Chicago: University of Chicago Press, 1986.

O'Brian, J. (ed.), *Clement Greenberg: The Collected Essays and Criticism*, vol.4: *Modernism with a Vengeance 1957–1969*, Chicago: University of Chicago Press, 1993.

Rosenblum, R., *Frank Stella*, Harmondsworth: Penguin, 1971.

Rubin, W., *Anthony Caro*, exhibition catalogue, Museum of Modern Art, New York, 1975.

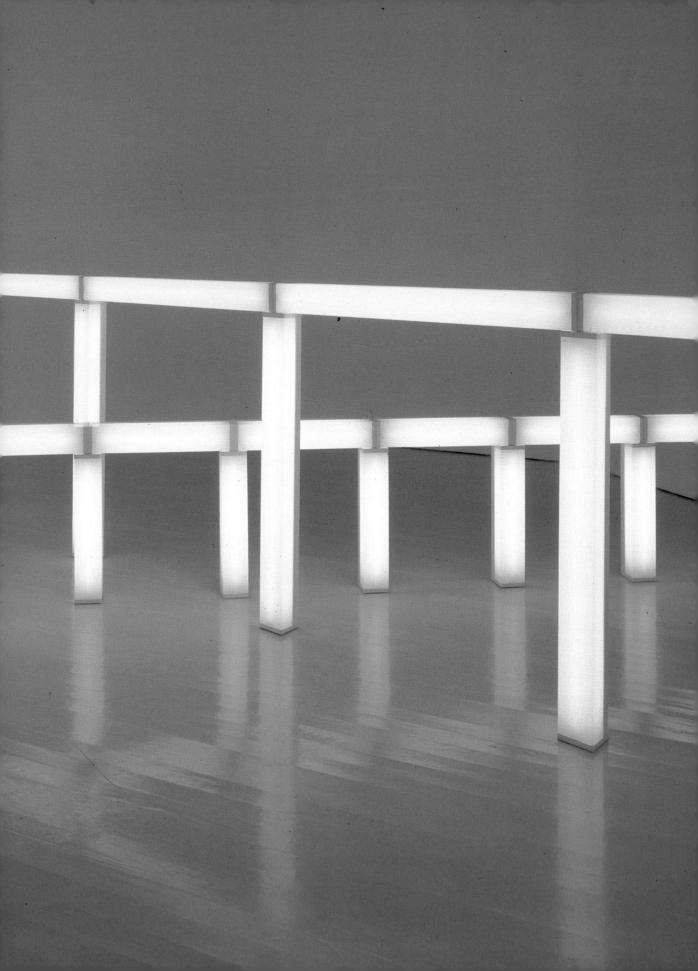

CHAPTER 7
Minimalism's situation
Ann Reynolds

The mid-1960s was a period of significant activity, debate and ultimately crisis in the art world, as curators and critics tried to come to terms with recent developments in abstract painting and sculpture in the USA. In their attempts to characterise this work in group exhibitions or in essays or reviews, some invented new labels – 'A B C', 'cool', 'literal' or 'minimal' art – or devised new media categories such as 'structures' to describe work that appeared to straddle or override the more traditional categories of painting and sculpture. Others questioned the effectiveness of such tactics, since the new art seemed to defy conventional formal and aesthetic categorisations. Establishing concise aesthetic categories of any kind, let alone clear distinctions between art and everything else, no longer seemed tenable or even relevant to this new art. Some critics avoided the problem of interpretation altogether, claiming that there was nothing to interpret: 'Nobody really likes this new art … It is uningratiating, unsentimental, unbiographical and not open to interpretation. If you don't like it at first glance, chances are you never will, because there is no more to it than what you have already seen.'[1]

The modernist critic Clement Greenberg commented on the situation in a 1967 essay entitled 'Recentness of Sculpture'. He claimed that arbitrary resemblances between abstract forms in art and in modern life – what he called the look of 'art' as opposed to 'non-art' – increasingly blurred the border between these two categories, adding that, while modern art had been consistently addressing the problem of boundaries to various degrees, 'by now we have all become aware that the far-out is what has paid off best in avant-garde art in the long run – and what could be further out than the arbitrary?'[2] Greenberg claimed that minimalism was exclusively preoccupied with the boundary between art and non-art. As a result, it remained too much a feat of ideation and provided too little aesthetic interest:

> Its idea remains an idea, something deduced instead of felt and discovered. The geometrical and modular simplicity may announce and signify the artistically furthest-out, but the fact that the signals are understood for what they want to mean betrays them artistically. There is hardly any aesthetic surprise in Minimal art, only a phenomenal one of the same order as in Novelty art, which is a one-time surprise.[3]

Whatever label was attached to it, and whether critics chose to engage with it or dismiss it, this new art revealed a blind spot in the critical discourse on contemporary art.

PLATE **7.1** (facing page) Dan Flavin, detail of *Greens Crossing Greens* (Plate 7.4).

Minimalism's legacy

Critics and art historians now acknowledge that minimalism is one of the primary artistic legacies of the 1960s, precisely because it most clearly embodied the decade's crisis or crux of aesthetic interpretation and a point of no return for the art object. As Hal Foster has described it, minimalism 'confront[ed], on the one hand, the rarefied high art of late modernism' (its adherence to a set of discrete media practices, namely painting and sculpture) and, 'on the other hand, the spectacular culture of advanced capitalism' (the relationship between art, media culture and everything else identified as not art) and was 'soon overwhelmed by these forces'.[4] This interpretive legacy raises a number of significant historical questions for art historians: how precisely did minimalist art confront these two aspects of contemporary culture? What features of these confrontations were discernible at the time and where were they visible?

The majority of critics who have written about minimalism, including Greenberg, and more recently Foster, regardless of their aesthetic or ideological orientation, spend little time addressing the specifics of minimalism's material aspects or its initial, heterogeneous exhibition situations: how and where it confronted and was confronted.[5] The very term 'minimalism' has been part of the problem, since no matter what has been said over the years about the significance of the art or artists it refers to, the term itself continues stubbornly to presuppose a reduction of form to a point of material insignificance – 'there is no more to it than what you have already seen'.[6]

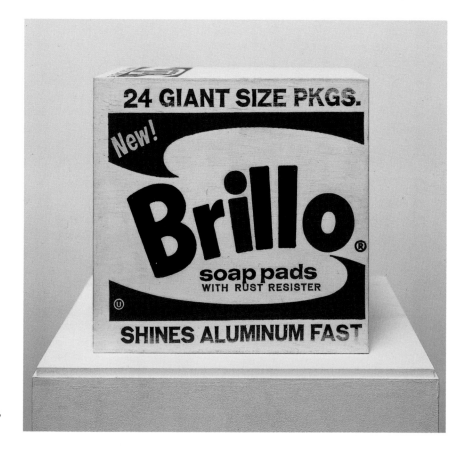

PLATE 7.2
Andy Warhol, *Brillo*, 1964, painted wood sculpture. (© Tate, London 2003.
© The Andy Warhol Foundation for the Visual Arts, Inc./ARS, New York and DACS, London 2004.)

Many of the works produced by some of the artists now associated with minimalism – for example, David Smith's *Cubi* series (see Plate 6.15), or the work of contemporary Pop artists, such as Andy Warhol's *Brillo* (Plate 7.2) – do appear reductive when compared with the work of their immediate predecessors. A sampling of works now called minimalist that were exhibited in the mid-1960s might include Carl Andre's stacked 9-foot[7] styrofoam planks, *Crib*, *Compound* and *Coin* (Plate 7.3); Dan Flavin's installations of unadorned fluorescent tubes (Plate 7.4); Donald Judd's galvanised iron wall pieces (Plate 7.5); Sol LeWitt's black-and-white open cubic frameworks of painted wood (Plate 7.6); and Robert Morris's seven simple, large-scale geometric plywood forms (Plate 7.7). A formal simplicity or reduction to a shared set of repeated geometric forms is evident in all of these contemporary works, but these qualities were not the only attributes that concerned the artists who made these works, and some of their initial critics.

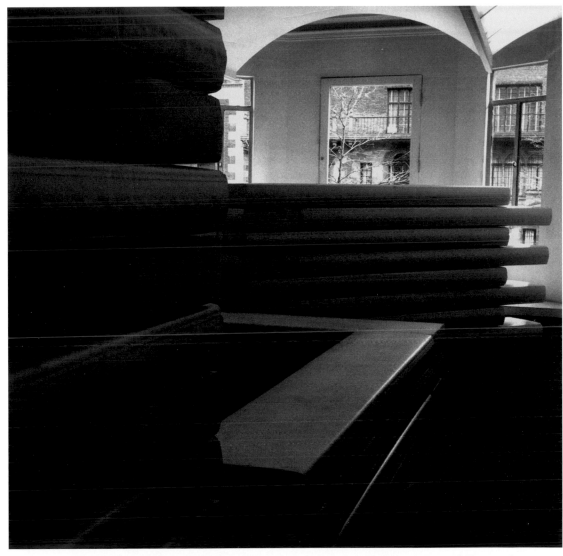

PLATE **7.3** Carl Andre, Installation view of *Crib*, 1965, *Compound*, 1965 and *Coin*, 1965, styrofoam planks, each 9 feet, Tibor de Nagy Gallery, New York, 1965. (Courtesy Paula Cooper Gallery, New York. © Carl Andre/VAGA, New York/DACS, London 2004.)

For the critic Barbara Rose, this new art was reductive in relation to the art that preceded it, namely Abstract Expressionism, but it was also more than a series of residual physical forms. In her 1965 essay 'A B C Art', one of the earliest extensive discussions of the work now called minimalist, Rose argues that this work's reductiveness was strategic: 'If the art they make is vacant or vacuous, it is intentionally so. In other words, the apparent simplicity of these artists' work was arrived at through a series of complicated, highly informed decisions, each involving the elimination of whatever was felt to be nonessential.'[8] The goal, according to Rose, was to isolate the subtle physical details and situations that determined shifts in meaning and critical judgements and call attention to them. In a later, more extended consideration of minimalism, Rosalind Krauss also maintained that if we read this type of work 'merely as part of a text of formal reordering, we miss the meaning that is most central to the work – the externality of meaning'.[9] Such meaning emerges not from some simple internal truth about the object, or by extension its maker, but arises through the 'connection of these shapes [of the work] to the space of experience', a space Krauss characterises as a 'public rather than a private space'.[10] Rose and Krauss agree that minimalism reorients the viewer's

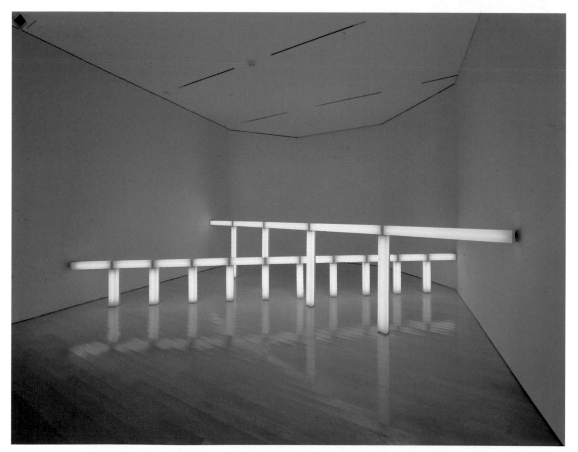

PLATE 7.4 Dan Flavin, *Greens Crossing Greens (to Piet Mondrian who lacked Green)*, 1966, fluorescent light fixtures with green lamps, 53 × 230 × 120 in. (Solomon R. Guggenheim Museum, New York, Panza Collection, 1991. Photo: David Heald. © Solomon R. Guggenheim Foundation, New York. © ARS, New York and DACS, London 2004.)

experience of the work of art: minimalist works of art cannot be interpreted as self-sufficient or reductive representatives of a conventional category of art – painting or sculpture – or as simple reflections of the private intentions of their makers. Their significance depends on the viewer's engagement with them as physical objects that occupy the same space in the world as the viewer.

The terms 'minimal' or 'minimalist' did not consistently adhere to individual works or the work of particular artists during the mid-1960s, but they and all the other terms used at the time did initially refer, even if in brief and isolated instances, to a cumulative effect produced by the ways in which certain works were grouped together and meant to be experienced in particular spaces. These spaces or contexts and the effect of the combinations of works within

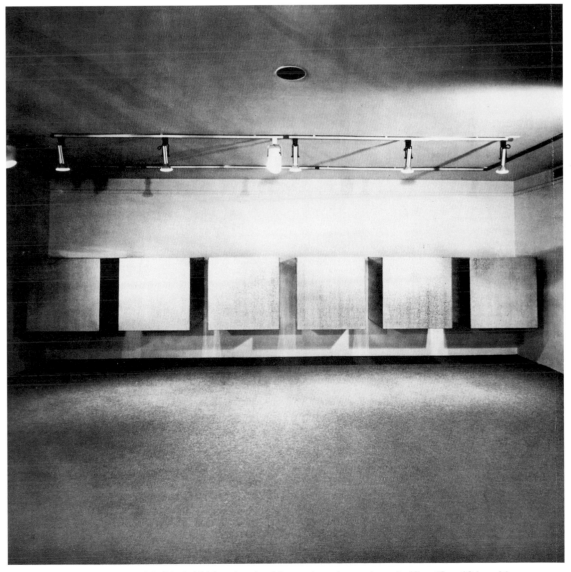

PLATE 7.5 Donald Judd, *Untitled*, 1966, galvanised iron, six units, each unit 40 × 40 × 40 in with 10-in intervals. (From *10*, exhibition catalogue, Dwan Gallery, New York, 1966. Art © Donald Judd Foundation/VAGA, New York/DACS, London 2004.)

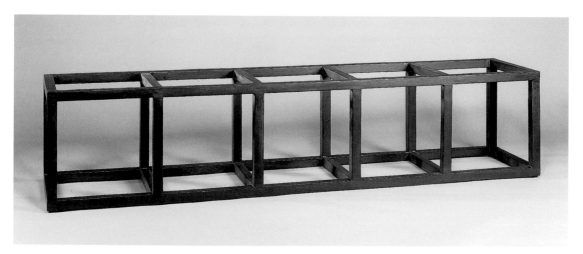

PLATE **7.6** Sol LeWitt, *Floor Structure Black*, 1965, painted wood, 18½ × 18 × 82 in. (National Gallery of Art, Washington, The Dorothy and Herbert Vogel Collection, Ailsa Mellon Bruce Fund, Patrons' Permanent Fund, and Gift of Dorothy and Herbert Vogel 1991.241.53. © ARS, New York and DACS, London 2004.)

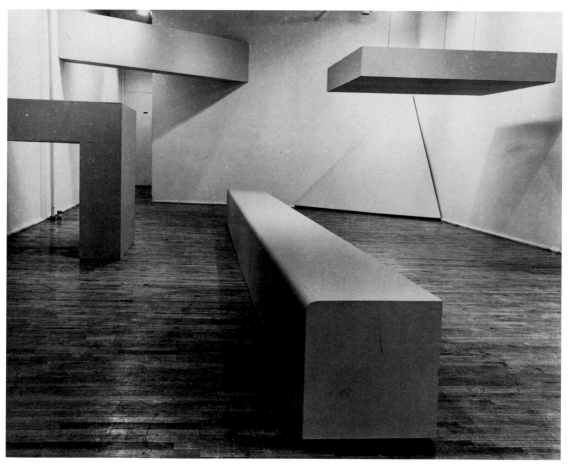

PLATE **7.7** Installation view of Robert Morris's solo exhibition, Green Gallery, New York, 1964–5. (© Robert Morris/ARS, New York and DACS, London 2004.)

them – their situation – no matter how temporary, was what made these works appear to be representative of a new category of art, 'minimalist', 'literal', 'A B C' or otherwise. If 'minimalism' is to continue to be the preferred descriptive term for an extremely rich and vital moment in postwar art, its history needs to incorporate some of these details and situational circumstances as well as discussions of the physical characteristics of individual works. Otherwise, minimalism's association with simple reduction or transitory feats of ideation will continue to hold sway over even the most elaborate arguments for its complexity. My task here is to reintroduce the initial experiential circumstances of minimalism to the discussion of minimalism's history and its legacy, since this visual and physical evidence clarifies some of the key terms of the formal and conceptual experiences intended by artists, some now associated with minimalism, others not. Such a consideration reveals how critics such as Rose and Greenberg derived their particular understanding of these artists' intentions from their experience of the work, and serves to delineate the interpretive stakes for critics and these artists at the time.

One way to track the unfolding sense of a 'minimalist effect' or 'situation' is to trace the emergence of a set of visual and verbal terms for describing this effect in the arguments of particular artists and critics, as some of the same works – some, but not all now categorised as quintessentially minimalist – moved from space to space and arrangement to arrangement during a crucial two-year period from 1965 through to 1967. Some of the concepts and images of 'minimalism' that emerged from these arguments and arrangements of works may now seem self-evident, but neither their visual consistency nor the term's stability or exclusivity were necessarily apparent at the time. Artists and critics were thinking their way through a moment when nothing was certain or fixed. In response, on numerous occasions, curators, artists and critics focused their exhibitions and discussions around many of the same works, in attempts to provide coherent and stable descriptions of a highly unstable situation as it unfolded.

Constants and differences

Judd's 1966 *Untitled* (Plate 7.5) consists of six cubic galvanised iron boxes, each 40 inches by 40 inches by 40 inches. The boxes are hollow, and their surfaces possess hard, clean edges and a lustrous matte finish. One could imagine such a group of uniform boxes in a number of different configurations. They could be stacked vertically, arranged side by side horizontally, equidistant from one another or at varying distances, or they could be placed haphazardly on the floor. But the artist has stipulated only one arrangement: the six boxes are to be hung on a wall at approximately eye level and at 10-inch intervals from each other. Because of this stipulation, how these forms relate to one another and collectively occupy space remains constant; their arrangement is built into any public experience of the work. One must assume, therefore, that the artist considers this fixed arrangement and the way the work occupies space to be central to the experience of the work.

PLATE **7.8** Installation view of '10', Dwan Gallery, New York, 4–29 October 1966. From left to right: Jo Baer, *Horizontal Flanking. Large Scale*, 1966; Carl Andre, *Field*, 1966; Sol LeWitt, *A5*, 1966; Donald Judd, *Untitled*, 1966; Robert Morris, *Untitled*, 1966; Robert Smithson, *Alogon*, 1966. (Courtesy of Virginia Dwan, New York. Photo: John D. Schiff. © Carl Andre/VAGA, New York/DACS, London 2004; © ARS, New York and DACS, London 2004; © Estate of Robert Smithson/VAGA, New York/DACS, London 2004; Art © Donald Judd Foundation/ VAGA, New York/DACS, London 2004.)

 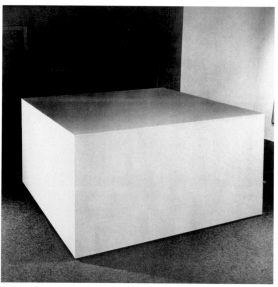

PLATE **7.9** Agnes Martin, *Leaves*, 1966, acrylic on canvas, 72 × 72 in and Robert Morris, *Untitled*, 1966, painted plywood, 8 × 8 × 4 ft. (From *10*, exhibition catalogue, Dwan Gallery, New York, 1966. © Agnes Martin, courtesy Pace Wildenstein, New York. © ARS, New York and DACS, London 2004.)

Judd's 1966 *Untitled* appeared in a number of different spaces in the mid-
1960s. Each of these contexts possessed its own set of constants: some
were dictated by the curator or author; others were set by the physical
terms of the exhibition space or the layout of the printed page. One of
Untitled's first public appearances was in a modest exhibition entitled '10'
organised by the artists Ad Reinhardt, Robert Morris and Robert Smithson at
Dwan Gallery, New York in 1966 (Plate 7.8).[11] Each of the ten artists included
in the exhibition – Carl Andre, Jo Baer, Dan Flavin, Donald Judd, Sol LeWitt,
Agnes Martin, Robert Morris, Ad Reinhardt, Robert Smithson and Michael
Steiner – contributed a single work. All of these works consist of simple
geometric forms, many repeat the same form in series and most are either
painted a shade of grey, black or white, or retain the original colour of the
materials used. But these shared formal elements do not establish the primary
relationship between the works, just an initial one. When placed together in
the exhibition space or in the exhibition's catalogue, the ten works take the
viewer beyond an initial recognition of geometric shape as a commonly
shared element to a consideration of the variety of permutations that these
basic shapes can generate in two and three dimensions. For example, Martin's
Leaves and Morris's *Untitled* embody the simple distinction between a
measured-out, drawn and painted, two-dimensional square of stretched canvas
and a three-dimensional cube constructed out of painted plywood (Plates 7.9
and 7.10). Similarly, one understands the cube as an expansion of a two-
dimensional square framework into a three-dimensional cubic framework
through LeWitt's *A5*, or as a repetition of a similar set of cubic dimensions

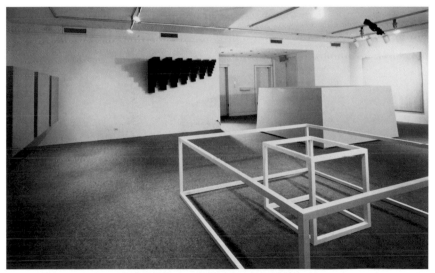

PLATE **7.10** Installation view of '10', Dwan Gallery, New York, 4–29 October
1966. From left to right: Donald Judd, *Untitled*, 1966; Robert
Smithson, *Alogon*, 1966; Carl Andre, *Field*, 1966; Sol LeWitt, *A5*,
1966; Robert Morris, *Untitled*, 1966; Agnes Martin, *Leaves*, 1966.
(Photo: Courtesy of Dwan Gallery Archives, New York. © Estate of
Robert Smithson/VAGA, New York/DACS, London 2004; © ARS,
New York and DACS, London 2004; © Carl Andre/VAGA, New
York/DACS, London 2004; Art © Donald Judd Foundation/VAGA,
New York/DACS, London 2004. © Agnes Martin, courtesy Pace
Wildenstein, New York.)

six times in Judd's *Untitled* (Plate 7.11). Also, hollowness, explicit and visible in LeWitt's work, is merely suggested by the way in which Judd's boxes seem to defy gravity by hovering above the gallery floor. And where, in the LeWitt work, the viewer can only infer surfaces stretching between the painted aluminium framing lines of the two nested forms, he or she must contend with the conspicuous lustre of the polished surfaces of galvanised iron that appear to dematerialise the six cubes that constitute the work by Judd. All of the works in the exhibition are variations of similar geometric forms. Their differences become apparent *because* they share these geometric shapes as a constant and as a point of departure.

All the works in '10' share the same space, an obvious point, but the way they share this space highlights both their similarities and their differences. Each work hangs or rests parallel to the walls and floor and lines up at a right angle or parallel to every other work in the gallery space (Plates 7.8 and 7.10). The deliberately ordered spatial relationships between the works themselves and between the works and the gallery's own spatial characteristics suggest that the exhibition's design depends on a strong sense of the exhibition space as a three-dimensional grid determined by the parallel and perpendicular planes of the gallery's walls, floor and ceiling. The individual works are woven together as geometrical units within this spatial system, a system that depends on the specific architectural elements and physical limits of the gallery space. This arrangement sets up a dialogue among the individual works, the spaces between them and the overall space of the exhibition. This dialogue articulates a complex and cumulative set of relationships: formal, spatial, conceptual and institutional. In a review of '10', the critic Annette Michelson took advantage of the subtlety of the formal relationships between the works in the exhibition to speculate on the nature of contemporary group exhibitions in general and why the ten artists put their works together at Dwan Gallery. She

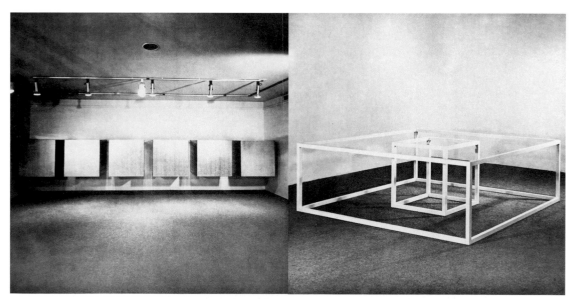

PLATE **7.11** Donald Judd, *Untitled*, 1966, galvanised iron, six units, each unit 40 × 40 × 40 in with 10-in intervals and Sol LeWitt, *A5*, 1966, painted aluminium, 84 × 84 × 28 in. (From *10*, exhibition catalogue, Dwan Gallery, New York, 1966.)

recognised the duality of formal clarity and disconcerting mutability in the works, calling '10' a 'Salon of the Problematic'. She proposed negation, a subtle but insistent cancellation of the initial observation of similarity, as the concept proper to understanding the relationships between these works. Difference was the operative experience: 'It is the series of patent but equivocal relationships obtaining between or among these works which is compelling. For what they share, they also dispute. A common accord is a basis for contention.'[12] Michelson noted, for example, how Andre's *Field* (Plate 7.12), a square of slightly uneven grey ceramic magnets arranged horizontally on the gallery floor, both formally resembled and yet contested Martin's *Leaves* (Plate 7.9), a similar grid of rectangular shapes drawn on a smooth, painted square canvas mounted vertically on the gallery wall. The differences between these works, their mutual contestation, served as a critique of traditional forms of categorisation, which were based on either formal similarities or established classifications such as 'painting' or 'sculpture'. This critique, according to Michelson, 'generate[d] a dialectic of frustration which stands as the "content" or "quality" of one's experience'.[13]

In a 1965 essay entitled 'Specific Objects', Judd also stated that the common aspects of the best new three-dimensional work were 'too general and too little common to define a movement. The differences are greater than the similarities.'[14] In fact, according to Judd, what this art truly shared was a rejection – a negation – of the standard premises, the fixed terms, of painting and sculpture or any simple categorisation by medium. All of the works illustrated in 'Specific Objects' appear to exemplify Judd's claim that 'the best new

PLATE **7.12**
Carl Andre, *Field*, 1966, ceramic magnets, 43^{7}/$_{8}$ × 43^{1}/$_{4}$ × 1/$_{2}$ in. (From *10*, exhibition catalogue, Dwan Gallery, New York, 1966. © Carl Andre/ VAGA, New York/ DACS, London 2004.)

three-dimensional work' deliberately disregarded the familiar terms of painting or sculpture by not adhering to the formal criteria of either. Judd mentioned, or the essay contains photographs of, the work of several of the artists included in '10' six months later – Flavin, Morris and himself – and his 1963 *Untitled* shares space in a two-page spread within the essay with Flavin's *Three Fluorescent Tubes (Red and Gold)* from the same year (Plate 7.13). But, combined with the three other works illustrated on these two pages and with the works illustrated in the essay as a whole, the Judd and the Flavin works make a somewhat different visual argument from that put forward in the 1966 Dwan Gallery exhibition. Rather than consisting of a limited number of the same simple geometric forms, all the works reproduced in the two-page spread seem to suggest themselves as familiar objects: fluorescent lights, books, tables, chairs and boats. In some cases, these objects are physically present in the work. Flavin's *Three Fluorescent Tubes (Red and Gold)* consists of exactly what its title suggests: three coloured fluorescent tubes, one red and two gold. Lucas Samaras and Yayoi Kusama covered an actual book and a boat with pins and stuffed fabric protuberances, respectively. Richard Artschwager's *Untitled* mimics the scale, basic form and image of a table and chair, and Judd's grouping of his 1963 *Untitled* with the work of Artschwager and the three other artists allows it to be read as a table-like form.

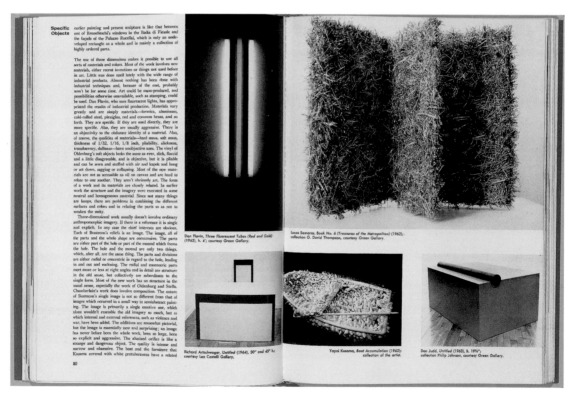

PLATE **7.13** Illustrations from Donald Judd, 'Specific Objects', *Arts Yearbook*, vol.8, 1965, pp.80–1. Clockwise from upper left: Dan Flavin, *Three Fluorescent Tubes (Red and Gold)*, 1963; Lucas Samaras, *Book No. 6 (Treasures of the Metropolitan)*, 1962; Donald Judd, *Untitled*, 1963; Yayoi Kusama, *Boat Accumulation*, 1962; Richard Artschwager, *Untitled*, 1964. (Reproduced by courtesy of *Arts Yearbook*. Photo: V&A Picture Library, London. © ARS, New York and DACS, London 2004; Art © Donald Judd Foundation/VAGA, New York/DACS, London 2004.)

None of these works derive their formal appearance or logic from precisely the same object; what was constant about them, according to Judd, was their specificity as objects. It was his choice and arrangements of individual images of these 'specific objects' alongside his 'Specific Objects' text that made his argument tenable. First, for Judd, these works were not representations of the objects they suggested, which is what they would have been if they were paintings or sculptures that depicted these objects; they were physical objects in their own right. Secondly, they demanded to be experienced on their own terms; their resemblance to more familiar objects served only to remind the viewer that the works were *not* those objects. Thirdly, Judd claimed that these 'specific objects' presented the viewer with a unitary 'wholeness' of form, material and image, and this experience of 'the thing as a whole, its quality as a whole',[15] was what Judd found interesting. As the differences between the works in '10' became apparent through their shared geometric shape, Judd sought to establish the 'wholeness' and specificity of his chosen works by calling attention to the palpable differences between a familiar object and a specific and somewhat unfamiliar manifestation of it.

Morris also began the first of a series of four essays entitled 'Notes on Sculpture' with a critique of the contemporary tendency to search for formal commonalities in the new art as an end in itself: 'At most, the assertions of common sensibilities are generalisations that minimise differences … In the interest of differences, it seems time that some of the distinctions sculpture has managed for itself be articulated.'[16] Although Morris still spoke of sculpture, rather than a new category of art such as specific objects, his description of the sculpture he was interested in resonates with the terms of Judd's argument. For Morris, the new sculpture was not involved with the business of reference: illusionism, representation or imagery. It consisted of complete, autonomous forms that existed in real space. But, unlike Judd, Morris favoured predominantly abstract geometric shapes that created 'strong gestalt sensations'.[17]

In the second instalment of his argument, 'Notes on Sculpture, Part 2', published eight months after the first, Morris elaborated on his conception of a sculptural gestalt by describing the experience of viewing Tony Smith's *Die* (Plate 7.14): 'The constant shape of the cube held in the mind, but which the viewer never literally experiences, is an actuality against which the literal changing perspective views are related. There are two distinct terms: the known constant and the experienced variable.'[18] In Morris's first essay, John McCracken's working drawings of *Yellow Pyramid*, as conceived from several points of view as a two-dimensional idea, represent the known constant, while a photograph of one of Morris's own works, *Untitled (Corner Piece)*, a single three-dimensional object occupying actual space and seen from only one point of view, illustrates the experienced variable (Plate 7.15). Because of the simplicity of Morris's work and its placement, one did not need – nor could one obtain – other points of view to comprehend the object's gestalt: 'One sees', according to Morris, 'and immediately "believes" that the pattern within one's mind corresponds to the existential fact of the object. Belief in this sense is both a kind of faith in spatial extension and a visualization of that extension.'[19] The viewer's phenomenological experience of the work, rather than an empirical understanding of it, is privileged here. For Morris, the space

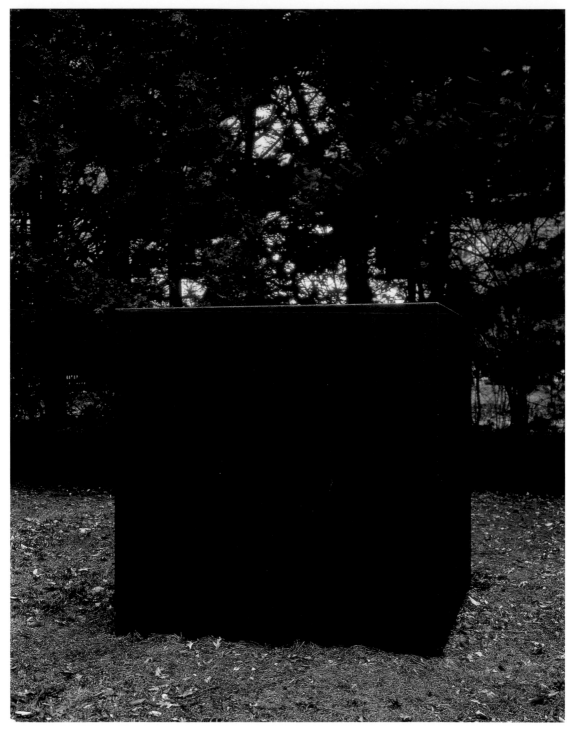

PLATE 7.14 Tony Smith, *Die*, 1962, steel, oiled finish, 6 x 6 x 6 ft. (© Tony Smith Estate/ARS, New York
and DACS, London 2004.)

PLATE 7.15 Illustrations from Robert Morris, 'Notes on Sculpture', *Artforum*, vol.4, no.6, February 1966, pp.42–3: Robert Morris, *Untitled* (*Corner Piece*), 1964 and John McCracken, *Yellow Pyramid*, 1965. (Reproduced courtesy of *Artforum*. Photo: V&A Picture Library, London.)

the work occupied and the temporal duration of the spectator's experience of it became key factors that were grounded by the spectator's awareness of his or her own body.

The illustrations for 'Notes on Sculpture, Part 2' present a visual argument analogous to the one provided by the exhibition '10'; a gap opens up between the identification of simple geometric constants and their manifestations as distinct objects in space. The similarities between these two visual arguments was no accident. Morris was one of the organisers of '10', and it opened in the same month and year – October 1966 – that his essay 'Notes on Sculpture, Part 2' appeared in *Artforum*. A full-page black-and-white photograph of a work by Morris accompanies the first page of the essay's text (just as one does in his first essay), but the essay's second two-page spread contains six images that provide variations on a sculptural process (the arrangement of identical or similar elements) or on a particular form (the cube) (Plate 7.16). On the left-hand page, the illustrated works by Tony Smith, Donald Bernshouse and Carl Andre all consist of arrangements of uniform units or, in the case of Bernshouse's *Platform*, a form – stairs – that is the result of graduated stacked units. On the right-hand page, LeWitt's work and Smith's *Die* echo *10*'s comparison of LeWitt's and Judd's open and closed cubic forms (Plate 7.11). Together the six images exemplify the two terms that Morris believed were necessary to an experience of gestalt: the known constant and the experienced variable.

In the accompanying text, Morris also argued that this new work had 'expanded the terms of sculpture' by drawing attention to the context in which it was perceived. This context included its placement on the pages of his essay and the creation of its exhibition situation in the gallery. Morris stated:

> That many considerations must be taken into account in order that the work keep its place as a term in the expanded situation hardly indicates a lack of interest in the object itself. But the concerns now are for more control of and/or cooperation of the entire situation. Control is necessary if the variables of object, light, space, body, are to function.[20]

Thus, he concluded: 'The object itself has not become less important. It has become less *self*-important.'[21]

Morris's assessment could easily have applied to the experience of similar works as they were arranged in '10' or as they were reproduced in its catalogue, because he acknowledged how much of the experience of this work depended on its spatial circumstances. The meaning of the work was largely external to it – as Krauss was to argue later on – but this meaning was produced by the shared yet contested physical terms of the individual works and the arrangements or situations within which viewers experienced them. Judd may not have agreed with these situational terms because he was so focused on the self-sufficiency of his specific objects, but he too was forced to put his specific objects in dialogue with each other to highlight their particular material and conceptual specificity.

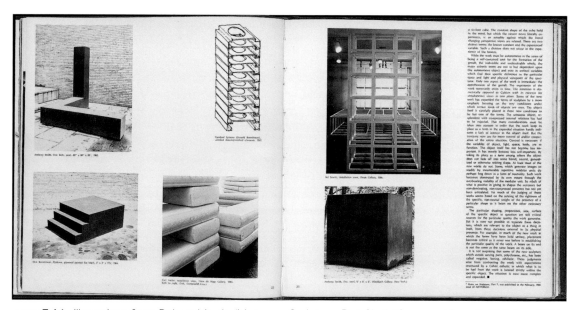

PLATE **7.16** Illustrations from Robert Morris, 'Notes on Sculpture, Part 2', *Artforum*, vol.5, no.2, October 1966, pp.22–3. Clockwise from upper left: Tony Smith, *Free Ride*, 1962; Donald Bernshouse, untitled drawing/stacked elements, 1965; Sol LeWitt, installation view, Dwan Gallery, 1966; Tony Smith, *Die*, 1962; Carl Andre, installation view, Tibor de Nagy Gallery, 1965; Donald Bernshouse, *Platform*, 1964. (Reproduced courtesy of *Artforum*. Photo: V&A Picture Library, London.)

The modernist critic and art historian Michael Fried's now infamous assessment of minimalism – he called it 'literalist art' – in his 1967 essay 'Art and Objecthood' is bracketed by two images of the exhibition '10'. The essay opens with an installation shot of Judd's 1966 *Untitled* (Plate 7.17) – the same image of the work that appears in the catalogue *10* (Plate 7.11) – and ends with another installation shot, also from the catalogue, of an untitled work by Steiner. In between these two images, Fried's text reiterates many of the points made by Judd in 'Specific Objects' and by Morris in the first two parts of 'Notes on Sculpture' to build a case *against* these two artists. For Fried, their work and work like it produced a theatrical effect that was, for him, the antithesis of art. Fried argued: 'the literalist espousal of objecthood amounts to nothing other than a plea for a new genre of theater; and theater is now the negation of art'.[22] Although Fried disliked what he saw, he too was describing a situation and an experience that emerged out of difference and negation.

According to Fried, literalist art negated painting, sculpture and ultimately art in general, by demanding that the spectator engage with it in relation to its specific setting and engage with it over time. One must, for example, walk around this work, or view it in relation to other works, in relation to other, non-art types of objects and experiences, and in relation to its surroundings, to understand it in terms of art. The experience was comparative, negative and hence always incomplete, whereas, according to Fried, the experience of art was positive, self-sufficient and instantaneous, no matter what its particular setting or one's particular point of view: '*at every moment the work itself is wholly manifest*' and perpetually '*present*'.[23]

PLATE **7.17** Illustration from Michael Fried, 'Art and Objecthood', *Artforum*, vol.6, no.10, June 1967, pp.12–13: Donald Judd, *Untitled*, 1966. (Reproduced Courtesy of *Artforum*. Photo: V&A Picture Library, London.)

Works of literalist art acted like ordinary objects and, like these objects, their compelling experiential 'difference' was short-lived. Both generated initial interest, but eventually they became just like anything else that takes up space. In certain respects, this was Greenberg's argument in 'Recentness of Sculpture', except that Fried described the experience of objects and literalist art, no matter how mundane, as inherently inexhaustible. This was not, Fried claimed, 'because of any fullness – *that* is the inexhaustibility of art – but because there is nothing there to exhaust. It is endless the way a road might be: if it were circular, for example.'[24] By incorporating its setting – its 'stage' – and requiring an experience that was durational, literalist art was for Fried like theatre; it was constantly a presence 'in play', constantly unfolding in time and never fully manifest. He might have agreed with Michelson's assessment of the experience of this work, that it 'generate[d] a dialectic of frustration which stands as the "content" or "quality" of one's experience'.[25] But this type of arbitrary phenomenological experience and the art that generated it left him cold.

The readymade and the handmade

Although Judd advocated the use of new, industrially produced materials because 'they aren't obviously art' and anticipated the use of mass-production techniques by artists, his stipulated arrangements of works such as his 1966 *Untitled* (Plate 7.17) made his beautifully hand-crafted, galvanised iron boxes initially appear to be mass produced and exactly equivalent, when they were not.[26] Also, the measured precision of the 10-inch spatial intervals between the boxes, which contributed to this image of manufactured equivalence, had to be created by hand every time the work was exhibited. Judd described such an ordering process as something that is 'not rationalistic or underlying but is simply order like that of continuity, one thing after another'.[27]

A publicity photograph that accompanies a *New York Times* article, published a few days before the opening of the Jewish Museum's 1966 sculpture exhibition 'Primary Structures', depicts the physical act of arranging individual units into a work of art, an aspect of minimalism that was rarely recorded (Plate 7.18).[28] The particular work in this photograph, Smithson's *Cryosphere* (Plate 7.19), like Judd's 1966 *Untitled*, comprises identical geometric units and a stipulated arrangement for these units. In a statement published in the 'Primary Structures' exhibition catalogue, Smithson indicated that *Cryosphere* consists of six visible modules, with twelve invisible modules in between and on either side of the six visible ones in a sequence of 0100100100100100100. He asked viewers to 'Invent your sight as you look. Allow your eyes to be an invention' to charge the pattern of repeated intervals between the modules – the zeros – with materiality.[29] Absence and dead space had to give way to a repeated sequence of physical and visualised images of units that reflected the artist's process of thinking about and measuring out the arrangement of *Cryosphere* on the wall of the exhibition space. The work was an after-image of the artist's arranging process, his time and labour, and both were meant to be reiterated through the mental process and time it took the viewer to see the work.

PLATE **7.18**
Friedman-Abeles, *Kynaston McShine and Primary Structures*, black and white photograph. (*New York Times*, 24 April 1966.)

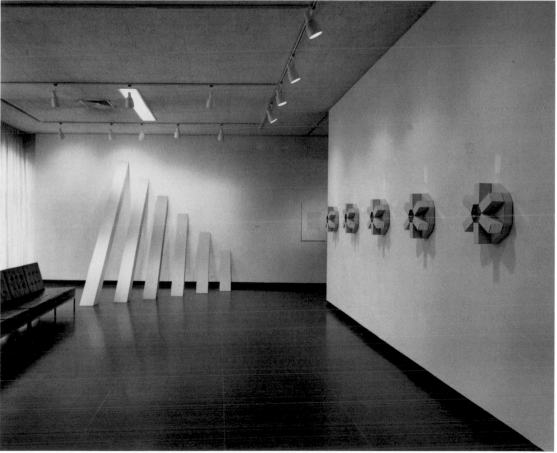

PLATE **7.19** Installation view of Robert Smithson's *Cryosphere* in 'Primary Structures', Jewish Museum, New York, 1966. (Photo: Jewish Museum, New York.)

In a review of 'Primary Structures', the critic David Bourdon noticed another type of absence from the exhibition – Warhol's recently exhibited *Brillo* (Plate 7.2) – that he claimed was, in fact, also covertly present:

> Warhol's ideas have subverted the thinking of the younger generation of abstract artists who deplore his pop images but who speak increasingly in terms of standardisation, units, and factory production. It is safe to assert that the Brillo boxes sit deeper in the psyches of some Primary Structurists than they care to admit.[30]

The resemblance between Warhol's *Brillo* and the cleaning product that was its source is literally superficial; a surface image was adapted from a small paper box and silkscreened onto a series of standardised, artwork-scale, white wooden cubes. Formally, Warhol's boxes shared the elements of standardisation and repetition with the contemporary art then associated with minimalism, such as Smithson's *Cryosphere* (Plate 7.19), Judd's 1966 *Untitled* (Plate 7.17) and Andre's *Field* (Plate 7.12). These two qualities – standardisation and repetition – reflected a mutual interest in mass production, even if this interest, as Rose and other critics noted at the time, was expressed in somewhat different styles.[31]

Artists and some critics at the time described minimalist artists' use of repeated standardised units in terms of Marcel Duchamp's readymades. They used the term not only to describe the status of the units, since these units were not always readymade, but also to describe the repetition of the units, which they associated with mass production and commodity culture. In 'A B C Art', Rose described works by Judd, Morris, Andre and Flavin that consist of repeated standardised units and concluded: 'To find variety in repetition where only the nuance alters seems more and more to interest artists, perhaps in relation to the increasing uniformity of the environment and repetitiveness of a circumscribed experience.'[32] This work and others, such as Warhol's *Brillo*, used this repetition, she claimed, to call attention to the uniformity of everyday life and, through its very own mechanism, reveal subtle material and experiential disparities. Anonymity and equivalence gave way to specificity and difference.

Scale was also a key consideration for minimalist artists, since it dictated the nature of the experience of such standardised units or of any singular, simple geometric form. In 'Notes on Sculpture, Part 2', Morris introduced the problem of scale by citing Smith's responses to questions about *Die* (Plate 7.14):

> Q: Why didn't you make it larger so that it would loom over the observer?
>
> A: I was not making a monument.
>
> Q: Then why didn't you make it smaller so that the observer could see over the top?
>
> A: I was not making an object.[33]

Sculpture, for Morris, fell somewhere in between a monument and an art object, and was judged by viewers relative to their own bodies: 'The quality of intimacy is attached to an object in a fairly direct proportion as its size diminishes in relation to oneself. The quality of publicness is attached in proportion as the size increases in relation to oneself … The qualities of publicness or privateness are imposed on things.'[34] Morris clearly preferred a scale that produced a more public experience, since this experience more fully engaged the body of the viewer and the space the work occupied.

Nevertheless, many artists, including Andre, LeWitt and Smithson, to name just a few, also made models or smaller versions of their larger-scale works, which critics and fellow-artists would have experienced on a much more intimate and physical level in the artists' studios and homes. For these privileged viewers, such encounters would have informed their more institutional experiences of these artists' works in galleries, museums and on the pages of art magazines. Even under these circumstances, the distinction that Krauss drew between private and public experience when describing the viewer's engagement with minimalism still holds, since she was not describing types of space as much as external versus internal experiences of art objects. Scale facilitates external experience in a number of ways. For example, Ruth Vollmer addressed the central terms of both scale and arrangement by scaling her work so that it could be easily and repeatedly handled. Her *Bound Sphere Minus Lune* (Plate 7.20) consists of a cast bronze sphere, 7½ inches in diameter. Three arcs cut in the shape of crescents intersect at the point where the two halves of the sphere are bound together to create a detachable lune. One sculpture generates two dependent sculptures, and, alternately, these same two sculptures create one integrated sculpture, and an enclosed void that can be easily accessed, opened up and then sealed shut in order to start the process all over again. The sculpture is an arrangement always in the process of being rearranged. Its handmade form, a unique cast, becomes a readymade form, subject to endless, repeated orderings and reorderings. In this way, for the viewer Vollmer's work permits a dimension of interaction with the sculptural object that could only be imagined in the more familiar institutional experience of minimalism.

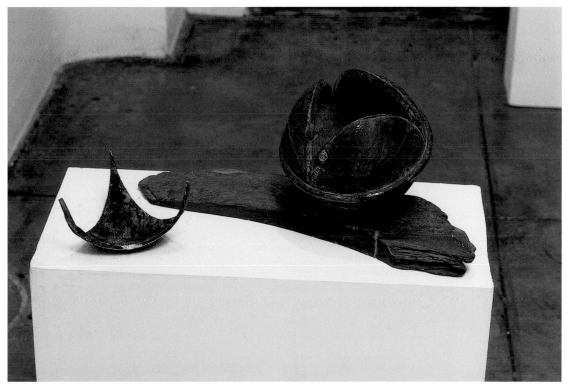

PLATE **7.20** Ruth Vollmer, *Bound Sphere Minus Lune*, 1963, unique cast bronze on slate, 7½ in diameter. (Courtesy Jack Tilton/Anna Kustera Gallery, New York.)

Minimalism's image

What is now called 'minimalism' originated as a series of situations and visual, phenomenological and conceptual effects that were defined by space and spatial arrangements and occurred in time. Artists and curators created these situations and their concomitant effects, and they and critics then described both using similar terms and many of the same images. These texts and pictures presented debates about minimalist art that were based on their authors' direct experience of these works and exhibitions, which some, but not all, of the contemporary readers of these texts or catalogues would then have been able to fill in with their own experiences of these same or similar works and exhibitions. The arguments and the arrangements of images that the artists and curators used were the result of thinking about their experiences of actual works in a variety of spaces and on a variety of scales, not images of them.

After the fact, all that was left of these experiences were images and descriptions frozen in predominantly black-and-white exhibition installation shots or arrangements of black-and-white photographs of individual works of art on the pages of art magazines.[35] These images have become minimalism's own constant, and the tension or gap between image and experience, constant and variable has disappeared. The scripted arrangements of these works, so central to the physical and mental experiences of constants and variables, were also, and continue to be, made new every time that the works were, or are, exhibited. Most still images cannot illustrate this fully either, but if one remembers that these images depict only isolated views of completed exhibition installations, or if one considers them in relation to their initial accompanying critical texts and in relation to a wider variety of contemporary works by artists either forgotten or now not considered to be minimalists, one can begin to recover what was significant about this work. Although almost always geometric, the work was never about forms *per se*. It was about arranging and experiencing the arrangement of these forms in space. In his fourth and final essay in the 'Notes on Sculpture' series, which he subtitled 'Beyond Objects', Morris seems to anticipate art history's overdependence on still photographic images and its consequent misreading of the moment of minimalism:

> Any activity, with perhaps the exception of unfocused play, projects
> some more or less specific end and in this sense separates the
> process from the achievement. But images need not be identified
> with ends in art. Although priorities do exist in the work under
> discussion, they are not preconceived imagistic ones.[36]

The complex experience of what one might call retroactively a minimalist effect in real time and space – both in spaces other than strictly institutional ones, for example private homes and studios, and even in institutional spaces during more informal moments of interacting with this type of work – was what Rose, Krauss, Michelson, Judd, Morris, Fried and others were describing. The photographs they or others chose to represent these experiences were not meant to replace them, but, in a way, they have. This history, this art and

what has now become its set list of artists all look very different when the art is understood as a situated experience rather than a set of simple geometric forms. While enabling easy categorisation, the seemingly clear boundaries art history has placed between Minimal Art, Pop Art, Conceptual Art and other terms used to describe a crucial moment in the mid-1960s belie the interplay of ideas and practices that characterised the crisis in art at that time.

Notes

1 Barbara Rose, quoted in 'Sculpture: Engineer's Esthetic', p.65.

2 Greenberg, 'Recentness of Sculpture' (1967), in O'Brian, *Clement Greenberg*, vol.4, p.252.

3 *Ibid.*, p.254.

4 Foster, 'The Crux of Minimalism', p.60. Pop Art, according to Foster, embodies the same crux and experiences the same fate.

5 Meyer, *Minimalism*, and Potts, *The Sculptural Imagination*, provide the principal exceptions to this tendency in recent scholarship.

6 Rosalind Krauss, in *Passages in Modern Sculpture*, notes: 'The very term minimalism itself points to this idea of a reduction of art to a point of emptiness, as do the other terms such as "neo-dadaism" and "nihilism" that were used to characterise the works of these artists' (p.254).

7 The works of Minimal Art discussed in this chapter were produced using imperial measurements (feet and inches) rather than metric measurements. Since the relationship of the objects to the spaces between them is often important, and involves whole-number ratios, the original measurement system has been retained.

8 Rose, 'A B C Art' (1965), in Battcock, *Minimal Art*, p.285.

9 Krauss, *Passages in Modern Sculpture*, p.266.

10 *Ibid.*, pp.267, 262.

11 Smithson, 'Interview with Paul Cummings for the Archives of American Art/ Smithsonian Institute' (1972), in Holt, *The Writings of Robert Smithson*, p.152.

12 Michelson, '10 × 10', p.31.

13 *Ibid.*

14 Judd, 'Specific Objects', p.74.

15 *Ibid.*, p.78.

16 Morris, 'Notes on Sculpture' (1966), in Battcock, *Minimal Art*, p.223. This essay is reprinted in Harrison and Wood, *Art in Theory*, VIIA6, pp.828–30.

17 Morris, 'Notes on Sculpture' (1966), in Battcock, *Minimal Art*, p.226.

18 Morris, 'Notes on Sculpture, Part 2' (1966), in *ibid.*, p.234. This essay is reprinted in Harrison and Wood, *Art in Theory*, VIIA6, pp.830–3.

19 Morris, 'Notes on Sculpture' (1966), in *ibid.*, p.226.

20 Morris, 'Notes on Sculpture, Part 2' (1966), in *ibid.*, p.234.

21 *Ibid.*

22 Fried, 'Art and Objecthood' (1967), in *ibid.*, p.125.

23 *Ibid.*, p.145.

24 *Ibid.*, p.144.

25 Michelson, '10 × 10', p.31.

26 Judd, 'Specific Objects', p.80.

27 *Ibid*.

28 'Primary Structures: Younger American and British Sculptors' brought together one of the largest and most ambitious selections of contemporary abstract sculpture at that time: forty-two American and British artists participated (McShine, *Primary Structures*). The exhibition is now considered to be a significant episode in the formulation of the category 'minimalist art'. The work of over half of the artists exhibited in '10' at Dwan Gallery had been included in it, and the Dwan exhibition was organised, in part, as a response to it. For a discussion of these two exhibitions in relation to 1960s exhibition practices, see Reynolds, 'Resemblance and Desire', pp.90–107.

29 Smithson, 'The Cryosphere' (1966), in Holt, *The Writings of Robert Smithson*, p.37.

30 Bourdon, 'Our Period Style', pp.55–6.

31 Rose, 'A B C Art' (1965), in Battcock, *Minimal Art*, p.281.

32 *Ibid.*, p.289.

33 Morris, 'Notes on Sculpture, Part 2' (1966), in Battcock, *Minimal Art*, pp.228–30.

34 Morris, 'Notes on Sculpture, Part 2' (1966), in *ibid.*, p.230.

35 In an endnote to 'Notes on Sculpture, Part 4', Morris disagrees with Rose's claim that the only way to make the art that he is discussing permanent is 'through media's "freezing" it into a static form'. He counters that 'such a conclusion identifies the record with the thing but work involving indeterminacy can have any number of "records" – the work itself does not come to rest with any of them' (p.54). This essay is reprinted in Harrison and Wood, *Art in Theory*, VIIB4, pp.881–5.

36 Morris, 'Notes on Sculpture, Part 4', p.54.

References

Battcock, G. (ed.), *Minimal Art: A Critical Anthology*, New York: Dutton, 1968.

Bourdon, D., 'Our Period Style', *Art and Artists*, vol.1, no.3, June 1966, pp.55–6.

Foster, H., 'The Crux of Minimalism', in *The Return of the Real*, Cambridge, MA: MIT Press, 1996, pp.34–69.

Harrison, C. and Wood, P. (eds), *Art in Theory 1900–2000: An Anthology of Changing Ideas*, Malden, MA and Oxford: Blackwell, 2003.

Holt, N. (ed.), *The Writings of Robert Smithson*, New York: New York University Press, 1979.

Judd, D., 'Specific Objects', *Arts Yearbook*, vol.8, 1965, pp.74–82.

Krauss, R., *Passages in Modern Sculpture*, New York: Viking Press, 1977.

McShine, K., *Primary Structures: Younger British and American Sculptors*, exhibition catalogue, Jewish Museum, New York, 1966.

Meyer, J., *Minimalism: Art and Polemics in the Sixties*, New Haven and London: Yale University Press, 2001.

Michelson, A., '10 × 10: "Concrete Reasonableness"', *Artforum*, vol.5, no.5, January 1967, pp.30–1.

Morris, R., 'Notes on Sculpture, Part 4: Beyond Objects', *Artforum*, vol.7, no.8, 1969, pp.50–4.

O'Brian, J. (ed.), *Clement Greenberg: The Collected Essays and Criticism*, vol.4: *Modernism with a Vengeance 1957–1969*, Chicago: University of Chicago Press, 1993.

Potts, A., *The Sculptural Imagination: Figurative, Modernist, Minimalist*, New Haven and London: Yale University Press, 2001.

Reynolds, A., 'Resemblance and Desire', *Center: A Journal for Architecture in America*, vol.9, 1995, pp.90–107.

'Sculpture: Engineer's Esthetic', *Time*, vol.87, no.22, 3 June 1966, pp.64–7.

CHAPTER 8

Vernacular modernism

Steve Edwards

Introduction

The transformation in the balance of global power after the Second World War meant that avant-garde practices associated with the prewar European Left, such as photomontage and the 'New Vision' photography – which developed in Germany at the end of the 1920s as a way of depicting the world in line with the mechanical and optical characteristics of the camera – echoed in postwar America only as pale spectres. For instance, László Moholy-Nagy, who had played a key role in the European avant-garde's engagement with photography, in his new role as the director of the Institute of Design in Chicago, put these techniques to work in the service of the American publicity and advertising industry.[1] The predominant American art-photography during the 1950s – centred on the magazine *Aperture* and its editor Minor White – took the form of a resurrected Pictorialism (Plate 8.2). Whereas the Pictorialists, around the turn of the twentieth century, drew on traditional forms of art, the art-photographers of the 1950s imitated post-Cubist painting. White, and his collaborators, believed that the arrangement of forms and tones in the photograph could express the artist's feelings or mystical experience. When these photographers attempted to imitate abstract art, their work ceased to play an important role in avant-garde culture and once again appeared as painting's shabby cousin.[2]

Throughout the twentieth century, however, there has always been a parallel history of photography occupying an uneasy relation to art (neither Pictorialist nor strictly avant-gardist). As was discussed in Chapter 13 of *Art of the Avant-Gardes*, modernist photographers in the 1920s and 1930s engaged in what the artist Jeff Wall calls 'an exploration of the border territories of the utilitarian picture'.[3] Some photographers, working in what can loosely be described as a 'documentary' mode, began in the 1930s to explore the threshold separating functional documents from art. In Europe, Henri Cartier-Bresson, André Kertész and others produced influential work in this vein. Working at the same time in the USA, Walker Evans pursued the model of everyday photographs to the point where his images could seem remarkable in their unremarkableness. His focus on the ordinary and the overlooked tested his audience's ability to see these photographs as *pictures* rather than simply as copies of the world. Evans, and others working in this mode, reinvented photography through a 'low-plane' vision (Plate 8.3). The idea of a low-plane vision was developed by the art historian Norman Bryson in a book on still-life painting, where he contrasted the elevated attention (both the literal lifting of the eyes and the idea of spiritual uplift) typical of religious or historical subjects to the focus on the ordinary objects of everyday life.[4] By concentrating attention on the mundane and the overlooked, Bryson argued, still-life painting revitalised habitualised vision. Photographers such as Evans employed a low-plane gaze drawn from an engagement with commercial and vernacular pictures.

PLATE **8.1** (facing page) William Eggleston, detail of *Jackson, Mississippi* (Plate 8.7).

Although the avant-garde sometimes laid claim to this photographic work, these pictures were as likely to be encountered in the mass media as in the small gallery. Photographs of this type found their place in the unstable and shifting ground between mass culture and critical attention, or, to state this differently, they rendered problematic the seemingly secure opposition between everyday images and autonomous art. On the occasion of Evans's solo show at the Museum of Modern Art, New York in 1938, Lincoln Kirstein wrote that these pictures revealed the civilisation of the eastern USA in a way that no painter had managed. He stated:

> Only newspapers, the writers of popular music, the technicians of advertising and radio have in their blind energy accidentally, fortuitously, evoked for future historians such a powerful monument to our moment. And Evans' work has, in addition, intention, logic, continuity, climax, sense and perfection.[5]

PLATE **8.3**
Walker Evans,
*Corrugated Tin
Façade*, 1936,
gelatin silver print,
17 × 23 cm. (David
H. McAlpin Fund.
DIGITAL IMAGE © 2003
The Museum of
Modern Art, New
York/Scala, Florence.)

This argument seems to advance a different thesis from that advocated by
Clement Greenberg in his essay 'Avant-Garde and Kitsch', which appeared the
following year. According to Kirstein, American popular culture possessed much
more dynamism and modernity than American art did. It was by engaging with
the products of the culture industry rather than turning one's back on them
that the artist – or at least the photographer – could produce critical art. In a
related fashion, the photographer William Klein argued that during the 1950s
the art journals were uninterested in innovative photography, while the photo
magazines where stuffed full of sunsets. Serious photography, Klein claimed,
was sponsored, at this time, by the fashion magazines *Harper's Bazaar* and
Vogue.[6] Modernist photography, as it became enshrined at the Museum of
Modern Art, was built out of these borderline practices that traversed autonomy
and heteronomy.[7] Jeff Wall's apparently contradictory phrase the 'art concept
of photojournalism' captures the borderline status of this practice.[8]

Robert Frank's photo-book *The Americans* encapsulated this tradition in the
1950s.[9] During 1955 and 1956, Frank, a Swiss photographer, travelled across
the USA taking pictures for this book. In the period of the Cold War, his
images did not go down well with the critics: one described *The Americans* as
'marred by spite, bitterness and narrow prejudices'. Another suggested that
the book was 'an attack on the United States', while Minor White described it
as 'a gross lie'.[10] Frank's book was, paradoxically, seen both as a nihilist assault
on all values and as anti-American. It is worth considering why these
commentators worked themselves up into such a lather over this book.

Frank combined attention to low-key subjects, photographing spaces and
things that were banal enough to be almost invisible, with a studied casualness
of composition that seemed to push his images towards the category of 'bad'
photographs. He described his subjects as: 'a town at night, a parking lot,

PLATE **8.4** Robert Frank, *Political Rally – Chicago*, 1956, vintage gelatin silver print paper, 28 × 35 cm.
(© The Americans, Robert Frank. Courtesy Pace/MacGill Gallery, New York.)

a supermarket, a highway … advertising, neon lights, the faces of leaders and the faces of followers, gas tanks and post offices and back yards'.[11] Frank combined these low-plane subjects with an approach that skilfully employed 'mistakes' in technique and anomalies thrown up by the document as a form: he seemed to wallow in shallow depth of field, blurs created by camera movement, flares of light produced by reflective surfaces, grainy images and abrupt cropping. The resulting pictures seemed incoherent, or banal, or both; the picture of the USA bleak and unforgiving. Above all, what seemed to perturb these critics was Frank's challenge to the prevalent forms of humanist documentary photography, embodied in his refusal to produce a clearly intelligible narrative meaning. One commentator spelled this out, claiming Frank was 'a poor essayist and no convincing storyteller'.[12] Instead, Frank seemed to question photographic norms to the point where even formal recognition was placed under duress. In *Political Rally – Chicago* (Plate 8.4) the frontality of the image, the cropping of bodies on the extremities, and the alignment of instrument and man are all techniques learned from popular photography. The resulting image produced a hybrid figure, while the flag seems to occupy the space of a cartoon thought bubble (perhaps it is intended as a visual equivalent for the sound made by the instrument). Frank's book set the tone for ambitious photography in the 1960s.

This chapter examines the tradition of modernist street photography as it was enshrined in the photography department of the Museum of Modern Art. In particular, I will concentrate on the work of a number of photographers – known as photographers of the 'Social Landscape' – who inherited the Frank legacy. I will engage with this project through the ideas of its most prominent spokesman, John Szarkowski. In the second part of this chapter, I will consider some important differences between photographers who have frequently been treated as a homogenous group: Diane Arbus, Lee Friedlander and Garry Winogrand.

From documents to modernism as 'false documents': photography at the Museum of Modern Art

The department of photography at the Museum of Modern Art was established in 1940, but the museum had from the outset collected and exhibited photographs.[13] Beaumont Newhall – the first curator of photographs – was committed to art-photography, but others in his department, and his successor Edward Steichen, held very different ideas about photography. From 1942 until (at least) the mid-1950s, exhibitions of photographs at the Museum of Modern Art were, predominantly, didactic displays of images by photojournalists and other document makers. The titles of these exhibitions are indicative of their content: 'Road to Victory' (1942); 'Power in the Pacific' (1945); 'Korea: The Impact of War in Photographs' (1951).[14] Utilising a 'debased' version of modernist montage techniques, these exhibitions juxtaposed images and text to produce unabashed propaganda displays.[15]

The most famous of these exhibitions was 'The Family of Man' (Plate 8.5), mounted in 1955 by Steichen, a former Pictorialist turned commercial photographer and curator. In Steichen's words, this was 'the most ambitious and challenging project photography has ever attempted'.[16] This exhibition employed photography as a medium for recording a supposedly unchanging and essential 'human condition'. In its own terms the exhibition was a spectacular success: it was seen by nine million people in sixty-nine countries and the accompanying book had, by 1978, sold some four million copies.[17] A project as public and didactic as this was bound to generate controversy. The view that has largely prevailed – that of the intellectual Left – argues that the exhibition propagated a homogenous vision of humanity that masked economic and political inequalities. These critics insist that the institutional power of the Museum of Modern Art enabled it to promote a timeless view of human nature across the globe, making 'The Family of Man' the epitome of the American cultural Cold War project.[18] In contrast, the conservative critic Hilton Kramer saw the exhibition as liberalism in pictorial form. For Kramer, the exhibition represented everything that was 'discredited in progressive ideology'.[19] In a sense, both of these positions are correct, since the exhibition embodied the growing dominance of liberal capitalism over more traditional or conservative opinion. What one sees in 'The Family of Man' depends very much on the political, and even geographic, position from which it is viewed.[20] I do not have space to elaborate on this important debate; the main point to grasp here is that Steichen's exhibition was rooted in a mass-media view of photography, where individual photographs were recropped and recaptioned to form components in a larger narrative. As one historian put it, the exhibition was a 'gargantuan paean to humanist documentary, and more specifically, to the popular aesthetic of the picture magazines'.[21] That is to say, Steichen's displays had more in common with the photojournalism of *Life* magazine than with what we commonly associate with an exhibition of art-photography. For him, photographs were instrumental tools suited to public instruction.

When the photographer John Szarkowski was appointed curator of photographs at the Museum of Modern Art in 1962, these priorities changed. Under Szarkowski, Steichen's 'hyperactive, chock-a-block' exhibitions gave way to single prints, simply framed, on white walls.[22] It was during Szarkowski's tenure as curator that photography gained a relatively stable identity as art at the Museum of Modern Art.[23] From the outset he refused to subsume photography into the mass media, and, while he did exhibit White and others from his circle, his real commitment was to a practice of street photography that he identified with 'vernacular' forms. One strength of Szarkowski's account of photographic modernism and medium specificity was that it was not prey to the dangers of technocratic vision found in many variants of the 'New Vision'.

In *The Photographer's Eye*, the catalogue that accompanied an exhibition of the same title at the Museum of Modern Art in 1964, Szarkowski argued that any study of photographic form had to engage with art-photography and the 'functional' uses of the medium as 'intimately interdependent aspects of a single history'.[24] Szarkowski pursued this agenda by paying particular attention to 'vernacular' practices. The term 'vernacular' literally means an indigenous or native language, but in design, or architecture, it refers to forms that have

PLATE **8.5** Ezra Stoller, photograph of the entrance to 'The Family of Man', New York, MOMA 1955. (Ezra Stoller © Esto.)

developed through time (usually in everyday practices) rather than those that have been consciously produced by a professional designer or architect. Szarkowski uses the term in this sense; as we will see, he believed that vernacular practices revealed what was essential in the medium of photography. The pictures taken by 'journeymen', 'hobbyists', and so forth, were, Szarkowski believed, radically unlike any previously existing pictures. For him, the key to photographic form lay not in imitating the styles of painting but in exploring the limits and possibilities of the photographic apparatus.

Vernacular modernism

The predominant forms and uses of photography have little to do with art: everyday photography is valued for its capacity to record events, persons and things. Functional photographs, from photojournalism to police pictures, are concerned with clarity and legibility rather than pictorial complexity. Amateur 'snapshots' constitute a second type of vernacular photography. These amateur photographs of family, friends or treasured things frequently slice off heads, or misalign objects. When he referred to the medium's vernacular forms Szarkowksi had amateur pictures and functional documents in mind. The photographers he championed – Garry Winogrand, Lee Friedlander, Diane Arbus, William Eggleston and others – produced autonomous pictures out of an engagement with vernacular practices. For these photographers, vernacular modes of attention provided a resource for reinventing photographic ways of seeing.

In what follows I want to give a brief indication of the way in which these four photographers employed the characteristics of vernacular pictures, before turning to Szarkowski's account of what I call 'vernacular modernism'.

In Lee Friedlander's *Lafayette, Louisiana* (1968) (Plate 8.6), a prominent vertical pole blocks the viewer's line of sight and interrupts the coherence of the image. This vertical plane pushes the viewer back and prevents an easy perception of the events occurring behind it.[25] In an important essay on Friedlander, Martha Rosler suggests that this effect was akin to the irritation you feel when your theatre seat is positioned behind a pillar, or when the view out of the car window is prevented by a passing truck.[26] These effects are common enough in amateur photography, but at the time this image was made, they were studiously avoided in art-photography in the name of artistic competence and good taste.

Eggleston's *Jackson, Mississippi* (1971) (Plate 8.7) presents a riot of forms and colours. Szarkowski famously hailed Eggleston's pictures as 'the discovery of colour photography'.[27] He did not mean by this that Eggleston had discovered a technical

PLATE **8.6**
Lee Friedlander,
Lafayette, Louisiana,
1968, gelatin silver
print, 28 × 35 cm.
(Museum of
Contemporary Art,
Los Angeles,
The Ralph M. Parsons
Foundation
Photography Collection.
Photo: Brian Forrest.
Courtesy Fraenkel
Gallery, San Francisco.)

colour process, but that he had freed photographic colour from its established uses. Colour photographs, Szarkowski claimed, either were black and white pictures in colour, or were based on painterly harmonies: most colour photography was, he said, 'either formal or pretty'. Eggleston, in contrast, worked with 'educated vernacular' colour. These colours, Szarkowski said, resembled the 'Kodachrome slides of the ubiquitous amateur next door'.[28] Put simply, Eggleston's jarring colour effects stem from his attention to amateur snapshots.

Whereas Friedlander and Eggleston drew on amateur pictures, Diane Arbus fused family snapshots with the conventions of instrumental documents to produce portraits in a manic mode. Her photographs frequently seem to exist on the border between family photography and the frontality, rigidity of pose and tight framing of the mug shot or police record picture; her practice of employing a flash in daylight to pick out her subjects enforces this analogy. The effect is not very flattering. Arbus relies on confronting the viewer with what Susan Sontag calls the 'assorted monsters and borderline cases' of American society.[29] Arbus's photographs present these people as specimens. The subjects in these pictures face us directly and engage our gaze: this does not make for a comfortable viewing position.

Winogrand's picture *Los Angeles* (1964) (Plate 8.8) seems to take its model from photojournalism. Winogrand famously said 'I photograph to find out what something will look like photographed.'[30] This picture is taken with a fast shutter speed to try to freeze the moving vehicle. It is informal and seems almost randomly organised, until, that is, we realise that the detail that grabs our attention – the plaster on the man's broken nose – is positioned more or less at the centre of the image. Winogrand's photographs often turn on these single moments of dramatic interest.

Szarkowski's argument for an art-photography rooted in the vernacular vision is made most clearly in his book *The Photographer's Eye*. The categories he established in this work should help us to understand this modernist project. Szarkowski isolates five properties deemed to be intrinsic to the medium: 'The Thing Itself'; 'The Detail'; 'The Frame'; 'Time'; and 'Vantage Point'.[31]

PLATE **8.7**
William Eggleston, *Jackson, Mississippi*, 1971. (Courtesy Cheim & Read, New York. © Eggleston Artistic Trust.)

Without going through these in detail, it is worth picking out some basic points. 'Vantage Point' is straightforward enough. Cameras are perspective machines that translate space into geometrical projections based on a single vanishing point: the photographer's point of view and angle of the camera are, therefore, clearly important determinants on the image. Vernacular pictures often display unusual vantage points. In Frank's *Political Rally – Chicago* (Plate 8.4), the strange alignment results from the selected vantage point. Moving the camera slightly would have prevented this effect. Friedlander seems to have been particularly interested in effects generated by photographic points of view: his pictures frequently compress space so that trees seem to sprout out of heads, or bodies fuse creating new hybrid forms. I want to pass over Szarkowski's comments on time, which display little grasp of the paradox of then and now experienced when looking at photographs.[32] What he called 'The Thing Itself' is the most difficult of these categories to unpack. The first thing that photographers were compelled to understand, he argued, was that their medium was restricted to depicting what actually existed. Painters could invent imaginary views or depict things that did not exist: photographers, however, were restricted to pre-existing scenes. At the same time, he argued, the images that resulted were not simply literal copies. The point, he felt, was that the photographer's selections had to anticipate the way the photographic apparatus transformed the actual things and people depicted (the pro-filmic scene) into an image.[33]

For our purposes, the two most important categories are 'The Detail' and 'The Frame'. Details occupied a central place in Szarkowski's account. Again, he begins from the argument that photographers could only 'record' and not invent or compose. As a consequence of this, he believed, photographs do not produce 'a coherent narrative'; instead, they reveal 'scattered and suggestive clues'. Photographs offer the viewer isolated fragments and 'trivial' but compelling details. The role of news-photographs, Szarkowski claimed, 'was not to make the story clear, it was to make it *real*'.[34] We have seen the prominent place of detail in Winogrand's *Los Angeles*; a vivid detail like this heightens the singularity of the image while reinforcing the 'reality effect'.

As was discussed in Chapter 6, the framing edge became a self-conscious concern for many painters working in the 1950s and 1960s. The frame also occupies a key role in photographic modernism. In an important sense, photographs are made by their edge, since taking a photograph entails using the frame to isolate a particular slice of reality. 'Photography', Szarkowski claimed, 'is a system of visual editing. At bottom, it is a matter of surrounding with a frame a portion of one's cone of vision, while standing in the right place at the right time.'[35] This practice of framing has three immediate consequences for photographic pictures. First, photographic composition consists of selecting or cutting with the frame: the arrangements of objects and forms in the photograph are the consequence of this process. As Szarkowski put it: 'The central act of photography, the act of choosing and eliminating, forces a concentration on the picture edge – the line that separates in from out – and on the shapes that are created by it.'[36] In this sense, photographs isolate and focus attention on fragments of things. Secondly, because the subject from which the picture is cut extends beyond the frame, it is probable that objects at the edges of the image would be sliced through. Szarkowski wrote:

> The edges of the picture were seldom neat. Parts of figures or buildings or features of landscape were truncated, leaving a shape belonging not to the subject, but (if the picture was a good one) to the balance, the propriety, of the image.[37]

Thirdly, the frame established relationships between unrelated things or people. Photographers make meanings by drawing unconnected things into new patterns of relationship.

In rhetoric, figures of speech that associate a thing with the properties that it is closely associated with are called metonyms: for instance we might use 'blue collar' and 'white collar' to designate types of worker, or 'top brass' to designate a military officer. Winogrand's photographs are often built out of these metonymic connections. In *Untitled* (c.1962), two unconnected incidents – the man and woman at the left of the image, and the prowling, caged wolf – produce a third meaning (Plate 8.9). There is no inherent relation between these disparate features but the frame acts to bind them together. In doing so, the viewer tends to transfer the values of one thing to another: we associate the wolf with the depicted man and view the woman as his prey. In a discussion of the pro filmic moment comparison of the man and wolf is essentially metaphoric since it generates meaning not by establishing a connection but by translating one thing into another: it posits an identity between things that are unconnected. In the photograph, however, the frame establishes a pattern of contiguity between these things. The patterns of metonymic comparison established by the photographic frame mark the image's distance from its pro-filmic event. Winogrand's framing here produces a sexualised version of the tale of Little Red Riding Hood. This image is a good example for Szarkowski's categories: as such, you may find it helpful to try to rehearse them for yourself with this picture.

Szarkowski's argument for an art-photography rooted in vernacular vision of 'amateurs' and 'journeyman' document makers hinges on the idea that photography possessed a singular, essential nature, so that the five categories discussed in *The Photographer's Eye* are deemed to characterise the medium.

PLATE **8.9** Garry Winogrand, *Untitled*, *c*.1962, gelatin silver print, 22 × 33 cm. (David H. McAlpin Fund. DIGITAL IMAGE © 2003 The Museum of Modern Art, New York/Scala, Florence. © Estate of Garry Winogrand. Courtesy Fraenkel Gallery, San Francisco.)

Particular photographs are, as such, manifestations of these categories. While anti-modernist images resist these categories in their attempt to imitate paintings, modernist photographers, in contrast, took these features to be structural characteristics of photography and worked with them. Critics writing subsequently, particularly those identified with 'postmodernism', have tended to dismiss Szarkowski as a 'formalist', suggesting that work of this kind is preoccupied with issues of form to the exclusion of social meaning (sometimes, problematically, identified with content).[38] The photographic work Szarkowski supported has often received the same fate. It may therefore be instructive briefly to compare Szarkowski's views on photography with those of Greenberg, with whom his critics directly compare him. The comparison is usually made with Greenberg's account of modernist painting; instead, I am going to look at his comments on photography. In fact, Greenberg saw photography in diametrically opposed terms to Szarkowski, arguing that what was significant about the medium was its ability to convey narrative. 'The art of photography', he wrote, 'is literary art before it is anything else: its triumphs and monuments are historical, anecdotal, reportorial, observational before they are purely pictorial.'[39] According to Greenberg, photographs told stories and worked best when form did not get in the way of the '"practical" meaning of the subject'.[40] The view Greenberg expressed here seems to be explicitly anti-formalist, at least in so far as his account of modernism turns on its opposition to narrative. Szarkowski, in contrast, systematically denied that photography was a narrative form; photography, according to him, was an art of details and fragments and not an art of

storytelling. What unites Greenberg and Szarkowksi is not any homogeneity of view but a concern with medium specificity. They did share, though, the view that vernacular form – what Greenberg called the 'demotic' – was central to good photographs.

Szarkowski did tend to focus on photography as a medium to the exclusion of wider patterns of historical and social value, but this emphasis was often tempered by the recognition that photographic form was tied to its subject. He wrote:

> In Photography the pursuit of form has taken an unexpected course. In this peculiar art, form and subject are defined simultaneously. Even more than in the traditional arts, the two are inextricably tangled. Indeed they are probably the same thing. Or, if they are different, one might say that a photograph's subject is not its starting point but its destination.[41]

For Szarkowksi, the photograph is bound to the world of appearances and, as such, can never constitute pure form. Although he does not use the terms, his account here corresponds to the view of photography derived from the work of Charles Sanders Pierce, which argues that the resemblance of things depicted in a photograph is caused by traces of light bouncing off those objects depicted. The iconic character (resemblance) of the photographic sign is, therefore, a result of its indexical character (trace). In this sense, photographs testify to the things they depict.[42] When Garry Winogrand (described by Szarkowski as the most 'outrageously thoroughgoing formalist that I know') was asked if his work entailed 'social comment', he replied that the photograph 'can't help but be a document or whatever you want to call it'.[43] In one sense, Szarkowski is not a formalist at all but an American vernacularist. If we can continue to describe his writing as formalist, it is not because of an over-attention to form (there is a great deal to be learned from serious reflections on form), but because he tends to detach vernacular modes and vernacular attention from use and history.

Szarkowski argued that photographers had been influenced not only by great photographs and great photographers, but also by 'the great undifferentiated homogenous whole' of '*photography*'.[44] Much of what innovative photographers produced was the gift of the medium 'itself'. This is a peculiar argument. While photographers are often seen to advance the understanding of the medium, it is photography itself that is the real object of Szarkowksi's attention. He often describes photography as an organism, or uses metaphors of organic growth – photography 'reproduces' and 'evolves'. In this way he speaks of photography as if it were a conscious agent, capable of making choices and decisions about how to develop. Sometimes, he conflates the consciousness of photographers with the consciousness of photography. 'Like an organism', he suggests, 'photography was born whole.'[45] Szarkowski seems to be suggesting that all the dimensions of modernist photography were inherent in the medium from the outset. If there is development in photographic practice, it is driven by the medium becoming conscious of itself. Sometimes photographers appear to be agents of this unfolding of photographic consciousness, but the implications were there all along in the photographic apparatus itself. The photographer's task, according to Szarkowski, consists in discovering, rather than creating, the particular vision imposed by their apparatus.

One of the problems with this account should become evident if we consider a photograph that Szarkowski reproduced in his book *Looking at Photographs*, as Jacob Riis, *Police Station Lodger, A Plank for a Bed* (*c*.1890).[46] Although Riis was a police reporter and journalist unconcerned with art-photography, Szarkowski suggested he displayed an intuitive interest in form and made many 'great' pictures.

Look at the two versions of Riis's photograph illustrated in Plates 8.10 and 8.11. Can you identify the ways in which the different uses of the framing edge produce distinct effects? Szarkowski opted to reproduce the full-frame version (Plate 8.11) in his book. Why do you think this was?

PLATE **8.10** Jacob Riis, *An Ancient Woman Lodger in Eldridge Street Police Station. A 'Scrub' with her Bed*, *c*.1890, cropped, lantern slide. (Museum of the City of New York, The Jacob A. Riis Collection #232. © The Museum of the City of New York.)

The cropped version of this photograph (Plate 8.10) excludes extraneous detail and concentrates our attention on the woman and the visible signs of her condition, such as her worn clothes. The full-frame version (Plate 8.11) preferred by Szarkowski displaces the central focus on the woman to the contingent details of the picture's edges: the hand of an assistant who had just lit the flash powder and the plaster form to the left of the woman. Szarkowski might further have noted the incongruous details: the hand again, the cast shadows and the way that the frame establishes a connection between the woman and the 'plank'. Szarkowski opted for a version of the photograph that downplays its documentary character in favour of pictorial effects and anomolous details. ■

The photo-historian Sally Stein has pointed out that the version printed in Szarkowski's book is a modern print from the original negative. She notes: 'No mention is made that Riis, for both his book illustrations and his lantern slide collection, had deliberately cropped the photograph to exclude what he considered to be extraneous information.'[47] The photograph as Szarkowski reproduced it was not Riis's historical image, but a different picture. In doing so he has extracted this image from the context in which it was produced and understood.

PLATE **8.11** Jacob Riis, *Police Station Lodger, A Plank for a Bed*, c.1890 (reproduced in *Looking at Photographs*), modern print from dry plate negative. (Museum of the City of New York, The Jacob A. Riis Collection #232. © The Museum of the City of New York.)

Rosalind Krauss's reflections on the history of the photographic frame are instructive here. In an examination of Alfred Stieglitz's *Equivalents* (Plate 8.12) – photographs of clouds that employed the frame to turn formless vapour and light into highly wrought artistic images – she argues that this technique of cutting is not inherent to photography. Krauss suggests that before Stieglitz made these pictures the framing edge had played no significant role in his work.[48] Seeing photographs as cuts in space came about at a particular moment: this was a historical conception of photographic form. Szarkowski's account of the Riis photograph is, in contrast, dehistoricising: he focuses on an abstracted sense of the image in the museum collection and not on images as they were used. Meanings and values of pictures, including those relating to forms, are, however, generated out of the ways they were actually used. It is noteworthy that Szarkowski pays scant attention to the beholder's experience of photographs, centring, instead, on the photographer's (or his own connoisseurial) vision.

PLATE **8.12**
Alfred Stieglitz,
Equivalent, Set G,
1929, gelatin silver
print, 12 × 9 cm.
(Museum of Fine
Arts, Boston.
Gift of Miss Georgia
O'Keeffe; 50.850.
Photo: © 2003
The Museum of Fine
Arts, Boston.)

Szarkowski's transhistorical conception has significant implications for the consideration of photographs. Throughout its history, photography has been employed in a diverse range of practices and institutions, many of them the antithesis of art. It is this type of photography – amateur pictures, geological survey work, social documentation etc. – that supplies Szarkowski with his idea of vernacular form. Szarkowski, however, ignores the problems that the wide range of everyday photographic practices present for writing the history of photography. He displaces what Allan Sekula has called photography's role in 'the dirty work of modernization' in favour of a unified history of autonomous forms.[49] But photography's double or contradictory character – its simultaneous existence in high and low forms – will always play havoc with any account of photographic art. Szarkowski's particular version of 'formalism' provides one ingenious way of stabilising art-photography. As Sekula put it, 'Formalism neutralizes and renders equivalent, it is a universalizing system of reading. Only formalism can unite all the photographs in the world in one room, mount them behind glass, and *sell* them.' [50]

The exhibition 'From the Picture Press', which Szarkowski curated in 1973, did just this. For this exhibition he selected photographs from newspapers and displayed them without their captions and text. Freed from their contexts of use, these images could appear as strikingly complex and ambiguous pictures. Szarkowski's practice as a curator was unconsciously Duchampian: designating vernacular practices as works worthy of art museum or gallery status. This essentialising of photography was ideally suited to the canonisation (and commodification) of photography in the Museum of Modern Art, since it allowed Szarkowski to build a tradition and a collection from disparate materials.

There is, however, a stronger account of formalism in Szarkowski's texts. He wrote: 'I think in photography the formalist approach is … concerned with trying to explore the intrinsic or prejudicial capacities of the medium as it is understood at that moment.'[51] This passage seems to suggest that medium must be understood as a historically defined category, rather than through an inherent property of the 'organism'. As I read it, this argument is akin to Michael Fried's claim that working with the conditions of the medium as they have come to be understood provided a critical, shared framework for art practice and discussion (see Chapter 6). This position is much less central than the essentialising tendency in Szarkowski's writings, but it is, I think, a much more interesting account of photographic form. Instead of seeing all photographs as displaying an inherent character, we could argue that some autonomous photographers picked up on the oddities of vernacular practice in order to question art-photography. 'Bad' or 'banal' pictures could be employed by these photographers as a way of stretching possibilities for art-photography and thereby challenging the critical attention of their audience. This is very different from claiming that this practice revealed photography's essential condition. Szarkowski, and most of his critics, tend to treat these photographers as directly comparable. In what follows I want to look at a different way of thinking about this vernacular practice, and to consider some differences between the photographers that Szarkowski championed.

Inattention as attention

The photographers whom Szarkowski singled out consciously toy with the look of non-art. This project, though, like other forms of anti-art, only makes sense from within the framing institutions of art. Highly trained and sophisticated artists/photographers clearly cannot turn themselves into amateurs.[52] Neither can they become instrumental picture makers without renouncing the forms of critical consciousness that make autonomous art distinct from the culture industry. What they are able to do is use amateur, or heteronomous, practices as resources for the critical re-examination of autonomous art. When the types of inattention characteristic of the postwar culture industries are transferred to the space of art, they simultaneously challenge the existing canon of art and stretch critical attention. Banality or incomprehension, at least since the 1960s, have been weapons in art's struggle to escape the forms of attention established by the culture of the spectacle. Martha Rosler has argued that Friedlander's work 'violated the dominant formal canons not by inattention but by a systematic negation'.[53] She means by this that his pictures deliberately and programmatically broke the rules of what had come to be understood as good taste in photography. That is to say, Friedlander consciously employed vernacular 'inattention' to push the viewer's attention beyond what he or she recognised as photographic skill and competence.

Friedlander's ruination of the canons of existing good taste produced some incredibly complex photographs. Because the camera is a perspective machine, photographs tend to present coherent and volumetric representations of space. In an effect similar to that of Cubist collage, these images create a tension between the whole and the fragmentary and the singular. Friedlander's work puts into question integral pictorial space while still maintaining the peculiar conjunction of iconic and indexical signs. Some of the pictures, such as *Hillcrest, New York* (1970) (Plate 8.13), are dizzying in their spatial complexity and visual fracturing. Friedlander's images from 1969 and 1970 frequently employ reflections in car mirrors to dislocate the coherence of the pictorial field. By including the mirror in the frame Friedlander draws the space behind him into the area in front. He also uses the edge, or shape, of the vehicle's mirror to split the photograph into discrete bands, producing diptychs or triptychs. But this mirroring has another effect, since it repeats *within* the image the frame's cutting of space. This was an imagery of the city built out of disjuncture *and* likeness.

The tradition of street photography, to which these pictures belong, has been central to the programme of modernist practice for a number of reasons.[54] Formalist thinking has often seen art as a creation of coherence out of formlessness or chaos. Aesthetic transcendence is deemed to result from creating an integrated aesthetic whole out of mere 'stuff'. Szarkowski, as much as Greenberg, adhered to this view. The street with its crowds and movement, unplanned development and diverse signage provides a privileged site for testing this conception. Winogrand, for instance, positioned himself in the flux of the metropolis and, working with a wide-angle lens and fast film, sought to create finely crafted works of art from the surrounding mêlée. There are, however, other arguments that could be made for the street as the paradigmatic space of modern photography. It could be suggested that

PLATE **8.13** Lee Friedlander, *Hillcrest, New York*, 1970, vintage gelatin silver print. (Patrons' Permanent Fund, Trellis Fund and Anonymous Gift. Image: © 2003 Board of Trustees, The National Gallery of Art, Washington DC. Photo: Lorene Emerson. Courtesy Fraenkel Gallery, San Francisco.)

the modern city provides the stage for modernist photography because it allows photographers to explore the characteristics of their apparatus. The framing views of doorways, windows and street vistas; fluidity of movement through space; surface reflections; unregulated signage and detail; light effects that produce strong shadows: all parallel the account of the medium outlined by Szarkowski. But if Szarkowski was concerned with the characteristics supposedly inherent in the medium, he ignored the way the street functioned as a second medium in modernist photography.

For much of the twentieth century, photographing in the city streets was an art of democratic and popular intent. It most frequently marked identification with the urban working class and the practices of everyday life. Szarkowski abandoned this aspect of street photography. This rejection is apparent from his important exhibition 'New Documents' of 1967. In it he presented Arbus, Friedlander and Winogrand as the inheritors of the documentary tradition. They were, however, working with a transformed idea of the document. In the 1930s, documentary had been associated with projects of social reform and political change. In the wake of the Cold War, Szarkowski argued that photojournalism, or the new documentary, was inadequate for its allotted task of telling news stories; instead, he advocated art-photography in the style of documents. Arbus, Friedlander and Winogrand, he claimed, documented their own moods and feelings rather than recorded society.

One consequence of Szarkowski's distancing of modernist street photography from the public commitments of the 1930s was unintentionally to foreground its dependence on the *flâneur*. The *flâneur* was a social type encountered in the great metropolis of the nineteenth century and made famous in the writing of Edgar Allan Poe and the criticism and poetry of Charles Baudelaire.[55] Walter Benjamin, in his account of nineteenth-century capitalist culture, reserved a prominent role for the literature of *flânerie*.[56] For Baudelaire, the *flâneur* was a 'passionate spectator' at home in the crowd: a man who specialised in watching, noticing details and observing social distinctions. Idling through the streets, seemingly above ordinary human affairs, the *flâneur* fills his empty time gazing at people and commodities: an activity that Benjamin memorably described as 'botanizing on the asphalt'.[57] It is a characteristic of the *flâneur* that this free-floating gaze was unconstrained by moral or social commitments: these men deemed themselves to be distanced from the objects (human or things) of their gaze. This 'eye' imagined itself to be outside society and its conflicts, capable of a detached view. The social vision of this 'man in the crowd' runs from wry irony to sheer disdain. The biting wit of Winogrand and even Friedlander's attention to the way his own image appeared reflected back from the surfaces of the modern environment seem rooted in the experience described by Baudelaire. Although street photography proper did not develop until much later (it was made possible by the development of 35 mm cameras in the later 1920s, and by faster film stock), its lineage is to be found in the nineteenth-century stroller. Interestingly, Victor Fournel, in his 1858 book *Ce qu'on voit dans les rues de Paris* ('Things To Be Seen on the Streets of Paris'), made the connection at the outset when he described the *flâneur* as a 'peripatetic daguerreotype upon whom every trace registers' (the Daguerreotype was an early photographic process).[58]

If the *flâneur* is imagined by some as a disembodied eye floating freely through urban space, in another sense the *flâneur* is clearly an embodied 'he'. The freedom to occupy public space or to wander alone through the streets looking at others is, in our society, largely confined to men.[59] The risks of physical or sexual violence continue to place definite boundaries on women's access to the city. There have been important female street photographers, Arbus among them, but on the whole this practice is gendered masculine. The figure of the *flâneur* introduces some important differences into Szarkowski's canon. The gender difference of modernist street photographers is clearly significant here. Winogrand's photographs – particularly those collected in the book *Women are Beautiful* – display the gaze of the sexual predator; Friedlander's photographs sometimes also partake of this voyeurism. It is often difficult to look at photographs by male street photographers and not think of stalking. Whatever their other peculiarities, Arbus's photographs seem, in contrast, to be posed and made in situations that are under her control.

As I have suggested, the *flâneur's* vision is not only gendered it is also characterised by social detachment. The photographer and theorist Victor Burgin argued that despite claims by Winogrand and Szarkowski that these are formal photographs, the metonymic relations established frequently reinforce stereotypical patterns of viewing.[60] As we have seen, people and animals are frequently paired in these photographs; the ensuing pattern of

contiguity often renders the depicted figures gross and vulgar. The most notorious of these pictures is *Central Park Zoo, New York City* (1967) (Plate 8.14). Burgin suggested that this combination of black man, white woman, and two chimpanzees in human clothing suggests a monstrous outcome from miscegenation. We need to be careful here: it is not that these photographs are racist or sexist (images do not have fixed meanings of this kind), but when they take their place in the stereotypical discourses circulating in society they affirm rather than challenge such views. Winogrand himself seems to have been aware of this possible interpretation of his picture. When asked what he thought of it, he said he was not sure if it was an interesting photograph: 'you know', he said, 'its sort of an automatic "yuk", I guess, and that could destroy you'.[61] The 'yuk' is revealing. One problem with Winogrand's pictures (and those of Arbus) is that they allow the viewer to feel secure in his or her humanity by placing those depicted outside the bounds of taste and compassion.

Friedlander's book *Self Portrait* (1970) seems to me to offer some different possibilities for viewing and identification. His complex image construction sometimes disrupts the easy conflation of viewer and camera position. Friedlander's reflections, spatial dislocations and hybrid forms call attention to his point of view rather than mask it. He also frequently includes images of his own rather gawky body in these photographs; in some of them, rather than adopt the position of voyeur, he puts himself on display as the object of scrutiny.

PLATE **8.14** Garry Winogrand, *Central Park Zoo, New York City*, 1967. (© Estate of Garry Winogrand. Courtesy Fraenkel Gallery, San Francisco.)

There seems to be an exploration of masculinity and its tribulations running as an undercurrent through his book (Plate 8.15). In other photographs, he includes the signs of himself in a way that invites the viewer to imagine other possible identities for themselves, thereby producing some of his most complex works. Friedlander employs vernacular misalignment so that reflections jumble the fragments of his body with those of other people and things. These photographs recall the grotesque bodies in Hannah Höch's montages made in the 1920s and 1930s, which often paste together fragments of male and female body parts. Like Höch, Friedlander combines male and female bodies to construct androgynous subjects. In one picture he gives a white man the face of a black woman. However, these images differ from Höch's montages in one important respect. Friedlander includes his reflection or shadow in the photograph in such a way that it draws the spectator – at least the male spectator – into identification with his grotesque constructions (Plate 8.16). The reflections or shadows seem to belong to the beholder, whose body is reflected back as male *and* female, black *and* white. In *Colorado* (Plate 8.17), he aligned a poster pasted on the inside of the window so that its blank reverse side replaced his head. For a male viewer, this anonymity has the effect of making the reflection appear to

PLATE **8.15** Lee Friedlander, *Philadelphia, Pennsylvania*, 1965, from the *Self Portrait* series. (Stedelijk Museum Amsterdam. Courtesy Fraenkel Gallery, San Francisco.)

belong to his own body. But that blank space of the poster is also interchangeable with the image of John F. Kennedy, which partly overlaps it. In this complex image, male viewers are invited to occupy the place of Kennedy. In the USA of the 1960s, this image offered a distinct political identification. The issue here is not whether Friedlander was conscious of these effects, but that his grotesque, vernacular forms produced viewing positions that destabilise the kind of secure identifications on offer in the work of some other postwar street photographers. Friedlander's photographs are often overtaken by whimsy, but at their best they invite us to imagine our selves otherwise.

PLATE 8.16
Lee Friedlander, *Westport, Connecticut,* 1968, from the *Self Portrait* series, gelatin silver print, 20 x 12 cm. (Patrons' Permanent Fund, Trellis Fund and Anonymous Gift. Image: © 2003 Board of Trustees, The National Gallery of Art, Washington DC. Photo: Lorene Emerson. Courtesy Fraenkel Gallery, San Francisco.)

PLATE **8.17** Lee Friedlander, *Colorado*, 1967, from the *Self Portrait* series, gelatin silver print, 17 x 24 cm. (Patrons' Permanent Fund, Trellis Fund and Anonymous Gift. Image: © 2003 Board of Trustees, The National Gallery of Art, Washington DC. Photo: Lorene Emerson. Courtesy Fraenkel Gallery, San Francisco.)

Notes

1 Solomon-Godeau, 'The Armed Vision Disarmed'.

2 The trajectory of Aaron Siskind is particularly revealing here. In the 1930s, Siskind was a central figure in the left-wing Photo League, producing a significant body of documentary photographs in Harlem. After the war he made 'abstract' photographs that resembled Abstract Expressionist paintings.

3 Wall, '"Marks of Indifference"', p.248.

4 Bryson, *Looking at the Overlooked*.

5 Kirstein, 'Photographs of America', p.187.

6 Brougher and Ferguson, *Open City*, pp.11–12; Kozloff, *New York*, pp.41, 44.

7 Whereas 'autonomy' is a term employed to designate the independence or separation of art from society, or from immediate contexts of use, 'heteronomy' refers to the opposite condition: the rootedness of images in social processes, or the immediate practical uses to which they are put.

8 Wall, '"Marks of Indifference"', p.249.

9 *The Americans* appeared in a French edition in 1958, and, with an introduction by Jack Kerouac, in the USA the following year. Klein's work was almost as significant. See, in particular, Klein, *Life is Good and Good for you in New York*.

10 Quotations from Green, *American Photography*, p.85.

11 Quoted in *ibid.*, p.82.

12 Quoted in Brougher and Ferguson, *Open City*, p.10.

13 The first exhibition of photographs was held in 1932; Evans had solo shows in 1933 and 1935; and Newhall's 'Photography 1839–1937' can be seen as one of the major 'didactic shows' held at the Museum of Modern Art in the 1930s (others include Alfred Barr's 1936 exhibitions 'Cubism and Abstract Art' and 'Fantastic Art, Dada and Surrealism'). The status of photography in the museum was, however, far from secure at this point.

14 See Phillips, 'The Judgement Seat of Photography', pp.27–8.

15 For this argument see Buchloh, 'From Faktura to Factography', pp.74–7 and Phillips, 'The Judgement Seat of Photography'.

16 Steichen, *The Family of Man*, 'Introduction'.

17 Sekula, 'The Traffic in Photographs' (1981), in *Photography against the Grain*, p.90.

18 See, for example, Barthes, 'The Great Family of Man' (c.1956), in *Mythologies*, pp.100–2 (this essay was first published at the time of the French showing of the exhibition); Sekula, 'The Traffic in Photographs' (1981), in *Photography against the Grain*, pp.88–96; Phillips, 'The Judgement Seat of Photography', esp. pp.28–31.

19 Kramer, 'Exhibiting *The Family of Man*', p.367.

20 For an attempt to reconsider 'The Family of Man', see Roberts, *The Art of Interruption*.

21 Badger, 'From Humanism to Formalism', p.13.

22 The phrase is from Phillips, 'The Judgement Seat of Photography', p.34.

23 The focus in this chapter is on the implications of this change for photography, but it is worth observing that there is an important lesson about the Museum of Modern Art here. The shifts in photographic curating reveal that the ideological project of the Museum of Museum Art, discussed in Chapter 3, was not standardised throughout the institution until a relatively late point. Before the mid 1960s, the departments pursued very different agendas.

24 Szarkowski, *The Photographer's Eye*. The debate on the vernacular has its roots in the 1930s search for an American rather than European art. One important source for Szarkowski was John A. Kouwenhoven's book *Made in America*.

25 Given the content of the photograph, the tonal division of the pole and Freidlander's shadow in its light zone may represent an oblique comment on American race relations.

26 Rosler, 'Lee Friedlander's Guarded Strategies' (1975), in Petruck, *The Camera Viewed*, p.97.

27 Quoted in Green, *American Photography*, p.187.

28 Szarkowski, *William Eggleston's Guide*.

29 Sontag, *On Photography*, p.32.

30 Quoted in Longwell, 'Monkeys Make the Problem More Difficult: A Collective Interview with Garry Winogrand' (1972), in Petruck, *The Camera Viewed*, p.127.

31 Szarkowski, *The Photographer's Eye*.

32 Instead, he suggested that all photographs exist in the present.

33 It is not really clear here whether 'The Thing Itself' refers to the pro-filmic event, or to the resulting image. The balance of Szarkowski's comments in this text, and elsewhere, indicates that the second interpretation is the most likely.

34 Szarkowski, *The Photographer's Eye*, in Gaiger and Wood, *Art of the Twentieth Century*, III.4.

35 Szarkowski, *William Eggleston's Guide*, p.6.

36 Szarkowski, *The Photographer's Eye*, in Gaiger and Wood, *Art of the Twentieth Century*, III.4.

37 *Ibid.*

38 For the claim that Szarkowski is a formalist, see Solomon-Godeau, *Photography at the Dock*, pp.xxv–xxvi, 48, and Burgin, 'Photography, Phantasy, Function', pp.208–9.

39 Greenberg, 'Four Photographers: Review of *A Vision of Paris* by Eugène-August Atget; *A Life in Photography* by Edward Steichen; *The World through my Eyes* by Andreas Feininger; and *Photographs by Cartier-Bresson*, introduced by Lincoln Kirstein' (1964), in O'Brian, *Clement Greenberg*, vol.4, p.183.

40 *Ibid.*

41 Szarkowski, *William Eggleston's Guide*, p.7.

42 For a discussion of Charles Sanders Pierce's taxonomy of signs and photography, see *Art of the Avant-Gardes*, Chapter 13.

43 Quoted in Longwell, 'Monkeys Make the Problem More Difficult: A Collective Interview with Garry Winogrand' (1972), in Petruck, *The Camera Viewed*, p.120. The reference to Szarkowski is quoted in Stange, 'Photography and the Institution', p.702.

44 Szarkowski, *The Photographer's Eye*, in Gaiger and Wood, *Art of the Twentieth Century*, III.4.

45 *Ibid.*

46 Szarkowski, *Looking at Photographs*, pp.48–9.

47 Stein, 'Making Connections with the Camera', p.10.

48 Krauss, 'Stieglitz, Equivalents'.

49 Sekula, 'The Body and its Archive', p.56.

50 Sekula, 'Dismantling Modernism, Reinventing Documentary (Notes on the Politics of Representation)' (1976/78), in *Photography Against the Grain*, pp.59–60.

51 Quoted in Stange, 'Photography and the Institution', p.702.

52 Roberts, 'In Character'.

53 Rosler, 'Lee Friedlander's Guarded Strategies' (1975), in Petruck, *The Camera Viewed*, p.92.

54 For street photography, see: Brougher and Ferguson, *Open City*; Kozloff, *New York*; Westerbeck and Meyorowitz, *Bystander*.

55 See Poe, 'The Man in the Crowd' (1840/5), in *The Fall of the House of Usher and Other Writings*, pp.179–88; Baudelaire, 'The Painter of Modern Life' (1863), in *The Painter of Modern Life and Other Essays*, pp.1–40; Baudelaire, *Fleurs du Mal*.

56 Benjamin, *Charles Baudelaire*.

57 *Ibid.*, p.36.

58 Fournel, 'The Art of *Flânerie*' (1858), in Harrison, Wood and Gaiger, *Art in Theory 1815–1900*, IIID7, p.492.

59 On the gendered character of *flânerie*, see: Pollock, 'Modernity and the Spaces of Femininity'; Wolff, 'The Invisible Flâneuse'.

60 Burgin, 'Photography, Phantasy, Function', pp.205–8.

61 Quoted in Longwell, 'Monkeys Make the Problem More Difficult: A Collective Interview with Garry Winogrand' (1972), in Petruck, *The Camera Viewed*, pp.122–3.

References

Badger, G., 'From Humanism to Formalism: Thoughts on Post-War American Photography', in P. Turner (ed.), *American Images: Photography 1945–1980*, exhibition catalogue, Barbican Art Gallery, London, 1985, pp.11–22.

Barthes, R., *Mythologies*, trans. A. Lavers, London: Vintage, 1972 (first published 1957).

Baudelaire, C., *Fleurs du Mal: The Complete Verse*, ed. and trans. F. Scarfe, London: Anvil Editions, 1989 (first published 1857).

Baudelaire, C., *The Painter of Modern Life and other Essays*, ed. and trans. J. Mayne, New York: Da Capo, 1964.

Benjamin, W., *Charles Baudelaire: A Lyric Poet in the Era of High Capitalism*, trans. H. Zohn, London: Verso, 1983.

Bolton, R. (ed.), *The Contest of Meaning: Critical Histories of Photography*, Cambridge, MA: MIT Press, 1989.

Brougher, K. and Ferguson, R., *Open City: Street Photographs Since 1950*, exhibition catalogue, Museum of Modern Art, Oxford, 2001.

Bryson, N., *Looking at the Overlooked: Four Essays on Still Life Painting*, London: Reaktion, 1990.

Buchloh, B., 'From Faktura to Factography', in Bolton, *The Contest of Meaning*, pp.49–81.

Burgin, V., 'Photography, Fantasy, Function', in V. Burgin (ed.), *Thinking Photography*, London: Macmillan, 1982, pp.117–216.

Edwards, S. and Wood, P., *Art of the Avant-Gardes*, New Haven and London: Yale University Press in association with The Open University, 2004.

Frank, R., *The Americans*, Manchester: Cornerhouse Publications, 1993 (first published 1958).

Friedlander, L., *Self Portrait*, New York: Distributed Art Publishers, 1998 (first published 1970).

Gaiger, J. and Wood, P. (eds), *Art of the Twentieth Century: A Reader*, New Haven and London: Yale University Press, 2004.

Green, J., *American Photography: A Critical History 1945 to the Present*, New York: Harry N. Abrams, 1984.

Harrison, C., Wood, P. and Gaiger, J. (eds), *Art in Theory 1815–1990: An Anthology of Changing Ideas*, Oxford: Blackwell, 1998.

Kirstein, L., 'Photographs of America', in W. Evans, *American Photographs*, New York: East River Press, 1975, pp.183–92 (first published 1938).

Klein, W., *Life is Good and Good for you in New York: Trance Witness Revels*, Paris: Editions du Seuil, 1956.

Kouwenhoven, J.A., *Made in America: The Arts in Modern Civilization*, New York: Octagon Books, 1975 (first published 1948).

Kozloff, M., *New York: Capital of Photography*, exhibition catalogue, The Jewish Museum, New York, 2002.

Kramer, H., 'Exhibiting *The Family of Man*: "The World's Most Talked About Photographs"', *Commentary*, vol.20, no.4, October 1955, pp.364–7.

Krauss, R., 'Stieglitz, Equivalents', *October*, no.11, winter, 1979, pp.129–46.

O'Brian, J. (ed.), *Clement Greenberg: The Collected Essays and Criticism*, vol.4: *Modernism with a Vengeance 1957–1969*, Chicago: University of Chicago Press, 1993.

Petruck, P.R. (ed.), *The Camera Viewed, Writings on Twentieth-Century Photography*, vol.2: *Photography After World War II*, New York: E.P. Dutton, 1979.

Phillips, C., 'The Judgement Seat of Photography', in Bolton, *The Contest of Meaning*, pp.14–47.

Poe, E.A., *The Fall of the House of Usher and Other Writings*, Harmondsworth: Penguin, 1986.

Pollock, G., 'Modernity and the Spaces of Femininity', in *Vision and Difference: Femininity, Feminism and the Histories of Art*, London and New York: Routledge, 1988, pp.50–90.

Roberts, J., *The Art of Interruption: Realism, Photography and the Everyday*, Manchester: Manchester University Press, 1998.

Roberts, J., 'In Character', in C. Harrison (ed.), *Art & Language in Practice*, vol.2: *Critical Symposium*, Barcelona: Fundació Antoni Tàpies, 1999, pp.161–75.

Sekula, A., *Photography Against the Grain: Essays and Photo Works, 1973–1983*, Halifax, NS: Nova Scotia College of Art and Design, 1984.

Sekula, A., 'The Body and its Archive', *October*, no.3. winter, 1986, p.56.

Solomon-Godeau, A., *Photography at the Dock: Essays on Photographic History, Institutions, and Practices*, Minneapolis: Minnesota University Press, 1991.

Solomon-Godeau, A., 'The Armed Vision Disarmed: Radical Formalism From Weapon to Style', in *Photography at the Dock: Essays on Photographic History, Institutions, and Practices*, Minneapolis: Minnesota University Press, 1991, pp.52–84.

Sontag, S., *On Photography*, London: Penguin, 1979.

Stange, M., 'Photography and the Institution: Szarkowski at the Modern', *Massachusetts Review*, vol.19, no.4, winter, 1978, pp.693–709.

Steichen, E., *The Family of Man*, exhibition catalogue, Museum of Modern Art, New York, 1955.

Stein, S., 'Making Connections with the Camera: Photography and Social Mobility in the Career of Jacob Riis', *Afterimage*, vol.10, no.10, May 1983, pp.9–16.

Szarkowski, J., *From the Picture Press*, exhibition catalogue, Museum of Modern Art, New York, 1973.

Szarkowski, J., *Looking at Photographs, 100 Pictures from the Collection of The Museum of Modern Art*, Museum of Modern Art, 1973.

Szarkowski, J., *The Photographer's Eye*, exhibition catalogue, Museum of Modern Art, New York, 1965.

Szarkowski, J., *William Eggleston's Guide*, exhibition catalogue, Museum of Modern Art, New York, 1976.

Wall, J., '"Marks of Indifference": Aspects of Photography in, or as, Conceptual Art', in A. Goldstein and A. Rorimer (eds), *Reconsidering the Object of Art: 1965–1975*, Cambridge, MA: MIT Press, 1995, pp.246–67.

Westerbeck, C. and Meyorowitz, J., *Bystander: A History of Street Photography*, London: Thames & Hudson, 1994.

Winogrand, G., *Women are Beautiful*, New York: Light Gallery Books, 1975.

Wolff, J., 'The Invisible Flâneuse: Women and the Literature of Modernity', *Theory, Culture & Society*, vol.2, no.3, 1985, pp.37–46.

The Resumption of the Avant-Garde

The 'neo-avant-garde'

Paul Wood

Introduction

What is the relationship of art to reality? And to other art, of course? These are questions so big they have no answers, or as many answers as there are works of art, but they certainly bear down on the art of the twentieth century, especially the art of its second half. Some claim that art went off the rails at this time, or at least onto a different track. This view of modern art has paintings on one side of a divide and a heterogeneous range of objects and performances on the other (people rolling in offal, talking to animals, dipping their heads in paint, wrapping up buildings and so on). Indeed, much of the motivation for studying modern art may be to find out what these kinds of activity might *mean*.

I do not want to overstate the case here. The post-Second World War 'neo-avant-garde' (so-called to distinguish it from the 'classic' avant-gardes of the interwar period, such as Dada, Surrealism and Constructivism[1]) is not all merely eccentric or confrontational. But even the normative art of the later twentieth century – for example, the art that can be seen in major art museums – often demands different forms of attention from that required for modernist painting. That much is beyond dispute. However, in order to bring the neo-avant-garde of the 1950s and 1960s into focus, it is useful to dispense with the basic model I referred to above: that of a mainstream tradition of modern painting being overtaken after *c.*1950 by a deluge of heterogeneous practices. For it can be argued that such practices have always been present in twentieth-century art. The idea of a modernist tradition centred on painting that is then eclipsed by something else (call it 'novelty art', as Clement Greenberg did, or 'neo-avant-garde', or 'postmodernist' – it makes little difference[2]) is itself in no small part the product of modernist hegemony. Modernist criticism foregrounded a tradition of painting running from the work of Paul Cézanne through that of Henri Matisse and Cubism to abstract art, reaching some form of culmination in the post-Second World War practices of Jackson Pollock, Mark Rothko and others. It is from *this* point of view that Dada, say, looks trivial, or Surrealism 'academic' and 'literary', that Futurism is 'provincial' or Robert Rauschenberg's work appears 'easy'.[3]

If we look at the past through different historical spectacles, we can, however, recover a different modern art, not so much peripheral to modernist painting as a continuing challenge to it: an art of performance and construction, an art of adding things together and occupying physical space rather than of purifying form in pictorial space; an art of disunity and disruption rather than harmony and wholeness; an art more interested in tipping you out of your armchair than applying spiritual balm as you sink into the cushions. If, from a formalist–modernist

PLATE **9.1** (facing page) Robert Rauschenberg, detail of *Odalisk* (Plate 9.6).

point of view, the products and practices of the avant-gardes are mere kitsch, novelty and fashion, from an avant-gardist position, modernist painting verges on the academic – at best a compensatory myth of bourgeois life, at worst the cultural fig leaf of a repressive social order. In the words of the Situationist Guy Debord, 'art is purely and simply recuperated by capitalism as a means of conditioning the population'.[4]

The legacy of 'action painting'

Having set up an opposition between modernist painting and a wider field of avant-garde activity, it is time to enter a qualification. No figure had a greater impact on the neo-avant-garde – from Japan and Europe to his native USA – than Jackson Pollock. This effect was not, however, solely the result of the formal resolution of his paintings, the aspect emphasised by formalist critics such as Greenberg and subsequently by Michael Fried. It was reinforced by two other factors: Harold Rosenberg's conception of 'action painting' and Hans Namuth's photographs of Pollock at work. In 1952, Rosenberg famously asserted that the canvas became 'an arena in which to act' rather than a space in which to represent some object, 'not a picture but an event'.[5] It is doubtful how true this ever was – Pollock, Willem de Kooning, Rothko, Barnett Newman, all continued to make paintings. But in marked contrast to Greenberg's assertion of the autonomy of art, Rosenberg argued that because of its activism 'the new painting has broken down every distinction between art and life'.[6] This idea that a distinction had opened up between modernist art and everyday life, and that it was the business of a properly avant-garde practice to overcome it, was one of the pervasive beliefs of the period. It was in the name of this striving that artists embraced such a wide range of non-art materials and strategies drawn from the world at large, from almost anywhere except the conventional traditions, materials and procedures of 'fine' art.

The legacy of the broadly existentialist understanding of action painting was, however, double-edged. The notion of increasingly direct action, in real space and real time, was widely influential, but artists reacted against other aspects of gestural abstraction. The main thing to fall from favour was the widespread commitment to subjective self-expression; in fact, the idea of the self-expressive artist became one of the principal objects of avant-gardist criticism. Rauschenberg said of 'the kind of talk you heard then in the art world', that 'it was all about suffering and self-expression and the State of Things. I just wasn't interested in that.'[7] In similar self-occluding vein, Jasper Johns remarked, 'I have attempted to develop my thinking in such a way that the work I've done is not me – not to confuse my feelings with what I produced.'[8]

Rauschenberg and Cage

History tends to be messier than its representation by historians, and art history is no exception. It is very easy to think of history in stages, particularly in the wake of Alfred Barr's diagram,[9] with its succession of 'isms', or, indeed, by following the progressivist bias of modernist history in general. It is therefore commonplace to think of the neo-avant-garde as coming after Abstract Expressionism. Of course, much neo-avant-gardist work was a response to

Abstract Expressionism, particularly to the routinisation of expression that was the fate of its second generation — labelled 'the academy of second-hand sensibility' by Robert Rosenblum.[10] But two qualifications need to be entered. On the one hand, as we have seen, the relationship of avant-garde artists to Abstract Expressionism was often much more nuanced than one of simple rejection. Indeed, in spite of what came later it is hard to imagine any serious modern artist in the 1950s denying the achievement of Pollock, Rothko and others. On the other hand, the very earliest manifestations of what has come to be seen as a counter-modernist sensibility occur not after the establishment and dominance of Abstract Expressionism but almost contemporaneously with its emergence.

Pollock and Rothko achieved their signature styles around 1948. Pollock was still making major technical innovations within the modernist canon in the early 1950s. Rauschenberg, generally regarded as the harbinger of a full-blown postmodernist art, produced the first of his photographic 'blueprints' with Susan Weil in 1949 (Plate 9.2). His literally iconoclastic *Erased de Kooning Drawing* (Plate 9.4) appeared in 1953, and the first 'combine' paintings (Plate 9.5) — the definitive breach with modernist medium-specificity from within the New York School — were produced in 1954/5, over a year before Pollock's early death.

But Rauschenberg had already done something that marked him out from Abstract Expressionism before he erased the de Kooning drawing. In 1951–2, he produced a series of completely white canvases, devoid of brushmarks and any other gestural traces of the passage of the artist's hand because they were painted with a roller (Plate 9.3). Not surprisingly, opinion about these was divided. Of the few critics who reviewed the paintings when they were exhibited in 1953, most saw them as an affront to art, an anti-art manifestation. However, the composer John Cage wrote a poetic statement to accompany the works that read in part: 'No subject / No image / No taste / No object / No beauty / No message / No talent / No technique (no why) / No idea / No intention / No art.'[11] The point being, of course, that from Cage's Zen-influenced perspective, these were compliments. Cage subsequently averred that Rauschenberg's 'white paintings', which he had encountered in 1952, were significant influences on his own composition *4'33"*, a piece that consisted of the pianist opening the lid of the piano, and closing it after 4 minutes 33 seconds. The colours of the ambient light and the shadows of any people in the room fell across the white paintings as the ambient noise of the world rippled the surface of Cage's silence.

It might seem on first acquaintance as if Rauschenberg's white paintings were the acme of modernist reductionism; in fact, something else was going on. Rauschenberg had met Cage in 1951 at his first exhibition in New York. They both had a connection with Black Mountain, an experimental art college in North Carolina, which had opened in the 1930s and was directed by the expatriate Bauhaus painter Josef Albers. Cage had first taught there in the summer of 1948, along with the dancer Merce Cunningham, and Rauschenberg had studied under Albers from later that year and again in 1949. Cage had become committed to Zen Buddhism and had evolved a compositional method — aimed at diminishing the subjective, expressive role of the author — based on chance operations determined by the *I Ching*, the Chinese 'Book of Changes'. Cage had, moreover, been friendly since the early 1940s with Marcel Duchamp, and the two often played chess together. Duchamp had

PLATE **9.2** Robert Rauschenberg and Susan Weil, *Untitled* (*Sue*), *c.*1950, exposed blueprint
paper, 177 × 105 cm. (Collection of Susan Weil. © Robert Rauschenberg/
VAGA, New York/DACS, London 2004, and courtesy of Susan Weil.)

PLATE **9.3** Robert Rauschenberg, *White Painting*, 1951, oil on canvas, 183 × 320 cm. (Collection of the artist. © Robert Rauschenberg/VAGA, New York/DACS, London, 2004.)

by then made a kind of anti-career out of an ironic indifference to art. He was able to make a living from it as an occasional exhibition organiser and dealer, while undermining most of the myths of creation and authenticity on which modernism stood through the few things he did produce, such as the suitcase full of miniature replicas of his own earlier work, *Box-in-a-Valise*.[12]

Duchamp's fastidiousness and irony were rather different from Cage's Zen-inspired passivity and disposition towards an acceptance of all things, but both distanced themselves from the almost aggressive urge to self-expression that was then the orthodox ideology of modernist art. A different sensibility was in evidence, one that manifestly did not accept the idea of the heroism of art. Duchamp seems to have found the latter rather boring (not as interesting as chess), and to have enjoyed subverting its protocols. For Cage, art should be 'an affirmation of life – not an attempt to bring order out of chaos nor to suggest improvements in creation, but simply to wake up to the very life we're living'. In marked contrast to hierarchical distinctions between 'high' art and the 'low' or 'popular' (or indeed, between 'avant-garde' and 'kitsch'), Cage's Zen philosophy committed him to the belief that 'No value judgements are possible because nothing is better than anything else. Art should not be different from life, but an act within life.'[13] This should not, of course, be taken too literally: everyone makes judgements of value every day, and Cage was no exception. But as a significant downgrading of the modernist shibboleth of the value

judgement both within the practice of art, and between art and everything else, Cage's example gave Rauschenberg the confidence to believe, as he later put it, that 'the way I was thinking was not crazy'.[14]

Rauschenberg said of the white paintings that he felt they were 'hypersensitive', that one could look at them 'and almost see how many people were in the room by the shadows cast, or what time of day it was'.[15] It is as if, by being so empty, the white paintings could be filled with anything. One could go so far as to say that Rauschenberg filled up the emptiness of the white paintings with the rest of his career. Over the next few years, he developed a practice whose hallmark was an inclusivity amounting to omnivorousness. What Cage wrote of Johns, he could equally well have said of Rauschenberg: 'The situation must be Yes-and-No not either-or.'[16] It is perhaps an elusive distinction, but it seems like an important one: the white paintings were not 'purified', in the modernist sense, so much as empty receptacles that could be filled up with life. This is precisely what Rauschenberg went on to do: to refuse to differentiate between things that could and could not be art. Rauschenberg staked his claim on an ability to incorporate anything into the work of art. As Cage said of Rauschenberg's work: 'It is a situation involving multiplicity.'[17]

Nowhere was this commitment to multiplicity more evident than in an event at Black Mountain in the summer of 1952: Cage's *Theater Piece #1*. No photographs were taken of the improvised event, which is indicative of its informality, and accounts do not agree in all their details, though the overall character of the performance is clear enough. The most vivid description is given by Calvin Tomkins in his book *The Bride and the Bachelors* (the 'bride' being Duchamp, the 'bachelors' Cage, Rauschenberg and the French sculptor Jean Tinguely):

> There was a score of sorts, arrived at by chance methods, but the performers also had considerable freedom of action during the forty-five minutes that the event lasted. The actions took place simultaneously, and included Cage reading one of his lectures from the upper rungs of a stepladder; Merce Cunningham dancing, both around and amid the audience, which was seated around four sides of a hollow square so that it faced itself; David Tudor playing the [prepared] piano;[18] Mary Caroline Richards and Charles Olsen reading their poems, in turn, from another stepladder; Robert Rauschenberg playing scratchy records [by Edith Piaf] on an ancient wind-up phonograph with a horn loudspeaker; and two other people projecting movies and still pictures on the walls around the room. Rauschenberg's white paintings were hung from the rafters above the audience.[19]

Although *Theater Piece #1* was informal to the point of being throwaway and gained a mixed reception from its small audience in 1952, its subsequent impact was considerable. It took on a legendary status, acquiring the mantle of precursor to the many dance- and performance-related activities that formed such a central part of avant-garde practice in the later 1950s and early 1960s, as artists again and again sought to go beyond the particular medium and the discrete object.

The distance between these kinds of activity and the centre ground of modernist art is nowhere more dramatically demonstrated than in Rauschenberg's *Erased de Kooning Drawing* of 1953 (Plate 9.4). The bare facts are that Rauschenberg asked de Kooning for a drawing, which he then intended to erase. De Kooning, surprisingly perhaps, gave him one – moreover, a particularly heavily worked

PLATE **9.4**
Robert Rauschenberg,
*Erased de Kooning
Drawing*, 1953,
traces of ink and
crayon on paper with
hand-lettered ink
label in gold-leaf
frame, 64 × 55 cm.
(San Francisco
Museum of Modern
Art. Purchased
through a gift of
Phyllis Wattis.
Photo: Ben Blackwell.
© Robert
Rauschenberg/VAGA,
New York/DACS,
London 2004.)

example. Rauschenberg then did, indeed, rub it out – taking a month to do so, according to his own somewhat implausible account. The result was a critical symbol of exceptional economy. By using gesture to efface gesture, his hand holding the eraser making movements that must have been comparable to de Kooning's original mark making, Rauschenberg in effect used the same device of meaning-making to un-make one set of meanings and institute another. By throwing the machine of meaning-making into reverse, Rauschenberg arrived back at the primordial unity of the work of art: the blank canvas, or in this case, the blank sheet of paper. But, and it is an interesting 'but', the result was not a pristine absence so much as a de-composed 'almost-blankness' bearing the traces of work. What the *Erased de Kooning Drawing* seems to achieve is to undo, not so much Abstract Expressionism as such, as the heavy-breathing authenticity surrounding it, the rhetoric of risk and self-expression that had already become mannered.

Beginning in 1953, Rauschenberg embarked on a heterodox series of predominantly red paintings, which had evolved by 1954/5 into what he called 'combine paintings'. By the end of the decade, over 60 of these had been completed. It was the combine paintings above all that caused Leo Steinberg to credit Rauschenberg with having been the first to achieve a 'postmodernist

painting'. He noted how 'on the New York art scene the great shift came in Rauschenberg's work of the early 1950s. Even as Abstract Expressionism was celebrating its triumph, he proposed the flatbed or work-surface picture plane as the foundation of an artistic language that would deal with a different order of experience.'[20] Steinberg explicitly connected the way Rauschenberg brought things together with the way a newspaper does, likening the surfaces of the paintings to 'tabletops, studio floors, charts, bulletin boards – any receptor surface on which objects are scattered, on which data is entered, on which information may be received, printed, impressed'.[21] Rauschenberg's subject was contemporary culture, with nothing ruled out. A statement of 1963 reads in part: 'The concept I struggle to deal with is opposed to the logical continuity in language and communication. My fascination with images is based on the complex interlocking of disparate visual facts that have no respect for grammar.'[22] Typical components of the combines included comic strips, collage elements such as bits of fabric or metal, and a wide range of photographic imagery, from sports pictures and images of developments in science and technology to more private family photographs (Plate 9.5). Also prominent was art itself, but significantly, art as already represented: Old Master paintings in mediated form such as book illustrations, wallpaper, even tea-towels. At their most extreme the combines could incorporate three-dimensional objects, including a goat, more than one hen and an eagle (Plate 9.6).

PLATE **9.5** Robert Rauschenberg, *Charlene*, 1954, combine painting: oil, charcoal, paper, fabric, newspaper, wood, plastic, mirror and metal on four Homosote panels, mounted on wood, with electric light, 226 × 284 × 9 cm. (Stedelijk Museum, Amsterdam. © Robert Rauschenberg/VAGA, New York/DACS, London 2004.)

PLATE **9.6** Robert Rauschenberg, *Odalisk*, 1955–8, combine painting: oil, watercolour, pencil, crayon, paper, fabric, photographs, printed reproductions, miniature blueprint, newspaper, metal, glass, dried grass and steel wool, with pillow, wood post, electric lights and Leghorn rooster, on wood structure mounted on four casters, 211 x 64 x 64 cm. (Museum Ludwig, Cologne, Ludwig Donation. Photo: Rheinisches Bildarchiv Köln. © Robert Rauschenberg/VAGA, New York/DACS, London 2004.)

Rauschenberg's aim seems to have been compatible with, or a kind of refiguring of, the old project of 'the painting of modern life'. He remarked that 'Painting relates to both art and life … (I try to act in the gap between the two.).'[23] He spoke of living in a world of excess, marked by television and other forms of mass media, commenting that 'I thought an honest work should incorporate all of these elements, which were and are a reality.'[24]

An international avant-garde

In the 1950s, New York became the capital of modern art. A school of informal abstraction, generically known by the French term *art informel*, had emerged independently in Europe, but international modernism was dominated by the impact of the New York School. The hegemony of modernist painting represented the internationalisation of an American style. The neo-avant-garde was also international in scope, but with significant initiatives in Europe, South America and Japan it evinced less of a sense of American dominance, more of a genuine symbiosis between American developments and initiatives framed elsewhere, even when those initiatives included reflection upon the new culture that was emerging in the USA.

Britain

The Independent Group, based at the Institute of Contemporary Art in London from 1952, mounted exhibitions and held discussions devoted in equal parts to criticising the notion of an established, aesthetically oriented fine art and to exploring the implications of the new consumer culture. The Scottish–Italian sculptor Eduardo Paolozzi had gone to Paris after the Second World War to see at first hand the works of the modern movement that had attracted him as a student. While there, in addition to the works of Alberto Giacometti, Max Ernst and Joan Miró that he expected to encounter, the consumer products and magazines of American GIs caught his eye. He made collages from this material as early as the late 1940s (Plate 9.7) and, on returning to London, gave illustrated presentations about this work to other members of the Independent Group.

One of the icons of this group's work is Richard Hamilton's 1956 collage *'Just What is it that Makes Today's Homes so Different, so Appealing?'* (Plate 9.8). The collage was originally made as an illustration for the catalogue of the exhibition 'This is Tomorrow' at the Institute of Contemporary Art in 1956. It is quite small, and densely packed with ironic juxtapositions from contemporary advertising and magazines, and its transition in status from mere 'illustration' to fully fledged iconic work of art is in itself as symptomatic of the expansion of the category as is the subject matter. Hamilton also worked on a larger scale in a more traditional painting medium, drawing similar allusions from popular culture into fine art, to produce a hybrid he called 'Pop'. In a short text of 1961, Hamilton explicitly invoked the legacy of Dada and Futurism, in opposition to what he regarded as an over-inflated dependence on decoration by contemporary fine – that is, abstract – art, arguing that: 'If the artist is not to lose much of his ancient purpose he may have to plunder the popular arts to

PLATE **9.7**
Eduardo Paolozzi,
Real Gold, c.1950,
collage on paper,
36 × 23 cm.
(Photo: © Tate,
London 2003.
© Eduardo Paolozzi,
2004. All rights
reserved, DACS,
London 2004.)

recover the imagery which is his rightful inheritance.'[25] It is significant that Hamilton was interested in the legacy of Duchamp, producing the first printed version of *The Green Box*, Duchamp's extensive notes on *The Large Glass*[26] and, in 1965–6, a replica of that work, co-signed by Duchamp.

An interest in the relationship between art and popular culture was also maintained by the Independent Group's principal theorist, Lawrence Alloway. In an essay published in 1958, he distanced himself from Greenberg's denunciation of popular culture as 'ersatz' in his essay 'Avant-Garde and Kitsch'.[27] Alloway argued that, far from popular art being synonymous with nineteenth-century academic values, 'stylistically, technically and iconographically, the mass arts are anti-academic'. He went on to claim that as the culture changed, so did the role of art within it, and that 'rejection of the mass produced arts is not, as critics think, a defence of culture but an attack on it'.[28]

PLATE **9.8** Richard Hamilton, *'Just What is it that Makes Today's Homes so Different, so Appealing?'*, 1956, collage, 26 × 25 cm. (Kunsthalle Tübingen, Germany/Bridgeman Art Library, London. © Richard Hamilton 2004. All rights reserved, DACS, London 2004.)

The most explicit riposte to Greenbergian modernism from within the British avant-garde was John Latham's assemblage *Art and Culture* of 1966 (Plate 9.9). Latham taught at St Martin's School of Art in London, which had become one of the leading outposts of modernism in England. Greenberg had visited the college and the modernist sculptor Anthony Caro was a major presence there. Latham had been producing unorthodox work since the mid-1950s, involving the use of spray paints, and complex collages of metal fittings, electric wires, plaster and, above all, books. In 1966, he contributed *Skoob Tower Ceremony* – a tower of burning books – to the Destruction in Art Symposium

PLATE **9.9**
John Latham, *Art and Culture*, 1966, assemblage: leather case containing book, letters, photostats etc., and labelled vials filled with powders and liquids, 8 × 28 × 25 cm. (Museum of Modern Art, New York Blanchette Rockefeller Fund. DIGITAL IMAGE © 2003 The Museum of Modern Art, New York/ Scala, Florence.)

organised by Gustav Metzger in London. Latham's ideas about time, process and the work as an 'event' were a long way from the modernist paradigm. Indeed, Greenberg's increasingly Procrustean modernist values meant that, for him, the book-collages could only be (mis-)represented as manifestations of late-Cubist 'tastefulness'. This led Latham to conceive of an anarchic project in retaliation. After withdrawing Greenberg's canonical collection of essays *Art and Culture* from the college library, he invited like-minded individuals to a 'chew-in' – which involved taking a page of the book, chewing it up, and spitting the results into a receptacle. Latham subsequently broke the pulp down with a chemical cocktail and bottled it – thereby 'distilling' Greenberg's modernism. When the book was recalled by the library, Latham presented the phial of liquid. In the climate of increasing student radicalism of the time, the college authorities were edgy; precise circumstances are unclear, but the episode was part of a series of events – including police interest in the Destruction in Art Symposium – which resulted in Latham's teaching contract not being renewed. In short order, Latham became an avant-garde martyr and the work became an avant-garde icon. The component pieces of the enterprise (including a copy of the book and Latham's letter of dismissal) were subsequently preserved and displayed in a Duchamp-style suitcase. It is a measure of how art changed in the second half of the twentieth century (and of what happened to the standing of modernist criticism) that when the Museum of Modern Art in New York installed its large millennium survey in 2000, Latham's suitcase stood at the entrance to the contemporary section.

Italy

In Italy, the defeat of Fascism generated a widespread debate about the terms on which an adequately contemporary art should be constructed. Until the mid-1950s, a socially committed realism was the dominant force, espousing a suspicious attitude to the modern movement because of its difficulty for a lay audience. But others sought to combine a social dimension with an openness towards modernist technical innovation. As early as 1947, artists of the group Forma 1 declared: 'We hereby proclaim ourselves *formalists* and *Marxists*, convinced as we are that the terms Marxism and formalism are not *irreconcilable*, especially today, when the progressive elements of our society must maintain a *revolutionary and avant-garde* position.'[29] In a drive to greater immediacy of impact, as well as a way of creating distance from the apparently compromised media and procedures of fine art, Alberto Burri began to make painting-constructions out of the canvas sacks used for transporting produce (Plate 9.10). The physicality of the works was emphasised by the cutting and burning procedures that Burri carried out on their surfaces. Unlike Pop Art, with its use of imagery from the mass media, Burri incorporated traces of the quotidian directly into an art that, while 'abstract' in the sense that it contained no imagery, emphasised its own materialism, its status as a non-idealised, worked physical object, in a world of work and physical objects.

A related interest in breaking the bounds of conventional art, as well as facing up to a postwar world in which science and technology seemed to be becoming dominant, can be found in the work of Lucio Fontana. In 'The White Manifesto' of 1946, Fontana argued that 'The discovery of new physical forces, the mastery of matter and space, have gradually imposed unprecedented conditions on mankind ... We are living in a mechanical age, in which plaster and paint on

PLATE **9.10** Alberto Burri, *Large Sack*, 1953, burlap, oil on canvas, 138 × 250 cm. (Fondazione Palazzo Albizzini 'Collezione Burri', Città di Castello.)

canvas are no longer meaningful.'[30] Fontana is best known for the monochrome paintings he made, under the collective title *Spatial Concept/Waiting*, first by punching holes through the surface of the canvas, and subsequently, in the late 1950s, by cutting long slits in the surface of the canvas with a knife (Plate 9.11). Among the most radical of his works, however, was not a discrete painting or sculpture as such, but the production in 1949 of an installation, now known only from photographs. *Spatial Environment in Black Light* (Plate 9.12) consisted of a darkened room in which there hung from the ceiling a variety of bone-like or gristle-like objects covered in fluorescent paint and illuminated by so-called 'black light'. From contemporary accounts, the effect seems to have been similar to a ride on a fairground ghost train, where forms loom up out of the darkness and disappear, disorienting the spectators moving around in real space and time, and confusing normal perception. In 'The White Manifesto', Fontana had argued the need to 'leave behind all known art forms, and commence the development of an art based on the union of time and space'.[31] There are echoes here of the early twentieth-century avant-garde, notably Italian

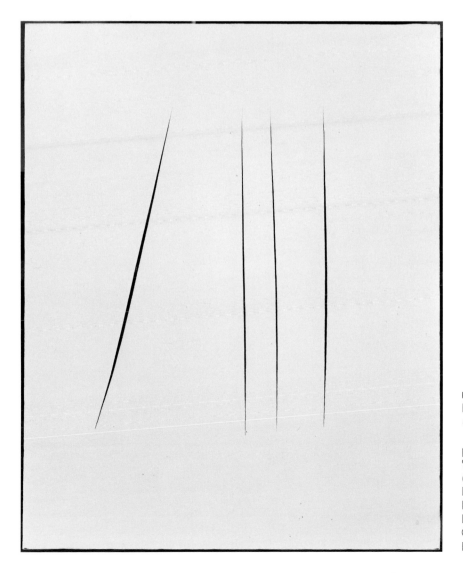

PLATE **9.11**
Lucio Fontana, *Spatial Concept/Waiting*, 1959, water-based paint on canvas, 91 × 121 cm. (Museco Civico Rivoltello, Trieste, Italy/Bridgeman Art Library, London. © Fondazione Lucio Fontana, Milan.)

Futurism, as well as some of Kasimir Malevich's enthusiasms. But beyond that, Fontana appears to be registering the impact of developments in which science and technology would go on to transform not merely the external world, but would contribute to a situation in which 'the application of these discoveries to all aspects of our lives brings about a change in human nature'.[32]

A younger figure influenced by the example of Fontana was Piero Manzoni, who exhibited the first of his *Achromes* in 1957 (Plate 9.13). These painting-like objects reflect the dual interest in an anti-expressionist understanding of

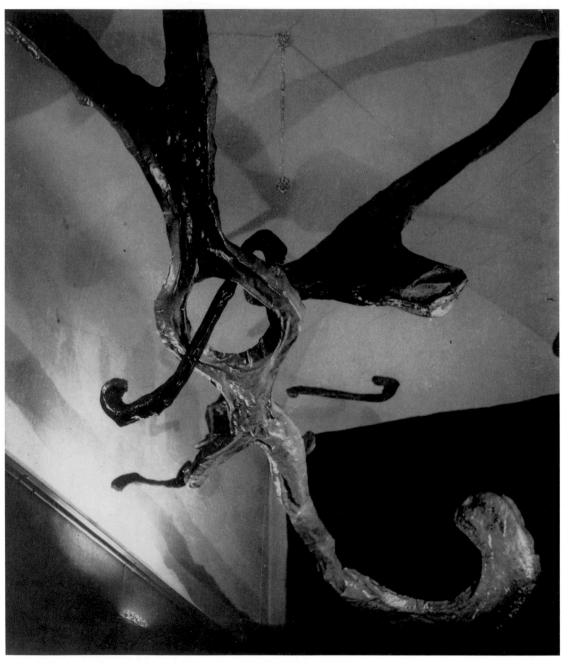

PLATE **9.12** Lucio Fontana, *Spatial Environment in Black Light*, 1949, papier maché, phosphorescent pigment, Wood's light, 330 × 520 × 440 cm. The dimensions are those of the reconstruction by Claudio Silvestrin, 1999. The photo is of the destroyed original. (© Fondazio Lucio Fontana, Milan.)

the role of the artist and in the materiality of the work of art. In his principal theoretical statement, Manzoni argued, 'to suggest, to express, to represent: these are not problems today'.[33] The *Achromes* were white surfaces, often made up of a grid of smaller rectangular pieces of canvas, and covered not with paint, but with kaolin, to produce a variety of subtly different nuances of pictorial effect. The ambivalence is captured by Manzoni when he writes that 'my intention is to present a completely white surface ... beyond all pictorial phenomena'. This surface is 'neither a polar landscape, nor an evocative or beautiful subject ... not even a sensation, a symbol or anything else: but a white surface which is nothing other than a colourless surface, or even a surface which quite simply "is"'.[34] Yet Manzoni's literalism coincided with a more poetic sense of the possibilities the situation opened up, as, for example, when he writes that the finite 'material contingency' of this surface, this state of Being, is held to be capable of being 'multiplied to the infinite'.[35]

PLATE **9.13** Piero Manzoni, *Achrome*, 1958, kaolin on canvas in squares, 90 × 70 cm. (Photo: © Tate, London 2002. © DACS, London 2004.)

The *Lines* that he subsequently produced were made by holding a pen on a revolving drum of paper for specified periods of time: the resulting 'drawings' being titled according to the time taken or the length of line (Plate 9.14). In a further twist, offering an oblique comment on the increasing commodification of art, Manzoni packaged each 'Line' in a cylindrical cardboard container, with a specimen of the line stuck on the outside in the manner of a label. The drawing as such remained inside, invisible. Manzoni's most extreme statement on commodification, a kind of limit-case of the classic anti-art gesture, which he was saved from having to trump by virtue of his early death in 1963, was the cans of *Merda d'artista* – tins of the artist's shit. These were sold for the then current value of their weight in gold (Plate 9.15). Needless to say, in the omnivorous culture of art that appeared in the late twentieth century, the market engulfed even this. The New York Museum of Modern Art's millennium survey contained one such can, carefully mounted on its own plinth, protected by a perspex cover: an icon of an institution that can market 'the emperor's new clothes' and see the price go up exponentially. Manzoni's point continues to resonate posthumously, desperately funny, and awfully true.

France

One of the enduring images of the neo-avant-garde is Yves Klein's *Leap into the Void*, and part of its enduring interest is that it is a fake – and that this does not matter (Plate 9.16). Klein's short career represents a kind of moving target, as he played with accepted notions of art and the artist, by turn night-club impresario, a devotee of Japanese culture, con-man and mystic. Having exhibited monochromes in a variety of colours the year before, Klein first showed his blue monochrome paintings in Milan and Paris in 1957 (Plate 9.17). He surrounded the events with a mixture of mass-culture-style publicity – releasing a thousand and one blue balloons, distributing blue postcards – and highly idealised assertions of the works' spiritual power: 'Through colour, I feel a total identification with space; I am truly free'[36] and 'My pictures represent an idea of absolute unity in perfect serenity.'[37] Among those most affected by the Milan exhibition was the young Manzoni, who turned to producing his *Achromes* as a result. The older Fontana also regarded the work as confirmation of his own practice during the previous decade.

With a lightness of touch reminiscent of Duchamp, Klein was running together incompatible aspects of art or, rather, bringing out the actual coexistence of what were assumed to be incompatible aspects: affirmation of the spiritual power of art and an acknowledgement of the market – as, for example, in his practice of differentially pricing apparently identical blue monochromes, and patenting his colour as International Klein Blue (IKB). Klein's next move was to proclaim the limitations of colour when applied as a material to the surface of a painting: 'My paintings are now invisible and I would like to show them in a clear and positive manner, in my next Parisian exhibition at Iris Clert's.'[38] This exhibition, staged in April–May 1958, was known as 'Le Vide' ('The Void'). The entrance to the gallery was surrounded by imposingly theatrical drapes in IKB, and the windows were also painted blue. The paraphernalia of embossed

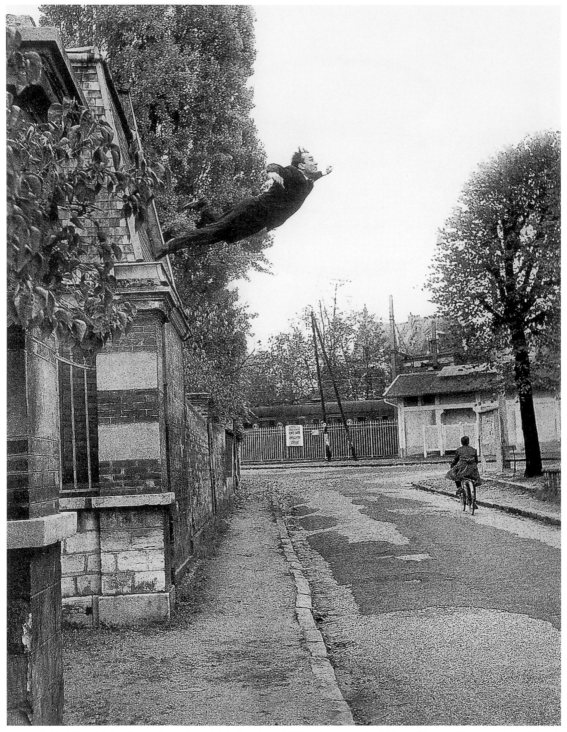

PLATE **9.16** Yves Klein, *Leap into the Void*, October 1960, photograph, 120 × 80 cm. (Photo: Harry Shunk. © ADAGP, Paris and DACS, London 2004.)

PLATE **9.17**
Yves Klein, *Blue Monochrome IKB 79*, 1959, paint on canvas on wood, 140 × 120 cm. (© Tate, London 2003. © ADAGP, Paris and DACS, London 2004.)

invitation cards in formal script, printed in blue ink, as well as a blue cocktail for the guests, was topped off by Clert's astute use of her social connections to get two members of the Republican Guard, in full-dress uniform, stationed on either side of the door for the opening. What the visitor experienced inside was 'the void', or as close as Klein could get to it, having spent the previous few days painstakingly removing all the furniture and fittings except for one (empty) display cabinet and a table covered in a white cloth, and painting every surface with several coats of pure white paint and varnish.

The performative aspects of 'The Void' installation were incorporated into the actual production of artworks in Klein's *Anthropométries* of 1960. These were paintings made as public performances, made, moreover, by nude female models who were smeared with IKB and who then rolled, dragged and pressed their bodies against sheets of white canvas – the whole event presided over by Klein in a white tie and tuxedo, while a nine-piece orchestra played his *Monotone Symphony* (twenty minutes of a single note, followed by twenty minutes of silence) (Plate 9.18). It hardly needs to be said how problematic this is from the point of view of contemporary gender politics: a besuited man presiding over naked women rolling around in the name of art, while

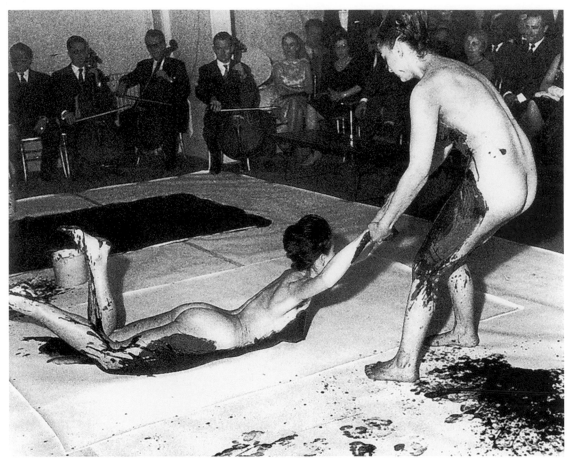

PLATE **9.18** Yves Klein, *Anthropometry Performance*, Galerie Internationale d'Art Contemporain, Paris, 9 March 1960. (Photo: Harry Shunk. © ADAGP, Paris and DACS, London 2004.)

PLATE **9.19** Yves Klein, *Hiroshima (Anthropometry Painting ANT 79)*, c.1961, 140 × 280 cm. (Menil Collection, Houston. Photo: Rick Gardner, Houston. © ADAGP, Paris and DACS, London 2004.)

subject to the gaze of an audience of upper-middle-class connoisseurs. Nonetheless, whatever the ethico-political pitfalls of the performance, in retrospect, for the present writer at least, its witty debunking of high culture outweighs its dubious politics. Moreover, it would be hard to dispute the evocative qualities of the resulting paintings: some still and hieratic, some apparently the product of violent movement, some inescapably sexual, some sinuous and dance-like, some (like the one entitled *Hiroshima*), blurred and vaguely haunting (Plate 9.19).

It would clearly be risky to attribute any unitary 'meaning' to a practice like Klein's. The *Leap into the Void* stands as a compelling metaphor for his view of the calling of the artist, even though it is as much a fake as a photograph of flying saucers or fairies at the bottom of the garden. Quite apart from its transgressive aspects and the sheerness of the line it treads between fraud and feeling, the diversity of Klein's output meant it was open to being read in radically different, even contradictory, ways. The monochromes meant that, on the one hand, his work could be assimilated to various forms of reductive modernism practised in the USA by artists such as Frank Stella, Donald Judd and other minimalists.[39] On the other hand, the *Anthropométries* meant Klein's work could just as readily be aligned with the installations and 'happenings' associated with figures such as Rauschenberg and Allan Kaprow. Klein himself remains difficult to pin down, seeming to fly in the face of the pervasive avant-garde emphasis on the concrete and the literal, as in his lecture delivered at the Sorbonne in June 1959 under the title 'The Evolution of Art towards the Immaterial'.[40] One suspects that part of the problem Klein presents for historians of the avant-garde is that he was capable of being both funny and serious, mystical and materialist, and often both at the same time.

Japan

In Japan after the Second World War, the sense of needing to generate a new social order, coupled with the penetration of ideas of western culture, combined to produce a small but radical artistic avant-garde. Particularly influential once again was the 'action painting' interpretation of Pollock's practice, with its emphasis on the material aspect of art-making. Indeed, the name of the group, 'Gutai', is conventionally translated as 'Concrete Art Group'. Formed in Osaka in 1954, with a journal appearing the following year, the group quickly established an international reputation. Jirô Yoshihara, the group's principal organiser and author of its manifesto published in 1956, wrote explicitly of his respect for Pollock and the French *informel* painter Georges Mathieu, contrasting their work with illusionism and formalism alike, regarding it as 'the loud outcry of the material, of the very oil or enamel paints themselves'.[41]

The enthusiasm for action painting and a direct engagement with materials had already been taken up and extended in 1955 by Kazuo Shiraga. Both of these are indicative of a tendency that took Gutai art beyond *informel* into the realm of performance: something that rapidly led to connections with the contemporary development of 'happenings' in the USA. Shiraga made paintings with his feet by swinging above the canvas on a rope, and in one particularly spectacular manifestation, *Challenging Mud*, writhed around using his whole body to 'compose' the work (Plate 9.20). In similar vein,

PLATE **9.20**
Kazuo Shiraga,
Challenging Mud,
1955. (© Matsumoto
Co. Ltd.)

Saburo Murakami constructed large wooden frames across which he stretched not canvas, but layers of handmade Japanese paper. These were then set up vertically in sequence, one behind the other, whereupon Murakami took a run-up and flung himself through them in one spectacular leap, thus *At One Moment Opening Six Holes*, as the performance was titled. The performative aspects of this art, and the concomitant use of the artist's body, completely take over the work in a piece such as Atsuko Tanaka's *Electric Dress* of 1956, a striking metaphor for the collision of traditional Japanese culture in the form of the kimono with modern technology symbolised by electric light (Plate 9.21). Gutai as a movement was relatively short-lived, with many of its adherents turning back to more conventional painting practices, but works such as the ones described ensured it a lasting position in histories of the international postwar avant-garde.

PLATE 9.21
Atsuko Tanaka,
Electric Dress, 1956.
(Photo: Ashiya City
Museum of Art and
History. © Atsuko
Tanaka and former
members of the
Gutai Group.)

Germany

The situation of the avant-garde in Germany in the years following the Second
World War was, as may be imagined, complex and difficult. After the suppression
of the prewar avant-garde by the National Socialists, and the subsequent
stabilisation of a generally very conservative socio-cultural formation in the
1950s, the ground was anything but fertile for any re-emergent artistic vanguard.
The historian Andreas Huyssen has argued that 'there was practically no
indigenous new painting in Germany throughout the 1950s ... as far as new
production was concerned, the visual field seemed exhausted'.[42] Somewhat
anodyne versions of abstraction and Expressionism were the order of the day.
One major source of stimulus for something new to emerge, however, was
the foundation of the 'Documenta' exhibitions in Kassel: the first, in 1955,
prompting a re-engagement with the legacy of the early twentieth-century
avant-garde; the second, in 1959, bringing contemporary American painting to
the notice of German artists (indeed, having an impact across Europe). Another
vital development came in the field of music, with the continuation of the
experiments of the Second Viennese School, which included the work of
Alban Berg, Arnold Schoenberg and Anton von Webern. As Huyssen notes,
'the center of avant-gardism in West Germany in the 1950s became tied neither
to literature nor to the visual arts, but precisely to musical experimentation'.[43]
In key sites such as Darmstadt and Cologne, in theoretical debates involving
the philosopher Theodor Adorno, as well as in the practice of Karlheinz
Stockhausen and others, a radical avant-garde flourished. Into this situation,

in 1958, came John Cage. Cage's new approach to composition, which was immediately seen as a fundamental critique of the procedures associated with figures such as Schoenberg and Stockhausen, had an effect on the younger generation comparable to its impact in the USA. Among Cage's most important encounters was that with the young Korean Nam June Paik.

Paik had graduated from the University of Tokyo in 1956, and had moved from there to Germany, where he worked on electronic music for German radio. After meeting Cage, Paik became one of the central figures in the development of Fluxus. The Fluxus festivals, involving among others Paik and Joseph Beuys, were some of the most important of the mixed-media avant-garde manifestations, and are discussed in the next section. But they were not alone. The late 1950s saw the flourishing of numerous performance-based activities in Germany. Otto Piene and Heinz Mack had formed the ZERO group in 1957, holding multimedia festivals and producing three journals between 1958 and 1961. These journals published texts by Klein, Manzoni, Tinguely and others, illustrated Klein's *Leap into the Void* and one of Manzoni's *Lines*, and even incorporated a burnt page in an article by Gustav Metzger which prefigured the Destruction in Art Symposium. In 1962, Wolf Vostell commenced publication of *dé-coll/age: Bulletin Aktuellen Ideen*. This was a journal that printed artists' writings from across the new avant-garde and publicised a variety of actions, happenings and Fluxus events, the title being a neologism intended to connote the simultaneously constructive and destructive aspects of creativity. One of Vostell's own most elaborate actions was the multi-episode *Nein-9-dé-coll/agen* of September 1963. During the evening, a group of spectators was conveyed around Wuppertal in a coach, participating in activities such as watching a film and visiting sites including a car wash and a factory. The evening culminated in the action *130 à l'heure, No.1*, in which a Mercedes Benz saloon car was parked across a railway line before being smashed into by a locomotive travelling at 130 km an hour. The symbolism of Vostell's critique of the German economic miracle scarcely requires emphasis.

Summary

Taken together these and many other examples testify to the existence of a widespread international tendency to try to move beyond the traditional media of art. This was sustained by the expectation that these forms of more direct bodily engagement with the physical materials of the world would somehow both manifest a keener awareness of contemporary modernity and simultaneously stimulate a kindred awareness in the spectator. By leaving behind traditional illusionism, grappling with real things in real time, and evacuating the hollowed-out conventions of a patrician, class-riddled culture – which it was widely felt had been exposed as empty and corrupt by the Second World War – avant-garde artists hoped to produce a shock of awareness about the actual conditions of the complacent 'consumer society' that was coming to dominate life in the developed nations. The extent to which this aspiration was borne out is, of course, debatable. Lay audiences appear to have been even more bemused or outraged by performance-based activity advanced as art than they were by non-representational painting. However, at the same time, the centre of gravity of art itself began to shift

away from what had been the privileged ground of the modern tradition no less than of the preceding academic tradition – namely painting – towards a heterogeneous range of objects, installations and performances, unified if at all only by their thoroughgoing *non*-medium-specificity, and their being advanced as *art* – that is, not as theatre, opera or ballet, or any other conventional genre involving bodily activity in real space. During the approximate period from the mid-1950s to the mid-1960s, when being crazy could still look like the sanest response to a largely conformist world that was always only a step away from nuclear destruction, avant-gardism retained its edge. In retrospect, the period presents a quite specific conjunction of cultural and political circumstances. The neo-avant-garde was not closely bound up with a coherent revolutionary political project, as the avant-garde of the 1920s had been, but neither was it yet the house-trained companion of the full-blown, media-fixated and spectacularised postmodernist culture of the end of the twentieth century. In the groundwork for what turned out to be the political and cultural upheavals of 1968, the avant-garde still had a substantial part to play.

'Happenings' and Fluxus

Allan Kaprow published the book *Assemblages, Environments and Happenings* in 1966, though he declared in the Preface that the book was largely written by 1961. Kaprow's text began with the claim 'A critical turning point has been reached in a major area of avant-garde effort', continuing: 'Certain advanced works being done at this moment are rapidly losing their traditional identities and something else, quite far-reaching in its implications, is taking their place … In short, contemporary art has moved out of its traditional limits.'[44] At the time it was written, this may have been overstating the case, as conventional practices of painting and sculpture, even conventionally *modernist* practices, still had some way to run. But as an anticipation of what was to come in the art of the last third of the twentieth century, it was prescient enough.

That said, it would be a mistake to regard the work Kaprow was talking about solely through the lens of subsequent postmodernism. The entire 'feel' of the work of those artists associated with happenings, with the Fluxus group, and beyond that, with the neo-avant-garde of the 1950s and 1960s in general, is quite distinct from the far more spectacularised 'post-medium' practices of late twentieth-century postmodernism. In particular, the work of the neo-avant-garde was not at the centre of a market operation; it was marked by a certain everydayness, an informality and, of course, low production costs. Much of its impact, which it now requires a considerable effort of imagination to project, derived from what it eschewed: namely, the increasingly commercialised world of contemporary canonical 'high art' and the attendant production of discrete objects for purposes of aesthetic contemplation. Its effects were characteristically achieved through a certain lightness of touch, the employment of distinctly everyday, even ephemeral, materials, and a generalised elevation of the ordinary over the culturally serious and would-be profound. Some of this ethos is captured in a retrospect by one of the leading participants disarmingly titled 'A Child's History of Fluxus'. Dick Higgins wrote of a time, 'Long long ago, back when the world

was young – that is, sometime around the year 1958', when certain artists recognised that 'coffee cups can be more beautiful than fancy sculptures. A kiss in the morning can be more dramatic than a drama by Mr. Fancypants. The sloshing of my foot in my wet boot sounds more beautiful than fancy organ music ... And they began to ask questions.'[45] Something of this wish to reveal the marvellous or uncanny in the mundane was facilitated by film. Jeff Perkins made a silent 'fluxfilm' of two men in profile, shouting at each other, thereby turning the 'argument' into a ballet of non-communication. Joe Jones used a high-speed camera, shooting at 2,000 frames a second, to make an eerie 'sculpture' out of the simple act of exhaling smoke from a cigarette.

In 1958, Kaprow similarly wrote of an expanded sense of what was now available to art, and made explicit the connection of this new attitude to the legacy of Pollock: 'Pollock as I see him left us at the point where we must become preoccupied with and even dazzled by the space and objects of our everyday life, either our bodies, clothes, rooms, or if need be, the vastness of Forty Second Street.'[46] He went on:

> Not satisfied with the suggestion through paint of our other senses, we shall utilize the specific substances of sight, sound, movements, people, odors, touch. Objects of every sort are materials for the new art: paint, chairs, food, electric and neon lights, smoke, water, old socks, a dog, movies, a thousand other things which will be discovered by the present generation of artists.[47]

The upshot, for Kaprow, was that 'The young artist of today need no longer say "I am a painter" or "a poet" or "a dancer". He is simply an "artist". All of life will be open to him.'[48]

Kaprow's first 'happening' in New York was staged at the Reuben Gallery in autumn 1959. He had attended Cage's course on experimental composition, which was first presented at the New School for Social Research in New York in 1956, and would therefore have been aware of the Black Mountain event of four years previously, which had become a benchmark for the group around Cage. For Kaprow's 'happening', the gallery was divided into three spaces by semi-transparent polythene sheets and partitions made out of earlier 'assemblages': independent multimedia constructions that had evolved out of action painting and collage. During the course of the action, the audience moved from space to space, according to instructions given out beforehand. The ringing of a bell marked the end of each of the *18 Happenings in 6 Parts*, as the whole performance was known. The performance consisted of a variety of apparently disconnected actions, not subject to any conventional narrative continuity. These included figures posing mutely in the rooms, or marching into position, various musical instruments being played, paintings being painted on canvases, gramophones being played and slides projected. Monosyllabic words were intoned and statements declared, including: 'I was about to speak yesterday on a subject most dear to you all – art. But I was unable to begin.' The whole apparently anarchic but, in fact, carefully rehearsed performance lasted 90 minutes; those who seek for a shorthand statement of its 'meaning' would do well to note Kaprow's own assertion before the evening that 'the actions will mean nothing clearly formulable so far as the artist is concerned'.[49]

Other New York artists rapidly followed suit, including Jim Dine and Claes Oldenburg, both of whom subsequently became well known as 'Pop' artists. In *The Smiling Workman*, Dine debunked action painting by pouring tins of red paint over his head and jumping through his canvas, on which he had written 'I love what I'm doing'. A collaboration between the two, the 'Ray Gun Show', involved filling the gallery with miscellaneous objects and junk 'sculptures' culled from the surrounding environment. In early 1960, Oldenburg put on 'Snapshots from the City' and 'The Street'. The latter consisted of an installation of forms made from ripped-up cardboard, echoing the shape of detritus picked up on the streets of the Lower East Side, partially painted over in black. Oldenburg's contemporary comments offer an indication of where the new work was coming from. In 1959, he wrote: 'What are my preferences in the real world; the city and the poor and the miserable; the streets … proletariat or common people, their inventions. Popular culture. Present-day primitives: children, madmen, the American cultureless. In general, the bleak grey face of things, not pastoral. Modern and citified.'[50]

Oldenburg's most ambitious enterprise of this time was 'The Store'. In autumn 1960, he had begun making drawings of clothing and other things for sale in local cut-price stores. Some of these he began to turn into objects made of plaster-soaked muslin over wire frames, subsequently painted over, first in tempera, later in enamel. They included a shirt and tie, a pair of sneakers, a piece of pie and a Statue of Liberty souvenir (Plate 9.22). These were first shown in a group exhibition at the Martha Jackson Gallery in New York in the spring of 1961, for which Oldenburg composed the manifesto-like text that begins: 'I am for an art that is political-erotical-mystical, which does something other than sit on its ass in a museum.'[51] The obvious intention is to underscore the difference between such an art and 'autonomous' modernism, something that becomes even clearer as the text continues: 'I am for an art that embroils itself with the everyday crap and still comes out on top. I am for an art that imitates the human, that is comic, if necessary, or violent, or whatever is necessary. I am for an art that takes its form from the lines of life itself.'[52] Oldenburg proceeded to turn his new studio, which had previously been a shop on East Second Street in the Lower East Side into 'The Store'. For two months, during December 1961 and January 1962, Oldenburg ran 'The Store' as a combined performance/studio/gallery, selling out front the objects he made in the back (Plate 9.23). In an accompanying statement, he wrote:

> The Store, or My Store, or the Ray-Gun Mfg. Co., located at
> 107 E.2nd St., N.Y.C., is eighty feet long and varies about 10 ft wide.
> In the front half, it is my intention to create the environment of a
> store by painting and placing (hanging, projecting, lying) objects
> after the spirit and in the form of popular objects of merchandise,
> such as may be seen in stores and store windows of the city …
> This store will be constantly supplied with new objects which I will
> create out of plaster and other materials in the rear half of the place.
> The objects will be for sale in the store … which is also of course
> my studio.[53]

In much subsequent art history, Pop Art has often been attacked for its apparently uncritical celebration of American consumer culture. This was undoubtedly true of some work produced on both sides of the Atlantic.

PLATE **9.22** Claes Oldenburg, *Man's Jacket with Shirt and Tie*, 1961, muslin soaked in plaster over wire
frame, painted with enamel, 106 × 75 × 30 cm. (Museum Ludwig, Cologne, Ludwig Donation.
Photo: Rheinisches Bildarchiv Köln. © Claes Oldenburg and Coosje van Bruggen.)

PLATE **9.23** Claes Oldenburg, 'The Store', 1961, colour photograph of installation (interior view). (© Claes Oldenburg and Coosje van Bruggen. Photo: Robert McElroy © Robert R. McElroy, VAGA, New York/DACS, London 2004.)

But certain other artists broke down the distinction between 'high' art and popular culture in order to gain a critical purchase on both. Oldenburg's 'Store' represents such an instance of an artist attempting to develop a critical practice by breaking down the barriers between 'high' and popular, between artwork and art gallery, between art gallery and shop and, indeed, between production (of objects) and process (of making). In his collection of *Documents from The Store*, Oldenburg wrote: 'this country is all bourgeois down to the last deathtail and most of the criticism is an exhortation to observe art and justice and good sense and humanity, which are also bourgeois values, so there is no escaping bourgeois values in America. The enemy is bourgeois culture nevertheless.'[54] The dilemma of avant-garde art is encapsulated in the fact that, while there is no record of what, if anything, the inhabitants of the Lower East Side made of Oldenburg's 'Store', the Museum of Modern Art acquired an object for its collection.

Fluxus emerged in New York around the same time. The name was coined in 1962, but its gestation period reached back into the late 1950s.[55] Once again, the influence of Cage's experimental composition and Cunningham's related dance activities was central. Fluxus was an amorphous collective with a fluctuating membership, prone to schism yet dominated, at least in his own view, by George Maciunas. It is not at all easy to say with any simplicity what Fluxus did, or was, short of enumerating the myriad of objects, texts or performances enacted by a considerable number of artists and musicians in relation to that name. The core of their varied activities is represented by a number of 'fluxus anthologies', 'fluxus yearboxes', 'fluxkits', the already-mentioned 'fluxfilms', and most notably, a series of 'fluxus festivals' held in various European cities in the early 1960s.

Maciunas's original plan was for a series of magazines, six of which had been worked out by the end of 1961, and which were due to appear quarterly from February 1962 onwards. This initial idea was for relatively conventional articles on a series of themes such as electronic music, experimental cinema and concrete poetry, with different issues related to activities in different locations, such as the USA, Europe and Japan. But the magazines never happened. The plan seems to have become caught up with the work Maciunas was doing designing another publication titled *An Anthology*, edited by yet another product of Cage's influence, the musician La Monte Young. In the end, *An Anthology* did not appear until 1963, and the Fluxus journal mutated into a wooden box holding a variety of papers and objects that was eventually mailed out to subscribers in 1964. These delays and mutations are typical. Fluxus was certainly culturally radical in aspiration, but actually getting things done was never easy, not least owing to a simple lack of resources.

Artists involved in Fluxus spanned a broad cross-section of the international avant-garde: George Brecht, Dick Higgins, Charlotte Moorman and others from the USA; Ben Vautier from France; the Czech Milan Knizak; Nam June Paik and Yoko Ono from Korea and Japan, respectively. Plus which, there were others involved in kindred types of work who had some relation with Fluxus, in positive and negative ways, during their careers. These included Metzger in England (who achieved the notable distinction of being expelled from the 'Festival of Misfits' in London in 1962); Wolf Vostell and Beuys from Germany;

Robert Morris in New York. There is no common denominator to the work, except that it often involved elements of performance and tended to avoid the medium-specificity of conventionally modernist painting and sculpture. Morris was involved with experimental dance and performance in New York, before achieving success as a minimal sculptor in the mid-1960s. Vautier ran a record shop, a kind of ongoing installation/performance based on the premise that anything in life could be art, combined with a reasonably alternative way of making a living. He also undertook elliptical actions, such as writing on a wall the phrase 'Ben écrit sur les murs' ('Ben writes on walls'), and there is a fluxfilm in which he sits motionless for an hour in a throng of holidaymakers on the promenade at Nice holding a placard inscribed 'Regardez moi cela suffit' ('Look at me that's enough') — the upshot being that those who stare at him become the object of the (film) viewer's gaze. Yoko Ono also staged performances, such as the sexually charged *Cut Piece* in which male members of the audience were invited to cut away her clothing with a large pair of scissors (Plate 9.24), and made 'instruction' paintings in which 'spectators' were asked to hammer a nail into the canvas, or burn a hole in it. Beuys's enigmatic performances and public lectures, which began under the auspices of Fluxus in the early 1960s, eventually elevated him to virtual figurehead status for the international avant-garde as a whole in the years after 1968 (Plate 9.25).

PLATE **9.24**
Yoko Ono, performing *Cut Piece* at the Carnegie Hall, New York, 1965. (Photo: Minoru Niizuma/Courtesy of Yoko Ono.)

Fluxus tends to be written about in histories of visual art, but that presupposes an expanded sense of the 'visual arts' that incorporates a variety of performative activities, including Cagean forms of music. George Brecht had been involved with Cage's experimental composition workshop and it was he who, in 1958, introduced the notion of the 'event score', which came to form the central motif for Fluxus performance: a statement or instruction, which it was up to the performer to realise in any way he or she thought fit. One such was Emmett Williams's *Voice Piece for La Monte Young* of 1963: 'Ask if La Monte Young is in the audience, then exit.' The first Fluxus festival in Wiesbaden in September 1962 was, indeed, titled 'Fluxus International Festival of New Music'. Taking place over four weekends, it was billed as including 'piano compositions ... compositions for instruments and other voices ... taped music and film ... [and] concrete music and happenings'.[56] One of the performances included a grand piano being dismantled and the pieces sold. This apparently involved the *mis*-interpretation of an 'event score' by Philip Corner. Paik's *Zen For Head* was first performed in Cologne in 1961, and subsequently repeated in 1962. Paik performed La Monte Young's *Composition #10. To Bob Morris*, which

PLATE **9.26** Nam June Paik, performing La Monte Young's *Composition #10. To Bob Morris* as his *Zen for Head* at Fluxus Internationale Festspiele Neuester Musik, Wiesbaden, 1962. (Photo: © PA.)

PLATE **9.27** Nam June Paik, *Zen For Head*, 1962, ink and tomato on paper, 406 × 36 cm. (Collection Museum Wiesbaden.)

consisted of the instruction: 'Draw a straight line and follow it.' Paik's chosen method for drawing the line was to dip his head in a bucket of ink mixed with tomato juice and, on hands and knees, retreat along a scroll of paper while dragging his head on its surface (Plate 9.26). As Elisabeth Armstrong writes, this 'work' raises a number of questions: who is the author – Paik, or Young; what is the work – music or performance, or, perhaps, a painting? Indeed, part of the problem of answering such questions is that, as art history takes an interest in Fluxus, its more ephemeral aspects become overtaken by a need to curate the disparate residues of the various performances. Paik's scroll is now framed and displayed, in effect as a kind of painting, in the Wiesbaden Stadtisches Museum (Plate 9.27).[57]

Of all those involved in Fluxus activity, the most complex and contested legacy has been that of Beuys. In the years after 1968, Beuys's performances and lectures resonated with the emergence of a new 'Green'-inflected political culture to make him arguably the single most influential figure of the new avant-garde. But these activities were rooted in an earlier period. Beuys evolved an elaborate personal mythology in the years after the Second World War, a mythology that is inseparable from certain biographical events that have always lain at the centre of the identity Beuys, the artist, constructed for himself. Pre-eminent among these is the claim that, as a radio operator in the German air force, he crash-landed in a snowstorm on the Eastern Front and was cared for by a nomadic Tartar tribe. From that point, certain materials including felt and fat, in which Beuys claims to have been wrapped and kept alive by the Tartars, and the sled on which he says they transported him, became invested with a symbolism of basic life forces. It appears that, from adolescence, Beuys was drawn to a critique of what he regarded as the superficiality of modern scientific means–end rationalism. This conjoined with an interest in Nordic myth and the anthroposophy of Rudolf Steiner to produce a deeply anti-materialist philosophy, in which the persona of the artist took on shaman-like attributes intended to lead people out of the errors of their modern, consumption-driven materialistic lifestyles.

During the 1950s, Beuys produced relatively conventional 'primitivist-expressionistic' drawings and sculptures that were undergirded by this personal mythology. It focused on the spiritual properties he invested in certain animals: in particular the hare, understood as a figure of movement, herd animals, such as the moose and the sheep, and bees. Beuys seems to have undergone some kind of crisis or breakdown in 1956–7, from which he emerged with a strengthened belief in the emancipatory role of the artist. He commented:

> In 1958 and 1959 I had finished all the literature which was available to me in the scientific field. At that point a new understanding of knowledge became clear to me. Through consideration and analysis, I came to the knowledge that the concepts of art and science in the development of thought in the western world were diametrically opposed, and that on the basis of these facts a solution to this polarisation in conceptions must be sought, and that expanded views must be formed … which means that everything, both human and scientific, stems from art. In this totally primary concept of art, everything is brought together.[58]

In 1961, Beuys was appointed Professor of Sculpture at the Staatliche Kunstakademie, Dusseldorf, a position in which, from 1962, he came into contact with key Fluxus figures such as Paik and Maciunas. From this point on, the various objects Beuys produced began to take on the role of props for increasingly elaborate performances. His first performance in a Fluxus event was the *Siberian Symphony*, in 1963. It seems, however, that the combination of violence, ritual and individualism attendant on Beuys's action marked a distinction from the 'event score' methods of Fluxus, which tended towards anonymity and more collective performance. One of Beuys's performances, *Eurasia*, from 1966, has been described in some detail by the critic and curator Troels Andersen. Beuys, kneeling down, pushed two small crosses that were lying on the floor towards a blackboard. On each cross

was a stopwatch. On the board he drew a cross, which he then half erased, and underneath wrote the word 'Eurasia'. Andersen continues:

> The rest of the piece consisted of Beuys slowly manoeuvring, along a previously drawn line, a dead hare, whose legs and ears were extended by long, thin, black wooden sticks. When he held the hare on his shoulders, the sticks touched the ground. Beuys went from the wall to the board where he laid the hare down. On the way back, three things happened: he scattered white powder between the legs of the hare, put a thermometer in its mouth, and blew through a tube. Then he turned to the blackboard with the half cross on it and made the hare's ears quiver while his own foot, to which an iron sole was tightly bound, hovered over another sole on the floor. From time to time he stamped on this sole.[59]

According to Andersen, these symbols have particular meanings: the division of the cross is the split between East and West, the half-cross signifies the union of Europe and Asia, the hare is journeying to that state of union, and the journey is hard, symbolised by the iron on the ground. These kinds of performance, and the enigma that accrued to their various props, such as sledges, shepherds' crooks, the artist's clothes and walking stick, conferred on Beuys over the next few years an extraordinary status at the centre of the avant-garde. The whole was dedicated to the conception of an expanded sense of art, and the belief that anyone was capable of being an artist: that is to say, a kind of radical democracy that became increasingly inflected by Green politics. Beuys went on to declare the need for a 'Fifth International' organised on these principles, to replace the supposedly obsolete, and materialistic, communist and Trotskyist Third and Fourth Internationals.

However, as a minority of critics have pointed out, these supposedly egalitarian principles and the meaningfulness of the activities in which they are anchored depend entirely on the stipulative definitions accorded to them by the artist himself. Erased crosses do not 'mean' the union of East and West, any more than dead hares are valid symbols of nomadic freedom from modern materialism. One of the key features of the contemporary social order has been, precisely, the loss of a common symbolic repertoire of the kind more organic cultures collectively invest in religion. Only the mass media comes close to providing a substitute – and that is a far cry from Beuys's intentions for his art. The danger perceived by hostile critics is that the artist thus conceived becomes an authority figure quite at odds with the liberation he preaches: a figure whose authority depends, moreover, not on reasoned argument, but on the most atavistic and irrational functioning of charisma and mystery (and that in turn is rooted in uncorroborated claims about Beuys's experiences during the Second World War). Given the history of German culture and politics in the twentieth century, the echo of such a stance, and its powerful potential for reaction rather than liberation, scarcely need spelling out.[60] Perhaps one point to remember here is that Beuys remained an artist. Despite his own magnified sense of the artist's social importance, contemporary western society has accorded significance to art largely as a cultural luxury, and not as a world-transforming crusade. Beuys may have blurred the boundaries, but in the end he was an artist and not a politician or a shaman. Whether one finds his activity inspirational or frightening, one is still responding to a form of representation rather than to actions with direct consequences in the world.

As long ago as the 1960s, one of the leading figures of Fluxus, Dick Higgins, offered the following as a defence of the expanded range of art activity. He wrote:

> Art is one of the ways that people communicate. It is difficult for me to imagine any serious person attacking any means of communication per se. Our real enemies are the ones who send us to die in pointless wars or to live lives which are reduced to drudgery, not the people who use other means of communication from those which we find most appropriate to the present situation.[61]

Higgins termed these 'means' 'intermedia', in implicit if not explicit contrast to the modernist stress on medium-specificity. Once again the starting point is a perception that the world has changed and that art practice has to change in order adequately to represent the experience of the changed world.

Many of these radical connotations were implicit in the name 'Fluxus' itself. Clive Phillpot has argued that Maciunas emphasised three principal senses of the word 'flux' that were fundamental to his idea.[62] He then incorporated dictionary definitions of them, collage fashion, into the *Fluxus Manifesto* of 1963 (Plate 9.28).

The three senses are those of a purging, a tide and a fusion. The first has a negative aspect and spells out what Fluxus is against: 'Purge the world of bourgeois sickness, "intellectual", professional and commercialized culture. PURGE the world of dead art, imitation, artificial art, abstract art', and concludes 'PURGE THE WORLD OF "EUROPANISM"'. There is some doubt as to whether this last is a neologism or a spelling mistake, but either way, the meaning is clear. Maciunas derived this critique of 'serious culture' from his Fluxus colleague Henry Flynt, who had been employing tactics adapted from the Civil Rights Movement: for example, picketing the Museum of Modern Art, or the Metropolitan Museum, which was then displaying the *Mona Lisa* on loan from the Louvre, with placards reading 'Demolish Serious Culture! Destroy Art! Demolish Art Museums!' As Maciunas put it in a letter of 1962, Europe was 'the area which strongly supports the idea of artistic professionalism, the *"l'art pour l'art"* ideology, the expression of the artist's ego through art etc etc', and was, moreover, 'the area which brought forth these ideas'.[63]

The other two senses of the word are angled more positively, to suggest what Fluxus aims at, in contrast to what is to be opposed. The first states: 'PROMOTE A REVOLUTIONARY FLOOD AND TIDE IN ART. Promote living art, anti-art, promote NON ART REALITY to be grasped by all peoples, not only critics, dilettantes and professionals.' In a further letter of 1964, Maciunas amplifies this point: 'Fluxus opposes serious art or culture and its institutions, as well as Europeanism. It is also opposed to artistic professionalism and art as a commercial object or means to a personal income.'[64] This, then, amounts to another variant on the ethos found in Cage and many other avant-gardists, to overcome a sense of art as something separate and specialised, and to intervene more directly in social life. The difference is that whereas in Cage's hands, it takes the form of a Zen-inspired 'active-passivity', Maciunas plugs Fluxus into a militant and explicitly political tradition.

Manifesto:

2. To affect, or bring to a certain state, by subjecting to, or treating with, a flux. "*Fluxed* into another world." *South.*
3. *Med.* To cause a discharge from, as in purging.

flux (flŭks), *n.* [OF., fr. L. *fluxus*, fr. *fluere*, *fluxum*, to flow. See FLUENT; cf. FLUSH, *n.* (of cards).] **1.** *Med.* **a** A flowing or fluid discharge from the bowels or other part: esp., an excessive and morbid discharge: as, the bloody *flux*, or dysentery. **b** The matter thus discharged.

<u>Purge</u> the world of bourgeois sickness, "intellectual", professional & commercialized culture, PURGE the world of dead art, imitation, artificial art, abstract art, illusionistic art, mathematical art, — PURGE THE WORLD OF "EUROPANISM"!

2. Act of flowing: a continuous moving on or passing by, as of a flowing stream; a continuing succession of changes.
3. A stream; copious flow; flood; outflow.
4. The setting in of the tide toward the shore. Cf. REFLUX.
5. State of being liquid through heat; fusion. *Rare.*

PROMOTE A REVOLUTIONARY FLOOD AND TIDE IN ART, Promote living art, anti-art, promote NON ART REALITY to be fully grasped by all peoples, not only critics, dilettantes and professionals.

7. *Chem. & Metal.* **a** Any substance or mixture used to promote fusion, esp. the fusion of metals or minerals. Common metallurgical fluxes are silica and silicates (acidic), lime and limestone (basic), and fluorite (neutral). **b** Any substance applied to surfaces to be joined by soldering or welding, just prior to or during the operation, to clean and free them from oxide, thus promoting their union, as rosin.

<u>FUSE</u> the cadres of cultural, social & political revolutionaries into united front & action.

PLATE **9.28** George Maciunas, *Fluxus Manifesto*, 1963, offset on paper 20 × 15 cm. (Gilbert and Lila Silverman Fluxus Collection, Detroit.)

His third point is in some ways the most telling: 'FUSE the cadres of cultural, social & political revolutionaries into united front & action.' It is telling, of course, because since the Russian Revolution that fusion is precisely what no one had been able to achieve. In the interwar period, the Surrealists were expelled from the official French Communist Party, and became involved with Trotsky's attempt to keep alive a Left opposition to Stalinism, cultural as well as political. After the Second World War, Trotskyism was reduced to relatively small sects, and the official communist movement atrophied; indeed, in cultural and artistic terms it stood for the most blatant conservatism. Maciunas, in the letter just cited, explicitly invoked the legacy of LEF, the revolutionary 'Left Front of the Arts' organised by Vladimir Mayakovsky and others in the early USSR. But LEF had failed, even in the post-revolutionary situation of the 1920s.

This whole question of the political orientation of Fluxus is difficult. It may be argued, for example, that to assert the desirability of such a revolutionary fusion in the conditions of the early 1960s was little more than wishful thinking. For some it was not even that. In fact, these revolutionary sentiments, as well as plans for socially disruptive 'performances' in New York, brought about serious disagreement within the Fluxus ranks. For some, including Brecht and Higgins, such actions were irresponsible, and an explicit attempt to align Fluxus with left-wing politics was mistaken.

Indeed, Huyssen has argued that Fluxus as a whole 'did not place itself in the tradition of political avant-gardism of the 1920s'; looking the other way, to assert a 'direct' link between Fluxus and the politics of the later 1960s 'would be to falsify the historical record'.[65] That said, in the early years of Fluxus, when Maciunas wrote his manifesto, things *were* moving. A 'New Left' was emerging, and within a few years 1968 would witness the biggest radical upsurge in western societies since the Second World War. The Situationists would play an active role in precipitating the student actions of 1968, and the film-maker Jean-Luc Godard would in his turn invoke the legacy of the Soviet avant-garde with his 'Dziga Vertov Group'. Maciunas's invocation of LEF, then, is double edged – a kind of testimony to what was not happening, yet an anticipation of what shortly would. It is for this kind of reason that Huyssen argues Fluxus was 'a threshold or boundary phenomenon', placed between the 'classic' avant-gardes and postmodernism: a threshold 'marked by the tension between the European, critical, negating side of Fluxus, best embodied in George Maciunas himself and his arch-rival in West Germany Wolf Vostell, and the affirming, expanding, though by no means uncritical aspects transmitted to Fluxus primarily through Cage and the emerging American avant-garde scene'.[66]

Perhaps the main point at issue here concerns the nature of '1968'. After all the dust had settled, the sphere of politics remained much the same: international capitalism survived and even extended its grip. But culture in the broadest sense – lived social and sexual relations between people – was transformed. Fluxus seems in retrospect to be a harbinger of that transformation. Both as an antecedent of the 'postmodern condition', and as a series of critical interventions in its own cultural-historical situation, Fluxus has a resonance out of all proportion to the actual, often slight, artefacts and documents it left behind.

Notes

1 See Part 4 of *Art of the Avant-Gardes*.

2 Greenberg's late writings make frequent reference to 'novelty' or 'far-out' art. See, for example, 'Avant-Garde Attitudes: New Art in the Sixties' (1968), in O'Brian, *Clement Greenberg*, vol.4, pp.292–303. For the concept of the 'neo-avant-garde', see, among others, Foster, 'Who's Afraid of the Neo-Avant-Garde' and Buchloh, *Neo-Avant-Garde and Culture Industry*.

3 The negative evaluations of 'academic', 'literary' and 'provincial' pervade modernist criticism. To state the case baldly, 'academic' points to conventional pictorial space; 'literary' signifies the presence of narrative elements, that is to say, a compromise in the 'autonomy' of the work of art; 'provincial' indicates work that emerged outside the centres of the 'modernist mainstream', principally Paris and, later, New York.

4 Debord, 'Preliminaries Towards Defining a Unitary Revolutionary Program' (1960), in Harrison and Wood, *Art in Theory 1900–2000*, VIA3, p.706.

5 Rosenberg, 'The American Action Painters' (1952), in *ibid.*, VA16, p.589.

6 *Ibid.*, p.590.

7 Quoted in Tomkins, *Ahead of the Game* (original American title, *The Bride and the Bachelors*), p.198.

8 Quoted in Harrison and Orton, 'Jasper Johns', p.92.

9 See Chapter 8 in *Art of the Avant-Gardes*.

10 Quoted in Russell and Gablik, *Pop Art Redefined*, p.54.

11 Quoted in Joan Young and Susan Davidson, 'Chronology' (1997/8), in Hopps and Davidson, *Robert Rauschenberg*, p.553.

12 See *Frameworks for Modern Art*, Chapter 2.

13 Quoted in Kotz, *Rauschenberg/Art and Life*, pp.89, 76.

14 Quoted in *ibid.*, p.89.

15 Quoted in *ibid.*, p.76.

16 Quoted in Russell and Gablik, *Pop Art Redefined*, p.23.

17 Cage, 'On Robert Rauschenberg, Artist, and his Work' (1961), in Harrison and Wood, *Art in Theory 1900–2000*, VIA13, p.735.

18 A prepared piano is a paino modification, devised by Cage in 1940, in which a variety of objects are inserted between the strings, changing both timbre and pitch, to create a one-person percussion ensemble.

19 Tomkins, *Ahead of the Game*, pp.113–14.

20 Steinberg, 'from *Other Criteria*' (1968–72), in Harrison and Wood, *Art in Theory 1900–2000*, VIID7, p.976.

21 *Ibid.*, p.973.

22 Rauschenberg, 'Note on Painting' (1963), in Russell and Gablik, *Pop Art Redefined*, p.101.

23 Quoted in Cage, 'On Robert Rauschenberg, Artist, and his Work' (1961), in Harrison and Wood, *Art in Theory 1900–2000*, VIA13, p.736.

24 Quoted in Kotz, *Rauschenberg/Art and Life*, p.99.

25 Hamilton, 'For the Finest Art, Try Pop' (1961), in Harrison and Wood, *Art in Theory 1900–2000*, VIA15, p.743.

26 See *Frameworks for Modern Art*, Chapter 2.

27 Greenberg, 'Avant-Garde and Kitsch' (1939), in Harrison and Wood, *Art in Theory 1900–2000*, IVD11, pp.539–49.

28 Alloway, 'The Arts and the Mass Media' (1958), in *ibid.*, VIA6, pp.715, 717.

29 Forma I, 'Manifesto' (1947), reprinted in Celant, *The Italian Metamorphosis*, pp.708–11.

30 Fontana, 'The White Manifesto' (1946), in Harrison and Wood, *Art in Theory 1900–2000*, VC8, p.653.

31 *Ibid.*, p.654.

32 *Ibid.*, p.653.

33 Manzoni, 'Free Dimension' (1960), in Harrison and Wood, *Art in Theory 1900–2000*, VIA8, p.723.

34 *Ibid.*, p.724.

35 *Ibid.*

36 Quoted in Stich, *Yves Klein*, p.132.

37 Quoted in a leaflet, *Yves Klein: Leap into The Void*, accompanying the exhibition at the Hayward Gallery, London, 1995.

38 Quoted in Stich, *Yves Klein*, p.133.

39 Discussed in Chapters 6 and 7.

40 Klein, 'The Evolution of Art towards the Immaterial' (1959), in Harrison and Wood, *Art in Theory 1900–2000*, VIIA1, p.818.

41 Yoshihara, 'Gutai Manifesto' (1956), in *ibid.*, VIA2, p.700.

42 Huyssen, 'Back to the Future: Fluxus in Context' (1993), in Armstrong and Rothfuss, *In the Spirit of Fluxus*, pp.141–51; quote p.148.

43 *Ibid.*

44 Kaprow, 'from *Assemblages, Environments and Happenings*' (1959–65), in Harrison and Wood, *Art in Theory 1900–2000*, VIA7, pp.717–18.

45 Higgins, 'A Child's History of Fluxus' (1979), in Armstrong and Rothfuss, *In the Spirit of Fluxus*, front jacket flap through half-title page.

46 Kaprow, 'The Legacy of Jackson Pollock', p.56.

47 *Ibid.*

48 *Ibid.*

49 Quoted in Goldberg, *Performance Art*, p.130.

50 Oldenburg, *Claes Oldenburg*, p.42.

51 Oldenburg, 'from *Documents from The Store*' (1961), in Harrison and Wood, *Art in Theory 1900–2000*, VIA16, p.744.

52 *Ibid.*

53 Oldenburg, 'The Store Described and Budget for The Store' (1961), in *Claes Oldenburg*, p.104.

54 Oldenburg, 'from *Documents from The Store*' (1961), in Harrison and Wood, *Art in Theory 1900–2000*, VIA16, p.744.

55 See Kristine Stiles, 'Between Water and Stone: Fluxus performance', in Armstrong and Rothfuss, *In the Spirit of Fluxus*, pp.62–99.

56 Fluxus poster (1962), cited in Owen F. Smith, 'Fluxus: A Brief History and Other Fictions' (1993), in *ibid.*, p.26, and reproduced in the original German, p.146.

57 *Ibid.*, p.14.

58 Quoted in Adriani, Konnertz and Thomas, *Joseph Beuys*, pp.65–6.

59 Quoted in Schimmel, 'Leap into the Void, p.83.

60 See Buchloh, 'Beuys: The Twilight of the Idol', *Artforum*, January 1980, pp.35–43, reprinted in Buchloh, *Neo-Avant-Garde and Culture Industry*, pp.41–64.

61 Higgins, 'Statement on Intermedia' (1966), in Armstrong and Rothfuss, *In the Spirit of Fluxus*, pp.172–3.

62 Phillpot, 'Fluxus: Magazines, Manifestos, *Multum in Parvo*' (1988), in Phillpot and Hendricks, *Fluxus*, p.10.

63 Maciunas, letter to Thomas Schmit, January 1962, reprinted in Adriani, Konnertz and Thomas, *Joseph Beuys*, p.83.

64 Letter to Wolf Vostell, 3 November 1964, reprinted in *ibid.*, p.85.

65 Huyssen, 'Back to the Future: Fluxus in Context' (1993), in Armstrong and Rothfuss, *In the Spirit of Fluxus*, p.143.

66 *Ibid.*, p.149.

References

Adriani, G., Konnertz, W. and Thomas, K., *Joseph Beuys: Life and Works*, trans. P. Lech, Woodbury, NY: Barron's Educational Series, 1979.

Armstrong, E. and Rothfuss, J., *In the Spirit of Fluxus*, exhibition catalogue, Walker Arts Center, Minneapolis, 1993.

Buchloh, B.H.D., *Neo-Avant-Garde and Culture Industry: Essays on European and American Art from 1955 to 1975*, Cambridge MA: MIT Press, 2000.

Celant, G., *The Italian Metamorphosis 1943–1968*, exhibition catalogue, Guggenheim Museum, New York, 1994.

Edwards, S. and Wood, P. (eds), *Art of the Avant-Gardes*, New Haven and London: Yale University Press in association with The Open University, 2004.

Foster, H., 'Who's Afraid of the Neo-Avant-Garde', in *The Return of the Real: The Avant-Garde at the End of the Century*, Cambridge, MA: MIT Press, 1996, pp.1–32.

Gaiger, J. (ed.), *Frameworks for Modern Art*, New Haven and London: Yale University Press in association with The Open University, 2003.

Goldberg, R., *Performance Art: From Futurism to the Present*, London, Thames & Hudson, 1988.

Harrison, C. and Orton, F., 'Jasper Johns: Meaning What You See', *Art History*, vol.7, no.1, March 1984, pp.76–101.

Harrison, C. and Wood, P. (eds), *Art in Theory 1900–2000: An Anthology of Changing Ideas*, Malden, MA and Oxford: Blackwell, 2003.

Hopps, W. and Davidson, S., *Robert Rauschenberg: A Retrospective*, exhibition catalogue, Solomon R. Guggenheim Foundation, New York, 1997, 1998.

Kaprow, A., 'The Legacy of Jackson Pollock', *Art News*, vol.57, no.6, October 1958, p.56.

Kaprow, A., *Assemblages, Environments and Happenings*, New York: Harry N. Abrams, 1966.

Kotz, M.L., *Rauschenberg/Art and Life*, New York: Harry N. Abrams, 1990.

O'Brian, J. (ed.), *Clement Greenberg: The Collected Essays and Criticism*, vol.4: *Modernism with a Vengeance 1957–1969*, Chicago: University of Chicago Press, 1993.

Oldenburg, C., *Claes Oldenburg: An Anthology*, exhibition catalogue, Guggenheim Museum, New York, 1995.

Phillpot, C. and Hendricks, J., *Fluxus: Selections from the Gilbert and Lila Silverman Collection*, exhibition catalogue, Museum of Modern Art, New York, 1988.

Russell, J. and Gablik, S., *Pop Art Redefined*, London: Thames & Hudson, 1969.

Schimmel, P., 'Leap into the Void: Performance and the Object', in *Out of Actions: Between Performance and the Object 1949–1979*, London: Thames & Hudson, 1998, pp.17–119.

Stich, S., *Yves Klein*, exhibition catalogue, Hayward Gallery, London, 1995.

Tomkins, C., *Ahead of the Game: Four Versions of Avant-Garde*, Harmondsworth: Penguin, 1965 (first published as *The Bride and the Bachelors*, 1962).

CHAPTER 10

How New York queered the idea of modern art

Gavin Butt

Avant-garde and queer

This chapter focuses on avant-garde art production in 1950s and early 1960s New York and asks to what degree its forms and representational strategies might be understood in the context of postwar lesbian and gay subcultures. I borrow my title from Serge Guilbaut's book *How New York Stole the Idea of Modern Art* (1983), which provided a historical appraisal of the rise to prominence of New York as a centre for the production of modern art in the immediate postwar decades. But rather than focus, as Guilbaut does, on the ideological meanings imputed to the work of the first generation of postwar artists – in particular the 'American-ness' of Abstract Expressionist painting – this chapter considers instead how *second*-generation New York art production might be understood in terms of a 'queering' of the cultures of the avant-garde: in particular by the practices of so-called 'neo-Dada' and Pop Art.

Focusing mainly, though not exclusively, on the work of selected artists of this generation who can be identified as lesbian, gay or bisexual, I will explore the thesis that New York art, from the early 1950s to the early 1960s, can be seen to be marked by what we might call a 'homosexualisation' of its forms: from the 'silent' aesthetics of the neo-Dadaists to the 'campiness' of Pop Art. I will analyse how avant-garde work at this time was involved in the complex processes of representing a homosexual identity – well in advance of the birth of the modern Gay Rights Movement inaugurated by the 1969 Stonewall riots in New York. To do this I will be drawing on recent lesbian and gay studies within art history that have striven to address the prominent role that homosexual artists played in the development of postwar American art. I will also be concerned to look at how the meanings that we might attribute to works of art by artists presumed to be straight, and by those identified as lesbian and gay, can be transformed by the ways in which gay identity and culture come to be embraced more broadly within, or even *as*, avant-garde culture – and how this alerts us to the complex ways in which sexual identity is articulated within visual arts practice in this period.

I have decided to use the term 'queer' to signal the manner in which the various cultural forms of New York avant-gardism might be taken to articulate a sexuality at variance with, or subversive of, dominant forms of sexual and gender identity. I am interested in how pre-existing strategies and tropes of avant-garde production, especially as they can be seen to be bound up with the reproduction of normative sexual and gender identities, become undone – become 'queered' – within the production of avant-garde art at this time.

PLATE 10.1 (facing page) Agnes Martin, detail of *Leaf* (Plate 10.6).

In part, as I shall argue, this 'queering' is undertaken by lesbian and gay artists – such as Agnes Martin, Jasper Johns and Andy Warhol – as they find ways to work as artists in the highly homophobic cultural contexts of the Cold War. Equally, however, I want to look at how avant-garde production was queered by 'straight' artists such as Larry Rivers, and indeed how the very construction of heterosexuality became 'queered' through the development of his painterly aesthetic.

In using 'queer' in this way, I follow other activists and theorists of the 1990s who appropriated the term from its history as a homophobic designation in order to 'reclaim' it as a defiant way of self-naming. This is how lesbian, gay, bisexual, transgender and transsexual activists have used the term to signal their refusal of the 'normalising' imperatives of straight culture, and to effect instead a questioning of the 'natural' right and privilege of heterosexual genders. What I am suggesting in this chapter, by projecting a contemporary understanding of 'queer' back onto the art of the 1950s and 1960s, is that we might usefully be able to see how gay and lesbian artists – as well as some straight artists – could be taken as resisting normative sexual values through their artistic practice. In some cases, perhaps in that of Warhol for example, we may even have an artist whose painterly celebration of queer pleasure, and the self-performance of his artistic identity, presage the 'in-your-face' and highly theatrical political expressions that we more readily associate with queer activism in the 1990s. That straights might lay claim to 'queer' is still a moot point in current queer theory, but I shall be prepared to entertain it here. I will choose to embrace an idea of queer expression as any discourse or strategy that 'enables not only gay men, but also heterosexual and lesbian women, and perhaps heterosexual men, to express their discomfort with, and alienation from, the normative sex and gender roles assigned to them by straight culture'.[1]

Although I spend much time in this chapter accrediting such a queering to certain artists and practices, I will have some time towards the end to turn to the idea of queer *readings*, and to reflect a little on how a work of art may effectively be 'queered' by some non-normative form of interpretation or consumption. This will not only give me cause to reflect on the role of the art historian and the art critic in queering works of art by looking 'queerly' at them (as I do here), but also to highlight the ways in which the art of the second-generation avant-garde might be understood as a practice of queer reading itself, in its reading and re-reading of the normative heterosexual values embedded within the practices of American avant-gardism.

The post-Abstract Expressionist avant-garde: social and sexual contexts

To begin with, we should note the shift in the sexual persuasions of second-generation artists from those of the Abstract Expressionists who went before them, and how this inaugurated, in turn, a gradual transformation of the masculinist, heterosexual values of avant-garde culture.

In writing about the artists who gravitated around the gay composer John Cage, the art historian Moira Roth has noted, 'the machismo attitudes proudly

displayed by the Abstract Expressionists were now countered by the homosexuality and bisexuality permissible and even common among the new aesthetic group'.[2] This group comprised a relatively private association of men including, in addition to Cage, the dancer Merce Cunningham, and the so-called 'neo-Dada' visual artists Jasper Johns and Robert Rauschenberg. This group was 'private' because its members rarely associated publicly with the Abstract Expressionist artists at their favoured social haunts, such as the Cedar Bar Tavern, the scene of drunken brawls that came to form part of the mythology of the 'authentic' masculinity of the 1950s artist. Set apart from this social scene, the group's sexual identity was also legible in its artistic preferences, which, as Roth notes, were for Marcel Duchamp rather than Pablo Picasso. Whereas the Abstract Expressionists tended to look to Picasso as their chief artistic progenitor, Duchamp appeared to offer to Cage's circle a less chauvinistic, perhaps even 'queer', role model, especially given the creation of Duchamp's drag alter ego, Rrose Sélavy, as part of the performance of his avant-garde masculinity (Plate 10.2).

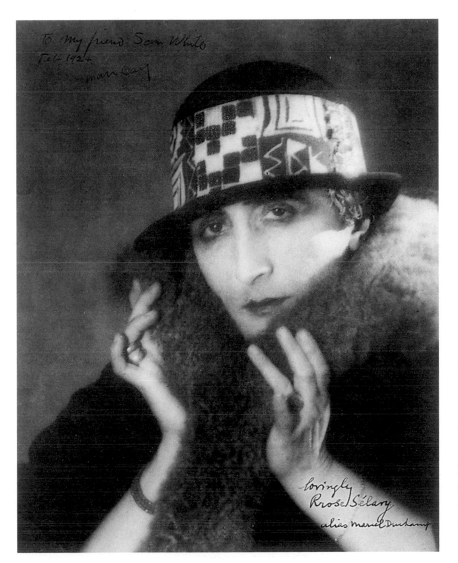

PLATE 10.2
Man Ray, Marcel Duchamp dressed as Rrose Sélavy, 1921, gelatin silver print, 22 × 17 cm. (Philadelphia Museum of Art: The Samuel S. White III, and Vera White Collection. © Man Ray Trust/ ADAGP, Paris and DACS, London 2004.)

But, in highlighting the homo- and bisexuality of the post-Abstract Expressionist avant-garde, Roth could equally have been writing about another grouping, which formed around Frank O'Hara, the charismatic central figure of the so-called New York School of poets. O'Hara, unlike the practitioners associated with Cage, did socialise with, and was even respected by, the Abstract Expressionists. Indeed, in his position as a curator of painting at the Museum of Modern Art in New York, and as an art critic, he worked to celebrate their achievements. And yet, along with his (gay) compatriots, such as the poet John Ashbery, and the 'straight' artist Larry Rivers, O'Hara worked to queer the modes of artistic utterance, by embracing the 'trivial' discourses of gossip and camp talk within avant-garde literary and aesthetic practice. In this way, O'Hara and Rivers – as we shall see later – sought to undermine the 'high' seriousness of much Abstract Expressionist work and – in celebrating the pleasures of everyday, stereotypically feminised and homosexualised forms of discourse – paved the way for what we might understand as Pop Art's 'camp' appreciation of mass culture.

The prevalence of gay men within these artistic groupings did not go unnoticed within 1950s culture, and was often the subject of art-world gossip and rumour. Indeed, in the wake of the McCarthy trials, it had become almost conventional homophobic wisdom to assume that a high number of gay men were 'at large' in the arts. Writing in the magazine *Esquire* in 1965, in an article promising to unveil a New York art world 'full of money, gossip, and anxiety', the critic Harold Rosenberg remarked on a relatively new phenomenon in the art establishment: 'Groupings based on sex', which comprised the 'banding together of homosexual painters and their non-painting auxiliaries in music, writing and museum work'.[3] Undoubtedly, Rosenberg was referring to the social, artistic and sexual relationships between artists Johns, Rauschenberg and Rivers, and their 'non-painting auxiliaries' Cage, Cunningham, O'Hara and the gallerist John Bernard Myers. This recognition of such 'groupings' signals something very important: namely, that in coming together primarily as *sexual* groupings in the face of a hostile art world and a homophobic society at large (in the 1950s homosexuality was still widely regarded in the USA as illness, criminality and sin), such gay practitioners were encouraged to work beyond the boundaries of any narrowly delimited idea of one's 'proper' discipline, whether as painter, poet or musician. The social and sexual basis of such 'inter-media' work should be understood as a crucial determinant for the emergence of the expanded field of postmodernist art practice that would later come to include happenings, performance and installation art.

This prevalence of gay artists in New York bohemia in general, and Greenwich Village in particular, should not mislead us into thinking that it was some kind of gay haven. On the contrary, for many artists – such as Johns and Rauschenberg – it was important to remain 'in the closet' about their homosexuality, while for others – such as Warhol – who found it more difficult to hide their sexual identity, homophobic responses to their homosexuality were effectively to prevent them from being accepted into the bohemian art world, despite their numerous attempts to 'make it' as artists in the 1950s. As the left-wing film maker Emile de Antonio puts it, Warhol was just 'too swish', too effete and *obviously* gay to be accepted into the world of avant-

PLATE 10.3 Andy Warhol in the Silver Factory, New York, 1965. (Photo: Jon Naar, © 1965, 2004.)

garde art at this time (Plate 10.3).[4] 'Too swish', that is, not only for the macho Abstract Expressionists, but also for closeted artists like Johns and Rauschenberg, whose success depended, at least in part, on them remaining silent about their homosexuality – and distanced from the dangers of recognition that would have attended any association with an overt homosexual like Warhol.

For lesbian artists, the problem was slightly different. They suffered a similar fate to most straight women artists in the highly masculinised contexts of the 1950s art world: that is, they struggled to be taken seriously by patriarchal institutions of art that were happy to confer critical recognition on the work of male artists. In a fascinating essay, Ann Gibson argues that if a gay male

artist could pass as straight in the 1950s art world, he could enjoy the privileges of being male, while women *as women* – as feminist art history has told us – were both socially and critically marginalised as a matter of course. Ironically, however, this discriminatory masculinist culture also worked to the 'benefit' of some lesbian artists. This is because lesbians were often seen stereotypically as being 'more like men', and this meant that New York bohemia provided a space in which it was possible to be accepted as a lesbian and be taken seriously as an artist – much more so than heterosexual women and effete gay men like Warhol. 'Men in dresses were funny', Gibson writes, 'women in pants were real artists.'[5]

This is borne out by Rivers's comments about the painter Nell Blaine, when he recalls in his 1992 memoir *What Did I Do?* that Blaine's unconventional social and sexual life was, for him as a would-be-artist, iconic of bohemian existence in the late 1940s: 'I thought being a lesbian … was so fantastic it became a lighted gateway into art, the jazz, the parties, the banter that went on in her studio' (Plate 10.4).[6] Blaine was seen by some as the image of the 'proper' artist, while other artists, such as Agnes Martin, found their lesbian sexuality to be of little hindrance in achieving success in the 1950s art world. By 1958, Martin was regularly showing her abstract gridded canvases in the same stable as established Abstract Expressionist artists: the Betty Parsons Gallery. Parsons (herself a lesbian) had been pivotal in establishing the reputation of male Abstract Expressionists, including Barnett Newman and Mark Rothko; in 1958, she took Martin onto her books and promoted her as assiduously as she did the men. Many commentators have seen Martin's artistic success partly as a function of the ways in which, through her seeming acceptance of masculine traits and values, she could readily fit in as 'one of the boys'. John Gruen, for example, in his 1976 profile of Martin, describes her femininity as being 'masked' by her 'heavy work clothes – blue jeans, blue tee shirt, beige zippered jacket and sneakers', as if, perhaps, for Martin, such a masculinisation of the female body was fundamental to the artistic profession (Plate 10.5).[7]

Of course, we should not be fooled into thinking that such an acceptance of a lesbian artist in a homophobic art world meant a wholesale approval and acceptance of lesbian sexuality (on the contrary, as outlined below, Martin's success can be attributed, at least partly, to the silencing – or closeting – of her sexual identity at the time). Nor should we assume that Martin's embrace of the trappings of female masculinity – workwear etc. – should be read as a straightforward ceding to conventional masculinist values. Reading them instead as the signifiers of sexual identity, namely, of the 1950s lesbian butch, we can quickly render complicated the meanings that we might ascribe to her artistic identity, ones that might put her very far indeed from that conventional object of male heterosexual desire in 1950s America: the paradigmatically glamorous figure of Marilyn Monroe.

But if Martin and others played out such non-normative sex/gender identities as artists, how (if at all) did these differences come to mark the making of their art? And how might the homophobic contexts of American culture have affected the nature of *the work* – as well as the lives – of gay and lesbian artists at this time?

PLATE 10.4 Robert Bass, John Ashbery, Nell Blaine, Barbara Epstein (later co-editor, *New York Review of Books*), and, far right, the poet Seymour Krim, in Blaine's studio, Halloween 1949, photograph. (Courtesy of the Estate of Nell Blaine and Tibor de Nagy Gallery, New York.)

PLATE 10.5
Mildred Talbot, Agnes Martin, 1954, photograph. (Harwood Museum of Art, New Mexico. © Mildred Talbot.)

Silence and the closet

As has been noted by numerous art historians, the work of Johns and Rauschenberg departs significantly from the work of their Abstract Expressionist forebears in its eschewal of the protocols of self-expression. As Rosenberg remarked in 1952, the Abstract Expressionist canvas was 'inseparable from the biography of the artist … made up of the same metaphysical substance as the artist's existence'.[8] Such a close association of the meanings of art with the artist's autobiography was anathema to the young neo-Dadaists. According to Rauschenberg, this mode of artistic practice had such an overpowering influence in the early 1950s art world that both he and Johns had to work hard each day just to 'move out' from under it.[9] In order to help them find a way to do this they looked, as I have already suggested, to Duchamp and his playful and conceptual undermining of an expressive art practice – one that avoided 'the stink of artists' egos', as Johns was later to put it.[10] But also important to them were Cage's ideas about 'silence', which played a profound role in the formulation of an anti-expressive visual arts practice in the period, and which I want to spend a little time discussing here.

Cage himself was equally unimpressed with what he took to be the self-aggrandisement at the heart of Abstract Expressionist painting. In responding to Willem de Kooning's avowed desire to be a great artist, Cage comments that 'it was this aspect of wanting to be an artist … who had something to say, who wanted through his work to appear really great … which I could not accept'.[11] This idea of not being an artist 'with something to say', indeed of being one with *nothing* to say, was starkly set out in Cage's 'Lecture on Nothing', which he delivered to members of the Abstract Expressionist circle at the Artists Club in 1949. During this lecture he famously proclaimed the statement that epitomises Cage's aesthetics of silence: 'I have nothing to say / and I am saying it.'[12] This was succinctly to announce Cage's investment in a non-expressive musical practice, one that was not about the communication of ideas or the expression of the composer's feelings, but rather an exploration of the 'silence' left by the stripping away of authorial presence. This was borne out by his most famous composition, *4'33"*, first performed in 1952, which comprises four minutes and thirty-three seconds without any conventional musical composition as such – a piece 'composed' of silence. However, this was no 'simple' silence but rather one that worked to foreground other kinds of ambient *noise* in the auditorium: 'The only body acoustically present in *4'33"* is the body of sound; the withdrawal of the performer's body from action paradoxically authorises our recognition of ambient noise.'[13]

Cage acknowledges that such a recognition of ambient sound was in part derived from first seeing Rauschenberg's white paintings early in 1952 (see Plate 9.3). In looking at these white canvases that are vacated of all the expressive marks typical of Abstract Expressionism, Cage was impressed by the degree to which they were nevertheless animated by the changes of light and shadow that played across their surfaces. He described them as 'airports for lights, shadows and particles'.[14] He suggested that the paintings

were not *without* colour at all, but had their constantly changing 'self-colour' resulting from the chance dappling of differing hues and shades variously brought about by the passage of the painting's spectator(s). This goes right to the heart of the Cagean interest in silence, and to Rauschenberg's attempt at painting 'nothing': if one composes 'silence' or paints 'nothing', one gets *something* in its stead, whether it be the ambient noise from the street or the auditorium, or the shapes and forms of cast and reflected light. In this way, the negation of an expressive act, the erasure of a subjective presence, brings about the creation of something else, something *new*. As Cage said, 'no silence / exists / that is not / pregnant / with / sound'.[15]

But how might such an aesthetics of 'silence' be construed within the context of gay identity in the 1950s? Some commentators have argued that it can only be properly understood by taking into account the composer's troubled relationship with his homosexuality. The art historian Jonathan Katz, for instance, has argued that Cage moved away from making expressive music in order to free himself from the artistic imperative of placing his (homosexual) self at the centre of his art, which would otherwise have made him visible and vulnerable as a gay man within homophobic society.[16] Cage's composed pieces of silence could therefore be understood as self-imposed forms of closeting behaviour, albeit rather complex ones that drew on his interest in Zen Buddhism. Zen had taught the composer that transcending individual feeling and emotion was a more desirable way of dealing with 'personal' issues than by talking endlessly about them through the confessional or the psychoanalytical talking cure (Cage underwent a brief – and unsuccessful – stint of therapy in the mid-1940s in an attempt to come to terms with his sexuality). This Zen-like approach, directed into an art of detachment, allowed Cage to make an aesthetic virtue of the queer survival strategies that necessarily fed into, and shaped, his work.

Something similar was perhaps true of Martin, who, though not strictly speaking part of the Cagean circle at this time, can be seen to perform a comparable closeting manoeuvre in her paintings of the late 1950s and early 1960s. Martin also took silence to be an important part of her aesthetic enterprise. She too was interested in Oriental thought – including Taoism as well as Zen Buddhism. She was also interested in 'experience that is wordless and silent', and in expressing this experience 'in art work which is also wordless and silent'.[17] Such an interest set her apart from artists who were keen to make themselves the autobiographical subject of their art and instead led her to make an art of apparent self-negation. Her canvases, such as *Leaf* of 1965 (Plate 10.6), are made up, one might almost say, of 'nothing', save for a delicately pencil-lined grid formation, which is more or less visible depending on the spectator's proximity to, or distance from, the painting's surface (Plate 10.1). As Anna C. Chave has argued, such paintings might readily be understood as forms of self-erasure: 'So suppressed or subtle were the traces of Martin's hand that there was a sense almost, as one critic put it, that "the painter has disappeared".'[18] In contrast to the 'presence' of the artist's body announced by the vivid gestural marks of an Abstract Expressionist canvas, Martin's paintings can be seen instead to register the withdrawal of her (lesbian) body from the field of meanings that one might ascribe to her work.

PLATE 10.6 Agnes Martin, *Leaf*, 1965, acrylic and graphite on canvas, 183 × 183 cm. (Collection of the Modern Art Museum of Fort Worth. Museum purchase, Sid W. Richardson Foundation Endowment Fund. © Agnes Martin.)

But is it enough to say that such forms of 'silencing' – whether in music or in painting – result in a simple *negation* of their gay creators? Like both Cage and Martin, Johns voiced a desire to make an art that was, in some significant manner, not *of* himself:

> I didn't want my work to be an exposure of my feelings. Abstract Expressionism was so lively – personal identity and painting were more or less the same, and I tried to operate the same way. But I found I couldn't do anything that would be identical with my feelings. So I worked in such a way that I could say that it's not me.[19]

If Johns did not want his work to be 'an exposure of my feelings', then we might readily imagine how such a reluctance could be understood as that of a

gay man unwilling (or afraid) to have those feelings made publicly available for possible ridicule in the homophobic, masculinist contexts of the 1950s art world. Johns was in a sexual relationship with Rauschenberg from the mid-1950s until the early 1960s, but has been generally loathe to talk publicly about such 'private' affairs, even to this day – possibly marking how his relationship to his sexuality was construed within the homophobic contexts of 1950s culture. But is this eschewal of the quasi-confessional practice of action painting – this refusal to express his feelings, to work in a way that was 'not me' – a form of artistic 'closeting' of his homosexuality? Does Johns choose to work in a Cagean manner – to 'silence' his gay self – in order simply to remove homosexuality from the range of possible meanings that might be attached to his art, to hide it away from prying eyes and inveterate gossip-mongers?

To try to answer this question I want to look at Johns's *Target with Plaster Casts*, made in 1955 (Plate 10.7). In this painting, Johns works with the 'impersonal' design of the target, just as he had worked with flags (Plate 10.8), numbers and letters in other paintings from the same period. Johns deploys such icons as 'readymades' that defer any easy communication of personal meaning. Across the upper edge of the painted target is a row of wooden compartments, most of which house painted plaster casts of fragments of a human body: part of a foot, part of a face, a hand, a breast, an ear, a penis and a heel. These can be seen as elements that, in contrast to the target, might normally give rise to an affective response in the viewer and indeed have been commented on as morbid and sinister. Taken together, however – target *with* casts – the painting has been read by art historians as a typical 'Johnsian' composition, in so far as it plays off the impersonal 'cool' of the target against the emotional 'hot' of the 'dismembered' body parts. It is typically Johnsian because, in doing so, it attempts to present an affective subject – human fragments – as no more meaningful than a target, or indeed than the collaged newspaper clippings also lodged within the painting's surface.

In this way, we might argue, Johns performs a 'silencing' of the habitual meanings and responses that might attend the human body as a subject of art. But, as with Cage and Rauschenberg, this silencing does not 'mute' the work, or cancel out the work's 'message' or significance. On the contrary, this silencing has the effect of making the work all the more mysterious – and fosters myriad questions about the work's potential meaning: whose body is represented here? Why are its parts shut away, 'closeted' within their respective wooden compartments? What kind of body is it that could or – with more moral force – *should* be hidden from view? Do the plaster casts represent some kind of secret, offered to us as a discreet peek? If so, what – and whose – secret is it? And how should we read the body parts in relation to the target? Is there some mysterious code to crack in order to let us in on the painting's secret?

These and other questions have been addressed in recent years by art historians concerned to enquire into the queer meanings of Johns's oeuvre. Caroline Jones, for one, argues that in silencing any obvious or expressive meaning, the painting indeed suggests that there *is* some secret, some mystery or surprise that eludes our attempts to apprehend it. Thus, she argues, we might understand Johns's work as presenting a 'closet-in-view' – a work that draws attention to the fact that it is hiding something away. This leads us, in turn, to put a whole new spin on the closet. As Katz has convincingly argued,

PLATE 10.7 Jasper Johns, *Target with Plaster Casts*, 1955, encaustic and collage on canvas with objects, 130 × 112 × 9 cm. (© Jasper Johns/VAGA, New York/DACS, London 2004.)

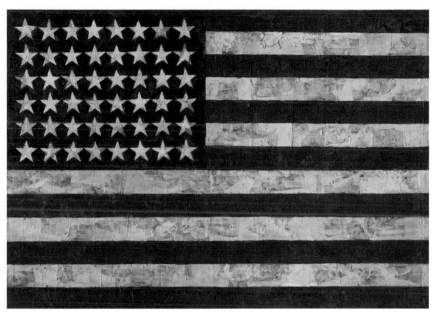

PLATE 10.8 Jasper Johns, *Flag*, 1954–5, encaustic, oil and collage on fabric mounted on plywood (three panels), 107 × 154 cm. (Museum of Modern Art, New York. Gift of Philip Johnson in honour of Alfred H. Barr Jr. DIGITAL IMAGE © 2002 The Museum of Modern Art, New York/Scala, Florence. © Jasper Johns/VAGA, New York/DACS, London 2004.)

if the strategy of closeted homosexual behaviour is normally to escape notice within a hostile homophobic climate, then the closeted silences of the works of Johns, Rauschenberg and Cage fail in so far as they *do not* evade our attention.[20] On the contrary, their silences are *performative*. That is to say, they draw our attention, explicitly, to their very acts of closeting and silencing: 'I have nothing to say / and I am saying it.' It is in this way that some historians have argued for an understanding of Johns's art – and *Target with Plaster Casts* in particular – as representing its gay subject through venturing it *as a significant absence*, by suggesting it as something significantly missing from the work of art and the meanings we might readily draw out from it.

Others have viewed things rather differently and have worked to make the 'silenced' gay self speak, to break the code of Johns's closeted representation, and finally and belatedly to bring the gay meaning of Johns's art 'out' of the closet into the full glare of art-historical recognition. Kenneth Silver, for example, puts together the target and the body fragments (which he reads as masculine) in order to suggest that Johns's painting can be understood as a latter-day, neo-Dada version of that homoerotic staple of western painting: the martyrdom of Saint Sebastian (Plate 10.9). In reading the painting in this way, Silver purports to unveil *Target*'s gay significance – to 'out' it – by drawing our attention to its buried homoerotic iconography (the male body as the target of hostile fire). He thus claims, grandly, that Johns's painting can be understood as the 'first portrait of the homosexual man of the postwar period'.[21] In Silver's hands, Johns's work appears to be less about a queer silence or invisibility – a queerness that cannot quite be represented – and more about a queerness that is available to be *read* once one knows how to crack the codes.

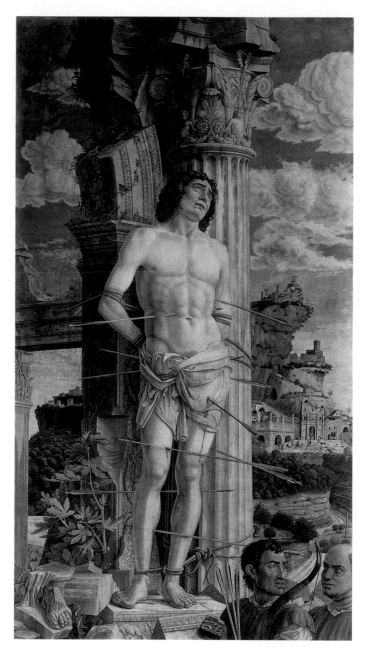

PLATE 10.9
Andrea Mantegna, *Saint Sebastian*,
*c.*1450, oil on panel, 255 × 140 cm.
(Louvre, Paris. Photo: RMN – J.G. Berizzi.)

Whether we choose to read Johns's painting as effecting a significant absenting of homosexual meaning or as a coded gay representation waiting to be deciphered (and there are indeed some significant tensions between these two different readings), there is one thing we can be sure of: Johns's art, that of his close compatriots Rauschenberg and Cage, and that of others such as Martin comprise a very different modality of self-expression from that of the Abstract Expressionists – one that *queers* the ways in which a (homosexual) self might find its expression in art. The self in the work of these artists is one that – perversely and paradoxically – emerges as hardly a self *at all*: it is one that speaks through silence; that appears through disappearing; and that makes its presence felt precisely through the forms of its solicitous and affecting absence.

You cannot be serious! Camp and the art of Larry Rivers

Pop Art also demonstrates an uneasy relationship with the heterosexual values of Abstract Expressionism but, rather than manifesting themselves in a Cagean silence, Pop's queer values tend to reside in its 'camp' approach to seriousness and significant meaning. Camp is often defined as a kind of performance or form of cultural appreciation that is crucially *non-serious* in some way. Or, as Susan Sontag put it in 1964: 'The whole point of camp is to dethrone the serious.'[22] Camp achieves this by theatricalising, and playfully appreciating, any object that comes under its sway: 'Camp sees everything in quotation marks. It's not a lamp, but a "lamp"; not a woman, but a "woman". To perceive camp in objects and persons is to understand Being as Playing a Role. It is the farthest extension … of the metaphor of life as theatre.'[23] It is this playful theatricalisation that I want to pay attention to now in the pre- or proto-Pop painting of Larry Rivers, who is held to be a somewhat transitional figure in art-historical terms — one whose work straddles the gap between Abstract Expressionism and Pop Art 'proper'. As we shall see, however, the fact that Rivers's work fits uneasily within art-historical categories might signal just one aspect of its campness, and the *queer* way in which his art plays with identity labels, including, perhaps above all, sexual ones.[24]

As Rosenberg made clear in 1952, abstract action painting was seen as a very *serious* artistic endeavour: 'the test of any of the new painting is its seriousness — and the test of seriousness is the degree to which the act on the canvas is an extension of the artist's total effort to make over his experience'.[25] But by the early 1950s, for Rivers and other artists such as Warhol, this kind of artistic project was coming to look less like a profound artistic–philosophical endeavour and rather more like a self-important, pumped-up performance of artistic machismo. As Rivers has put it in commenting on the work of Jackson Pollock:

> What I had seen in his work as depth of involvement … (by 1954) seemed narrowed simply to his point of view. My devotion to art and a life of art had taken on a distinctly anti-Pollock tone. What was obviously gorgeous in his work was becoming infused with a mindlessness impossible to separate from his social personality.[26]

Indeed, what Rivers seems to point to here is the degree to which, for a new generation of artists, the high-minded practice of Abstract Expressionism — and its attendant, stridently heterosexual culture — was something that, for a second generation of New York avant-gardists, was increasingly difficult *to take seriously*.

Rather than being attracted to Abstract Expressionists, Rivers was drawn instead to a largely gay bohemian milieu that provided him with inspirational figures and intellectual associates, as well as with friends and lovers. These people included the poets Frank O'Hara and John Ashbery, the painter Nell Blaine, his dealer, John Bernard Myers, and the gallerist Tibor De Nagy to name but a few. Rivers slept with both men and women, including a brief liaison with Myers and a tempestuous relationship with O'Hara. Despite all

of this, however, Rivers has always maintained his heterosexual orientation: 'I was in a rather conventional tradition of men who are mainly heterosexual, or have had mostly heterosexual experience, who when they get with men who are homosexual act as if they are allowing themselves to be had.'[27] But this did not prevent him trying to emulate his gay peers, and allowing his work as a (heterosexual) painter to be influenced by the values of gay and lesbian bohemia.

What Rivers was impressed with above all, and what he worked to build into his practice as an artist, was the act of 'camping'. As a term within gay male argot in the 1940s and 1950s, 'camp' usually referred to an effeminate homosexual or 'queen', and particularly to 'her' bodily deportment and the bitchy talk that was characteristic of 'her' speech. By referring to one another through stereotypically feminine forms of address, O'Hara and his circle of gay compatriots demonstrated their penchant for camp talk, and particularly for its parodic citation of conventional gender norms. Rivers writes approvingly of the extent of this parodic speech in the circles of artists and poets that he knew at the time:

> Men often referred to one another by women's names. Even things and places were given female proper names. Out at the beach in the Hamptons, if our new friend Waldemar went for a swim, either Frank O'Hara or Jimmy Schuyler flat on the wicker would sit up: 'Oh, look! There goes Wilma, off to Ophelia Ocean for her afternoon dip.'[28]

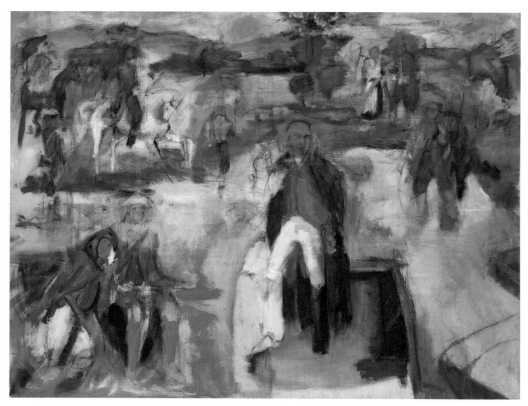

PLATE 10.10 Larry Rivers, *Washington Crossing the Delaware*, 1953, oil, graphite and charcoal on linen, 212 × 283 cm. (Museum of Modern Art, New York. Given anonymously. DIGITAL IMAGE © 2002 The Museum of Modern Art, New York/Scala, Florence. © Larry Rivers/VAGA, New York/DACS, London 2004.)

Such an affected, and apparently incongruous, adoption of feminine gender codes drew attention to the fact that these codes were being performed. As one of the characters in Christopher Isherwood's 1954 novel *The World in the Evening* comments, it is precisely a 'swishy little boy with peroxided hair, dressed in a picture hat and a feather boa, pretending to be Marlene Dietrich [that] in queer circles they call ... camping'.[29] To earn its moniker as camp, the male body had to make it apparent that feminine gender codes were being quoted and that they were not, at some level, being taken 'seriously'. Camp was therefore understood as a mode of 'being' that owed more to the logic of *performance* – to artifice and acting – than to conventional, naturalised constructions of gender identity. That the objects of camp performance, in this case Marlene Dietrich, were in themselves artificially staged constructions of femininity only went to underscore camp's theatrical aspect and its proximity to, and overlap with, the practices of gay male drag.

But how did Rivers import the values of such everyday gay camping into painting? This we can see if we look at his 1953 painting *Washington Crossing the Delaware* (Plate 10.10). The patriotic subject is General George Washington's crossing of the icy Delaware river, which marked a turning point in the American War of Independence. Rivers's decision to attempt a modern history painting – with its attendant expectations of significant meaning and grandeur – at the high point of avant-garde abstraction was to do something that 'no one in the New York art world would doubt was disgusting, dead, absurd'. Nothing could have been 'dopier' in this context than a painting dedicated, as Rivers himself puts it, 'to a national cliché'.[30] Thus, the seriousness of *Washington* was already compromised from the very outset. Further, Rivers's dissociation from the heroicism of Emanuel Leutze's nineteenth-century painting of the same subject appears to have been rooted in a distinctly unserious appreciation of the moral drama of Leutze's canvas (Plate 10.11). Apparently, Rivers thought that

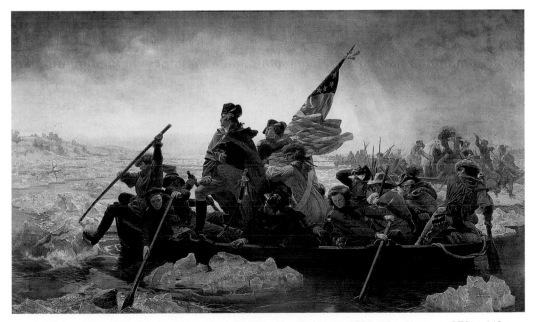

PLATE 10.11 Emanuel Leutze, *Washington Crossing the Delaware*, 1851, oil on canvas, 378 × 648 cm. (Metropolitan Museum of Art, New York. Gift of John Stewart Kennedy, 1897 (97.34). Photo: © 1992 The Metropolitan Museum of Art, New York.)

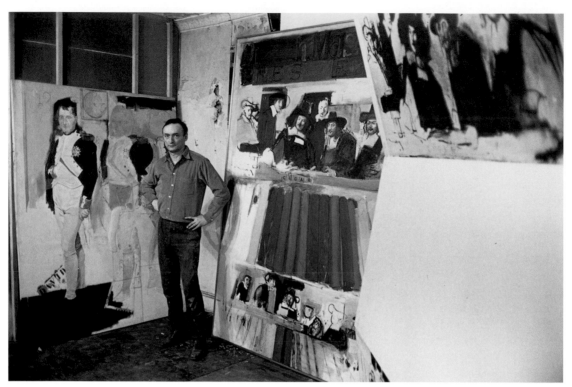

PLATE 10.12 Peter Moore, Larry Rivers in his studio, New York City, 1965, photograph. (© Estate of Peter Moore/VAGA, New York/DACS, London 2004.)

it just looked *too chilly* to be going out on the river around Christmas time and to be putting on any kind of swaggering militaristic performance.

In this way, we might argue that Rivers's painting can been seen as camp by dint of its non-serious approach to its subject, and particularly in its attempt to send up the nationalistic machismo at the heart of its painterly scene. But also, we might argue, it is Rivers's *painterly treatment* of his subject that belies the 'campiness' at the heart of his work. Some critics have referred to *Washington* as a kind of 'Broadway' or 'Hollywood' style painting because of the way in which history is rendered as an overblown, theatrical performance, thereby making it 'too much' to be taken seriously. Rivers himself can be seen to have contributed to such a view by saying that he was more concerned with what the subject could offer him in terms of painterly spectacle than anything else: 'there was plenty in *Washington Crossing the Delaware* to dazzle me – horses, water, soldiers, and so on'.[31]

This apparent superficiality and concern with painterly artifice is what has led some of Rivers's critics to dismiss him as a frivolous artist. In 1953, both the painting and its maker were attacked by the artists Elaine de Kooning and Gandy Brody for their perceived lack of authenticity: de Kooning criticised Rivers's painting for its lack of drama and weak coloration, inviting comparison with the work of the Bulgarian painter Jules Pascin by dubbing it 'Pascin Crossing the Delaware'; Brody called Rivers a 'phoney', denigrating him as a fake rather than a genuine artist.[32] Since these remarks would have resonated within a culture of art in which the heterosexual masculinity of Abstract Expressionism provided the marker of an 'authentic' art practice and subjectivity, it is not difficult to see how such criticisms could be construed as homophobic responses

to the painting's campness, and Brody's remark in particular as a slur on Rivers's masculinity, viewing him as something less than a 'proper' man.

But it was precisely such constructions of a proper, 'authentic' masculinity that Rivers worked to undermine in his art. Attacking the idea that an artist had to be a 'naturally' hard-bitten and rugged heterosexual male in order to be successful, Rivers embraced the play of camp performance in the construction of his own artistic masculinity. For instance, let us consider a photo-portrait of Rivers in his New York studio in 1965 by Peter Moore (Plate 10.12). Rivers is flanked by two of his paintings: on the right *Dutch Masters and Cigars* (1963) and on the left *The Greatest Homosexual* of 1964. This latter painting (Plate 10.13) was based on Jacques-Louis David's portrait of Napoleon (Plate 10.14), which struck Rivers as mincing and affected – hence Rivers's choice of title. In the photograph by Moore, Rivers stands before the painting with his hands on his hips and a smile, I like to think, almost breaking out across his face as he too adopts an affected, almost effeminate, pose. On one level, of course, this could be construed as a joke shared between artist and photographer as well as between artist and viewer, as Rivers mimics the pose of the affected and painted Napoleon. However, on another level, this is more than an ironic performance and it can be seen instead as being continuous with the campness of Rivers's artistic identity – he can no more

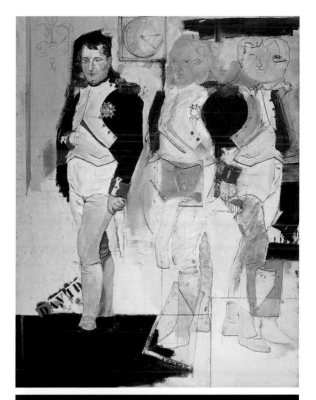

PLATE **10.13** (top)
Larry Rivers, *The Greatest Homosexual*, 1964, oil, collage, pencil and coloured pencil on canvas, 203 × 41 cm. (Hirschhorn Museum and Sculpture Garden, Smithsonian Institution. Gift of Joseph H. Hirschhorn Foundation, 1972. Photo: Lee Stalsworth. © Larry Rivers/VAGA, New York/DACS, London 2004.)

PLATE **10.14** (bottom)
Jacques-Louis David, *Napoleon Bonaparte in his Study at the Tuileries*, 1812, oil on canvas, 205 × 128 cm. (Private collection. Photo: Bridgeman Giraudon/Lauros.)

stop posing than he can stop being an artist, since the very 'being' of his artistic self *is* the posing. To adopt an old adage, if this image is a lie – an affectation – then it is the lie that tells the truth: the truth, that is, of Rivers's queer performance of artistic masculinity.

Reading queerly

I say *queer* performance here because Rivers enacts his heterosexuality (paradoxically?) through the very codes of gay male camp. In highlighting this aspect of Rivers and his work, I have been arguing for an understanding of him as a *gay-acting* straight artist, one who is 'queer' by dint of the ways he troubles the normative relations that we might expect to exist between sexuality and sexual identity. In this way, he takes his place alongside the queering of identity we have considered in the art of the neo-Dadaists. Although the precise features of such a queering are different in both cases – for Johns, for example, as we have seen, it takes the form of an unsettling of *any* conventionally staged authorial or artistic presence – I have tried to trace in this short chapter some of the differing ways in which avant-garde art troubles the sexual values and representational practices of straight culture. The 'queerness' I have been at pains to illuminate is one principally rooted in a challenge to the ways in which sexual and gender identities are commonly represented within culture, a challenge that was undertaken by both 'gay' and 'straight' artists – categories that, after Johns and Rivers, fail to invoke such clearly demarcated and opposing forms of sexual embodiment. A very queer effect indeed.

The readings I have offered in this chapter could also be termed 'queer' in so far as I have troubled the conventionally sexualised or non-sexualised (read 'straight') meanings habitually attributed to the works of the artists discussed by the discourses of art criticism and art history. As lesbian and gay/queer scholars have recently argued, the narratives of art history have frequently worked to limit any mention of an artist's homosexuality to the realm of the 'private', or to dismiss any reference to it as inconsequential tittle-tattle – as something of far too little significance, that is, to be taken seriously by interpretative discourses of art. Here, I have attempted to show how avant-garde art was actively involved with sexualised forms of representation, and how problems of sexuality and sexual identity were an important determinant in the development of avant-garde practice. To read the signs of art and culture in this manner is to recognise the ways in which the writing of art history can also be seen to take an active role in the production of sexual meanings – both for the art of the past and within the narratives that we produce about it in the present.

Notes

1 Robertson, *Guilty Pleasures*, pp.9–10.

2 Roth, 'The Aesthetic of Indifference', p.49.

3 Rosenberg, 'The Art Establishment', p.46.

4 Quoted in Warhol and Hackett, *POPism*, p.11.

5 Gibson, 'Lesbian Identity and the Politics of Representation in Betty Parsons' Gallery', p.252.

6 Rivers with Weinstein, *What Did I Do?*, p.105.

7 Gruen, 'Agnes Martin', p.91.

8 Rosenberg, 'The American Action Painters' (1952), in *The Tradition of the New*, pp.27–8.

9 Tomkins, *Off the Wall*, p.132.

10 Johns, Obituary of Marcel Duchamp (1968), in Harrison and Wood, *Art in Theory 1900–2000*, VIA23, p.761.

11 Quoted in Sandler, *The New York School*, p.164.

12 Cage, 'Lecture on Nothing', in *Silence*, p.ix.

13 Quoted in Jones, 'Finishing School', p.650; also published in Cage, Julliard Lecture (1952), in *A Year from Monday*, p.98.

14 Quoted in Sandler, *The New York School*, p.174.

15 Quoted in Jones, 'Finishing School', p.646.

16 Katz, 'John Cage's Queer Silence'.

17 Martin, *Writings*, p.89.

18 Chave, 'Agnes Martin', p.139.

19 Quoted in Raynor, 'Jasper Johns', p.22.

20 Katz, 'John Cage's Queer Silence'.

21 Silver, 'Modes of Disclosure', p.190.

22 Sontag, 'Notes on Camp', p.527.

23 *Ibid.*, p.519.

24 For a more extensive account of the following argument see Butt, 'The Greatest Homosexual?'

25 Rosenberg, 'The American Action Painters' (1952), in *The Tradition of the New*, p.33.

26 Quoted in Sandler, *The New York School*, p.15.

27 Quoted in Gooch, *City Poet*, p.229.

28 Rivers with Weinstein, *What Did I Do?*, pp.109–10.

29 Isherwood, *The World in the Evening*, p.125.

30 O'Hara, interview with Larry Rivers, 'Why I Paint as I Do', p.98.

31 Quoted in Hunter, *Larry Rivers*, p.24.

32 Quoted in O'Hara, interview with Larry Rivers, 'Why I Paint as I Do', p.98.

References

Butt, G., 'The Greatest Homosexual? Camp Pleasure and the Performative Body of Larry Rivers', in A. Jones and A. Stephenson (eds), *Performing the Body/Performing the Text*, London and New York: Routledge, 1999, pp.107–26.

Cage, J., *Silence: Lectures and Writings by John Cage*, Middletown, CT: Wesleyan University Press, 1961.

Cage, J., *A Year from Monday: Lectures and Writings by John Cage*, Middletown, CT: Wesleyan University Press, 1967.

Chave, A.C., 'Agnes Martin: "Humility, the beautiful daughter … All of her ways are empty"', in B. Haskell (ed.), *Agnes Martin*, exhibition catalogue, Whitney Museum of American Art, New York, 1992, pp.131–53.

Gibson, A., 'Lesbian Identity and the Politics of Representation in Betty Parsons' Gallery', in W. Davis (ed.), *Gay and Lesbian Studies in Art History*, London: Harrington Park Press, 1994, pp.245–70.

Gooch, B., *City Poet: The Life and Times of Frank O'Hara*, New York: HarperPerennial, 1993.

Gruen, J., 'Agnes Martin: "Everything, everything is about feeling … feeling and recognition"', *ArtNews*, vol.75, no.7, September 1976, pp.91–4.

Guilbaut, S., *How New York Stole the Idea of Modern Art: Abstract Expressionism, Freedom, and the Cold War*, trans. A. Goldhammer, Chicago: University of Chicago Press, 1983.

Harrison, C. and Wood, P. (eds), *Art in Theory 1900–2000: An Anthology of Changing Ideas*, Malden, MA and Oxford: Blackwell, 2003.

Hunter, S., *Larry Rivers*, New York: Harry N. Abrams, 1970.

Isherwood, C., *The World in the Evening*, London: Methuen, 1954.

Jones, C.A., 'Finishing School: John Cage and the Abstract Expressionist Ego', *Critical Inquiry*, vol.19, summer 1993, pp.628–65.

Katz, J.D., 'John Cage's Queer Silence; or, How to Avoid Making Matters Worse', in D.W. Bernstein and C. Hatch (eds), *Writings through John Cage's Music, Poetry, and Art*, Chicago: University of Chicago Press, 2001, pp.41–61.

Martin, A., *Writings*, ed. D. Schwarz, Winterthur: Kunstmuseum Winterthur/Edition Cantz, 1992.

O'Hara, F., interview with Larry Rivers, 'Why I Paint as I Do', *Horizon*, vol.2, no.1, September/October 1959, pp.95–101.

Raynor, V., 'Jasper Johns: "I have attempted to develop my thinking in such a way that the work I've done is not me"', *ArtNews*, vol.72, no.3, March 1973, pp.20–2.

Rivers, L. with Weinstein, A., *What Did I Do?*, New York: HarperCollins, 1992.

Robertson, P., *Guilty Pleasures: Feminist Camp from Mae West to Madonna*, Durham, NC: Duke University Press, 1996.

Rosenberg, H., *The Tradition of the New*, New York: Horizon Press, 1959.

Rosenberg, H., 'The Art Establishment', *Esquire*, vol.63, January 1965, pp.43, 46, 114.

Roth, M., 'The Aesthetic of Indifference', *Artforum*, vol.16, no.3, November 1977, pp.46–53.

Sandler, I., *The New York School: The Painters and Sculptors of the Fifties*, New York: Harper & Row, 1978.

Silver, K., 'Modes of Disclosure: The Construction of Gay Identity and the Rise of Pop Art', in R. Ferguson (ed.), *Hand-Painted Pop: American Art in Transition, 1955–1962*, exhibition catalogue, Museum of Contemporary Art, Los Angeles, 1993, pp.179–203.

Sontag, S., 'Notes on Camp', *Partisan Review*, vol.31, 1964, pp.515–30.

Tomkins, C., *Off the Wall: Robert Rauschenberg and the Art World of our Time*, New York: Doubleday, 1980.

Warhol, A. and Hackett, P., *POPism: The Warhol Sixties*, New York: Harcourt Brace Jovanovich, 1980.

CHAPTER 11

Warhol's 'Factory': painting and the mass-cultural spectator

John Roberts

Introduction

This chapter looks at Andy Warhol's development of an industrial aesthetic at the Factory in New York as the basis for a discussion of debates in postwar American art. For Warhol, the key to the industrial model is the social interactivity of collective studio production. It is Warhol's singular pursuit of this collective life in the studio that is crucial to our assessment of what is radical about his art in the early 1960s for, by placing our emphasis on the studio and its forms of labour, we will be able to establish a clearer sense of what is critically significant about Warhol's turn to silkscreen printing and film. Readings of his work from this period tend to diverge into two schools: Warhol is presented as either a stooge of capital and mass culture, or as their unerring and sardonic critic. Both accounts, however, are too one-dimensional. Warhol's art does not emerge from a politicised understanding of mass culture, even if politics frames his judgements about how mass culture seduces and invades the consumer and spectator. Rather, what preoccupied Warhol was the problem of how to develop a post-artisanal role for the modern artist that would allow him to avoid what he believed to be the costs of both modernism (the expressive, inward, self-heroicising artist) and of commercial art (the loss of the artist's autonomy), while embracing the sceptical imperatives of modernism and the democratic impulses of mass culture.

This is the critical terrain of Warhol's art: not the critique of capitalism and modernism as such, but the repositioning of the modernist artist within the public forms and collective fantasies of post-1950s capitalism. Warhol is an artist who turns to the collective traditions of art and design theory, traceable back to the German Werkbund[1] and Bauhaus. But at the same time he had little interest in producing art *as* design, or films *for* a mass audience, although ironically, in 1971 in Germany, his film *Trash* almost outgrossed *Easy Rider* at the box office. What is first and foremost of concern to Warhol is how the artist might give himself or herself over to the forms and modes of attention of mass culture without giving up his or her independent identity as an artist. This is why, despite all the films, design work, fashion and projects with musicians, paradoxically, he retains a core identity as a collaborative producer of paintings. Primarily, Warhol was interested in establishing a new democratic space for the production and reception of art, in which a deflated, deheroicised and collectivised version of 'high culture' might participate in, and revivify, the banal and kitsch-exotic forms of mass culture. This is a big claim, but it is made convincing, in my view, by Warhol's debt to early

PLATE 11.1 (facing page) Andy Warhol, detail of *Vote McGovern* (Plate 11.15)

modernist notions of how industrialised art might bridge the gap between art and production, the market for luxury goods and the mass market. In common with the Werkbund and Bauhaus, Warhol believed that the industrialisation of art could, in the critical language of this tradition, re-enchant the disenchanted world of modern mass production. In defiance of the Romantic idea that mechanical reproduction diminishes the aesthetic value of art, and therefore that artists should resist modern technology, Warhol embraced the 'industrialisation' of the art object as a democratic and uplifting force.

Warhol's first Factory studio occupied one floor of an old commercial building on East 47th Street in Manhattan from 1963 to 1968 (Plate 11.2). The spacious, open-plan floor was once the location of a hat manufacturer, and reputedly it was this former use of the space that was the origin of the studio's name. Notoriously, the interior was decorated in an amalgam of Futurist and bat-cave Gothic styles: all the windows were painted black, preventing any natural light from entering, and the walls were covered entirely with silver foil – which by the mid-1960s was fraying and peeling. Pipes and free-standing

PLATE 11.2
231–41 East 47th Street, location of Andy Warhol's Factory, c.1968. (Copy photo taken by Caroline A. Jones from New York Department of Building file, as reproduced in C.A. Jones, *Machine in the Studio*, Chicago University Press, Chicago, p.193.)

objects were also covered in foil, although in some instances Warhol and his associate, the photographer Billy Name, decided to paint them silver (see Plate 10.3).

The open-plan character of the studio was central to its identity as a place of work and sociability. All Warhol's screenprinting was done flat on the floor, which allowed maximum productivity when demand necessitated. As a space that allowed easy manoeuvrability, the floor also doubled as a performance area for filming, film screenings and band rehearsals (by, for example, The Velvet Underground). Whether working on the screenprints or on the films, Warhol collaborated with assistants. Indeed, by 1964–5 the Factory had become a space where the dynamics and demands of collaboration and collective production were being worked out. In 1963, Warhol described his turn to the commercial product image and mechanical reproduction as the basis of a kind of 'Commonism'.[2] The Factory came into existence in order to test and promote this 'democratic' principle. However, this ideal of collective production was never put on an open commercial footing by Warhol in the early years. The Factory may have been producing assembly-line art, but it was not a business in any conventional sense. Most of the labour Warhol used was voluntary. Only one of his assistants was ever on a salary; most people worked for board and occasional meals. As Warhol's reputation grew, this fluidity in the division of labour became, in fact, an increasing source of grievance as his assistants and his collaborators came to feel exploited. These grievances are cited as one of the reasons for Valerie Solanas's assassination attempt on Warhol in 1968.[3] Warhol was the 'Plastic Man' whose management model, despite impressions to the contrary, was a reflection of the 'system', as she called it.

The year 1968 is an extraordinarily important date in the development of Warhol's art and career. Not only was he shot and severely injured in that year, but he moved out of the East 47th Factory (after the building was condemned) into the new Factory in the Union Building in downtown Union Square, to start a very different kind of Factory production. From this point on there was no talk about assembly-line art and others doing the work, and the documentation of production – so integral to the public identity of his early notion of 'Commonism' – ceased. Warhol's authorial presence became stronger (after 1968 his diaries began to be published, his *Interview* magazine appeared and the glamour 'stalking' began), people were no longer encouraged to drop by, and for the first time Warhol employed receptionists who were asked to use any description but the Factory when answering the phone. It is possible, then, to talk about two distinct phases to Warhol's career with two distinct ideological formations: the early Factory, with its dissolution of the notion of the unitary author and critique of conservative notions of craft and expression, and the period after the shooting, in which the work (still produced on the whole by Warhol and assistants) is redirected through the signature style of Warhol and through Warhol as a grand courtier to the New York upper-middle-class social scene. It is the first period of Warhol's work that I will examine in this chapter, because it is on the strength of the early work's engagement with art as industrial practice, the function of the studio and the identity of the artist, that his reputation largely stands today.

Art, industry and collaboration

Postwar American art was driven overwhelmingly by the reworking and extension of early modernist and late Romantic notions of art as the sensuous, free play of form and gesture. In opposition to the vernacular American traditions of the 1920s, the social realism of the 1930s and the post-Dada avant-garde, Abstract Expressionism looked back to the achievements of Monet, van Gogh, Renoir, Cézanne, Matisse, Miró and Picasso for its cultural bearings. The social and cultural reasons for this 'return' are complex and dynamic, and not just an expression of nostalgia and American insecurity about the riches of European culture. Nevertheless, the conservative implications of the cultural return of this move are hard to ignore. The value of European high modernism is held to lie not just in the technical challenges it places on the artist but in its spiritual demands: through a primary commitment to the spontaneous, expressive mark, the studio painter's virile creativity is opposed to the pursuit of a mere craft or technique and the repetitions of 'ordinary' labour. The sensuously expressive painting carries with it the possibility of alienated cultural experience. The notion of artistic authenticity and freedom won through the solitary depths of the (male) studio-bound painter is very much what defines Abstract Expressionism's ambition in the 1950s, as it comes to terms with the ideological polarities of the Cold War and the relative isolation of the modern artist. In the 1960s, however, in a world where rapid capitalist development of the cultural industries was dissolving the links between creativity and the artisanal, and where radical cultural change was shifting the social role of the artist, this metaphysical commitment to the spontaneous, embattled, heroic artist began to appear bathetic. For younger artists, Abstract Expressionism's repositioning of painting within a late Romanticist programme of spiritual affect was seen to divide painting from the world of the modern image and experience. It is this sense of the loss of the contemporary and the crisis of a heroicised model of modernism that is the immediate context for Warhol's 'Commonist' art in the early 1960s/1970s. Indeed, from the mid-1960s to the early 1970s, a number of younger American artists set out to critique and displace the 'expressionist sublime' of the Abstract Expressionists – that is, to question the idea of the expressive risks and uncertainties of abstract modernist painting.[4] This was achieved precisely through a reconsideration of the artist's function and labour in the studio and the character of the studio itself.

If Jackson Pollock, Barnett Newman and Mark Rothko presented themselves as solitary shamans or latter-day alchemists in the 1950s, in the 1960s American artists presented themselves variously as a worker and executive (Frank Stella), a worker and designer (Donald Judd), a worker and manager (Warhol), a worker and researcher (Robert Smithson) and a worker and technician (Richard Serra). For a period of around ten years, this diffuse range of industrial/ technical and worker/management artistic identities shattered the Romantic postwar return to the idea of the studio as the site of the 'solitary master'. Rather than regarding the studio as a crucible of elemental emotions and intense self-examination, Warhol, Stella, Judd and Smithson, and later Serra, reclaimed the alienated space of the studio as factory and business premise, turning it into a potential site of collective and democratic practice. The

studio became a place where mechanical, theoretical, administrative and manual-repetitive forms of labour were incorporated into the production of the work, extending the division of labour well beyond the artist and his (or her) studio assistants — some part or all of the production of a work might be given over to others elsewhere. But if Stella, Judd, Smithson and Serra had little time for the masculine metaphysics of Abstract Expressionism, they nevertheless identified the repetitive processes of industrial production with the corroboration of another kind of virility: the artist as labourer. For instance, in the early part of his career, Stella liked to think of himself as a 'house painter'. Judd identified his work with a world of hard, sharp, engineered, functional objects. Warhol undoubtedly embraced aspects of this kind of functionalist thinking in the early Factory, but significantly he also adulterated it, derogated it, 'queered' it, in fact. The early Factory was certainly a place where repetitive labour took place, and as such was central to Warhol's self-image as a deflator of artistic hubris, but it was also a place where this process was interrupted by various kinds of play, informal learning and sexual provocation. Moreover, these forms of exchange included the primary contributions of women, transvestites and those whose creativity was overlooked or undervalued — albeit mediated through the roles of 'beautiful losers'. 'I use the leftovers of show business [people] turned down at auditions all over town', Warhol said.[5] Indeed, unlike the solitary male studios of the New York art world of the 1940s and 1950s, Warhol's Factory was a place of high sociability and interaction between the sexes.

This sense of the early Factory as a place of social inclusion, of play, performativity and the feminine deflation of heroic male imposture distances Warhol's project not only from the aggressive masculine topos of the Abstract Expressionists, but also from the virile postures of most of his peers. In this, Warhol's relationship to the industrial model of the avant-garde traditions, out of which his 'Commonism' model of art emerged, is ambiguous on a number of levels.

Warhol trained at the Carnegie Institute of Technology in Chicago, from which he graduated in 1949. It is clear that he had read and studied László Moholy-Nagy's *The New Vision* (1946), a utopian (social democratic) account of art's revitalisation as an industrial and design-based practice. In fact, by the late 1940s, Moholy-Nagy's largely depoliticised and technocratic version of early Soviet productivist and constructivist models and Bauhaus industrial art practices dominated the most advanced sectors of American art and design departments. As a student of design, Warhol was not immune to this model's novel and ambitious claims for a new sense of art as industrial practice. This is something that he clearly carried with him from his early days as an illustrator in the fashion trade into his artwork proper. As such, his debt to this tradition at the time when he most openly appropriated from it is hedged with all this tradition's qualifications. That is, in the early Factory, Warhol may have revived the idea of the industrial workshop for art, but it has little connection with Aleksandr Rodchenko's *Metfak* (metalwork faculty) at the VKhUTEMAS ('Higher State Artistic and Technical Workshops') or the original Bauhaus. Warhol did not see the Factory as part of the vanguard of social change or a place where artists/assistants might be encouraged to become industrial designers.

Similarly, although Warhol had a highly developed sense of the need for art to be produced out of teamwork, and had been exposed, through his friend the Marxist documentary film maker Emile de Antonio, to Bertholt Brecht's notion of art as a 'community of ideas', Warhol's 'Commonism' was not committed to some hidden, systematic left-wing agenda. On the contrary, what attracted him to notions of teamwork, collaborative practice and mechanical reproduction was that they dissolved the ego. For Warhol, the exaltation of the (male) ego was a means of blocking certain productive and destabilising forms of community and sociability that resisted what he saw as 'straight' and 'uptight' (heterosexual) culture. By giving over the process of making art to collaboration and the repetitive, objective processes of mechanical reproduction, the artist was able to focus on the project in hand, and not on maintaining the idea of a signature style through the proclaimed unity of the painter's expressive power (Plate 11.3). The burden of identifying meaning with 'self-expression', with all its masculine distancing from the 'other', drops away to be replaced by the notion of the artist as 'technical director' and editor of collectively produced ideas. In this regard, there are overlaps with the counter-cultural politics of the period. It is hard to imagine Warhol's Factory separate from the self-activism and 'collective consciousness' of the political collectivities of the 1960s: the Black Panthers, the San Francisco Diggers and Emmett Grogan's Free City Collective, or for that matter Jean-Luc Godard's film collective, the Dziga-Vertov Group. For all Warhol's ideological reticence, his 'Commonism' undoubtedly existed within this moment of communal self-reflection in art and politics.

But what separates Warhol's notion of teamwork from these political forms, or from overtly artistic political forms, is that the collaborative production of work at the Factory was *never a form of political representation*, even if 'politics' and 'representation' were certainly features of his turn to mechanical reproduction – as I will discuss below. Rather, teamwork for Warhol was closer to the preferred notion of the group performance, of sensuous display, of the carnivalesque and circus, those aspects of collective activity that insist on multiple and shifting activities and identities.

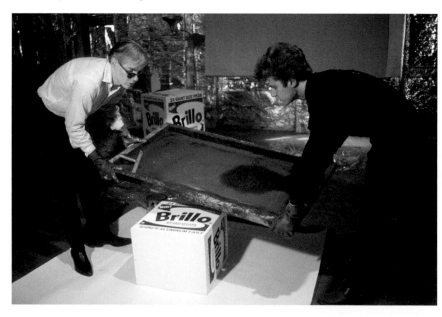

PLATE 11.3
Andy Warhol and Gerard Malanga screening Brillo boxes at the Factory, June 1965. (Photo: © Ken Heyman/Woodfin Camp. © The Andy Warhol Foundation for the Visual Arts, Inc./ARS, New York and DACS, London 2004.)

One group in particular seems to have played a formative role in this expansive vision of industrial art practice: the fashion group Paraphernalia (Plate 11.4). Formed in the mid-1960s by Betsey Johnson, Deanna Littell, Elisa Stone and Diana Dew, the group was well known for developing a work space that encouraged performance and play in the presentation of ideas – a far cry at the time from the disciplinary image of the design workshop. Moreover, Paraphernalia was renowned for using industrial materials, such as plastic, paper and metal, in its clothes, which blurred what was deemed appropriate to fashion and what was not. All this appealed to Warhol, confirming his intuitions that certain tendencies in other creative fields were in sympathetic alignment with his own model of a performative 'industrial aesthetic'.[6] Consequently, what Warhol picked up from this model of fashion design at this point was the idea that the space in which art is produced and the means by which it is produced are not bound by any singular tradition, set of means or source of ideas. Hence his extensive range of collaborations across different media (film, silkscreen printing, music and book design) during the period of the early Factory, as if the dissolution of the ego was identifiable with the dissolution of artistic purism.

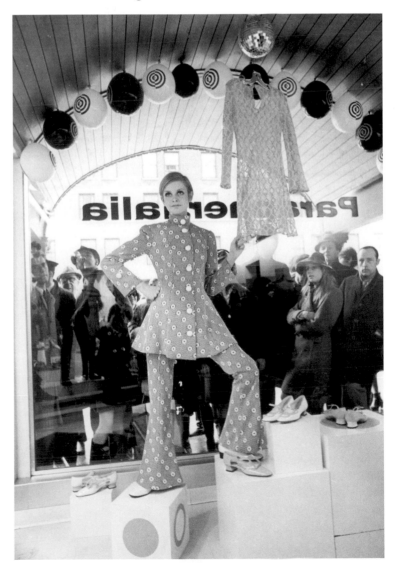

PLATE 11.4
Twiggy modelling in the Paraphernalia store front, March 1967. (Photo: © Bernard Gotfryd/Woodfin Camp.)

Painting and the technological sublime

Yet Warhol's dissolution of the artist's ego through the anonymity and repetitions of mechanical production was not only concerned with 'expanding' the frame of artistic activity, as many other artists were in the 1960s. If this was all it was, Warhol's art would be no more than another affirmative version of 'interactivity' and 'theatre' and the 'popular' in art. Rather, what remains compelling about the early work is how much the screenprinted paintings, in particular, instate, reproduce and disclose the major cultural and social tendencies in postwar capitalism from a position that is essentially ambivalent about these tendencies. When Warhol said, famously, he wanted 'to be a machine',[7] there is both a thrill at the prospect of the ego's submission to the modern technological image, and an embrace of the democratising power of mechanical reproduction's dissolution of the ego. 'Mechanical means are *today*, and using them I can get more art to more people. Art should be for everyone.'[8] It is the thrill at the prospect of the ego's submission, however, that is crucial here. Mechanical means effectively open out the experience of art to the dominant content and experiences of mass culture: repetition, iconic simplicity and the inert pleasures of identification over those of critical reflection. In this respect, what is significant about the early works is the way they invoke those feelings of passivity or awe in front of technological power. That is, their success lies not simply in their reproduction of the prurient and violent content of the mass media, but in how they put in place the ambivalent pleasures, narcotic repetitions and daily traumatic encounters of the modern mass-cultural experience itself – the 'technological sublime'.[9] In these early screenprints we encounter the engulfing and intrusive effects of the new capitalist image technologies.

For Warhol, performing the dissolution of the artist's ego in the anonymous processes of the mechanical image is a way of embracing the seductive and abstract power of these new cultural forces. Thus, what distinguishes the early Factory is that Warhol not only employs technology to multiply the skills of the artist, but he develops it as a system for a technological re-encounter with traditional artistic forms and identities. This is because, in conjunction with his pursuit of a more socially participatory spectator, Warhol also wanted spectators who were first and foremost able to reflect on painting and imagery from *inside* the mass-cultural experience, spectators who could see painting as they might see an advertisement – as something that demands their attention, that cathects them instantaneously. This suggests that Warhol's commitment to a multifunctional aesthetic had its limits. Warhol may have argued for an art that broke down disciplinary boundaries and that involved the active participation of many, but not to the extent that this defined him as a socially marginal avant-gardist and weakened the popular content of his industrial aesthetic. This fear of the loss of social position is something that is reflected in his later career. The assassination attempt seems to have forced him to pull back sharply from the deflationary and transgressive impact of his avant-gardism, encouraging him to emphasise the pictorial aspects of his art at the expense of the work's socially participatory aspects.

The screenprint paintings remain key both to the development of Warhol's career overall and to what is most consistently convincing about his engagement with mechanical reproduction and the modern technological

sublime as a whole. By identifying painting with mechanical reproduction, he brings painting into full *alignment* with both the democratising and the fetishising aspects of mass culture. He achieves this in two significant ways: first, by treating the mechanical as constitutive of the experience of the painting, and not simply as the neutral ground for painterly expression – photographic image and canvas are united in a singular and iconic form. (In silkscreen printing the screen is coated with light-sensitive material and then exposed to a projected black and white photograph. Fine inks are then pushed evenly through the screen with a squeegee (the light areas being less impervious to the ink), enabling multiple images to be produced that vary only in density and registration.) Secondly, by focusing on those traditional genres of painting (the portrait, the still life and the landscape) that are connected to some pre-established notion of the popular spectator, Warhol conjoins the experience of painting with the dominant expectations of the mass-culture spectator for directness and clarity. The portrait, still life and landscape are reworked, therefore, not as traditional markers of anti-modernist taste (as things to be despised), but as culturally and psychologically rich sites of reflection on the desires, distracted forms of attention and alienation of the modern mass spectator. In this way, the production of painting as a mechanical process enables Warhol to shift the focus of judgement and interpretation to the relations between genre, image and technique within the wider orbit of technologically driven image making. The works achieve, or fail to achieve, their vividness against the larger world of pictorial, commercial representations.

Warhol embarked on this modernist pictorialism in the early 1960s in the non-silkscreen paintings, which employed comic-book details and commodity images and advertising slogans. Incorporating the various anti-expressive strategies developed by late modernist artists such as Jasper Johns, Robert Rauschenberg and Yves Klein (repetition, the incorporation of the photographic readymade, the monochromatic surface), Warhol interfused the vernacular content of mass-cultural forms with the effects of modernist painting. But it is not until the *Disasters*, *Commodities* and *Stars* series of the mid-1960s, when photographic reproduction and painterly form are combined in a single iconic image or set of images, that Warhol achieved a breakthrough to an actual industrial mode of painting and therefore to a provocative sense of painting as a 'hand-free' technology. Consequently, what is particularly disruptive about these early works is their deflation of the 'expressionist sublime' within the conventions of a flat pictorialism. By extracting the photographic image from its expressive context in Rauschenberg's work, and the popular image from its faintly pastoral, folksy condescension in Johns, Warhol disconnected the use of modernist strategies of formal subtraction and the vernacular from painterly judgement and evaluation. The *Disasters*, *Commodities* and *Stars* series are paintings that refuse to identify the value of painting with expressive surface or form. They are *resolutely* flat and pictorial. In this respect, Warhol may have recognised the achievements of Johns and Rauschenberg and their (limited) attempt to reintroduce the pictorial into modernism, but he did not want this pictorialism to be confined to certain modernist protocols about painterly expression. Rather, he wanted a painting that actually invoked and reproduced the life of the mass-produced image under capitalism. Hence, from 1963, there is a discernible rejection by Warhol of the aesthetic, painterly signifiers customarily associated with the 'expressive subjectivity' of Abstract Expressionism.

The perverse spectator and the queering of mass culture

Warhol's silkscreened paintings often use unsaturated colours which do not invite visual penetration of the surface. Moreover, the recourse to multiple images in the *Car Crash* series (1963), *Tunafish Disaster* (1963), *16 Jackies* (1964) and many other canvases, establishes our aesthetic attention within the aggressive sequentiality and repetitiveness of mass production (Plates 11.5, 11.6 and 11.7).

In this respect, Warhol's early art was polemically, as much as sensuously, one of surface. In postwar American modernism, the emphasis on repetitive surface effect and on mechanically produced decoration tended to be associated with a passive femininity, and as such with the failure of the artist to transform material into expressive, sublimated form. Indeed, a fear of decoration and prettiness haunted many of the Abstract Expressionists, despite their obvious reliance on decorative motifs and areas of intense colour. Pollock was forever fearful that the tautness and virility of his lines would dissolve into mere pattern making. Warhol's systematic use of the flat, decorative and repeated image is clearly, then, not the contingent outcome of a neutral appropriation of an available technology. On the contrary, the flatness and decorative aspects of silkscreen printing are purposefully embraced, allowing Warhol to link late modernist painting ambitiously to its historically derogated and denuded forms. That is, the pejorative feminine associations of decoration and the repeated motif allowed Warhol to open up a range of formal options through which he could explore his subjectivity as a gay man and his willing failure as a heroic modernist, so to speak. Crucially, he did this without declaring that this was his explicit intention. The term 'Commonism' and his obsession with the gender-neutral desire to become a machine dissemble these de-masculinising motivations, or at least make them ambiguous. In the 1960s, his sexuality was never explicit or could never be explicit: rather, it was always mediated publicly through reference to the generalised desire of the mass, democratic spectator (the love of glamour). To do otherwise was to court what he feared the most — ideological transparency and social marginalisation. Yet by heightening our awareness of the surface through a graphic inertness, and playing on the decorative artificiality of the repetitive kitsch image, the portrait or still life becomes the complex and compelling 'scene' for various camp and desublimating interventions into mass culture. There is a sense in which by linking a 'feminised' flatness and repetition with the reproduction of a mass-cultural image, Warhol allows certain indirect and perverse forms of pleasure to shape the spectator's relationship to the work. For, contrary to popular belief, Warhol's replication of mass-cultural images and forms is strangely heterodox, discomforting and unnerving. There are no shiny cars cruising down freeways, no grand buildings or monuments, no brave images of the future, and no reproductions of what might be construed as public events of the moment, with perhaps the exception of *Red Race Riot* (Plate 11.8) — which, in fact, Warhol mistitles (the image is of Civil Rights marchers in Birmingham, Alabama, being attacked by police dogs). Rather, the images he used in the early work, and which we now identify as 'Americana', are invested either with a coy nostalgia or affection for the domestic or possess a melancholic allure and darkness quite distant from the received idea of Warhol as Pop Artist or artist *of* the 'popular'. For instance, the Coca-Cola bottles and Campbell's soup tins were not images of contemporaneity in the 1960s (Plates 11.9 and 11.10). Both date back to the beginning of the twentieth century.

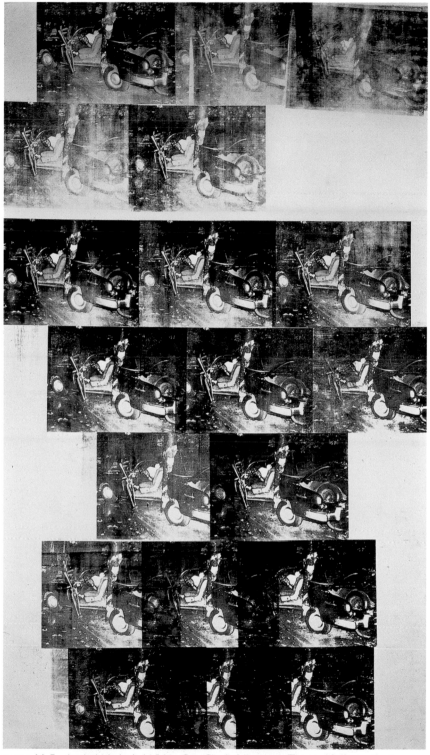

PLATE 11.5 Andy Warhol, *White Car Crash Nineteen Times*, 1963, synthetic polymer paint and ink screen on canvas, 368 × 211 cm. (Private collection. Photo: The Andy Warhol Foundation/Art Resource/Scala, Florence. © The Andy Warhol Foundation for the Visual Arts, Inc./ ARS, New York and DACS, London 2004.)

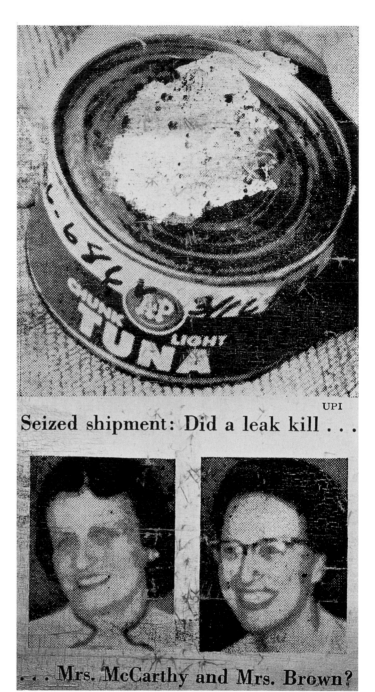

PLATE 11.6 Andy Warhol, *Tunafish Disaster*, 1963, synthetic polymer paint and silkscreen ink on canvas, 104 × 56 cm. (Photo: The Andy Warhol Foundation/Art Resource/Scala, Florence. © The Andy Warhol Foundation for the Visual Arts, Inc./ARS, New York and DACS, London 2004.)

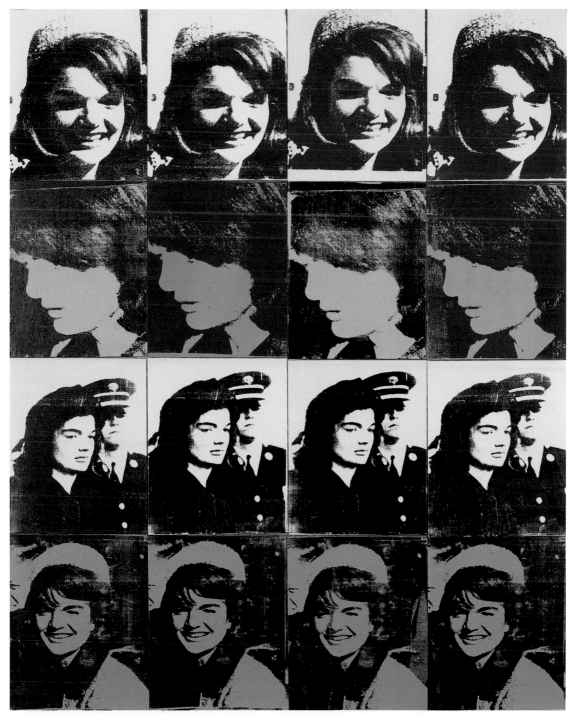

PLATE 11.7 Andy Warhol, *16 Jackies*, 1964, acrylic enamel on canvas, 203 × 163 cm. (Collection Walker Art Center, Minneapolis. Art Center Acquisition Fund 1968. © The Andy Warhol Foundation for the Visual Arts, Inc./ARS, New York and DACS, London 2004.)

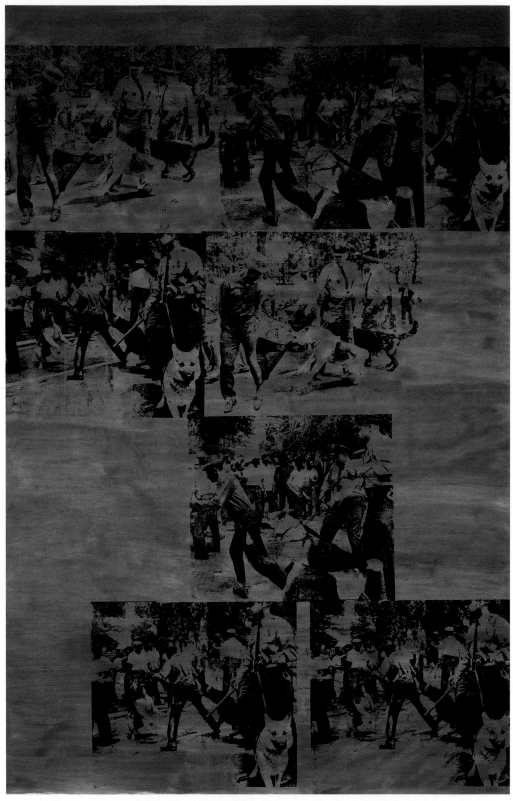

PLATE 11.8 Andy Warhol, *Red Race Riot*, 1963, silkscreen ink on synthetic polymer paint on
canvas, 350 × 210 cm. (Rheinisches Bildarchiv Koln. © The Andy Warhol Foundation
for the Visual Arts, Inc./ARS, New York and DACS, London 2004.)

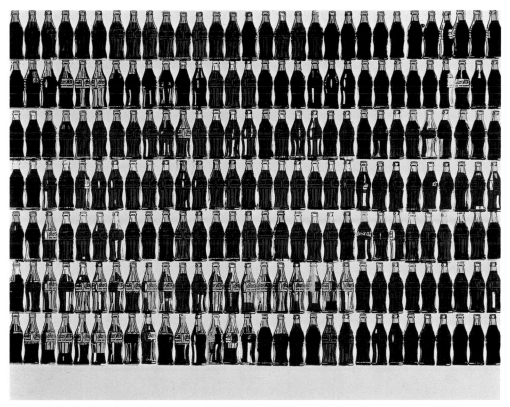

PLATE 11.9 Andy Warhol, *210 Coca-Cola Bottles*, 1962, synthetic polymer paint and silkscreen ink on canvas, 208 × 267 cm. (Collection of Martin and Janet Blinder. Photo: The Andy Warhol Foundation/Art Resource/Scala, Florence. © The Andy Warhol Foundation for the Visual Arts, Inc./ARS, New York and DACS, London 2004.)

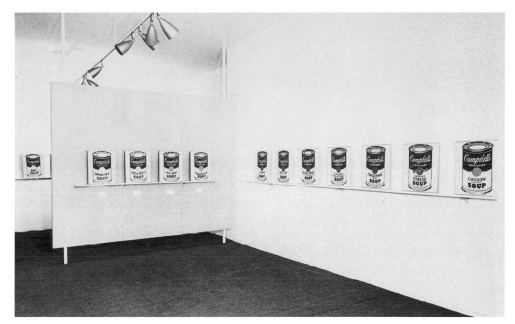

PLATE 11.10 Installation of Warhol's exhibition of *Campbell's Soup Can* paintings, Ferus Gallery, Los Angeles, 1962. (Photo: Seymour Rosen. © The Andy Warhol Foundation for the Visual Arts, Inc./DACS, London 2003. Trademarks licensed by Campbell Soup Company. All rights reserved.)

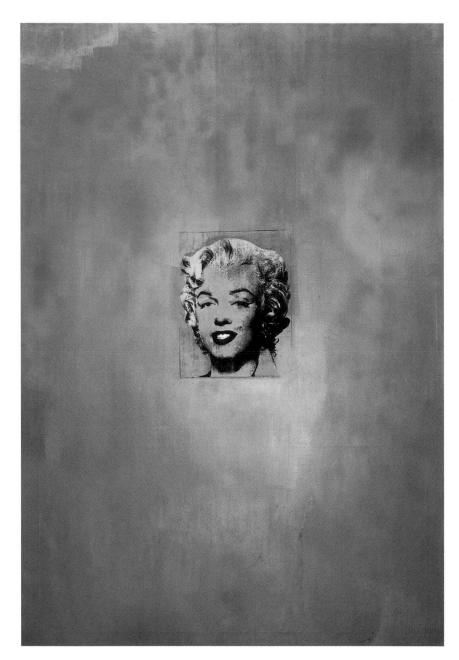

Similarly, when Warhol began using photographs of Elvis Presley and Marilyn
Monroe in the early 1960s, they were not mass-cultural icons in the way
they are understood to be now. Moreover, the portraits of Monroe, such as
Gold Marilyn Monroe (Plate 11.11), are a parodic and slightly grotesque
reading of female beauty and Monroe's status. They honour her in a way that
is decidedly non-erotic. In this respect, the sources of many of the *Disaster*
and *Suicide* paintings, among others, are less obvious in terms of their popular,
prurient content than we would imagine. In the *Disaster* and *Suicide* series,
for example, Warhol does not rely on newspaper or magazines sources for
his gruesome content, but more specifically on press-agents' prints normally

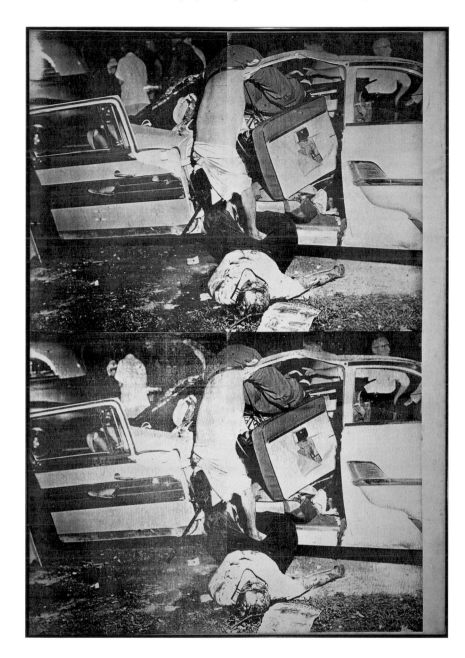

PLATE 11.12
Andy Warhol,
Saturday Disaster,
1964, synthetic
polymer paint and
silkscreen enamel on
canvas, 302 × 208 cm.
(Collection of the
Rose Art Museum,
Brandeis University,
Waltham, MA.
Gevirtz-Mnuchin
Purchase Fund, by
exchange, 1966.20.
Photo: 2001.
© The Andy Warhol
Foundation for the
Visual Arts, Inc./ARS,
New York and DACS,
London 2004.)

only seen by journalists and editors. In fact, these images were not produced for mass consumption because of their gruesomeness. They languished, invariably, in newspaper and police files. Furthermore, the 'genre' of the horrific car crash – suitably edited – was emphatically a local newspaper phenomenon in the USA in the 1950s and 1960s (Plate 11.12).[10] The images Warhol chose during this period were not selected because of their relation to some notion of the saturation of the media by violent images – the standard cliché about Warhol's early work. Neither were the product images chosen for their cutting futurity. This means we have to look elsewhere for Warhol's motivations.

If we accept the argument that Warhol's central concern through the period of the early Factory was the deflation of the 'metaphysics of expression', it becomes clear – once we examine the details of the silkscreened prints – how much this motivation unites around various notions of the 'perverse' recoding, or adulteration, of modernist painting and the mass-cultural sign. Warhol's sexuality, largely hidden in the 1960s, shapes this ideological deflation. Much of his art during this period is practised in what might be called a queering and devirilising of 'high culture', mass culture and industrial society. From the high artificiality of the Monroe portraits to the later 'transvestite perversion' of public figures in the portraits of Fidel Castro, Mao Tse-tung and Richard Nixon, there is an exposure and reconfiguration of the representation of power through the display of its publicly constructed image. We need to be clear, though, what we mean by the term 'perversion' here: I am using it, specifically, to mean the subversion of a normative or constricting ideology. In other words, the transvestitism of the portraits is a way of destabilising identity. In the Monroe portraits, this effect is twofold. By heightening her glamorous status as a women who is subject to the machinations of the Hollywood publicity machine (thereby privileging her status as a bruised victim for the gay spectator), Warhol presents her image as if it was the image of a *male* Monroe impersonator (Plate 11.13). The image of Monroe is transformed into that of a drag queen. In the case of Castro, Mao and Nixon, the blurring of sexual identity is similar, but the effect is somewhat different.

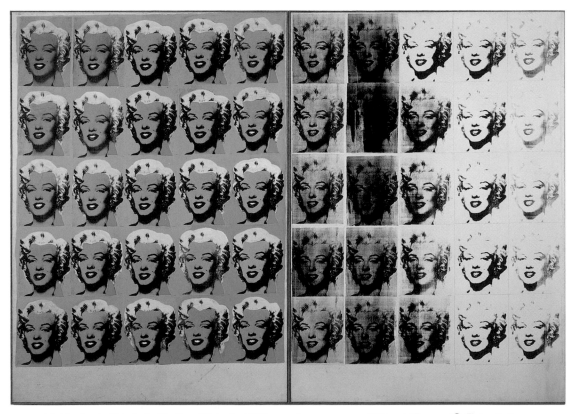

PLATE 11.13 Andy Warhol, *Marilyn Diptych*, 1962, acrylic on canvas, 208 × 145 cm. (© Tate Gallery, London 2002. © The Andy Warhol Foundation for the Visual Arts, Inc./ARS, New York and DACS, London 2004.)

Look at Warhol's portraits of Mao and Nixon (Plates 11.14 and 11.15). How do you think he 'perverts'/subverts the images of these public figures? Pay particular attention to the cosmetic qualities of the colours and to the misregistrations of the printing.

The glossy lips and garish colours perform a blatant challenge to the male preening and brinkmanship across the Cold War divide, undermining the gravitas of statesmanship. In the 1970s, when major politicians were treated with greater public veneration than they are today, this would have seemed particularly demeaning. These may be icons of glamour, but they are not glamorous icons. Warhol here reveals the public image of power by identifying masculinity with the constructedness or the masquerade of femininity, thereby turning the public image of male power into a glamorised fiction or imposture. In short, the hard carapace of executive power is subject to a subversive, transvestite make-over. ■

But this is not to say that, in the early 1960s, Warhol was a social critic of American capitalism. Interpretations of this period that place him in this 'deconstructive' tradition belie the way in which the experience of the mass subject is constructed in these works. Warhol is interested in two areas of experience: first, how a gay, camp or 'swishy' sensibility might extend or expose the kitsch pleasures of mass culture; secondly, how mass culture, in particular the mass media, generates a shared yet anonymous collective culture. There are two kinds of perverse sensibility at play in the early work. One is a subordinate perverse sensibility, which seeks to displace what we might call a classless, heterosexual, corporate American spectator (the centripetal force of American consumer capitalism and mass culture in the 1950s and 1960s). This is reflected in the overt gay recoding of public icons and the inclusion of obvious feminine working class taste into the mass-cultural pantheon, as in Warhol's use of Campbell's soup tins. The second is a unifying perverse sensibility, in which the mass-cultural sign is presented as the outcome of two powerful, if opposed, subjective forces central to the construction of the modern mass spectator: sadism and masochism.[11] That is, the success of the *Disasters* and *Suicides* sequences and the celebrity portraits lies in the focus Warhol brings to the way the mass reproduction of the photographic image under capitalism feeds a compulsive attention to the 'other', through either a continuous masochistic identification ('that could be me') or a sadistic pleasure in catastrophe ('thank God, that's them, not me').

This is Warhol's great theme, and his vitality as an artist in this period is due largely to how he mobilises and bears witness to these forces. The success of his work from the early 1960s lies, then, in the way it traces the fault lines of our alienated pleasures, providing an entry point for Warhol's own disaffected sensitivities as a gay consumer of mass culture. The heightened artificiality, repetitions and slippages of the images, and the blankness and flatness of the canvas's ground are more than formal contingencies. Rather, they cohere to perform a series of interruptions in the bland and anonymous surface of the commodity, be it domestic product or tabloid photograph. The misregistrations and repetitions introduce a palpable sense of anxiety across the surface of the forms and scenes of mass-mediated experience. In this way, the early work draws on how the mass-media representation of the traumatic event produces its own trauma: the heightened emotional

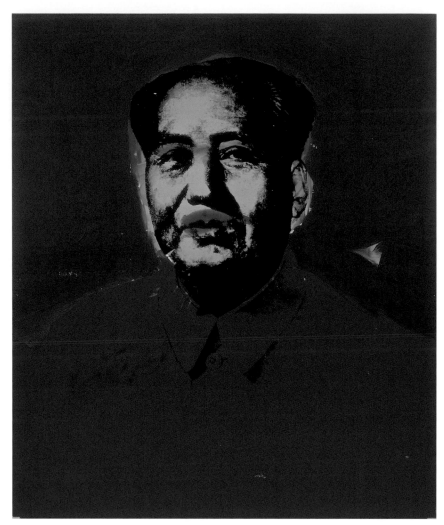

PLATE 11.14 Andy Warhol, *Mao 6*, 1973, acrylic and silkscreen on canvas, 30 x 25 cm. (Photo: The Andy Warhol Foundation/Art Resource/ Scala, Florence. © The Andy Warhol Foundation for the Visual Arts, Inc./ARS, New York and DACS, London 2004.)

exposure to an event separated from any real intimacy with it. But, if it is easy to point to the traumatic gap between representation and referent in the overtly violent content of the *Disasters* and the *Suicides*, the 'traumatic' content of the celebrity portraits is less straightforward. On the one hand, as flat and affectless, they are witness to the fetishisations of the commodity form, and the willingness of the modern mass subject to invest in the celebrated lives of others; but as admired images they represent the triumph of American capital and the American drive for self-transformation.

This suggests that in this period Warhol was not simply a social realist in the making. The early work does not provide us with a stable position of political critique in which to anchor any sense of anxiety we may have about the

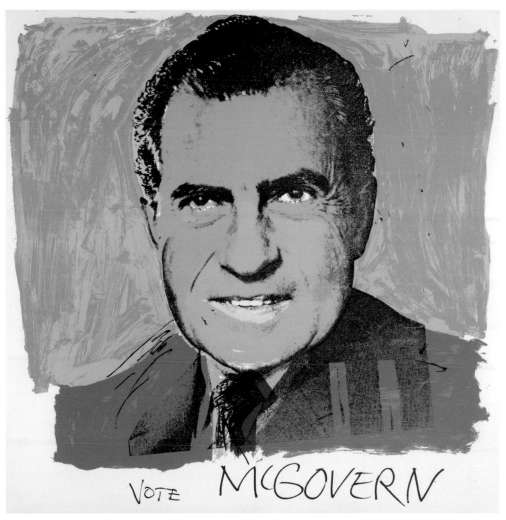

PLATE 11.15 Andy Warhol, *Vote McGovern*, 1972, screenprint printed on Arches paper, composition 105 × 104 cm, sheet 107 × 107 cm. (Museum of Modern Art, New York. Gift of Philip Johnson. © 2003, DIGITAL IMAGE, The Museum of Modern Art, New York/Scala, Florence. © The Andy Warhol Foundation for the Visual Arts, Inc./ARS, New York and DACS, London 2004.)

instrumentalism of mass culture. It is as if Warhol was drawn too strongly by the ambivalent pleasures of celebrity. Even in the early work the pull was strong, and, as we know, the masochistic pleasures of celebrity culture eventually won out. By the late 1960s, the *Disasters* are as much a memory as the radical commitment to a multifunctional aesthetic. Rather, what is borne along by these early works is the possible *re-eroticisation* and *re-enchantment* of mass production. In short, what began to shape Warhol's work in the early 1960s – and increasingly and sentimentally so after 1968 – was the possible *spiritualisation* of the commodity. Warhol, above all, wanted to bring enchantment to the commodity and to the machine. And the best way to do this, he believed, was to continue to invest in the mechanically produced painting.

The re-enchantment of mass production

The spiritualisation of capitalist production is an old theme in the history of twentieth-century art and modern technology. The emergence of new technologies of mass reproduction provided artists with the opportunity to think about using technology to increase the aesthetic well-being of all. In this way, Warhol's submission to technology and mass production as the democratisers of desire and pleasure has strong echoes of debates on commodity culture and technology developed 60 years before the advent of the Factory in the Werkbund in Germany, the precursor to the Bauhaus. Writers such as Georg Simmel and Werner Sombart were involved in a lengthy and intense discussion of the function of art and design under capitalism.[12] Capitalist production, they argued, causes the decline of culture and the alienation of human beings. But, they also claimed, capitalism was able to advance out of its internal contradictions through the development of technology. Capitalism may transform what Simmel calls style (stable and universal systems of representation) into fashion (the fragmentation of form), but the mass production and distribution of well-designed and well-made commodities provide the basis — through the diffusion of identical forms — for a common culture. Mass-produced commodities are able to redeem the alienation of self and fragmentation of culture produced by the market. From this perspective, fashion — as inscribed in the changing surface of things — was held to be the bearer of a comforting sameness. This strange, idealist vision of an enchanted mass production is close to Warhol's idea of 'Commonism' and assembly-line art. Like the Werkbund, Warhol was not interested in the critical place of artistic production within the social totality, but in how art might intervene in and reinvigorate capitalist forms of production — how art in mass production might allow us to see sameness as difference. Again, like the Werkbund, Warhol sees this occurring through a reunification of art and design as a means of transcending the division between 'high culture' and popular culture, intellectual labour and manual labour. In this respect, the Werkbund's theories of production and Warhol's notion of assembly-line art converge around two ideas in tension: on the one hand, the mistaken notion that art-as-design or design-as-art might re-enchant the alienated nature of capitalist production; on the other, the more promising notion that the mass forms of capitalist culture might be meaningful for art and not something to which art should be absolutely opposed.

On this basis, Warhol is the first major postwar American artist systematically to incorporate the reality of an alienated and disenchanted mass production into art. He is the first major postwar modernist to work within the culture industry's orbit without assuming that this diminished his seriousness as an artist. The economic imperative of mass production and the mediating role of the media are visibly entwined in the art's relations of production. The result is an art that constantly enacts the tensions between art's claims for autonomy and the economic imperative of the market. Twenty-five years later, this conjunction is, of course, what we now call postmodernism, or the culture of late capitalism — a space in which art's position inside the dynamic of mechanical reproduction and logic of the culture industry is taken to be, not the death of value and meaning, but the present site and destiny of art's (unhappy) modernity.

Notes

1 The Werkbund was a loose alliance of applied artists, designers and cultural theorists in Germany from 1907 to 1914, who were committed to raising the quality of the industrialisation of applied arts, rather than a return to small crafts production. The group organised exhibitions and lecture programmes and helped found a museum of applied arts. See Schwartz, *The Werkbund.*

2 For a discussion of Warhol's use of the term 'Commonism', see Jones, *Machine in the Studio.*

3 Valerie Solanas was the founder and director of the Society for Cutting Up Men (SCUM), the author of the SCUM manifesto (1967) and a member of Warhol's circle.

4 For a discussion of this critique in relation to Warhol, Stella and Smithson, see Jones, *Machine in the Studio.*

5 Warhol, *From A to B and Back Again*, p.92.

6 See Wollen, 'Plastics'.

7 Warhol, interview with Gene Swenson (1963), in Harrison and Wood, *Art in Theory 1900–2000*, VIA17, p.748.

8 Warhol interviewed by Douglas Arango, 'Underground Films: Art or Naughty Movies', in *Movie TV Secrets*, June 1966, quoted in Michelson, *Andy Warhol.*

9 For an extended discussion of the technological sublime in relation to postwar American painting, see Jones, *Machine in the Studio.*

10 See Crow, 'Saturday Disasters'.

11 For an extended analysis of this theme, see Foster, 'Death in America' and MacCabe, Francis and Wollen, 'Death in America'.

12 For a discussion of the Werkbund, Simmel and Sombart, see Schwartz, *The Werkbund.*

References

Crow, T., 'Saturday Disasters: Trace and Reference in Early Warhol', in Michelson, *Andy Warhol*, pp.49–66.

Foster, H., 'Death in America', in A. Michelson (ed.), *Andy Warhol: October Files*, vol.2, Cambridge, MA and London: MIT Press, 2001, pp.69–88.

Harrison, C. and Wood, P. (eds), *Art in Theory 1900–2000: An Anthology of Changing Ideas*, Malden, MA and Oxford: Blackwell, 2003.

Jones, C.A., *Machine in the Studio: Constructing the Postwar American Artist*, Chicago: University of Chicago Press, 1996.

MacCabe, C., Francis, M., Wollen P. (eds), 'Death in America', in *Who is Andy Warhol?*, London: British Film Industry and the Andy Warhol Museum, 1997, pp.117–30.

Michelson, A. (ed.), *Andy Warhol: October Files*, vol.2, Cambridge, MA and London: MIT Press, 2001.

Moholy-Nagy, L., *The New Vision*, trans. D.M. Hoffman, New York: George Wittenborn, 1946.

Schwartz, F.J., *The Werkbund: Design Theory and Mass Culture before the First World War*, New Haven and London: Yale University Press, 1996.

Warhol, A., *From A to B and Back Again: The Philosophy of Andy Warhol*, New York: Harcourt Brace Jovanovich, 1975.

Wollen, P., 'Plastics: The Magical and the Prosaic', in M. Francis and M. King (eds), *The Warhol Look: Glamour, Style, Fashion*, Boston and New York: Bulfinch Press, 1998, pp.142–51.

In search of a revolutionary consciousness: further adventures of the European avant-garde

Robert Graham

Introduction

The division of Europe into opposing camps after 1945 rapidly dispersed the mood of euphoria at the Second World War victory over Fascism, and instead the Cold War and the growing threat of nuclear annihilation led to widespread pessimism over any lasting prospects for social emancipation. In this chapter, I shall be examining avant-garde responses to the alienation caused by being apparently trapped between the repressive tolerance of a triumphant capitalism and a doctrinaire Stalinist communism. My main focus will be on developments in France between 1945 and 1968.

Despite exhibiting considerable diversity, responses during the first postwar decade shared an element of common ground in a fragile utopianism. In the aftermath of war and the Holocaust, enquiry into notions of a common humanity tended to focus on the nature of the human 'subject' itself. Two major intellectual influences on developments in the arts at this point were on the one hand a shift towards a 'humanist' reading of Karl Marx's early writings (as opposed to the prevailing view of him as an economist), and on the other the rise to prominence of the philosopher Jean-Paul Sartre's Existentialism. These critical re-evaluations of the alienated human subject in terms of culture and everyday life led to ongoing disputes with and within the Communist Party, whose official doctrine was based on a 'scientific' reading of Marxism, in which 'consciousness' was seen as completely determined by socio-economic conditions. The final section of the chapter will consider the Situationist International, a movement that developed a socio-cultural critique based on the transformation of everyday life into a form of revolutionary praxis, posited against the resurgent capitalism that accompanied the revival of western European economies in the mid-1950s and 1960s.

PLATE 12.1 (facing page) Constant (Constant A. Nieuwenhuys), detail of *After Us, Liberty* (Plate 12.12).

Paris 1945–54

France, and Paris in particular, provided a focal point for these critical re-evaluations. In the immediate postwar years, the city had appeared to regain its prewar international status, the American critic Clement Greenberg declaring in June 1946 that the 'School of Paris remains still the creative fountain-head of modern art, and its every move is decisive for advanced artists everywhere'.[1] But Greenberg was soon to withdraw that judgement, and artists in other European countries began to resist Parisian claims to continuing centrality. To Leftist artists and intellectuals within Europe, calls for a 'conciliatory form of modernism' that would rebuild on the 'sure foundations of Fauvism, Cubism and abstraction'[2] were an inadequate response to economic hardship and political uncertainty. The postwar decade has been termed the *phase de deuil* ('mourning phase'[3]), the dramatist Antonin Artaud giving voice to the mood of pessimism and disenchantment in his claim that 'we are not yet in the world … things have not yet been created, the raison d'être has not yet been found'.[4]

The dominant radical avant-garde movement of the prewar period, Surrealism, was largely regarded as exhausted, and its leading members lacking in Resistance credentials. Most of them had left occupied Europe during the war, many going to New York, and the group was never to recover from this fragmentation. André Breton was not to return from the USA until May 1946, almost two years after the liberation of Paris from the occupying German forces. When he sought to regain Surrealism's position of avant-garde leadership with the 'Exposition Surréaliste Internationale' ('International Surrealist Exhibition') at the Galerie Maeght in 1947, the exhibits revealed the movement's misalignment with the mood of postwar France. The exhibition's 'supernatural' themes of black magic, voodoo and hidden sexual desires seemed superficial and trivial in the light of the recent history of Occupation and Resistance.

In the early postwar period, the French Communist Party (PCF) enjoyed considerable public support, buoyed by its Resistance record as the party of 75,000 martyrs. However, its increasing adherence to the bureaucratic and oppressive nature of the Stalinist artistic orthodoxy of Socialist Realism made it an unwelcome ally for independent radical artists. For many of these, although they were sympathetic to the Left, the call from Moscow for an art claiming to represent 'the inevitable triumph … of the democratic masses … and which … enriches the people with its lofty ideals and noble images',[5] was as out of tune with present needs, as was Surrealism's tendency towards mysticism. Although major figures such as Pablo Picasso[6] and Fernand Léger (Plate 12.2), both now Party members, had sufficient international status to assert their artistic independence, the Party's official aesthetic was typified by the propagandising heroics of André Fougeron's *Homage to André Houiller* (Plate 12.3). (André Houiller, a militant Party member, was shot and killed by an off-duty policeman in December 1948 while distributing posters for the PCF, which claimed that a proposed alliance with Germany would lead to nuclear war against the USSR.)

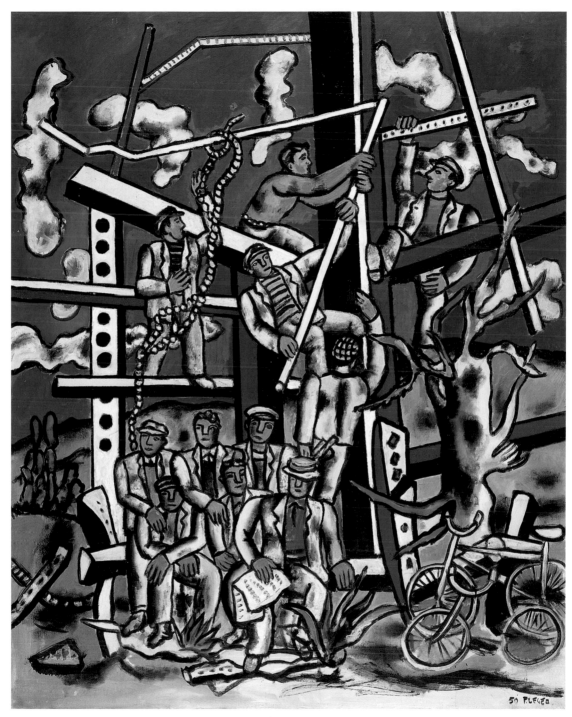

PLATE 12.2 Fernand Léger, *Study for The Constructors: The Team at Rest*, 1950, oil on canvas, 162 × 130 cm. (Scottish National Gallery of Modern Art, Edinburgh. © ADAGP, Paris and DACS, London 2004.)

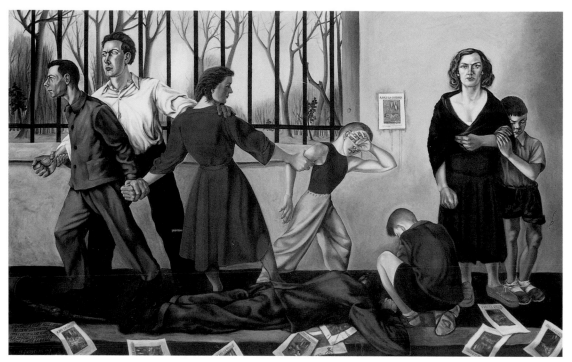

PLATE 12.3 André Fougeron, *Homage to André Houiller*, 1949, oil on canvas, 255 × 410 cm. (Pushkin Museum, Moscow. © ADAGP, Paris and DACS, London 2004.)

It was Existentialism rather than Surrealism that best responded to the mood of disillusion expressed by Artaud, and in so doing mounted the strongest ideological challenge to the PCF. Simone de Beauvoir described an 'Existentialist offensive',[7] in which Existentialist ideas caused a furore in Paris, infiltrating themselves into mainstream culture through literature, drama, poetry, lectures and journals. The central figure was Sartre, who, after the war and experience of the Resistance, sought to popularise Existentialism, broadening its social appeal by recasting it as a form of humanism.[8] In addition to Sartre's own prolific writings, the works of Jean Genet, de Beauvoir, Albert Camus and Francis Ponge in the field of literature, Samuel Beckett and Eugene Ionesco in the theatre, and Maurice Merleau-Ponty in philosophy all contributed to the Existentialist discourse on 'man's' origins and existence. Although a serious intellectual enquiry, Existentialism also took on the mantle of a fashionable sensibility of alienation, expressed in a vogue for self-dramatisation over the 'meaninglessness' of life, while indulging in the new freedoms played out in the bars and cafes of the Left Bank of the Seine.

The mood found its most resonant expression in the Theatre of the Absurd. Arguably, it is through Estragon and Vladimir, the two tramps in Beckett's play *Waiting for Godot* (first performed in Paris in 1953), vainly waiting for the supernatural revelation that would provide meaning for their existence, that Existentialist ideas have filtered through into the English-speaking world. Beckett identified the work of the painter Bram van Velde as paralleling his own, awarding him the dubious accolade of 'the painter of failure'. His *Expression or Composition* (Plate 12.4) is almost a parody of the geometric abstraction favoured by the School of Paris, which at this time

PLATE 12.4
Bram van Velde,
Expression or Composition, 1948,
oil on canvas,
100 × 81 cm.
(Musée Granet,
Aix-en-Provence.
Anonymous donation
to the state held in
usufruct, 2000.
Photo: RMN –
Michèle Bellot.
© ADAGP, Paris and
DACS, London 2004.)

constituted a sort of 'official avant-garde', a reassuring symbol to many that Paris's position at the forefront of modernism was secure. Van Velde's works have been described as possessing 'a very real sense of the incomplete … [of] lack of resolve … lines go nowhere … images are hinted at, yet come to nothing'.[9] To Beckett, van Velde's paintings showed that 'there is nothing to paint and nothing to paint with'. He described him as 'the first to admit that to be an artist is to fail … For what is this coloured plane, that was not there before … It seems to have nothing to do with art.'[10]

A leading Marxist critic, the Hungarian philosopher Georg Lukács, was to diagnose this 'absence of meaning … of paralysis … this vision of a world dominated by *angst*' – which he located in the work of modernist artists, citing the writings of figures such as Beckett and Franz Kafka – as symptomatic of 'a desire to escape from the reality of capitalism'.[11] For Sartre, however, angst was not a negative experience contingently dependent upon socio-economic structures, but was accorded a positive value within the Existentialist conception of a free human being. As such, it became a key concept in the

construction of a meaningful existence. According to Sartre, 'in anguish I apprehend myself … as totally free and as not being able to derive the meaning of the world except as coming from myself'.[12] Such freedom follows from each person's realisation that they and the rest of humankind have been abandoned in a godless universe for the brief interval of each individual's lifespan. For Sartre, 'man is nothing else but that which he makes of himself'. In order to construct a purposeful and moral life it is axiomatic that 'our point of departure is … the subjectivity of the individual',[13] for only as beings that are fully conscious of the conditions of our existence can we realise the true nature of our freedom of choice. For the most part, Sartre argues, we hide from the truth of this condition, escaping the burden of responsibility as if our choices were predetermined by the situations and social roles that we inhabit. In this case we are guilty of *mauvaise foi* ('bad faith' or 'self-deception'). Only by acknowledging that 'there is no determinism – man is free, man *is* freedom' can we bear the responsibility of the choice, no matter what situation may face us. Given this basic condition of consciousness, Sartre believed that as 'what we choose is always the better, and nothing can be better for us unless it is better for all'.[14] By emphasising Existentialism's intersubjective and social character, it seemed possible to Sartre that he could bring about a kind of rapprochement between Existentialism and Marxism. He believed that Existentialism could rescue Marxism from the determinism that threatened to render it inadequate to modern society with its emphasis on the individual.

Un art autre

Sartre maintained that whereas 'ideas' could be given cogent expression in literary form, they could only inadequately be expressed in the visual arts, and used his own novels and plays as a polemical medium to awaken the free choice of the individual reader. What Existentialist thought valued in painting and sculpture was work that expressed, at a more phenomenological level, 'the universal horror of being-in-the-world'.[15] Sartre claimed to discern this quality in certain artists, whom he regarded as seeking to define themselves within this existent reality rather than imposing a hierarchy of predetermined values upon the world.

Coincident with the rising status of Existentialism was the development in France of non-geometric abstraction. Such works typically ranged from the fully abstract to the loosely figurative, but in general they affected a sense of spontaneity, of a struggle for expression and definition. *Art informel* ('informal art'), as such painting became known, served to underpin a call by the critic Michel Tapié for *un art autre*, an 'other' art free from all formal constraints. Tapié's essay resonated with Existentialist notions, asserting that it was now 'impossible to create some new "ism" … Our interest is not in movements, but in something much rarer, authentic Individuals.'[16] The works of three artists in particular, Jean Dubuffet, Jean Fautrier and Wols (whose full name was Alfred Otto Wolfgang Schulze), each given individual exhibitions at the Galerie René Drouin soon after the liberation of Paris, have been identified as the precursors of *art informel*, and pioneers of what has been termed a search for new origins in the postwar period.

Jean Fautrier's *Head of a Hostage No. 14* of 1944 (Plate 12.5) was first displayed in his 'Otage' ('Hostage') exhibition at the Galerie René Drouin in October 1945. It was one of a series, each of a similar scale and format suggestive of the remains of a human face, as if it was dissolving into the delicate hues of the surrounding ground. The 'face' itself is heavily impastoed, Fautrier using up to 50 tubes of white paint, fused with crystals, powders and oils, in the preparation of a heavy paste, which he worked up into near bas-relief.[17] Brushmarks loosely delineate profiles, eyes, noses or mouths, although never a complete face. The similarly disfigured and anonymous images were hung in deliberately monotonous rows, providing a visual analogy with the systematic techniques with which the occupying German forces had dealt with their victims. Fautrier's own history is relevant here, for after being briefly imprisoned by the Gestapo in 1943 on suspicion of Resistance activities, he took sanctuary in the grounds of a sanatorium on the outskirts of Paris. German occupying forces used the surrounding woods for torture and summary executions and Fautrier's studio was in earshot of the firing guns and the cries of victims.

PLATE **12.5**
Jean Fautrier, *Head of a Hostage No. 14*, 1944, oil on paper 35 × 27 cm, frame 40 × 31 cm. (Museum of Contemporary Art, Los Angeles. The Panza Collection. Photo: Valerie Walker. © ADAGP, Paris and DACS, London 2004.)

In what ways do you think Fautrier might have marked out an avant-garde status for himself with works such as *Head of a Hostage No. 14*?

One point you might consider is Fautrier's innovative technique, whereby elusive figuration within an abstract ground, part oil painting, part relief-sculpture, enables him to avoid categorisation within the tradition of *belle peinture*, and its elevated position in western culture. The small scale of the work contrasts with Fougeron's heroic Socialist Realist treatment of martyrdom for a cause in his *Homage to André Houiller* (Plate 12.3), as does the anonymity of Fautrier's victim of oppression, devoid of iconographic symbols that might link the figure to his or her individual history, to nation or to abstract ideals, to the tricolour, red flag or whatever. As it shows neither the heroism of the victim nor the brutality of the aggressor, without the aid of the title and date of production it would be hard to connect this work to events of the Occupation. However, the connotations of solitariness, of death and decay serve to align the work with the Existentialist sensibilities of the postwar period. ∎

The exhibition of Fautrier's *Hostage*s caused a minor sensation, some observers finding the delicate colours of the ground surrounding the stark and jagged features of the decaying heads uncomfortably attractive. But the strongest criticism was reserved for the work's form, or rather what was perceived as its absence. The critic Waldemar George, a supporter of Fautrier's practice in the 1930s, declared that 'his art … is the triumph of the formless. It has become reduced to a puerile scribble grafted on to a colour which remains totally alien to him. The case of Fautrier is that of a great painter who commits suicide.'[18] The poet Francis Ponge, whose own work centred on the continuing metamorphosis of decomposition and recomposition of the organic and inorganic elements of the world in which reality is essentially formless, took the opposite view, praising Fautrier's technique in terms of 'a cat relieving himself in the embers … [of] a pasty sticky mortar … by clawing the ashes, with a dash of earth, a dash of ash … ritually covering over the excrement'. For Ponge, these works displayed a 'new human resolve',[19] and from that point of view, 'formlessness' does not so much represent a breakdown of aesthetic values, as an engagement with reality at the level of matter itself, one in which Fautrier's effects give expression to the processes of mutation and transformation.

It was in the work of Wols that informal and Existentialist notions most closely coincided. A quotation from Sartre's novel *La Nausée* ('Nausea'),[20] included in the preface to Wols's 1945 exhibition at the Galerie René Drouin, reflected the anguished condition of Being itself: 'objects shouldn't touch, for they don't live. And yet they touch me: it's unbearable. I'm afraid of coming into contact with them.'[21] Before the war, Wols had been a photographer, linked to the Surrealists, but as a German national he was interned as an enemy alien in 1939, and on his release a year later lived a fugitive and poverty-stricken life in the South of France, moving to Paris after the Liberation, where he was befriended by Sartre.

First in the watercolours shown at the Galerie René Drouin in 1945, and then after taking up painting in oils, Wols developed a form of expression that has been termed 'psychic improvisation'.[22] In a series of aphorisms composed during the 1940s Wols expressed a view of human existence as ephemeral, unstable and insignificant:

Man is no more interesting
than other temporary manifestations ...

It is doubtful if man
can reach the level of wasps ...

One is born – one dies
one comes from the great nothing and one goes back there
it is laughable ...[23]

It is interesting to view Wols's *Untitled* (Plate 12.6) in terms of his own description of his work as it developed after 1941, as that in which 'personal dramas hardly count/and where ugliness and beauty become one'.[24] Although suggestive of structures that might be found in the natural world, the loosely elliptical shape that occupies the central plane, seemingly suspended in an undefinable space, is a product of Wols's imagination. In Sartre's view, Wols does not treat these unknown objects as 'abstract forms', but as 'concrete ... *others*',[25] through which man seeks to visualise his being-in-the-world. For Sartre, the indeterminate articulation of pictorial elements was alienation in plastic form, and signified Wols's escape from the literary art of the Surrealists in which 'the Verb is king'.[26] We might see Wols's painting as a metaphor for Sartre's theory of consciousness, in which consciousness is always projecting forward to a world that is beyond our grasp, hence the never-ending need to redefine ourselves within the world. For Sartre, Wols captures the anguish of this endless 'becoming', each work existent but untranslatable into a coherent sense of Being, this certainty being denied to the experiencing viewer by the work's 'incessant metamorphosis'.[27]

PLATE 12.6 Wols (Alfred Otto Wolfgang Schulze), *Untitled*, c.1944–5, drawing, watercolour and gouache on paper, 9 × 14 cm. (© Tate, London 2003. © ADAGP, Paris and DACS, London 2004.)

Dubuffet and *l'art brut*

Dubuffet declared himself an enthusiastic but uncomprehending convert to Existentialism. His attempts to engage with the 'authentic' led him to incorporate the 'art' of marginalised elements within contemporary society into his own avant-garde practice. In order to distance this work from the connotations of 'fine' art, Dubuffet coined the term *l'art brut*, which roughly translates as 'crude' or 'raw' art: the art of the 'uncultured', including graffiti and the art of the maladjusted, psychotics and children. He regarded such individuals as sufficiently alienated from mainstream culture to be capable of producing works of innocence and originality, and as such devoid of 'bad faith'. Hanz Prinzhorn's 1922 study *Artistry of the Mentally Ill* was an important influence on Dubuffet, who had acquired a copy soon after its publication. Prinzhorn, a psychiatric doctor who had earlier studied art history and philosophy, amassed a collection of 5,000 examples of art works from psychiatric institutions, and his study of these led him to conclude that the development of modern civilisation repressed the natural creative urge that was common to all people. To Prinzhorn, the 'semi-chaotic structure' of the Expressionist-like *Abstract-decorative Play* (Plate 12.7), by an unidentified patient, 'cannot be reduced to a set of rules but springs from the arbitrariness of a personality liberated from some restraint'.[28] To Dubuffet, such art was proof of the failings of the 'art of the museums, galleries and salons …[of]

PLATE **12.7** Case 229, *Abstract-decorative Play*, crayon, 31 × 23 cm. (From H. Prinzhorn, *Artistry of the Mentally Ill*, Springer, Vienna, 1972, reprint 1995, opp. p.50.)

cultural art'. He posited an identical character common to all as potential producers of art, declaring that 'there is no more an art of the mad than there is … an art for those with bad knees'.[29]

Dubuffet followed up his interest in the art of the 'outsider', building up his own collection of the art of the marginalised. In 1948, he established the Compagnie de l'Art Brut, in association with Breton, Tapié and the poet Jean Paulhan. He believed that the expressive potential of 'those untouched by artistic culture …[where] the artists take everything (subjects, choice of materials …) from their own inner being …[is] an artistic enterprise that is completely pure, basic'.[30] To an extent, one can see Dubuffet here reworking early twentieth-century primitivism. Once again, when contemporary culture seemed to be in crisis, an avant-garde response was to look beyond, or beneath, the conventional limits of what was regarded as art for material to reinvigorate a critical practice.

Dubuffet's interest in the 'primitive' was to serve as an invaluable resource for his own work, helping to establish a vigorously anti-cultural position, based upon the belief that modern man is capable of divesting himself of his own culture and acquiring a primeval 'purity' through art practices. His second major exhibition at the Galerie René Drouin in May 1946, 'Mirobulus Macadam & Cie/Hautes Pâtes', caused a scandal, doing much to establish his avant-garde credentials. Peter Selz writes that 'in the best dada tradition, paintings were slashed by infuriated spectators … nothing had so outraged the Paris art world in a great many years'.[31] In works of this period and later works such as *The Busy Life* (Plate 12.8), Dubuffet went beyond Fautrier's innovations,

PLATE 12.8 Jean Dubuffet, *The Busy Life*, 1953, oil on canvas, 130 × 196 cm. (© Tate, London 2002. © ADAGP, Paris and DACS, London 2004.)

using a thick impastoed paste – his *haute pâte*. It was this, rather than the deliberate crudity and naivety of his subjects, that caused the greater affront to the viewers' sensibilities. The paste was prepared from mixtures of oils and water, tar, varnish, cement, plaster, coal dust, grit and glues, and the support was pasted with a dense layer, which he could physically dig into and gouge away, working both within and on the surface. The calculated naivety of the subject matter, the drawing's echoes of the 'uncultured' art of children and the roughness of surface suggest the raw vigour of urban graffiti. He expressed his aims in terms of an art of the common man: 'it is the man in the street that I'm after, whom I feel closest to … *he* is the one I want to please'.[32]

Dubuffet's declaration that 'my art is an attempt to bring all disparaged values into the limelight'[33] reflected his subversive intent towards 'fine art' tradition in all its forms. He continually experimented with materials and worked through thematic subject matter in series until he had exhausted their potential. He wrote of his pastes as possessing an animal-like 'disposition' or 'being', such that 'formless does not mean inert, far from it'. Dubuffet described how the paste that he used in his *Corps des Dames* ('Women's Bodies') series of paintings – a mixture of zinc oxide and a thin but viscous varnish – changes its character as it dries, and how as glazes are then applied they 'organise themselves into enigmatic branches'. These techniques also provided the means to challenge the traditional representation of the female body, a 'subject, so typical of the worst painting [and] … of all the objects in the world … the one that has long been associated (for Occidentals) with a very specious notion of Beauty (inherited from the Greeks)'. Dubuffet's intention was to dismantle what he regarded as an unhealthy cultural convention, in place of which he would 'substitute another and vaster beauty, touching all objects and beings, not excluding the most despised'.[34]

Look at *Tree of Fluids* (Plate 12.9), one of the *Corps des Dames* series. How has Dubuffet subverted 'high art' conventions? How might the work 'bring all disparaged values into the limelight'?

Clearly, the representation of 'Woman' in this work challenges a range of artistic treatments of the subject, most notably those employing idealised representations of classical beauty. The figure is ill proportioned and crudely outlined, the arms and hands mere schematic suggestions, with an undersized head perched on top of a bulbous body. The path of the glazes across the body is suggestive of the viscous quality of bodily fluids, and the sense of immateriality is strengthened through the lack of definition of the figure itself, the bodily form almost flowing into the pinkish glazes of the ground. The flattened appearance – the almost total absence of volume and pictorial depth – is suggestive of graffiti art, and the explicit indication of sexual parts might also point to the artistic efforts of the 'uncultured', which for Dubuffet, of course, are not failings but virtues. You might also consider the 'crudity' of depiction in terms of its energetic vigour, perhaps noting that the figure's facial expression is strangely incongruous in relation to its body. Finally, how far such work subverts the traditional relationship between humankind and nature, in which humanity is positioned at the peak of a hierarchical pyramid, merits thought, for here it seems that the value placed upon the materials of Dubuffet's practice – the pastes and glazes – accords matter itself equivalent weight to the representation of the human figure. ■

PLATE 12.9
Jean Dubuffet,
Tree of Fluids, 1950,
oil on canvas,
116 × 89 cm.
(© Tate, London
2002. © ADAGP,
Paris and DACS,
London 2004.)

Giacometti

Several of the leading intellectual figures of Existentialism responded positively to the work of the Swiss sculptor and painter Alberto Giacometti. Genet saw in figures such as *Man Pointing* (Plate 12.10) that 'most irreducible fact' of human existence, 'the loneliness of being exactly equivalent to all others'.[35] Ponge wrote of 'the free individual ... alone – reduced to a thread – in the dilapidation and misery of the world',[36] while Merleau-Ponty argued for the authentic nature of Giacometti's 'perceptual experience, which like the sight of a new born child, precedes knowledge'.[37]

Giacometti had abandoned the Surrealism of his prewar practice in favour of a return to modelling the human figure. His efforts to represent the partial nature of our perceptions of another living presence situated at some distance from us met with enthusiastic acclaim from Sartre, who shared the artist's

PLATE 12.10
Alberto Giacometti,
Man Pointing,
1947, bronze,
176 × 90 × 62 cm.
(© Tate, London
2002. © ADAGP,
Paris and DACS,
London 2004.)

opposition to the classical tradition. In his catalogue essay 'The Search for
the Absolute' to accompany Giacometti's 1948 exhibition in New York, Sartre
characterised the fully modelled sculptural form in terms of 'bad faith': 'for
three thousand years, sculpture modelled only corpses … one must begin
again from scratch'.[38] For Giacometti, the 'great mass of dead clay' of a fully
modelled head, also failed to convey his understanding that 'in a living head
the inside is as organic as the surface'. His process of finding 'the real through
external appearances' was achieved through figures such as *Man Pointing*
that were slim and elongated, capturing an 'appearance which is almost
transparent … light'.[39] For Sartre, this process of elongation was a means to
give 'sensible expression to … pure presence'. He seemed to regard
Giacometti's achievement, in representing 'man … as he appears in an
intersubjective world' as one that could overcome the condition of humankind
as alienated and solitary; 'each shows us that man is not there first and to be
seen afterwards, but that he is the being whose essence is to exist for others'.[40]

Cobra

Sartre's efforts to liberate man from alienation were to find an active political outlet in 1948, when he became a founding member of the Rassemblement Démocratique Révolutionnaire (RDR: 'Revolutionary Democratic Union'), formed in liaison with other members of the non-communist Left. However, his hopes of uniting a humanist version of the Marxist concept of class struggle with the Existentialist 'free' subject as a socially critical force were soon frustrated. The RDR was to survive barely a year, collapsing in June 1949, but in November 1948 a group of artists meeting in a Paris café formed a politicised avant-garde art movement, Cobra. The group members shared common ground with many of Dubuffet's anti-cultural attitudes and practices, and his promotion of an art of the 'common man'. However, they differed from his apolitical universalism, seeking to locate their work within an emancipatory programme of experimental art supportive of revolutionary socialism. Constant A. Nieuwenhuys (known generally as Constant), the Dutch artist and founder member of Cobra, expressed this in the claim that 'any real creative activity that is, cultural activity in the twentieth century – must have its roots in revolution'.[41] The group's name was drawn from the initial letters of the capital cities Copenhagen, Brussels and Amsterdam, and the group described itself as a 'flexible bond between the experimental groups of Denmark [Høst], Belgium [Surréaliste-Revolutionnaire] and Holland [Reflex]'.[42] Although this international association of artists was formed in a Paris café, the group consciously excluded the École de Paris. The Belgian poet and chief chronicler of the group, Christian Dotremont, observed that 'Paris is no longer the centre of art, it has become the centre of difficulties'.[43]

The belief that experimental art was revolutionary had been vividly expressed by Dotremont in October 1947, a year before the formation of Cobra: 'he who has the experimental spirit must necessarily be a Communist'.[44] The occasion was the foundation of the group Surréaliste-Révolutionnaire ('Surrealist Revolutionary'), organised by Dotremont and composed mainly of a small group of Belgian poets and writers, who rejected both Breton's tendency to occultism and his refusal of all forms of collaboration with the official Communist Party (having been expelled in 1929). After the formation of Cobra, Dotremont remained a member of the Party, and his attempts to retain an independent artistic practice infused with a spirit of militant communism represented one of the diverse theoretical streams that fuelled the group's art practices. There was, however, agreement about what the members termed the 'three dangers to Cobra'. These they identified as 'Surrealism, Abstract Art, Social Realism', which in their view constituted the '*formalism*' that was responsible for what the Cobra artists regarded as the cultural paralysis of society.[45] Against this they posited an experimental art drawing upon a variety of 'primitive' or 'outsider' practices, including popular culture, folk art, Scandinavian mythology and the presocial art of children. In by now familiar fashion, their aim was to recover the elements of spontaneity and creativity that they believed would provide the basis of a socially radical art.

Such attempts to reposition the radical within the realm of a spontaneous uninhibited creativity were given support by ideas drawn from the writings of Henri Lefebvre and Gaston Bachelard. Lefebvre's *Critique of Everyday Life*,

published in 1947, was a re-evaluation of Marx's writings, arguing that cultural practices, as much as economic ones, were forms of production. Thus, the site of revolutionary engagement should lie within the cultural production of human existence as much as the traditional spheres of politics and economics. For Lefebvre, 'in so far as the science of man exists, it finds its material in the "trivial", the everyday'. It is the science of man in this sense that Lefebvre claims 'has blazed the trail for our consciousness'.[46] Such a critique would counter cultural alienation at the level of quotidian experience, and contribute to the '*the art of living*'; Lefebvre's utopian vision of the future that 'presupposes that life as a whole – everyday life – should become a work of art'.[47]

Bachelard had published a number of works in the 1940s, in which he argued for the material nature of the imagination. In *Water and Dreams*, he suggested that the imagination 'is the facility of forming images which go beyond reality, which sing reality … Imagination invents more than objects and dramas; it invents a new spirit; it opens eyes which have a new type of vision.'[48] This concept of an active imagination directed onto the external world as the means to create a new revolutionary reality lent philosophical support to what the Cobra artist Asger Jorn termed 'material realism'. This insistence on prioritising the material and phenomenological experience of the world informed Jorn's criticism of Breton's Surrealism. He argued that the notion of '*pure* psychic automatism' was contradictory, contending 'that psychic automatism is linked organically to physical automatism … the reality which *forms* thought is … man's *body*'.[49]

The collaborative nature of the Cobra enterprise is represented by Dotremont's and Jorn's word-picture *I Rise, You Rise, We Dream* (Plate 12.11). Although drawing on Surrealist automatism, the dual production of the work suggests that the 'dream' is not the realisation of an individual neurosis, but in a wider sense represents the collective aspirations of its joint authors, as well as of those it addresses. According to Jorn, the dream is not to be dismissed as mere fantasy, but is an imaginative path through which the falsities of present 'reality' can be overcome. Dotremont described the process as an attempt to '(automatically) … mix words and images organically',[50] and it is in this sense that the work can be seen as exploring Jorn's claim that, 'the dream is the material world's realistic means of correction'.[51]

Constant's manifesto statement, published in *Cobra* no.4 under the title 'Our Own Desires Build the Revolution', reflected these attempts to shift the common-sense view of reality. He placed the emancipatory potential of dream/desire within a dialectical process, which would release the creativity curtailed by present cultural bonds:

> *it is impossible to know a desire other than by satisfying it, and the satisfaction of our basic desire is revolution* … Dialectical materialism has taught us that consciousness depends upon social circumstances, and when these prevent us from being satisfied, *our needs impel us to discover our desires.*[52]

The article was accompanied by reproductions of children's paintings and drawings, as well as a painting by Constant himself (Plate 12.12). The idea that freedom was to be found in the 'elementary' forms of the art of children and similarly those of primitive art, these representing a natural art, and

thereby opposed to the perverted forms found in the illusionistic pictorial space of the academy or social realism, underlies Cobra practices and beliefs. In his article 'Forms Conceived as Language', Jorn argued that 'the origins of art are instinctive and thus materialistic'. Jorn observed that 'no primitive person in the world will apply himself to the direct and slavish copying of a thing'. Thus, for Jorn the realism of 'elementary signs [is] … that which primitive people … do when they draw the child in the womb of the mother: it is known to be there, but though unseen it is rendered visible'.[53]

PLATE 12.11 Christian Dotremont and Asger Jorn, *I Rise, You Rise, We Dream*, 1948, oil on canvas, 38 × 33 cm. (Collection Alechinsky, Bougival. © DACS, London 2004. © Asger Jorn/DACS, London 2004.)

PLATE 12.12 Constant (Constant A. Nieuwenhuys), *After Us, Liberty*, 1949, oil on canvas, 140 × 107 cm.
(© Tate, London 2002. © DACS, London 2004.)

PLATE 12.13
Karel Appel,
Questioning Children,
1949, painted wood
relief, 105 × 67 cm.
(Stedelijk Museum,
Amsterdam. © Karel
Appel Foundation/
DACS, London 2004.)

In a similar vein, the Cobra artists rejected what they saw as the sterile
aesthetic of modernist abstraction, Constant writing that they should 'fill
Mondrian's virgin canvas, even if it is only with our misfortunes'.[54] In contrast,
Cobra's 'materialist realism' typically exhibited a powerful expressive form,
but whereas the Dutch artists tended towards an art that took on the guise
of that produced by children (Plate 12.13), the Danes looked to their own
Nordic past as a resource (Plate 12.14). In Karel Appel's *Questioning Children*
(Plate 12.13), the rough wood relief and elemental forms of the images

combine to imbue the inquisitive gaze of the children with a vigour and penetration whose energy is matched in Carl-Henning Pedersen's *Starred Heads* (Plate 12.14) by the strongly impastoed forms of these joyously radiant creatures of the night drawn from Scandinavian mythology. Comparisons with the anarchic vitality of much of Dubuffet's work are evident, as is the sense of naive hedonism, and these give emphasis to the contrast between Cobra's vigour and optimism, and what the group saw as the ascetic rigour of Sartre's Existentialism or the idealist 'purity' of Piet Mondrian. The group's attitude is captured in an aphorism in *Cobra* no.4 by the Dutch artist Corneille G. van Beverloo (known as Corneille) that 'whoever denies happiness on earth denies art'.[55]

Cobra promoted its work through co-operative ventures, publishing its magazine and exhibiting in a number of European countries. Similarly to the prewar Surrealist movement, the group brought artists into its orbit whose works seemed to share some common ground. Artists from Canada, Cuba and the USA, as well as from eight European countries, took part, including Joan Miró and Giacometti, although some of the works verged on a level of lyrical abstraction only loosely related to Cobra principles.

However, the group was to find its path to a new vision littered with obstacles, ultimately becoming victim to the very circumstances that gave it birth. The developing Cold War intensified the divisions on the Left between Stalinists and the Cobra artists and poets broadly sympathetic to Marxism, but not to the version promulgated by the USSR. Dotremont's attempts to bridge the gap between the Stalinists and the Surrealist Revolutionaries were to end in failure. His belief that science and poetry or art could be employed in unison to explore reality through the creative imagination was illustrated in a series

PLATE 12.14
Carl-Henning Pedersen, *Starred Heads*, 1949, oil on canvas, 102 × 121 cm. (Louisiana Museum of Modern Art, Humlebaek, Denmark. © DACS, London 2004.)

of comparisons in *Cobra* no.3. The proximity of Surrealism and scientific materialism was indicated by the juxtaposition of images such as the head of a waterflea, filmed through a microscope, and the head of an Indonesian shadow puppet (Plate 12.15). Dotremont justified the validity of this Bachelardian experiment, claiming that 'at the deepest source what animates the wise man and the poet … is the same indestructible mixture of desire and curiosity, of need and taste'.[56]

None of this cut any ice with orthodox communists, committed to an artistic doctrine of Socialist Realism, and soon afterwards Dotremont broke with the Communist Party, severing Cobra's links with organised left-wing politics. In the middle of 1950, Dotremont finalised his break with the communists by publishing a sixteen-page pamphlet, *'Socialist Realism' against the Revolution*.

PLATE 12.15 (above) Head of a waterflea, taken from a film by Jean Painlevé, 1928. (© Les Documents Cinématographiques, Paris.) (below) Head of an Indonesian shadow puppet.

The optimistic character exhibited by much Cobra painting was also undermined by wider political contingencies. In 1950, as the Cold War intensified, Constant produced a series of paintings entitled *War*. In June 1950, Jorn exhibited a series of eight paintings, *War Visions*. An example from a later series is *The Eagle's Share* (Plate 12.16), painted in 1951. The work retains the sense of spontaneity evident in the Cobra paintings we looked at earlier, but the joyousness of Pedersen's *Starred Heads* is replaced by an angry intensity. The red, pink and violet hues are all encompassed by the harsh thickness of the black-feathered body of the two-headed eagle, rendered more horrific by a third set of bared teeth below the dual heads. The skull and black cat add to the macabre and threatening nature of the work. The art historian Guy Atkins records that in other versions of the work hordes of troops emerge from the underbelly, as if from a troop-carrying aircraft,[57] and Jorn was later to write of how *The Eagle's Share* summed up the Cold War atmosphere 'when everyone was living in constant dread of nuclear disaster'.[58] Although Atkins regards the 'symbolism [as] narrow and didactic',[59] the work still retains the Cobra aesthetic, the imaginative response required being of a different order from the literary reading offered by Fougeron's *Homage to André Houiller* (Plate 12.3).

PLATE 12.16
Asger Jorn,
The Eagle's Share,
1951, oil on masonite,
75 × 60 cm. (Silkeborg
Kunstmuseum,
Denmark.
Photo: Lars Bay.
© Asger Jorn/DACS,
London 2004.)

Cobra dissolved as a group following its final exhibition in October–November 1951. Tellingly, after the break-up of Cobra, Constant changed the original commanding title of *To Us, Liberty* to the more resigned *After Us, Liberty* (Plate 12.12), expressing his 'doubts about the possibility of "free art" in an unfree society'.[60]

The Situationist International

Cobra was not, however, the only attempt by left-wing artists and intellectuals in western Europe to find a way beyond Socialist Realism while rejecting the aestheticism of the modernist mainstream. Two movements that developed in tandem with the economic recovery of the mid-1950s and subsequent 1960s boom were Nouveau Réalisme ('New Realism') and the Internationale Situationniste ('Situationist International', SI). Both of these took up the challenge of a burgeoning capitalism whose principal cultural form was that of the mass media and consumerism. One of Nouveau Réalisme's main strategies was the incorporation of materials of mass consumption into works of art in a fashion not dissimilar from contemporary Pop Art (Plate 12.17). For their part, the Situationists sought to engage with the culture of capitalism at a more fundamental level. In particular, this involved the claim that the dominant mode of contemporary society was that of the 'spectacle'.[61] For the SI, a society of unconstrained affluence yoked to the fetishism of the commodity was an impoverished society, subjected to a form of cultural imprisonment. Guy Debord, the group's leader and main theoretician, argued that the commodity had colonised social life to the point that 'commodities are now *all* that there is to see'.[62] Life itself acquires the form of 'spectacle', within which social relationships are mediated by images and individuals represent themselves to the world and to themselves as if mere commodities. Consequently, for Debord, 'the spectacle's function in society is the concrete manufacture of alienation'.[63]

Fundamental to this critique is the belief that capitalism continually creates artificial needs, but not only was it 'directly geared to the fabrication of habits, [it] manipulated people by forcing them to repress their desires'.[64] Against this, the SI projected an experimental programme that would identify genuine, albeit primitive, desires, and would ultimately enable individuals to construct their own destinies through the emergence of new desires. Here, 'desire' is to be distinguished from the Surrealist concept of the liberation of the *un*conscious in an attempt to hasten social revolution. Debord contended that it is 'consciousness of desire and desire for consciousness together … [that] indissolubly constitute [the revolutionary] project'.[65] Central to the SI's programme was the 'construction of situations',[66] which were moments of life concretely and deliberately selected, and within which a range of critical strategies were employed to explore and develop new affective states of consciousness. The most important of these were *détournement* (the re-use and transformation of existing artistic elements) and the *dérive* (a form of loosely programmed drift through urban spaces). The experiences of *dérives* were to contribute to a new science of 'psychogeography' (the study of the effects of the 'environment, consciously organised or not, on the emotions and behaviour of individuals'[67]), located within an overarching programme of 'unitary urbanism'.

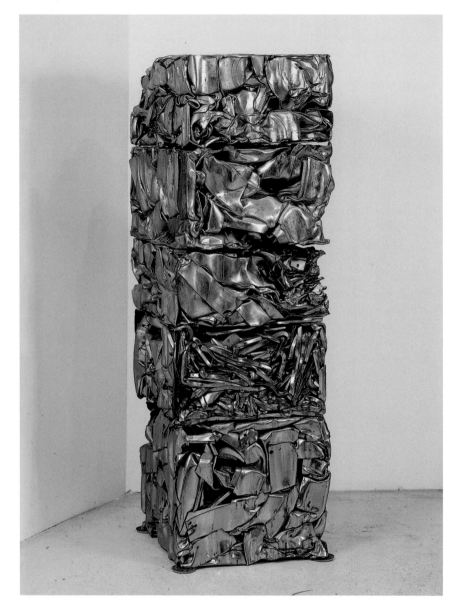

These ideas did not originate within the SI, but for the most part had been formulated within the earlier post-Surrealist avant-garde groupings of Isidore Isou's Lettristes and a later, breakaway faction, the Internationale Lettristes ('Letterist International', LI). Debord and other founder members of the LI criticised Isou and his Lettristes for too narrow a focus on culture as a means to revolutionary change. They were intent upon a more politicised avant-gardism as the path to the creation of a revolutionary subjectivity. *Détournement*, for instance, was perceived as the means towards the supersession of all existing art. Art was

> no longer ... justified as a superior activity ... Since the negation of the bourgeois concept of art and artistic genius has become pretty much old hat, [Duchamp's] drawing of a moustache on the

Mona Lisa is no more interesting than the original version of the painting. We must now push this process to the point of negating the negation.[68]

Following its formation in July 1957, the SI was to expound its policy of constructing 'situations' through its journal *Internationale Situationiste*, and at its annual conferences held in major European cities. The SI was formed principally out of the LI's union with another vanguard splinter group, the Mouvement Internationale pour un Bauhaus Imaginiste ('International Movement for an Imaginist Bauhaus'), which included the former Cobra figures Jorn and Constant, and the Italian artist Guiseppe Pinot-Gallizio, and was to grow into a genuinely international avant-garde movement of considerable effect. The SI declared itself to be 'a very special kind of movement ... different from preceding artistic avant-gardes', identifying itself as 'a research laboratory', in search of 'a certain future of culture, of life', that has yet to be discovered.[69] Although the SI's claims have the characteristic flavour of avant-garde excess, the group's ideas were to have an impact in May 1968 that had been virtually unknown to the avant-garde since the high point of the 1917 Russian Revolution.

The research undertaken in the practice of the *dérive* was directed towards a critique of the contemporary urban landscape, not least the 'excessively reactionary notion of life'[70] now evident in modernism's functionalist architecture. Modern cities, such as Paris, Berlin and London, were identified as laboratories for an exploration of relationships between space, desire and behaviour. The methodology adopted could be described as spontaneity systemised, in which the collation of affective experiences of the total environmental atmosphere – incorporating not just architectural forms, but visual fields, acoustic elements, movement, the distribution of food and drink – would lead to the creation of new aesthetic categories. Debord's account of a journey with Wolman on Tuesday 6 March 1956 provides a sense of the 'playful-constructive behaviour' that they hoped would open up the path towards new visions of time and space. Intending to head north from the Rue des Jardins-Paul, 'in order to explore the possibilities of traversing Paris at that latitude', they drift east, yet soon find that 'their itinerary is inflected in a north-westerly direction' and so on. The accidental juxtaposition of situations encountered – such as chancing upon a delicatessen bearing the name 'A. Breton' – tends to be of greater significance than instrumental purposiveness. They observe that the 'poor commercial standardisation' of a section of the 11th arrondissement is 'a good example of a repulsive petit-bourgeois landscape', whereas the charm of an abandoned eighteenth-century neo-classical tollhouse, now a 'virtual ruin ... is singularly enhanced by the curve' of a nearby elevated subway line. The *dérive* drew to a close as the pair wandered along the canal Saint-Denis 'heading north, making stops – sometimes long, sometimes brief – at various bars patronised by the barge men', ending up in a Spanish bar locally known – appropriately enough – as the 'Tavern of the Revolters'.[71] In contributing to an experimental programme of unitary urbanism, the *dérive* differed from Surrealist city excursions, in that it was not merely a subjective experience relying on undirected chance, but an 'objective' mapping exercise of the 'varied ambiences' encountered

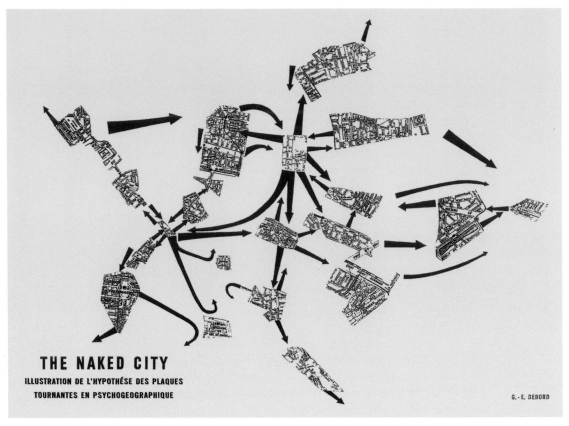

THE NAKED CITY

ILLUSTRATION DE L'HYPOTHÉSE DES PLAQUES
TOURNANTES EN PSYCHOGEOGRAPHIQUE

G.-E. DEBORD

PLATE 12.18 Guy Debord, *The Naked City*, 1957, fragments of a map of Paris, 33 × 48 cm.

and recorded by small groups of observers. *The Naked City* (Plate 12.18), which was produced by Debord with Jorn's assistance in 1957, illustrates how 'the lessons drawn from the *dérive* [would] permit the drawing up of the first psychogeographical articulations of a modern city'.[72] By collaging selected areas of Paris from a commercial street guide, the city is reconstructed on the basis of zones of specific 'ambient' values. The relationship between these 'unities of ambience' rejects the logical, spatial ordering of conventional mapmaking in favour of arrow-headed red lines, whose varying thicknesses are indicative of their 'psychogeographic gradients', which might be thought of in terms of the degree to which such zones might attract or repel transit between them.[73]

Constant was to go beyond the Situationist critique of contemporary urbanism, producing architectural designs for a post-revolutionary society. As it was supposed that automated production would abolish alienated labour, so it was supposed that the *dérive*, as 'play', would replace work. Constant's New Babylon project, which reconceptualised urban space as that of a continuously shifting ambience, has been described as 'one vast site for an extraordinarily pure sort of drift'.[74] *Yellow Sector – New Babylon Project* (Plate 12.19), for example, models one zone of this future city project, its space frame offering unlimited opportunities for the creation of 'situations' through its 'standardised mobile construction elements, like walls, floors and staircases'.[75]

PLATE 12.19 Constant (Constant A. Nieuwenhuys), *Yellow Sector – New Babylon Project*, 1958, metal, plexiglass, wood, 90 × 84 × 24 cm. (Gemeentemuseum, The Hague. © DACS, London 2004.)

Constant was to resign from the SI in June 1960, accused of colluding with the capitalist technocracy, but the view that the authentic individual of the future would be released from the tyranny of Fordism,[76] and that humankind was no longer to be defined by work, underpinned the SI's radical programme (Plate 12.20). 'The value of automation', wrote Jorn, 'depends on projects that succeed it and open the way for expression of human energies on a higher plane.'[77] The increase in leisure time so far achieved under capitalism had not freed the proletariat, but further enchained it within a new form of commodity consumption. To Debord, leisure was now 'an incomparable instrument for stupefying the proletariat', typified by 'the abundance of televised imbecilities [which] is probably one of the reasons for the American working class's inability to develop any political consciousness'.[78]

The SI's engagement with art as a specific practice was principally through *détournement*, theorised around 'two fundamental laws': first, the negation of existing elements, and secondly, 'the organisation of another meaningful ensemble that confers on each element its new scope and effect'.[79] In separate major exhibitions held in Paris in 1959, Jorn and Pinot-Gallizio presented different methods of 'detourning' the bourgeois tradition of easel painting. Pinot-Gallizio, a former chemist, used his laboratory at Alba in Italy for the manufacture of 'industrial paintings' (Plate 12.21). In thus transforming the production of painting he could be seen to fulfil the first of Debord's two basic 'laws' of *détournement*, negating the tradition of the artist-creator through the use of painting machines, producing paintings in rolls up to 145 metres long with spray guns and fast-drying resins. The 'new scope and effect' of the second law might be seen as the deflation of art's commodity value, in so far as sections of the works could be bought by the length, cut off the roll, and used as wall-hangings or tablecloths or wrapped around the future urban spaces of Constant's New Babylon.

PLATE 12.20 *Never Work*, 1953, photograph of graffiti, Paris. First published in *Internationale Situationiste*, no.8, January 1963, p.42 with the accompanying text: 'This inscription, on a wall of the rue de Seine, can be traced back to the first months of 1953 ... The inscription reproduced above seems to us one of the most important relics ever unearthed on the site of Saint Germain-des-Prés: a testament to the particular way of life that tried to assert itself there.'[80] (Photo: V&A Picture Library, London.)

PLATE 12.21 Guiseppe Pinot-Gallizio, *Industrial Painting*, various pigments on paper, 119 × 717 cm. (Silkeborg Kunstmuseum, Denmark.)

Jorn's *détournements*, in a series of works called *Modifications* (*Peinture Detournées*), retained the form of easel painting. Jorn purchased in fleamarkets 'kitsch' works by unknown amateur artists, which he partially over-painted, retaining enough of the earlier works for them to be identifiable in terms of form and subject matter. *Paris by Night* (Plate 12.22) has been modified by Jorn through the addition of Pollock-like dribbles and splashes of black, blue, maroon and white, within which is discernible a form drawn from the realms of Nordic myth floating above the man leaning on the railings. In his catalogue entry for the 1959 exhibition, Jorn wrote: '*Détournement* is a game born out of the capacity for *devalorization*. Only he who is able to devalorize can create new values. And only there where there is *something* to devalorize, that is, an already established value, can one engage in devalorization.'[81] By drawing together the appropriated sub-academic work representative of a worn-out 'fine art' tradition, modernist 'action painting' and folk art in the shape of the Nordic primitivist echoes of Jorn's own pre-SI practice, his

PLATE **12.22** Asger Jorn, *Paris by Night*, 1959, oil on re-used canvas, 53 × 37 cm. (Collection Pierre and Micky Alechinsky, Bougival, France. © Asger Jorn/DACS, London 2004.)

modification might be seen as working to establish a multi-layered sign. Uncertain of its own history and significance, it refuses to accede to easy ideological resolutions, wherever they might come from.

Although Jorn's modifications were acclaimed within the SI at the time, the role of specialist artists in the group was to be relatively short lived. Pinot-Gallizio had been expelled in the summer of 1960, Jorn resigned in April 1961, and general mass expulsions and resignations of artists followed subsequent to the group's fifth international conference at Gothenburg in August 1961. The conference resolved that 'all artistic works by members of the SI' would inevitably be 'recuperated by … society and used against us'.[82] In effect, any 'meaningful ensemble' (in accordance with the second law of *détournement*) could be 'meaningful' only in so far as it conformed to the requirement that 'every situation contains its own negation and moves inevitably towards its own reversal'.[83] It is significant in this respect that Pinot-Gallizio's industrial paintings were immediately embraced by the market, being purchased not by members of the public but by professional collectors, as if demonstrating that 'artistic works', even those that contained their own critique, were not resistant to assimilation within the commodity culture.

This did not result in the SI abandoning its engagement with cultural artefacts, but its sphere of activity was redefined in an effort to exclude the production of objects and images that might possess 'any durable autonomous existence'.[84] In fact, the SI asserted that it was 'the only movement able, by incorporating the survival of art into the art of life, to speak to the project of the authentic artist'.[85] In this regard, *détournement* continued to be employed in tracts and pamphlets, and most notably in the *Internationale Situationiste*. Use was made of detourned media images and already existent comic strips, in which theoretical and political dialogues spoken by the characters rendered the original plot of the images incongruous and absurd, all of which served as a form of agit-prop[86] subversion in the months leading up to the events of May 1968.

Conclusion

Whether the construction of a radical subjectivity necessarily demands the total rejection of existing cultural practices is a far-reaching question, as indeed is the question of whether radical subjectivity is a legitimate or even practical goal for artists to pursue. Debord argued against the production of any artwork, even that displaying 'revolutionary sympathies', which could be 'stocked in the form of commodities'.[87] But the SI has itself become a kind of cultural commodity — the subject of exhibitions, conferences, academic careers and texts, of which this chapter is just one example.[88]

Artists associated with the SI, such as Jorn, tended to be less dogmatic than the 'theorists' as to the attitude they should adopt toward revolutionary consciousness, which the SI sought 'on the other side of culture. Not before it, but *after*.'[89] The complexities of Jorn's own post-SI practice suggest that he did not fully accord with Debord's view that 'commodities are now *all* that there is to see'. He established a reputation within the art market, producing easel paintings with a vigorously expressive form of loose figuration. At the same time, he provided financial support both to Debord and the SI, and to expelled artistic groups, including a breakaway Second Situationist International and the German Gruppe Spur ('Spur Group'). A series of 'modifications' Jorn produced in 1962, *New*

Disfigurations, demonstrated the continuation of *détournement* (Plate 12.23) as a subversive strategy within the tradition of painting. Jorn's own near-mural size painting, which was first shown in 1956 as *The Retreat from Russia*, was continually reworked, undergoing a range of modifications until the final version of 1972, *Stalingrad, No Man's Land or The Mad Laughter of Courage* (Plate 12.24). As a modern history painting, it stands securely in the western 'high art' tradition, yet during this same period Jorn was engaged in producing posters for the May protests of 1968 that aimed to dismantle this very tradition. Jorn's art practice thus encompassed contradictions that Situationist theory refused to countenance, and perhaps that is its strength. Jorn described the painting as 'an *inner* record of a historical event', an event that 'surpassed the human imagination and could no longer be expressed in pictorial terms'.[90] Jorn had written in his 1959 catalogue entry on detourned paintings that 'it is impossible to establish a future without a past. The future is made through relinquishing or sacrificing the past. He who possesses the past of a phenomenon also possesses the sources of its becoming.'[91] On these grounds, we might suppose – or we might suppose that Jorn supposed – that art continued to be a means through which past phenomena could be grasped, not least those phenomena that defied literal depiction or description.

PLATE 12.23
Asger Jorn,
*The Avant-Garde
Doesn't Give Up*,
1962, oil on canvas,
73 × 60 cm.
(Collection Pierre and
Micky Alechinsky,
Bougival, France.
© Asger Jorn/DACS,
London 2001.)

PLATE 12.24 Asger Jorn, *Stalingrad, No Man's Land or The Mad Laughter of Courage*, 1956, 1957–60, 1967, 1972, oil on canvas, 296 x 492 cm. (Silkeborg Kunstmuseum, Denmark. Photo: Lars Bay. © Asger Jorn/DACS, London 2004.)

Notes

Unless otherwise accredited, where quotations from works in French are given in English, the translations are my own.

1 Greenberg, 'Review of an Exhibition of School of Paris Painters' (1946), in O'Brian, *Clement Greenberg*, vol.2, p.87.

2 Viatte, 'Aftermath: A New Generation', p.12.

3 Henry Rousso, quoted in Wilson, 'Paris in the 1960s', p.248.

4 Quoted in Viatte, 'Aftermath: A New Generation', p.12.

5 Kemenov, 'Aspects of Two Cultures' (1947), in Harrison and Wood, *Art in Theory 1900–2000*, VC9, p.658.

6 Picasso's post-liberation artistic status was such that he was claimed as a 'heroic' exemplar across a broad spectrum of political and cultural viewpoints. It is notable that a retrospective exhibition of 74 of his works was included in the 'Salon d'Automne' in October 1944, the same month in which he joined the PCF.

7 De Beauvoir, *Force of Circumstance*, p.38.

8 In a lecture of October 1945, later published under the title of *Existentialism and Humanism*, Sartre argued that the Existentialist concept of absolute individual freedom was concomitant with a broader 'universal' form of moral and social responsibility.

9 Morris, 'The Artists', p.171.

10 Beckett and Duthuit, *Three Dialogues* (1949), in Harrison and Wood, *Art in Theory 1900–2000*, VB7, pp.618, 619.

11 Lukács, 'The Ideology of Modernism' (1957), in *The Meaning of Contemporary Realism*, p.36.

12 Sartre, *Being and Nothingness*, p.40.

13 Sartre, *Existentialism and Humanism*, pp.28, 44.

14 *Ibid.*, pp.34, 29.

15 Sartre, *Situations, IV*, p.422.

16 Tapié, from *An Other Art* (1952), in Harrison and Wood, *Art in Theory 1900–2000*, VB12, p.630.

17 A term used for carving or embossing that protrudes only moderately from the background plane.

18 Quoted in Viatte and Wilson, 'Aspects of Realism', p.53.

19 Quoted in Morris, 'The Artists', pp.90, 89.

20 Sartre, *Nausea*.

21 Sartre, quoted in Wilson, 'Paris Post War', p.35.

22 Hans Haftman, quoted in Bauer, *Sartre and the Artist*, p.150.

23 Wols, Aphorisms (1940s), in Harrison and Wood, *Art in Theory 1900–2000*, VB1, p.596.

24 *Ibid.*, p.599.

25 Sartre, 'Doigts et Non-Doigts' ('Fingers and Non-Fingers') (1963), reprinted in *Situations, IV*, p.426.

26 *Ibid.*, p.433.

27 *Ibid.*, p.431.

28 Prinzhorn, *Artistry of the Mentally Ill*, pp.50–1.

29 Dubuffet, 'Crude Art Preferred to Cultural Art' (1949), in Harrison and Wood, *Art in Theory 1900–2000*, VB4, pp.606, 608.

30 *Ibid.*, p.607.

31 Selz, *The Work of Jean Dubuffet*, p.20.

32 Quoted in *ibid.*, p.10.

33 Quoted in *ibid.*, p.19.

34 Dubuffet, 'Landscape Tables, Landscapes of the Mind, Stones of Philosophy' (1952), in Selz, *The Work of Jean Dubuffet*, pp.63–4.

35 Quoted in Wilson, *The Tate Gallery*, p.196.

36 Ponge, 'Reflections on the Statuettes, Figures and Paintings of Alberto Giacometti' (1951), in Harrison and Wood, *Art in Theory 1900–2000*, VB10, p.625.

37 As summarised by Morris in 'The Artists', p.105.

38 Sartre, 'The Search for the Absolute' (1948), in Harrison and Wood, *Art in Theory 1900–2000*, VB6, p.612.

39 Giacometti, in Sylvester, 'An Interview with Giacometti by David Sylvester' (1964), reprinted in Drew and Harrison, *Giacometti*, p.7.

40 Sartre, 'The Search for the Absolute' (1948), in Harrison and Wood, *Art in Theory 1900–2000*, VB6, p.615.

41 Constant, 'Our Own Desires Build the Revolution', p.3. Extracts are reprinted in Harrison and Wood, *Art in Theory 1900–2000*, VC11, pp.659–60.

42 *Cobra*, no.1, 1949, p.1.

43 Quoted in Lambert, *Cobra*, p.24.

44 Quoted in *ibid.*, p.22.

45 Dotremont, quoted in *ibid.*, p.134.

46 Lefebvre, *Critique of Everyday Life*, p.133.

47 *Ibid.*, p.199.

48 Quoted in Lambert, *Cobra*, p.17.

49 Jorn, 'Conversations with Penguins', p.8.

50 Quoted in Lambert, *Cobra*, p.95.

51 Quoted in Birtwistle, *Living Art*, p.65.

52 Constant, 'Our Own Desires Build the Revolution', p.3. Extracts are reprinted in Harrison and Wood, *Art in Theory 1900–2000*, VC11, pp.659–60.

53 Quoted in Birtwistle, *Living Art*, pp.35, 180.

54 Constant, 'Our Own Desires Build the Revolution', p.3. Extracts are reprinted in Harrison and Wood, *Art in Theory 1900–2000*, VC11, pp.659–60.

55 Corneille, in *Cobra* no.4, 1949, p.14. This was one of a series of ten aphorisms spread throughout the whole issue of the journal. Others included 'realism is the negation of reality' (p.12) and 'the best picture is one that reason cannot admit' (p.19).

56 Quoted in Lambert, *Cobra*, p.123.

57 Atkins with Andersen, *Jorn in Scandinavia*, p.64.

58 Quoted in *ibid.*, p.63.

59 *Ibid.*, p.65.

60 Constant, in a letter to the Tate, reprinted in *The Tate Gallery*, p.502.

61 Canjuers and Debord, 'Preliminaries Towards Defining a Unitary Revolutionary Program' (1960), in Knabb, *Situationist International Anthology*, pp.305–8.

62 Debord, *The Society of the Spectacle*, p.29.

63 *Ibid.*, p.23.

64 'The Bad Days Will End', unattributed article originally published in *Internationale Situationiste*, no.7, April 1962, reprinted in Knabb, *Situationist International Anthology*, pp.82–7; quote p.87.

65 Debord, *The Society of the Spectacle*, p.34.

66 The SI's concept of 'situation' went beyond Sartre's Existentialist understanding of *given* contexts within which individual choices are made, to that of *positive* interventions within social life leading to its radical transformation.

67 Debord, 'Introduction to a Critique of Urban Geography' (1955), in Knabb, *Situationist International Anthology*, p.5.

68 Debord and Wolman, 'Methods of Detournement' (1956), in Knabb, *Situationist International Anthology*, pp.8–9.

69 'Detournement as Negation and Prelude', unattributed article originally published in *Internationale Situationiste*, no.3, December 1959, reprinted in Knabb, *Situationist International Anthology*, pp.55–6; quote p.55.

70 Debord, quoted in Levin, 'Geopolitics of Hibernation', p.114.

71 Debord, 'Two Accounts of the Dérive' (1956), in Sussman, *On the Passage of a Few People through a Very Brief Moment in Time*, pp.138–9.

72 Debord, 'Theory of the *Dérive*' (1958), in Knabb, *Situationist International Anthology*, p.51.

73 The reverse side of *The Naked City* explains that 'The arrows represent the slopes that naturally link the different unities of ambiance; that's to say the spontaneous tendencies for orientation of a subject who traverses that milieu without regard for practical considerations.' Quoted in Sadler, *The Situationist City*, p.88.

74 *Ibid.*, p.141.

75 Constant, quoted in *ibid.*, p.132.

76 'Fordism' refers to the mass production and consumption characteristic of highly developed economies in the 1930s–1960s. The term derives from the name of Henry Ford, originator of the Ford car industry.

77 Jorn, 'The Situationists and Automation' (1958), in Knabb, *Situationist International Anthology*, p.46.

78 Debord, 'Report on the Construction of Situations and on the International Situationist Tendency's Conditions of Organization and Action' (1957), in Knabb, *Situationist International Anthology*, p.24.

79 'Detournement as Negation and Prelude', unattributed article originally published in *Internationale Situationiste*, no.3, December 1959, reprinted in Knabb, *Situationist International Anthology*, pp.55–6; quote p.55.

80 Quoted in Marcus, *Lipstick Traces*, p.175.

81 Jorn, 'Detourned Painting' (1959), in Harrison and Wood, *Art in Theory 1900–2000*, VIA4, p.709.

82 Kotányi, 'The Fifth SI Conference in Göteborg', unattributed conference report originally published in *Internationale Situationiste*, no.7, April 1962, reprinted in Knabb, *Situationist International Anthology*, pp.88–9; quote p.88.

83 'The Sense of Decay in Art', unattributed article originally published in *Internationale Situationiste*, no.3, December 1959, reprinted in *October 79*, pp.102–8; quote p.106.

84 Debord, *The Society of the Spectacle*, p.146.

85 'Questionnaire', unattributed article originally published in *Internationale Situationiste*, no.9, August 1964, reprinted in Knabb, *Situationist International Anthology*, pp.138–42; quote p.139.

86 A term coined following the Russian Revolution of 1917 to describe art employed specfically for political and agitational purposes.

87 Debord, 'Perspectives for Conscious Alterations in Everyday Life' (1961), reprinted in Knabb, *Situationist International Anthology*, p.75.

88 The SI refused the term 'Situationism'. The group defined this as a 'meaningless term, which would mean a doctrine of interpretation of existing facts': 'Definitions' (1958), quoted in *ibid.*, p.45.

89 'The Avant-Garde of Presence', unattributed article originally published in *Internationale Situationiste*, no.8, January 1963, reprinted in *October 79*, pp.129–38; quote p.137.

90 From a résumé record by Guy Atkins of conversations with Jorn in 1963 and 1970, in Atkins with Andersen, *Asger Jorn*, p.49.

91 Jorn, 'Detourned Painting' (1959), in Harrison and Wood, *Art in Theory 1900–2000*, VIA4, p.709.

References

Atkins, G. with Andersen T., *Asger Jorn: The Crucial Years, 1954–1964*, London: Lund Humphries, 1977.

Atkins, G. with Andersen, T., *Jorn in Scandinavia, 1930–1953*, New York: George Wittenborn, 1968.

Bauer, G.H., *Sartre and the Artist*, Chicago: University of Chicago Press, 1969.

Birtwistle, G., *Living Art: Asger Jorn's Comprehensive Theory of Art between Helhesten and Cobra (1946–1949)*, Utrecht: Reflex, 1986.

Cobra: bulletin pour la coordination des investigations artistiques, nos 1–10, 1948–1951 (facsimile reprint), Paris: Éditions Jean-Michele Place, 1980.

Constant (Nieuwenhuys, Constant A.), 'Our Own Desires Build the Revolution', *Cobra*, no.4, 1949, pp.3–4.

De Beauvoir, S., *Force of Circumstance*, trans. R. Howard, London: André Deutsch and Weidenfeld & Nicolson, 1965 (first published 1963).

Debord, G., *The Society of the Spectacle*, New York: Zone Books, 1994 (first published 1967).

Dotremont, C., *'Socialist Realism' against the Revolution*, Brussels: Éditions Cobra, 1950.

Drew, J. and Harrison, M. (eds), *Giacometti: Sculptures, Paintings, Drawings*, exhibition catalogue, Arts Council of Great Britain, London, 1980.

Harrison, C. and Wood, P. (eds), *Art in Theory 1900–2000: An Anthology of Changing Ideas*, Malden, MA and Oxford: Blackwell, 2003.

Jorn, A., 'Conversation with Penguins' *Cobra*, no.1, 1949, p.8.

Jorn, A., 'Forms Conceived as Language' *Cobra*, no.2, 1949, unpaginated.

Knabb, K. (ed. and trans.), *Situationist International Anthology*, Berkeley: Bureau of Public Secrets, 1981.

Lambert, J.-C., *Cobra: Un Art Libre*, Sotheby Publications, London, 1983.

Lefebvre, H., *Critique of Everyday Life*, vol.1: *Introduction*, trans. J. Moore, London: Verso, 1991 (first published 1947).

Levin, T., 'Geopolitics of Hibernation: The Drift of Situationist Urbanism', in L. Andreotti and C. Xavier (eds), *Situationists: Art, Politics, Urbanism*, exhibition catalogue, Museu d'Art Contemporani de Barcelona, 1996, pp.111–46.

Lukács, G., *The Meaning of Contemporary Realism*, trans. J. Mander and N. Mander, London: Merlin Press, 1963.

Marcus, G., *Lipstick Traces: A Secret History of the Twentieth Century*, London: Secker & Warburg, 1989.

Morris, F., 'The Artists', in *Paris Post War*, pp.63–204.

Morris, F. (ed.), *Paris Post War: Art and Existentialism 1945–55*, exhibition catalogue, Tate Gallery, London, 1993.

O'Brian, J. (ed.), *Clement Greenberg: The Collected Essays and Criticism*, vol.2: *Arrogant Purpose 1945–1949*, Chicago: University of Chicago Press, 1986.

October 79, Cambridge, MA: MIT Press, 1997.

Prinzhorn, H., *Artistry of the Mentally Ill: A Contribution to the Psychology and Psychopathology of Configuration*, trans. E. von Brockdorff, Vienna: Springer, 1995 (first published 1922).

Sadler, S., *The Situationist City*, Cambridge, MA: MIT Press, 1998.

Sartre, J.-P., *Being and Nothingness*, trans. H.E. Barnes, London: Methuen, 1957 (first published 1943).

Sartre, J.-P., *Existentialism and Humanism*, trans. P. Mairet, London: Methuen, 1948 (first published 1946).

Sartre, J.-P., *Nausea*, trans. L. Alexander, London: H. Hamilton, 1962 (first published 1938).

Sartre, J.-P., *Situations, IV*, Paris: Gallimard, 1964.

Selz, P., *The Work of Jean Dubuffet*, exhibition catalogue, Museum of Modern Art, New York, 1962.

Sussman, E. (ed.), *On the Passage of a Few People through a Very Brief Moment in Time: The Situationist International, 1957–1972*, Cambridge, MA: MIT Press, 1989.

The Tate Gallery, 1984–1986: Illustrated Catalogue of Acquisitions, London: Tate Gallery Publications, 1988.

Viatte, G., 'Aftermath: A New Generation', in Viatte and Wilson, *Aftermath: France 1945–54*, pp.11–14.

Viatte, G. and Wilson, Sarah, *Aftermath: France 1945–54: New Images of Man*, exhibition catalogue, Barbican Art Gallery, London, 1982.

Viatte, G. and Wilson, Sarah, 'Aspects of Realism', in *Aftermath: France 1945–54*, pp.42–71.

Wilson, Sarah, 'Paris Post War: In Search of the Absolute', in Morris, *Paris Post War*, pp.25–52.

Wilson, S., 'Paris in the 1960s: Saint-Germaine-des-Prés: Antifascism, Occupation and Post-War Paris', in *Paris: Capital of the Arts 1900–1968*, exhibition catalogue, Royal Academy of Arts, London, 2002, pp.236–49.

Wilson, Simon, *The Tate Gallery: An Illustrated Catalogue*, London: Tate Gallery Publications, 1990.

Further reading

Part One

Ades, D., Benton, T., Elliott, D. and Boyd-Whyte, I. (eds), *Art and Power: Europe under the Dictators 1930–45*, exhibition catalogue, Hayward Gallery, London, 1995.

Curtis, P., *Sculpture 1900–1945*, Oxford: Oxford University Press, 1999.

Green, C., *Art in France 1900–1940*, New Haven and London: Yale University Press, 2000.

Mundy, J. (ed.), *Surrealism: Desire Unbound*, exhibition catalogue, Tate Publishing, London, 2001.

Richardson, M. (ed.), *Refusal of the Shadow: Surrealism and the Caribbean*, London: Verso, 1996.

Part Two

Frascina, F., *Pollock and After: The Critical Debate*, second revised edition, London and New York: Routledge, 2000.

Hemingway, A., *Artists and the Left*, New Haven and London: Yale University Press, 2002.

Leja, M., *Reframing Abstract Expressionism*, New Haven and London: Yale University Press, 1993.

O'Brian, J. (ed.), *Clement Greenberg: The Collected Essays and Criticism*, four volumes, Chicago: University of Chicago Press, 1986–93.

Polcari, S., *Abstract Expressionism and the Modern Experience*, Cambridge: Cambridge University Press, 1991.

Part Three

Batchelor, D., *Minimalism*, London: Tate Publishing, 1997.

Causey, A., *Sculpture since 1945*, Oxford: Oxford University Press, 1998.

Crow, T., *The Rise of the Sixties*, London: Weidenfeld and Nicolson, 1996.

Fried, M., *Art and Objecthood: Essays and Reviews*, Chicago: University of Chicago Press, 1998.

Guilbaut, S. (ed.), *Reconstructing Modernism*, Cambridge MA and London: MIT Press, 1990.

Meyer, J., *Minimalism: Art and Politics in the Sixties*, New Haven and London: Yale University Press, 2001.

Potts, A., *The Sculptural Imagination*, New Haven and London: Yale University Press, 2000.

Westerbeck, C. and Meyerowitz, J., *Bystander: A History of Street Photography*, London: Thames & Hudson, London.

Part Four

Buchloh, B.H.D., *Neo-Avantgarde and Culture Industry: Essays on European and American Art from 1955 to 1975*, Cambridge MA and London: MIT Press, 2000.

Debord, G., *The Society of the Spectacle*, trans. D. Nicholson-Smith, New York: Zone Books, 1994.

Knabb, K. (ed.), *Situationist International Anthology*, Berkeley, CA: Bureau of Public Secrets, 1981–9.

Orton, F., *Figuring Jasper Johns*, London: Reaktion Books, 1996.

Stiles, K., 'Performance', in R. Nelson and R. Shiff (eds), *Critical Terms for Art History*, second expanded edition, Chicago: University of Chicago Press, 2002.

Acknowledgement

Grateful acknowledgement is made to the following source for permission to reproduce material within this product: Alfred Otto Wolfgang Schulze Wols, 'Aphorisms', 1940s, translated by Peter Inch and Annie Fatet in *Wols: Aphorisms and Pictures*, published by the Arc Press, Gillingham, 1971.

Index

Page numbers in **bold** refer to plates. Exhibitions, galleries and museums are listed alphabetically under 'exhibitions' or 'galleries and museums' rather than as independent entries.